AFRICA AND THE RENAISSANCE

AFRICA AND THE RENAISSANCE: ART IN IVORY

EZIO BASSANI AND WILLIAM B. FAGG

EDITED BY SUSAN VOGEL
ASSISTED BY CAROL THOMPSON

WITH AN ESSAY BY PETER MARK

THE CENTER FOR AFRICAN ART
AND PRESTEL-VERLAG

for Gustave Schindler

Africa and the Renaissance: Art in Ivory is published in conjunction with an exhibition of the same title organized and presented by The Center for African Art, New York, and at The Museum of Fine Arts, Houston.

The exhibition is supported by grants from the National Endowment for the Arts; The National Endowment for the Humanities; The New York State Council on the Arts; and the Samuel H. Kress Foundation.

Trade edition distributed by Prestel-Verlag, Mandlstrasse 26, D-8000 Munich 40. Distributed in the United States of America and Canada by te Neues Publishing Company, 15 East 76th Street, New York City 10021.

Library of Congress catalogue card no. 88-30423
Clothbound ISBN 3-7913-0880-7
Paperbound 0-945802-01-3
Printed in Japan.

CONTENTS

CURRENT DONORS

Charles B. Benenson
Sidney and Bernice Clyman
Mr. and Mrs. Irwin Ginsburg
Denyse and Marc Ginzberg
Lawrence Gussman
Jay and Deborah Last
Helene and Philippe Leloup
Adrian and Robert Mnuchin
Carlo Monzino
Mr. and Mrs. James J. Ross
Lynne and Robert Rubin
Cecilia and Irwin Smiley
Sheldon H. Solow
Paul and Ruth Tishman
Robert Aaron Young

Alain de Monbrison
George and Gail Feher
John Friede
Dr. and Mrs. Gilbert Graham
Clayre and Jay Haft
Jill and Barry Kitnick
Mr. and Mrs. Joseph Knopfelmacher
Helen and Robert Kuhn
Mr. and Mrs. Brian Leyden
Marian and Daniel Malcolm
Burton and Junis Marcus
Robert and Nancy Nooter
Freddy Rolin
Mr. and Mrs. Edwin Silver
Saul and Marsha Stanoff

Mr. and Mrs. S. Thomas Alexander
Ernst Anspach
William Bolton
William W. Brill
Oliver and Pamela Cobb
Roland de Montaigu
Sulaiman Diané
Patrick Dierickx
Elisabeth Ely
Jeremiah H. Fogelson
Phyllis Goldman
Rita and John Grunwald
Agnes Gund
Herbert Waide Hemphill, Jr.
Mr. and Mrs. Stuart Hollander
Daniel Hourdé
Helen Kimmelman
Don and Lee Krueckeberg
Samuel and Gabrielle Lurie
Balene McCormick
Anuschka Menist
Mr. and Mrs. Howard Nelson
Dorothy Brill Robbins

Eric Robertson
Alfred L. Scheinberg
Maurice W. Shapiro
Stephen and Tania Slifer
Mr. and Mrs. John H. Smither
Thomas Z. van Raalte
Faith-dorian and Martin Wright
William U. Wright

Dr. and Mrs. Pickward J. Bash, Jr.
Jane Bedichek
Dr. F. Beineke
Richard Benenson
Dr. Michael Berger
Mr. and Mrs. Michael Cohen
Mr. Gaston T. de Havenon
David DeRoche
Drs. Nicole and John Dintenfass
Mr. and Mrs. Richard Faletti
Ms. Jamie Gagarin
John Giltsoff
Jacques Hautelet
Udo Horstmann
Jerome L. Joss
Mr. and Mrs. Morton Lipkin
Mr. Stanley Lederman
Lee Lorenz
Mr. William Machado
Mrs. Natalie G. Maran
Mr. and Mrs. Thomas Marill
Leonard L. Milberg
Robin Mix
Dr. Werner Muensterberger
Don H. Nelson
Mr. and Mrs. Klaus Perls
Mr. and Mrs. Fred Richman
Mr. and Mrs. Milton Rosenthal
Mr. and Mrs. Harry Rubin
Gustave and Franyo Schindler
Dr. and Mrs. Jerome H. Siegel
Vincent M. Smith
Mr. and Mrs. Arthur Solomon
Mr. and Mrs. Morton Sosland
Mrs. Betty Stanley
Mr. Dwight V. Strong
Peter Wengraf
Ruth E. Wilner
Mr. and Mrs. William S. Woodside

Mr. and Mrs. Edward Aboudi
Arnold Alderman
Barbara and Daniel Altman
Barbara S. Aronson
Isabel Ault
Andrea Azar

Dr. Sheldon Bach
Sigmund R. Balka
Neal Ball
Joan Barist
Howard and Saretta Barnet
Leonard S. Barton
Armand Bartos, Jr.
Ralph Baxter
Stephen Benjamin
Dr. and Mrs. Samuel Berkowitz
Sid and Gae Berman
Creighton Berry
Mildred Bijur
Alan Brandt
Rev. Raymond E. Britt, Jr.
Edward and Marianne Burak
Anthony Chen
Glenda D. Cohen
Jeffrey Cohen and Nancy Seiser
Mr. and Mrs. Alan D. Cohn
Carolyn Cohn
Priscilla Colt
Scott and Soussan Cook
Mr. and Mrs. Herman Copen
Daniel and Joyce Cowin
Mr. and Mrs. DuVal Cravens
Katherine D. Crone
Robert and Mary Cumming
Marie Eliane d'Udekem d'Acoz
Gerald and Lila Dannenberg
Louis de Strycker
Mr. David Deiss
Morton Dimondstein
Sergio Dolfi
Mrs. Jannett T. Downer
Linda Einfeld
Harrison Eiteljorg
John Elliott
Mr. and Mrs. Francis M. Ellis
Marc Felix
Vianna Finch
Richard Fishman
Mr. and Mrs. Donald Flax
Charles Flower
Mr. Gordon Foster
Marc and Ruth Franklin
Dr. Joseph French
Dr. and Mrs. Murray B. Frum
Clara K. Gebauer
Dr. and Mrs. Joseph Gerofsky
Nelsa Gidney
Larry Mark Goldblatt
Mr. and Mrs. Joseph Goldenberg
Hubert Goldet
Mr. and Mrs. Neal Gordon

Donald S. Gray
Edwin Greenblatt and
 Ursula von Rydingvard
Dr. Irwin E. Gross
Mr. and Mrs. Murray Gruson
Mrs. Melville W. Hall
Dr. Sidney Hart
Ronald S. Hansford
Lenore Hecht
Mr. and Mrs. John Heller
Mr. and Mrs. Paul Herring
Arnold Herstand
Mr. George H. Hutzler
Claudette and Robert Isaacs
Eugene D. Jackson
Harmer and Judith Johnson
Mr. and Mrs. Charles Jones
Mr. Isidor Kahane
Jerome and Carol Kenney
Lynn and Jules Kroll
John W. Kunstadter
Leroy Latta
Amy and Elliot Lawrence
Sol and Josephine Levitt
Richard and Mimi Livingston
Heidi Loeb
Joan Lovell
Mrs. J. Hart Lyon
Mr. and Mrs. Lester Mantell
The Hon. and Mrs. Anthony
 Marshall

Barry D. Maurer
Anne and Jacques Maus
Nancy G. Mayer
Dr. Margaret McEvoy
Mr. and Mrs. John McGee
John McKesson
Robin and James McMillin
Risha Meledandri-Espiritu
Jane B. Meyerhoff
Edwin Michalove
Mr. and Mrs. Peter Mickelsen
Sam Scott Miller
Mrs. F. Franklin Moon
Mrs. John R. Muma
Ms. Judith Nash
Mr. Arthur H. Nethercot, Jr.
Mr. and Mrs. Roy R. Neuberger
Mace and Helen Neufeld
Mr. and Mrs. Ricard Ohrstrom
David T. Owsley
Pearl Oxorn
Joseph Pulitzer, Jr.
Ronald E. Pump
Mr. and Mrs. Cecil A. Ray
Mr and Mrs. C. W. Reiquam
Paula D. Rice
Mrs. Beatrice Riese
Warren M. Robbins
John B. Rosenthal
Mr. and Mrs. Daniel G. Ross
Mr. and Mrs. David B. Ross
Mr. and Mrs. Philip Rothblum

Mr. and Mrs. Stephen Rubin
Mr. William Rubin
Jean-Pierre Ruquois
Barbara and Ira Sahlman
Mr. and Mrs. Arthur Sarnoff
Eugenia Shanklin
Sydney L. Shaper
Mr. and Mrs. John Sharp
Ms. Mary Jo Shepard
Mr. and Mrs. James D. Silbersack
Paul Simon
Thelma and Adrian Sokoloff
Gary Spratt
Mr. and Mrs. Dixon Stanton
John and Carolyn Stremlau
Mr. and Mrs. Arnold Syrop
Mr. and Mrs. William E. Teel
Mr. Paul LeBaron Thiebaud
Mrs. Edward Townsend
Mr. Jack Travis
Dr. and Mrs. Saul Unter
Lucien van de Velde
Phyllis Tucker Vinson
Anthony and Margo Viscusi
Dr. and Mrs. Bernard M. Wagner
Frederic and Lucille Wallace
Dr. and Mrs. Leon Wallace
Byron R. Wien
Mr. and Mrs. O. S. Williams
Susan Yecies
Bernard Young

INSTITUTIONAL DONORS

Arcade Gallery
Celanese Corporation
Damon Brandt Gallery
Davis Gallery
Department of Cultural Affairs,
 City of New York
Donald Morris Gallery
L & R Entwistle
IBM Matching Grants for
 Hospitals & Arts
Institute of Museum Services
James Willis Gallery

Samuel H. Kress Foundation
Montedison USA Inc.
National Endowment for the
 Arts
National Endowment for the
 Humanities
New York State Council
 on the Arts
New York Council for the
 Humanities
Pace Primitive and
 Ancient Art

Philip Morris Companies Inc.
Puget Sound Fund
Reader's Digest Foundation
 Matching Gift Program
Rockefeller Foundation
Sotheby's
Tambaran Arts, Inc.
The Olfert Dapper Foundation
The Xerox Foundation
Universal City Studios Inc.

Current as of August 15, 1988

THE CENTER
FOR AFRICAN ART

We hope this exhibition startles—even disconcerts—many people and that visiting it and reading this book will lead them to abandon ideas they have carried along comfortably since childhood. The Center for African Art was founded to increase appreciation and understanding of the continent and her ancient cultures. We do this by presenting art exhibitions and by publishing new ideas about African art. *Africa and the Renaissance* is an unusual exhibition in that it connects ancient Africa to the wider world, and reaches further back in time than most African art exhibitions. The ivories presented here were created by African artists between 1490 and 1600, a period barely recognized in nonspecialist thinking about Africa.

This book and exhibition contradict assumptions about the isolation and backwardness of Africa, about her primitiveness and the difference between her people and Europe's. Africa is often said to "have no history." The ivories here, made at the moment of first contact, are evidence of sophisticated artists working in African kingdoms and courts in the fifteenth and sixteenth century, an era when African ambassadors resided at the Vatican, when Europeans and Africans traded on an equal footing. The precious ivories gathered for this exhibition come from the far reaches of Europe and America. They have never been under one roof before. Seeing them together, we will be privileged to discover things even their makers may not have known. When the ivories disperse it will probably be for the rest of our lifetimes.

The Center has presented eleven exhibitions since its founding four years ago. We hope they have all added to what is known about Africa. Without a collection of its own, The Center draws on the storerooms of the world, presenting the finest objects, famous and unknown, reinterpreted in the light of new juxtapositions and fresh ideas. The Board of Directors recently voted to accept donations or bequests of whole collections of high aesthetic quality with the objective of ultimately forming a collection that will be superlative rather than encyclopedic. The Center's collection will be used to maintain our high level of activity: we will use it with loans in exhibitions like the ones we presently do; to form thematic exhibitions for universities; and as a hands-on education collection. We will not freeze it in a permanent exhibition or bury it in storage.

EXHIBITIONS

AFRICAN MASTERPIECES FROM THE MUSÉE DE L'HOMME, 1984
(Catalogue by Susan Vogel and
Francine N'Diaye)

IGBO ARTS: COMMUNITY AND COSMOS, 1985
(From the University of California,
Los Angeles)

SETS, SERIES, AND ENSEMBLES IN AFRICAN ART, 1985
(Catalogue by George Preston and
Polly Nooter)

ARTS OF THE GURO OF IVORY COAST, 1985
(From the Reitberg Museum, Zurich)

AFRICAN AESTHETICS: THE CARLO MONZINO COLLECTION, 1986
(Catalogue by Susan Vogel)

THE ESSENTIAL GOURD: FROM THE OBVIOUS TO THE INGENIOUS, 1986
(From the University of California,
Los Angeles)

AFRICAN MASTERPIECES FROM MUNICH: THE STAATLICHES MUSEUM FÜR VÖLKERKUNDE, 1987
(Catalogue by Maria Kecskesi)

PERSPECTIVES: ANGLES ON AFRICAN ART, 1987
(Catalogue by James Baldwin, Romare
Bearden, et al.)

ART/ARTIFACT: AFRICAN ART IN ANTHROPOLOGY COLLECTIONS, 1988
(Catalogue by Arthur Danto, R. M.
Gramly, et al.)

THE ART OF COLLECTING AFRICAN ART, 1988
(Catalogue by R. and N. Nooter, E.
Anspach, Arman, et al.)

In two exhibitions we turned our attention to the Western audience and scrutinized how we look at African art. *Perspectives: Angles on African Art* (1987) invited ten individuals to select and discuss African objects from their differing points of view. They ranged from an African diviner to an American curator of twentieth century art. *Art/artifact* (1988) questioned the classification of African objects according to those terms and installed objects in four different ways to show how museum presentations influence the viewer.

Masterpieces from distant collections of surpassing excellence were shown from the Musée de l'Homme, the Staatliches Museum für Völkerkunde in Munich, and from the Carlo Monzino collection. The first was an examination of the history of collecting and of the tensions between aesthetics and anthropology in a great research institution. The second was a compendium of research on African art, and a consideration of changing tastes and styles visible in a collection amassed over a century. The third was an exercise that sought to understand how much our judgments of aesthetic excellence in African works of art agree with the opinions of the original owners.

The exhibitions we originate also travel; the following museums in twenty-four American cities have presented or soon will present Center exhibitions: The High Museum, Atlanta; The Baltimore Museum of Art; Birmingham Museum of Art; Buffalo Museum of Science; The Art Institute of Chicago; Cincinnati Museum of Art; The Cleveland Museum of Art; Columbus Museum of Art; Dallas Museum of Art; The Denver Art Museum; The Museum of Fine Arts, Houston; Wight Art Gallery, Los Angeles; Madison Art Center; Lowe Art Museum, Miami; New Orleans Museum of Art; The Chrysler Museum, Norfolk; The Carnegie, Pittsburgh; Virginia Museum of Fine Arts, Richmond; San Diego Museum of Art; Henry Art Gallery, Seattle; Tucson Museum of Art; National Museum of African Art, Washington; and Worcester Art Museum. The Center aspires to be a true center, collaborating with museums in other communities to bring African art to the widest possible public.

ACKNOWLEDGMENTS

The Center for African Art is grateful to the institutions, their directors and curators, and to the collectors who lent their precious objects to this exhibition. For help and enthusiastic support received during the research and preparation of the catalogue, we are grateful to Dr. Malcolm McLeod, of the Museum of Mankind, London; Mrs. Maria Helena Mendes Pinto, of the Museu Nacional de Arte Antiga, Lisbon; Mr. Roberto Fainello of Sotheby's, London; Tim Teuten of Christie's, London; Dr. Wendy Hefford and Dr. Claude Blair, of the Victoria and Albert Museum, London; Dr. Charles W. Talbot, of Trinity University; Dr. Richard Randall; Dr. Lionello Boccia, of the Museo Stibbert, Florence, and Dr. Giovanni Piazza, of the Biblioteca Trivulziana, Milan. We are especially grateful to Hermione Waterfield, of Christie's, London, for her dedicated perseverence and kind assistance throughout the duration of this project.

At The Center, the efficiency and dedication of the staff saw the completion of this complex project. John Morning and Jerry Thompson brought their considerable expertise to the design and photography of the catalogue. Special thanks to Ron Siegel, indefatigable typesetter at David E. Seham Associates. For assistance in the preparation of the first draft we warmly thank Polly Nooter; Jeanne Mullin copy edited and revised the text for which enormous undertaking we are most grateful. Lisa Ely, Georgina D'Alessandro and Stacy Marcus all helped with early revisions of the book. Charles Little, James Boon and Robert Farris Thompson read the manuscript in its early stages and provided us with useful comments. We thank Jeffrey Strean for the design of the exhibition installation.

We are particularly grateful to Carol Thompson without whom this project could not have been completed. She oversaw every stage of the production of this complex publication. We are thankful also to Pam Bash, Ima Ebong and Amy McEwen, who assisted in the completion of the project. Robert Rubin, Thomas Wheelock, Melanie Forman, Patricia Gloster and all at The Center brought unreserved energy and assistance to the project.

The Center for African Art is grateful for the support received from the National Endowment for the Humanities, the National Endowment for the Arts, The New York State Council on the Arts and the Samuel H. Kress Foundation.

E.B.

W.B.F.

S.V.

LENDERS TO THE EXHIBITION

Baltimore, The Walters Art Gallery
Bologna, Museo Civico Medievale
Cologne, Rautenstrauch-Joest-Museum für Völkerkunde
Copenhagen, The National Museum of Denmark
Detroit, The Detroit Institute of Arts
Ecouen, Musée National de la Renaissance, Château d'Ecouen
Edinburgh, Royal Museum of Scotland
Florence, Museo degli Argenti, Palazzo Pitti
Glasgow, Glasgow Museums & Art Galleries
Leiden, Rijksmuseum voor Volkenkunde
Lille, Musée des Beaux Arts
Lisbon, Museu Nacional de Arte Antiga
Lisbon, Palàcio Nacional da Ajuda
Liverpool, Merseyside County Museums
London, Museum of Mankind, The British Museum
Los Angeles, The Paul and Ruth Tishman Collection of African Art,
 The Walt Disney Company
Lugano, Carlo Monzino collection
Minneapolis, The Minneapolis Institute of Arts
Modena, Galleria e Museo Estense
Munich, Staatliches Museum für Völkerkunde
New York, Ernst Anspach collection
New York, W. Graham Arader III Gallery
New York, Ruth Blumka collection
New York, Sidney and Bernice Clyman collection
New York, Jay and Clayre Haft collection
New York, Drs. Daniel and Marian Malcolm collection
New York, The Metropolitan Museum of Art
New York, New York Public Library
New York, Francesco Pellizzi collection
New York, The Schomburg Center for Research in Black Culture
New York, Paul and Ruth Tishman collection
New York, William and Niki Wright collection
Oberlin, Allen Memorial Art Museum, Oberlin College
Oxford, Pitt Rivers Museum, University of Oxford
Palm Harbor, Florida, Mario Meneghini collection
Paris, Madame N. Kugel collection
Paris, Musée National des Thermes et de l'Hôtel de Cluny
Paris, Foundation Dapper
Prague, Náprstkovo Muzeum
Richmond, The Virginia Museum of Fine Arts
Rome, Museo Nazionale Preistorico e Etnografico
Seattle, Seattle Art Museum
Tervuren, Musée Royal de l'Afrique Centrale
Toronto, Barbara and Murray Frum collection
Turin, Museo Civico di Torino
Vienna, Museum für Völkerkunde

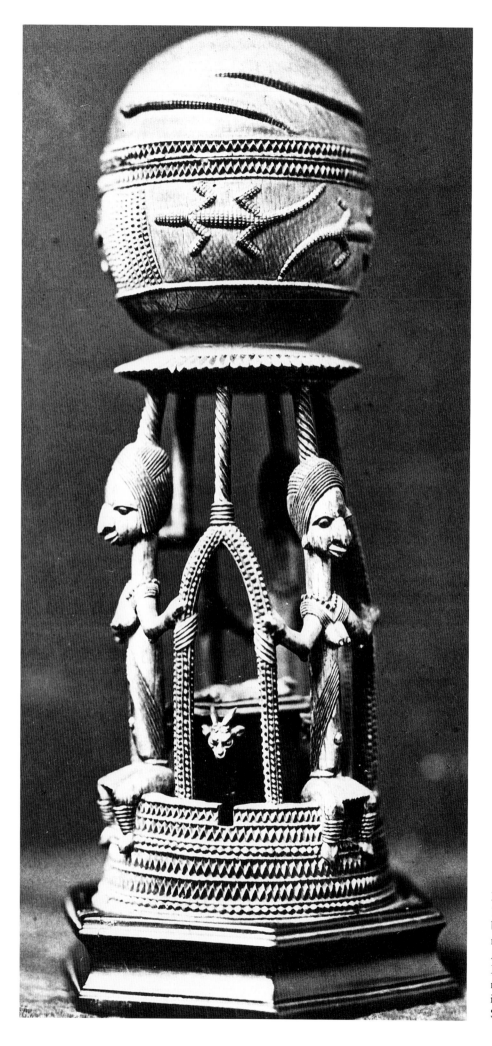

I. Saltcellar. Sapi-Portuguese, ca. 1490-1530. The spherical container, resembling a gourd or round-bottomed pot, rests atop an openwork base that recalls African pot stands. Since there are no European prototypes for this configuration which is close to the African one, it can be assumed to be African in origin. Size and whereabouts unknown (no. 36).

INTRODUCTION
AFRICA AND THE RENAISSANCE

BY SUSAN VOGEL

The first objects from Black Africa to reach European collections were ivories brought from West Africa to Portugal in the last years of the fifteenth century. Records of import duties paid at Lisbon for the year 1504-05 show that on eighteen occasions in the course of that year alone sailors and merchants returning from the coast of West Africa paid taxes on ivory spoons and *saleiros,* or saltcellars. The Portuguese had first landed on the Sierra Leone coast in 1460, only forty years earlier. By 1520-21 the painter Albrecht Dürer had bought two saltcellars in the Netherlands—the first examples recorded in Europe outside of Portugal.

Though the customs records indicate that these were relatively inexpensive items—a saltcellar cost less than a linen shirt—their exotic origin, exquisite craftsmanship and precious material made them worthy gifts to persons of importance. An Afro-Portuguese hunting horn bearing the arms of Castile, Aragon, and Portugal was given to Ferdinand and Isabella when their daughter married Manuel I, King of Portugal. The ivories made their way into papal collections and royal *cabinets de curiosités,* where they remained largely neglected and often misattributed to Indian or Turkish sources until the nineteenth century. None are known to have been found in Africa after the seventeenth century.

When the British capture of Benin in 1897 revealed to Europe finely wrought ivories and bronzes, new interest was focused on these earlier ivories, some of which were then erroneously published as Benin works.

In 1959, William Fagg's book *Afro-Portuguese Ivories* identified this body of work as a separate entity, named it, and began to explore the question of where in Africa it might have originated. The main types were also established: saltcellars, spoons, forks, dagger handles, and horns or oliphants. Subsequent research since then has identified over two hundred Afro-Portuguese works, uncovered African and European models on which they are based and located three major points of origin.

A consensus has been reached on the identity of the ethnic group or groups responsible for the creation of the ivories. Art historical analysis reveals three distinct style clusters related to works of art known to come from the coast of Sierra Leone, the Kingdom of Benin, and the mouth of the Congo River. Further, a sequence can be established. It appears that the Sapi people of what is today Sierra Leone were the first to produce carved ivories for Europe, and that Benin became an important source only when production in Sierra Leone declined. The Congo River area was never their equal as an exporter of carved ivories.

Ezio Bassani and William Fagg have painstakingly traced the European and African origins of motifs on the ivories. For a variety of reasons, however, the surviving sources are unequal: a great deal of the European material culture of the fifteenth and sixteenth centuries has survived, but very little has survived from that period in Africa. Mr. Bassani and Mr.

Fagg have enormously increased what we know about the artistic exchange that took place between Africans and Europeans during the years of their first contact; I would like to speculate here about what we do not know.

A SPECULATION ABOUT THE MISSING SOURCES

It is probable that fundamental elements of the Afro-Portuguese saltcellars are of African rather than European origin simply because no European prototypes for them have surfaced in the extensive search conducted by Mr. Bassani and Mr. Fagg. Most conspicuous is the lack of a clear source for the overall configuration of the saltcellars. No vessels of their shape nor European objects with decoration resembling theirs have been located.

Wars and invasions swept through what is now Sierra Leone in the mid-sixteenth century, leaving almost no trace of the Sapi civilizations with which the Portuguese traded on the coast. Only a couple of ivory horns have survived, and nothing at all remains of leadership regalia or court objects. The art that does remain from the earlier civilizations consists of small stone sculptures that have been found in the earth, worked in a sophisticated, relatively naturalistic style that resembles the style of the Sapi-Portuguese ivories. In a somewhat circular argument, the stones have been dated by their similarity to the ivories, while the ivories have been located geographically in relation to the stones. There is every reason to expect that the Sapi who created the sophisticated stone sculptures and the Afro-Portuguese ivories also had a well-developed tradition of carving ivory for their own use. But we are left with only speculations about Sapi art in ivory, and the elements that went into the art that is Sapi-Portuguese.

The almost total absence of African models for Sapi-Portuguese ivories contrasts with the abundance of sources for Bini-Portuguese objects. We know of no European prototypes for the form and decoration of the saltcellars or spoons. I would suggest that when political turmoil on the Sierra Leone coast cut off sources for the ivories there, Sapi ivories were used as a model (actual or remembered) for those commissioned in that other ivory-producing station, Benin. The similarity is especially marked among the spoons: Sapi-Portuguese and Bini-Portuguese spoons resemble each other more than either resemble spoons from anywhere else.

The evidence in Benin is much richer, but still inconclusive. In contrast with the Sierra Leone coast, a great deal of sixteenth century (and later) art has survived from Benin where an unbroken succession of kings ruled in the same palace for about six centuries. However, virtually no Benin art can be unequivocally dated to a period before the arrival of the Portuguese.

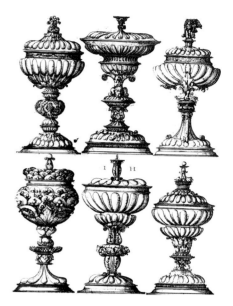

II. Six covered cups. Engraving. Albrecht Altdorfer, ca. 1530. European prototypes for lidded vessels like the Afro-Portuguese saltcellars are very different in form and decoration from the African ivories. Sculptural decoration merges with and partly conceals the underlying form in a way seldom seen in the salts or in other African objects. The European forms are more integrated and less geometric, and the decoration is rarely figurative; the object is a complex shape, not a sphere or an ovoid, and the vessel is deep with a shallow lid.

All the Afro-Portuguese saltcellars have spherical containers, including those whose round form has been concealed by the decoration. These containers generally have a feature characteristic of African containers but less common among European ones: the separation between lid and vessel occurs at the midpoint on the container, creating a relatively shallow container and a rather high lid. European lidded vessels and chalices are more likely to have deep containers and shallow lids. In many instances, the artists carving the Afro-Portuguese saltcellars followed another minor precept of their training and created a change in the border pattern or a notch in the lid and vessel to indicate how to align the parts correctly.

The spherical form of the saltcellar vessel seems quintessentially African. It recalls innumerable round-bottomed gourd, pottery and even wood vessels from all parts of Africa. Indeed, one could say that round-

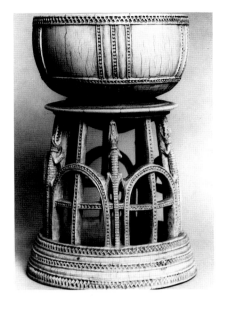

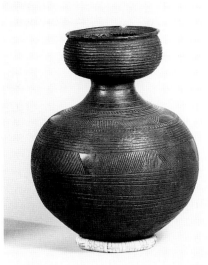

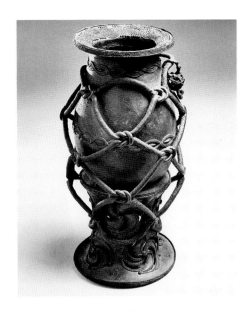

III. Saltcellar, missing lid. Sapi-Portuguese, ca. 1490-1530. In a typically African way, all the parts of the vessel and all the elements of the decoration are clearly separate. Like virtually all African works this is carved of a single piece of ivory. Size and whereabouts unknown (no. 50).

IV. Pot. Nupe, Nigeria, 20th century. This round-bottomed pot rests on a raffia pot ring. It has been given a sculptural form which is aesthetic rather than functional. Incised linear decoration lies on the surface, entirely distinct from the underlying form. Terracotta, 41 cm. The Newark Museum.

V. Roped pot on a stand. Igbo Ukwu Nigeria, 9th-10th century. Though cast in one piece, this archaeological bronze depicts what may have been a round-bottomed terracotta pot on an openwork stand. A rope is depicted loosely holding the two together. This extraordinary casting is unique. Bronze, 32.3 cm. The Nigerian National Museum, Lagos.

bottomed vessels predominate in Africa. They are practical in a world where vessels usually rest directly on the irregular ground because they can always be shifted to be level (whereas a flat-bottomed vessel cannot). They may also be suspended in nets, supported on other vessels, or placed on rings or stands. Decorated cylindrical pot stands are found throughout Africa in historical times, and in the archaeological record. One need only consider the famous roped pot on a stand, excavated at Igbo Ukwu in Nigeria, dated to the ninth century. There we see depicted in bronze what must have been a clay or metal vessel on an openwork stand, loosely held together by a knotted rope. An examination of the bronze shows the bottom of the stand to be open, a curved hollow cylinder inside which is visible the round bottom of the vessel.

A pottery water jar on a separate pottery stand made in more recent times by the Baule people of the Ivory Coast provides another example. There too a round-bottomed vessel is supported on an openwork stand that is basically a hollow cylinder. It seems probable that objects like these provided the overall conception for the saltcellars with cylindrical bases. The Afro-Portuguese salts are all open on the bottom as are the African stands. The Bini saltcellars can be seen as a variant of this composition in which the spherical container is held deep in the openwork stand composed of figures (which is again open on the bottom). The Sapi saltcellars have a flat platform between vessel and stand that, had they been actual vessels, would have defeated the purpose of the stand.[1] Though this platform departs from the configuration of the African prototype, the ivories nevertheless remain much closer to it than to the nearest European model.

A rarer type of African container, made of an ostrich egg with basketry base and neck, is even more reminiscent of the saltcellars. The straps of woven rattan that cross the egg resemble the textured bands carved on the saltcellars with cylindrical bases. The saltcellar containers are only a little smaller than an ostrich egg, and both the delicacy and whiteness of the material are similar. The Sapi coast is far from any natural habitat of ostriches, so any eggs that made their way there would surely have been precious, treasured objects. They provide another possible model for the Sapi-Portuguese saltcellars.

But the African elements in the Afro-Portuguese ivories, the salts and spoons particularly, are not limited to the overall configuration; they include the decoration. In the absence of surviving objects, it may be worthwhile to turn to characteristics of African design in general because they are the only clues we have to the repertoire of form and decoration available to the artists who created the Afro-Portuguese ivories.

A REFLECTION ON AFRICAN DESIGN

The African elements in the ivories seem to be as broad and fundamental as the European elements are specific and local. The Afro-Portuguese ivories as a whole are decorated with a predilection so basic to African art that it might be overlooked. Insofar as it is reasonable to generalize, three fundamental characteristics of African aesthetic sensibility are visible in the ivories: a focus on the human figure, a clear articulation of parts, and a preference for pure geometric forms.

African decoration at its most elaborate focuses almost exclusively on the most interesting thing in the visual universe: the human form. In cases where European decoration might almost automatically call for a flower or a flourish, African decoration turns to the human face or figure. Animals are a distant second choice and plant motifs are rare. Whereas European goblets, covered cups, and hunting horns of the period have a largely nonfigurative ornamentation, decoration on the Afro-Portuguese ivories is mainly made up of human and animal images. These are typically African when they appear frontal and motionless, isolated as decorative motifs, especially when they repeat; they are more European when they seem to occupy a deep space and interact in scenes or tableaux.

There are two main kinds of nonfigurative ornament in African art: most prevalent is the geometrization of the object itself. Usually the parts of the object are conceived as separate, pure geometric forms that become structurally functional. Thus the legs of a bed may be shaped as cones; the sides of a neckrest are formed as arcs without further elaboration. The underlying geometric or decorative form is usually so sharply articulated it appears to be made up of pieces that could be taken apart.

The second kind of nonfigurative decoration consists of textures and flat linear patterns of great sophistication applied to surfaces. We find this on surfaces of all kinds—the surface of an object, a building, on even the human body. African ornament of this kind is never confused with the shape of the object itself and never obscures it. Again, it is a wholly discrete element that lies on the surface of the object as though it could be peeled off.

African figurative decoration is used in the same two characteristic ways: either it is fully integrated into the object so that the human figure becomes functional—as the handle on a spoon, the support of a stool, or the body of a drum—or it lies on the surface as a sculptural or linear element that is distinctly separate from the body of the object. In both cases the different parts of the object and of the decoration are clearly demarcated, discrete elements. The decoration found on some European

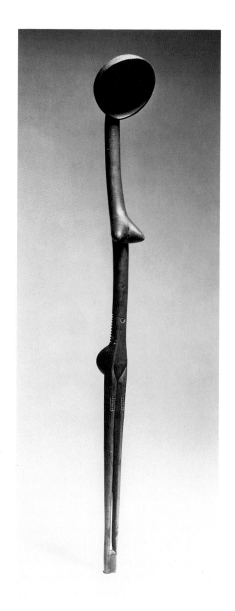

VI. Spoon. Anonymous Zulu artist, 19th-20th century. Decoration and utility are one in this masterpiece of economy where the figure is the handle and the spoon. Wood, 56 cm. Musée de l'Homme, Paris.

VII. Water pot on stand with lid and coconut shell cup. Akwe Baule artist, Ivory Coast, 19th-20th century. The round-bottomed pot rests on a hollow openwork stand when it is in the house. It is transported without the stand. Terracotta, approx. 38 cm. Koffi Nguessan family collection, Kami.

VIII. Ostrich egg vessel. Cameroon, 19th-20th century. Rattan binding added to the eggshell make it possible to hang or carry it, to stand and stopper it. Such vessels could have been the models for some Sapi-Portuguese salts. (From Roy Sieber, *African Furniture and Household Objects,* 1980, p. 168.).

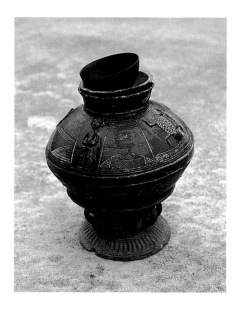

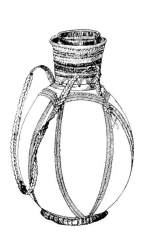

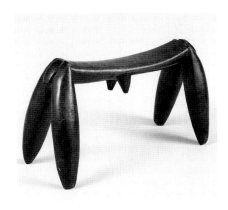

objects (such as the oliphant on page 91) wherein the figure is conceived as inhabiting a deep space, indistinct from the object, is virtually never found in African art.

The bas-relief carving on the Sapi-Portuguese oliphants is thus completely European in character and subject even to the extent that no Africans are depicted. The artists, however, have moderated the elements most alien to their own tradition. The bas-relief figures on the horns are shown in action in scenes suggesting space, but not a deep space. In contrast, the isolated figures carved on the oliphants in high relief, a technique more characteristically African, do not occupy a specific space; they are motionless and frontal in the tradition of African figure sculpture (see for example, page 99, ill. 109).

AFRICAN SOURCES FOR THE AFRO-PORTUGUESE IVORIES

The types of objects that African artists made for their first European clients seem to have been limited to things they already made for themselves. Among the more than two hundred ivories, the only exceptions are three pyxes and three forks. Lidded containers, horns, spoons, and knife handles are among the object types widely found in Africa today and in the past.

Most of the decoration on the Afro-Portuguese ivories is African in character in that it consists either of human and (to a lesser extent) animal figures, or is made up of linear, textured patterning used in the characteristic way just described. The shaping of the ivories also displays a clear African preference for pure geometric forms. Where the European prototypes are curved, their parts more fluidly integrated, the underlying elements of the African ones are often a simple sphere on a cone or cylinder; their different parts are sharply articulated. The gadrooning on the shaft of a horn, or the scalloping of the sphere of a container, for example, stands out as a European device, as do scenes and narrative.

A comparison of the African use of spiraled forms with the European use of gadrooned ones is enlightening. The handle of an African gong striker is itself made up of twisted, entwined forms (not a form readily suggested by the medium of carved wood). The neck of the European horn has had its outer contours shaped into a spiral, but the scalloped spiral is not separable from the underlying shape of the horn, neither is it the body of the horn.

IX. Neckrest. Anonymous Shona artist, Southern Africa, 19th-20th century. The geometrization of parts, and the clear articulation of all elements is typical of African design. Often, as here, formal allusions are to the human body. Wood, 17.5 cm. Armand Arman collection.

X. Slit drum. Anonymous Yangere artist, Central African Republic, 19th century. The body of the animal serves as the sounding chamber of the drum. The sculptural decoration and the functional object are merged. Wood, 229 cm. Musée de l'Homme, Paris.

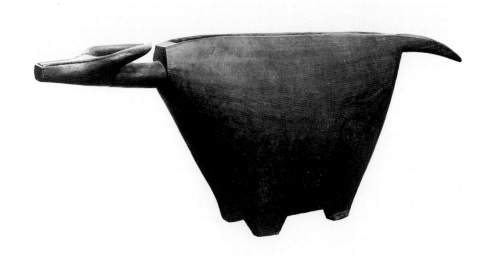

AFRICAN AND EUROPEAN ASSUMPTIONS ABOUT ART: A COMMON GROUND

The most interesting question about the intermingling of styles that the Afro-Portuguese ivories represent is the question of how they came about. What was the creative process like? Ezio Bassani and William Fagg discuss the means by which the European motifs might have been transmitted to Africa and conclude that the African artists worked from drawings supplied by their Portuguese clients. There are, however, many steps between a drawing and a finished sculpture in the round, even in cultures where artists are accustomed to working from drawings. How much more challenging it must have been in this case—how much more experimentation and failure there must have been along the way. Ivories that did not meet with the approval of the Portuguese customers were not purchased and apparently perished. With them vanished the experiments in fusion, the mixtures of cultural and artistic elements that were the African artists' preferences rather than those of their patrons. Artists and patrons, however, lived in surprisingly congruent worlds when it came to art, and the similarity of their expectations about their respective roles surely facilitated the exchange.

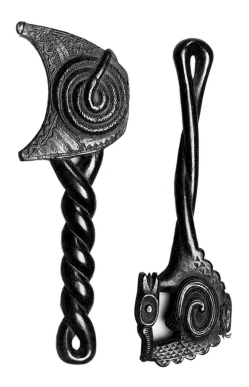

The fascination the Afro-Portuguese ivories inspire owes much to romantic imagining of a vast difference between the participants—the Portuguese commissioner in his heavy velvet, visiting the bare-chested African artist in a thatched house. The reality was less dramatic, the differences less marked than we might imagine, and the deep commonalities were more apparent to those who experienced the exchange. Renaissance Europe and traditional Africa were more alike than either is like our twentieth century. (Hundreds of thousands of Europeans, for example, lived in thatched houses.) European artists, who created soaring cathedrals and rose windows, tapestries, panel paintings of richly costumed figures, and gilded altarpieces, lived in a world whose social structure, working situation, and belief system had much in common with the world of African artists, who carved wood masks and ivory tusks, cast bronze figures and wove fine raffia.[2]

Society was based on the extended family in Africa and in Europe, and arts as well as trades were a family undertaking. The young artisan, always male, became an apprentice and underwent long, intensive training, more to earn a living in the family business than to express a natural talent.

In Renaissance Europe, art was produced for profit, and a mastery over materials and technical skills was prized. As in Africa, the finished object was judged for its functional design, workmanship and durability as well as for its beauty. In both places, the apprentice training system was necessitated by the high standard of craftsmanship. Among the workshop artists, it encouraged a collective (rather than an individual) style, and a great degree of anonymity. While individuality is the main attribute of today's artists, who are expected to find unique ways to express their ideas, the artists in a workshop were expected to subordinate their personal styles and ideas to conform to the master's. Though the master's style and techniques were passed down through generations, experimentation and slow changes took place within the bounds of iconographic requirements.

In fourteenth and fifteenth century Europe, even most of the sculptors and painters were anonymous artists. The exceptions are known: the Renaissance geniuses whose works were commissioned by the important figures of their time and who became famous. The African masters who were famous among their contemporaries are unknown to us. In both

XI. Gong strikers. Anonymous Baule artists, Ivory Coast, 19th-20th century. The handles have been geometricized and elaborated so that the decoration becomes the handle. Wood, 22 cm. Carlo Monzino collection.

XII. "Garb of the servant, of the woman of the people, and of the gentlewoman." From Pigafetta, *Relazione del Reame di Congo. . .*, Rome, 1591. European depictions of Africans during the Renaissance show them as indistinguishable from Europeans. The city and countryside in the background are also conceived as being like Europe's.

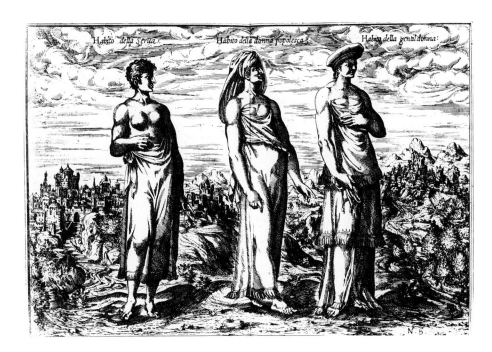

worlds, even great artists directed workshops and used lesser talents to assist with important works.

In Africa and in Europe, most objects were produced on commission, and their specifications were spelled out by the commissioner. Serious art today is assumed to be the expression of an individual's spirit, but both African and European artists expected many details of a work to be dictated by the commissioner. African artists working on commissioned sculptures for shrines, masquerade societies or private patrons, then as now, expected divination and traditional iconography to determine the form and content of their work, much as European artists expected the commissioner of a tomb or altarpiece to specify the subject and materials, and to suggest modifications at different stages of the work.

One overarching element links the world view of the Portuguese commissioner and the African artist. Magic and the presence of the supernatural in the everyday world were taken for granted in Europe and in Africa. Religion permeated both worlds. Neither society relied on writing to reach the people. In Europe literacy was very limited, so Christianity was taught and its power was preserved through images. Church frescoes, altar triptychs and the carved figures of saints were vital forces in everyone's daily life. And since superstition was strong, the images and emblems of the holy figures were thought to have a power of their own. Much African art is associated with spirits, gods or ancestors, and certain sculptures and objects are believed to be numinous.

THE AFRO-PORTUGUESE IVORIES AS DOCUMENTS OF AN ERA

Works of art created during that brief interlude of first contact in Africa between Africans and Europeans reveal how they saw each other at the time. The depictions of Europeans by African artists, and those of Africans by Europeans, at first seem strikingly inaccurate. Europeans portray Africans as if they were simply darker versions of themselves. The body type, postures, and kinds of drapery conform to artistic conventions used to portray Europeans, and have little to do with the way Africans looked. Africans carve the pale strangers the same way they carve themselves. In the Afro-Portuguese ivories, often only details of clothing (or the lack of it), sharp noses, straight hair and long, straight-haired beards distinguish Africans from Europeans.

All evidence suggests that in this period Europeans and Africans did not perceive each other as fundamentally different.[3] In the case of European depictions of Africans, they were almost always made by artists working from sketches or descriptions. This makes their work even more telling since it shows what Europeans imagined Africans to be—rather than a version of what they observed. African cities appear (as Jerusalem frequently did) as fantastical versions of European cities.[4]

By the seventeenth century an ugly ideology had begun to change this sense of a deep commonality. A growing slave trade made it expedient for Europeans to view Africans as radically different from themselves, as ignorant savages, hardly human. How else to justify trading in human lives? A genuine widening of the differences in modes of life and thought of the two cultures in the eighteenth century was spurred by the increasing importance of empirical science in Europe. The two cultures further diverged in the nineteenth century as a result of the industrial revolution (made possible partly by the machines created by empirical science). This new prosperity and technological difference was used by Europeans to argue their cultural superiority, and to justify colonial rule. During the period of the slave trade and the colonial era, European artists—including writers—either expressed the prevailing ideology and portrayed Africans as inferior or, in reaction against these attitudes, idealized Africans (and other non-European peoples). For their part, African artists in these later periods (and most works known today date from the nineteenth and twentieth centuries) depicted Europeans as cruel oppressors, strange, ridiculous, undignified, or drunk.

The Afro-Portuguese ivories are rare and precious not only as works of art, but as the only surviving African documents of this earliest contact. At that time as never since, the exchange between Africans and Europeans was relatively benign and untroubled by the history of domination and exploitation that followed.

XIII. Figures of Europeans. Anonymous Thonga artist, Southern Africa, 1900-1915. The men are portrayed as self-satisfied, military, and slightly alcoholic while the sexless woman holds her poor dog on a rope like a prisoner. Post-Renaissance depictions of Europeans by Africans are often satirical and frequently, as here, show men holding bottles and glasses. Wood, 30 cm. Jay and Clayre Haft collection.

NOTES

1. The presence of this platform shows that the open bottom was not dictated by the natural cavity in the ivory tusk. The platform requires that the object be carved almost entirely from a part of the tusk which is completely solid.

2. No detailed documents have survived about the lives of African artists in the fifteenth and sixteenth centuries, but the great stability and continuity of African culture permits us to safely extrapolate backward from what we know about the late nineteenth and twentieth centuries, which are better recorded.

3. Sectarian differences outweighed racial ones. The Portuguese were allies of the *oba* of Benin in wars with neighboring peoples, and alliance at the time carried the implication of marriage ties between rulers as well as military and economic bonds. This would, however, have been out of the question, mainly because marriage could occur only between coreligionists.

4. It should be noted that this did not apply exclusively to Africans; at the time, European artists generally depicted non-Europeans according to prevailing European artistic conventions and seldom based their portrayals on observation. The same could be said of African artists—that their works usually were not a depiction of the visible world, and hence would not be expected to depart from their usual artistic canons. The similarities referred to here, however, go beyond style to suggest a deep commonality.

EUROPEAN PERCEPTIONS OF BLACK AFRICANS IN THE RENAISSANCE

BY PETER MARK

The Renaissance was a seminal period for the development of European conceptions of and attitudes towards Black Africans. Beginning in the 1440s, Portugal undertook the first successful seaborne explorations of the West African coast. By the end of the sixteenth century, Northern Europeans too had entered the growing African trade and Black men were familiar visitors to cities from Venice to Antwerp. This period was an interlude between inception of direct contact between Europe and sub-Saharan Africa, and the seventeenth century growth of the Atlantic slave trade.

Through studying the representation of Africans by European artists during the fourteenth and fifteenth centuries, we may gain insight into an early image—or, more accurately, multiple images, of Blacks at a time when these images were only marginally affected by the African slave trade. This in turn may help us to assess the role later played by the slave trade in the evolution of predominantly negative attitudes towards Blacks.

Unlike the roughly contemporaneous "discovery" of Native Americans, the existence of Africans did not come as a total shock to Renaissance Europe. There had been sporadic but ongoing diplomatic, religious, and commercial contact between southern Europe and sub-Saharan Africa since antiquity. Classical writers and even medieval authors had been aware of Africa—although there is little more than myth in the image presented by the latter group of writers. From the early fourteenth century, Europe maintained diplomatic missions to the Christian kingdom of Ethiopia.

The Muslim conquest of Spain brought further contact with Black Africans, of whom some were slaves but others were free men. In fact, free men from Takrur, a Muslim state located in the Senegal River Valley in West Africa, served as spearmen in Muslim Spain during the eleventh century. Through the filter of Arabic written sources, a few literate Europeans had acquired a vague awareness of the existence of kingdoms or states south of the desert. In 1283, for example, Raymon Lull faintly echoed the Arabic geographies when he mentioned "Ghana" in his own writing. There were a few African domestic servants in thirteenth century Italy.

Most domestic slaves in Europe at the time were Turks and even Mongols and Circassians from the Near East. Iris Origo has pointed out that fear of slave violence may have led to heightened anxiety and to negative stereotypes about these groups.[1] This would have focused attention away from Blacks and towards Asians as the object of negative attitudes stemming from slavery. At the same time, the Ottomans constituted the chief military threat to the Christian world, adding to anti-Asian sentiment.

In late medieval Europe, anti-Muslim sentiment far outweighed anti-Black feeling. This is expressed in literature of the period. One telling passage occurs in John Mandeville's *Travels,* which dates to about 1356. In discussing the biblical explanation for the diversity of human physical types, Mandeville refers to the story of Noah and to the mark God placed

on Ham. In later times, this story was frequently used as a justification for theories of Black racial inferiority. In this context, Mandeville's rendition of the story of Noah's drunkenness and of the curse placed upon Ham for viewing his father in his nakedness, is of interest. He writes:

> And Cham for his cruelty took the greater and best part toward the east, that is called Asia. And Sem took Affryk and Iapeth took Europe.[2]

It would appear then that in the mid-fourteenth century, the descendants of Ham were at least sometimes seen as Asians. It is surely not irrelevant that, during the fourteenth century, most of Europe's slaves came from the East.

Not all medieval sources agreed with Mandeville. In the twelfth century, Benjamin of Tudela, a Jewish merchant who participated in the trans-Saharan trade, which even then linked sub-Saharan Africa to the Mediterranean, wrote of a group of Egyptian captives, "These sons of Ham are black slaves." Evidently, Ham's accursed descendants tended to be variously identified with whatever people seemed uncivilized or who served as slaves.[3]

Equally important in terms of implications for the formation of a popular image of Blacks were the diplomatic missions and religious delegations late medieval Europe received from Ethiopia. In 1306 King Wadem Arad sent an embassy to Pope John XXII in Avignon. In Rome by the late fifteenth century, there were so many Ethiopian pilgrims that the church of S. Stefano degli Abissini was granted to them to use during their stay in the Holy City. In 1316 Pope John sent eight Dominicans on a mission to the Emperor of Ethiopia.

Several Ethiopian emperors proposed military and even marriage alliances with European rulers. Against this background, it is not surprising that in the fourteenth century the legendary Christian monarch Prester John was frequently identified with the emperor of Ethiopia. A more positive image could hardly have been found for a foreign ruler. There was thus a strong foundation for a positive image of Africans in the popular consciousness on the eve of the first European sea voyages to the West African coast.

In 1324 the *hajj,* or pilgrimage, to Mecca of Mansa Musa, the ruler of the West African empire of Mali, brought Musa and his entourage— including 100 camels laden with gold—through Alexandria on their way to Mecca. The Mansa showered so much gold as gifts on the local economy that the value of the local currency was still debased eight years later. At this time there were Venetian and Genoese trading firms in Alexandria; no self-respecting merchant could have ignored this Black monarch's wealth. Reports of Mansa Musa and his riches quickly spread through southern Europe, with several consequences. First, the Prester John image of a powerful and wealthy ruler— albeit a Christian—was strengthened. Second, interest in direct commercial contact with West Africa was stimulated. There was at least one documented effort to sail to West Africa in the period immediately following Mansa Musa's journey. Finally, representations of the Malian ruler himself soon appeared in European iconography, mainly as illustrations on maps of Africa.

Fourteenth century cartographers from Majorca had knowledge of the trans-Saharan trade. As early as 1339 a world map made by Angelino Dulcert carried the inscription "rex Melli" beside the representation of a king, seated in the middle of West Africa. The most important of these early maps was made in 1375 by Abraham Cresques and came subsequently

to be known as the "Catalan Atlas of Charles V." On this map, oases that were important to the trans-desert trade are clearly labeled. South of the desert is "Ginyia." Enthroned there is a monarch, sceptre in hand. He is bearded, wears a crown, and carries a large sphere which was once apparently gilded. The illustration carries the inscription:

> This Negro lord is called Mansa Musa, Lord of the Negroes of Guinea. So abundant is the gold which is found in his country that he is the richest and most noble king in all the land.

The image of a rich and powerful ruler, together with growing knowledge about trans-Saharan commerce, became fixed in the European consciousness. This in turn helped to foster interest in exploring direct routes to Africa. That search was an important stimulus for the subsequent Portuguese exploration of the African coast, which began in 1434 when Gil Eannes set sail against the winds of West Africa rounding Cape Bojador; by 1444, the first voyage had returned safely from Guiné.

During the first centuries of sea-borne trade, Europeans and Africans who interacted with each other did not do so across the great and widening technological gap which developed during the nineteenth century. When the Portuguese first sailed up the Congo River to the Kingdom of the Kongo, they found that it was on a cultural par with Portugal. Most of the European sailors and some traders who frequented the African coast could not read. Although Christians, they would have found much in common between their own religious ideas and local African concepts about the world of the spirit.

As late as the seventeenth century, beliefs in witchcraft were widely held in Europe. African witchcraft beliefs thus often struck a resonant cord among visitors. The experience of the English trader Richard Jobson, who traveled up the Gambia River in 1620, is a case in point. Anchored near a Mandinka village one night, his party heard raucous sounds which, their hosts informed them, were the voice of the spirit Ho-re. This spirit, evidently meant to frighten nefarious spirits and uninitiated boys, also frightened members of Jobson's crew:

> Our people who were lying and dwelling in the country had been at several times frightened with the voice of this Ho-re, for . . . being abroad until night hath overtaken them . . . they have heard the voice of Ho-re, as they might conceive, some miles from them and before they could pass twenty steps, he hath seemed to be in their very backs, with fright whereof, maintained by their imagination, they have not, without a ghastly dread, recovered home.[4]

Witchcraft, along with visual and auditory manifestations, was an important element of African religious belief that many early European visitors could share. Similarities between European and African witchcraft beliefs may have been even greater than this account suggests. West African metaphysical systems are characterized by a sense of the continuity and the close causal relationship between the visible and the invisible world. In addition to witches who could harm members of the human community, African cultures posited the existence of a second category of beings. These were human clairvoyants who possessed comparable supernatural powers which, however, they placed at the service of society. These clairvoyants were often witch-hunters. Thus, for example, among the Jola people of Senegal, the *bukan bujak* or "good people" fought off the nocturnal onslaughts of the *kussay* or cannibal-witches.

In rural European societies, even as late as the 1600s, belief in the existence of beneficent clairvoyants who protected against harmful witches was probably widespread. Carlo Ginzburg, in his masterful reconstruction of witchcraft cults in seventeenth century Friuli, (in northeastern Italy) documents local beliefs in the *benandanti,* clairvoyant individuals who fought against witches.[5] Friulian belief in "good witches" reflects the existence of a substratum of pre-Christian belief in Europe that was undoubtedly not limited to this one region. These European beliefs were similar to African ideas about good and bad "witchcraft."

It is difficult to reconstruct sixteenth century African religious practices. Oral sources do not provide detailed information for so early a period, and written sources are few and marked by a Eurocentric bias. To extrapolate backwards from modern ethnographic information, while tempting, is also methodologically flawed. Nevertheless, the more reliable seventeenth century sources such as Olfert Dapper suggest, in their descriptions of anti-witchcraft rituals and associated medicinal practices, broad continuities with more recent traditions. In Sierra Leone, for example, Dapper mentions the presence of diviners and the use of protective charms (*gris-gris*) as two important defenses against illness. Both institutions have survived, sometimes in Muslim form, to the present.[6] In Sierra Leone, as throughout West Africa, illness and death were often attributed to the nefarious activities of people who possessed supernatural powers, like the "witches" of European narratives.

This approach to illness is not very different from disease theory in Early Modern Europe. When one recalls the responses to the Plague in fourteenth and fifteenth century Europe, the distance between European and African ideas about disease and prevention was not nearly as great as it would become in the nineteenth century. African belief systems that attributed disease, and especially epidemics, to witchcraft were not unlike late medieval and even Renaissance European beliefs. In some areas of Europe, the Black Death of 1348-50 was attributed to the agency of human beings possessed of supernatural powers. In Vienna in 1349, the disease's spread was commonly attributed to a *Pest Jungfrau.* Ziegler recounts that this "plague maiden" was thought to fly through the air and to infect her victims by simply raising her hand.[7]

During the Renaissance, recourse to nonscientific thought was still common, particularly among the less educated classes. As late as 1665 in London, the reappearance of the Plague was marked by all manner of superstitious and magical beliefs. This led Daniel Defoe to observe:

> . . . the people, from what principle I cannot imagine, were more addicted to prophesies and astrological conjurations, dreams, and old wives' tales, than ever they were before or since . . . Next to these public things were . . . the interpretations of old women upon other people's dreams, and these put abundance of people even out of their wits.[8]

Other individuals saw visions in the sky, while still others took advantage of the fear and credulity that had overtaken the population, by turning to practicing magic, or "the black art." Defoe continues:

> With what blind, absurd, and ridiculous stuff, these oracles of the devil pleas'd and satisfy'd the people, I really know not, but certain it is, that innumerable attendants crowded about their doors every day, and if but a grave fellow in a velvet jacket, a band, and a black cloak, which was the habit those quack conjurers generally went in, was but seen in the streets, the people would follow them in crowds.[9]

Perhaps the greatest similarity between African and European medicine in the seventeenth century was in the production of protective charms. Throughout West Africa, ritual specialists fashioned amulets which, when attached to the body, were supposed to protect the wearer from physical harm or from specific ailments. Both traditional specialists and Muslim experts made these charms, or *gris-gris,* as they were called. Some *gris-gris* made by Muslims consisted of verses from the Koran encased in leather, while others contained secret, nonalphabetic inscriptions in the form of "magic squares." Even today, the use of *gris-gris,* both the Muslim and the non-Muslim variety, is widespread; during the seventeenth century, such amulets would have been found virtually everywhere along the West African coast.

A slightly later eyewitness description of these African charms is provided by the Englishman Philip Beaver. Beaver led a party of settlers to present-day Guinea–Bissau in 1792. There, he observed such charms, manufactured by Muslim *dyula* traders:

> . . . their *gris-gris* . . . are nothing more than sentences of the Koran neatly sewed up in leather or cloth, and attached to the neck, arms, wrist, or ankles of the people, who firmly believe in the efficacy of their virtue.[10]

In seventeenth century Europe, medicinal amulets were frequently worn by the common people. What is more remarkable, some of these charms contained magical writing very similar to Islamic *gris-gris* from West Africa. In London in 1665, many of the common folk tried to ward off the pestilence by wearing such charms. Defoe observes:

> But there was still another madness beyond all this, which may serve to give an idea of the distracted humor of the poor people at that time . . . and this was in wearing charms, philters, exorcisms, amulets, and I know not what preparations, to fortify the body with them against the plague; as if the plague was not the hand of God, but a kind of a possession of an evil spirit; and that it was to be kept off with crossings, signs of the zodiac, papers tied up with so many knots; and certain words or figures written on them as particularly the word Abracadabra, formed in triangle or pyramid, thus

<div align="center">

ABRACADABRA
ABRACADABR
ABRACADAB
ABRACADA
ABRACAD
ABRACA
ABRAC
ABRA
ABR
AB
A[11]

</div>

The poor Londoner wearing such an amulet, and the West African farmer with his Koranic *gris-gris,* would surely have understood each other's protective medicine. In fact, to some extent, their charms had a common origin, for the Londoner's "abracadabra" was certainly derived from Arabic. Indirectly, Islamic influence, unfortunately more as magic than as scientific knowledge, had spread as far north as England. Thus, even in the seventeenth century, Islamic medicine provided common elements which helped to link Western European medicinal practices to West African

methods of protection against disease. Without a doubt, the unlettered Europeans who travelled to Africa in the sixteenth and seventeenth century would not have found African medical practices to be entirely foreign. Where later European visitors looked down on the "superstitious" practices of Africans, during the Renaissance, Africans and Europeans met on more even footing.

There were also important Muslim populations in parts of West Africa, especially Senegal and the Gambia. Interestingly, some early European travelers were favorably impressed by the way of life (especially the sobriety) and the religious devotion of West African Muslims. Jobson respectfully wrote of Gambian *marabouts,* or holy men:

> They do worship the same as we do, the true and only God, to whom they pray and on his name they call, in their language, expressed by the word "Alle."[12]

This relative compatibility and mutual respect between the religious worlds of African hosts and European visitors diminished during the Enlightenment. By the end of the eighteenth century, religious beliefs and practices had become an important parameter by which Europeans judged Africans to be inferior.[13] During the earlier period of the Renaissance, however, African and European religious concepts show significant similarities.

These similarities are echoed in other areas, as well. Even in habits of daily life—such as eating—there was not the marked disparity that came to divide European and African cultures at a later date. In most of Europe during the Renaissance, knives were a common eating utensil. Forks and spoons only appeared later. Forks, in particular, were almost unknown north of the Alps until the latter part of the sixteenth century and even then, were used primarily by royalty and by the wealthy merchant class. Most European visitors to West Africa would not, therefore, have found it remarkable that Africans did not use knives and forks when eating.

In those parts of West Africa where Europeans and Africans interacted on an equal footing, one might expect to find evidence of intercultural collaboration, such as resulted in the creation of the Afro-Portuguese ivories. Significantly, in at least two of the areas where the ivories were created, Africans either controlled commerce with Europeans, or were at least able to regulate the development of the slave trade. In Benin, the political strength of the kingdom enabled Africans essentially to control commerce with the Portuguese and, later, the Dutch. In the case of Sierra Leone, historical sources do not mention a slave trade in the Sherbro-Cape Mount area until 1680. The relatively late development of slaving there may, as Adam Jones suggests, have been due to the existence of other export goods, most notably ivory.[14] Together, the abundance of ivory, the existence of local craftsmen, and the maintenance of equal partnership in trade relations stimulated the development of a local export industry in carved ivory.

EUROPEAN DEPICTIONS OF AFRICANS

In studying images of and attitudes toward particular groups of "others," art can serve as an historical document. Art reflects both the dominant attitudes and social relationships of the culture from which it comes and—at least in Western art since the Renaissance—it also reflects to some extent the ideas of the individual artist. Representations of Africans can suggest several things to us. First, they can serve as strong indication that the artist of a particular work had had personal contact (or, as is

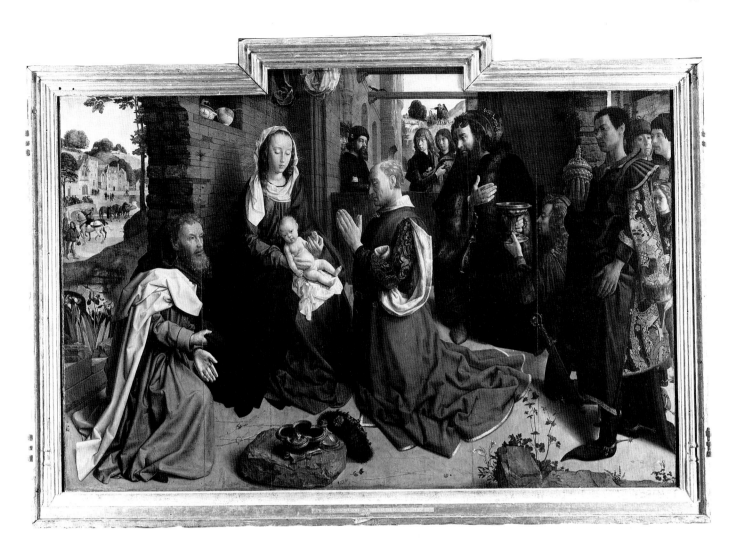

XIV. Hugo van der Goes. Monforte altarpiece. Panel painting, Flemish, ca. 1472-1480. The dignified Magi to the right is probably of African ancestry. He wears a flowing plush cape and holds an ornately decorated chalice typical of the period. Staatliche Museen Preussischer Kulturbesitz, Gemäldegalerie, Berlin.

sometimes the case, was *not* familiar) with an African. Paintings can document that there were, for example, Blacks in Venice in the early 1490s and that they served in a variety of capacities. Pictorial representations may record the presence of foreign dignitaries. Art may even reflect the growing presence of Blacks, for example, in the Low Countries after 1470.

Though one cannot read a painting in the same way that one reads written descriptions in travel narratives, nevertheless, prevailing attitudes or conceptions are frequently evident in pictures. Perhaps one can hope to delineate a constellation of attitudes that are reflected in artistic portrayals of Africans before the expansion of the Atlantic slave trade in the seventeenth century. Of course, modern interpretations should where possible be buttressed by reference to the travel literature of the day. There, too, however, one finds no single image of Africans but often a complex and even contradictory series of views.

During the fifteenth century, the most common role in which Africans were represented in European iconography was as one of the Three Kings at the Adoration of the Christ Child. The visual tradition of an African king had developed first in medieval Germany.[15] In Italy, the earliest appearance of Blacks in representations of the Adoration was usually as one of the servants to the kings. Nicola Pisano's Siena pulpit (1266) is perhaps the oldest example of this theme. Even after the Black king is widely introduced, African servants often appear along with him. The African servant appears alone in Ghiberti's 1407 relief of the Adoration for the Florence Baptistry doors, as well as in works by Bartolo di Fredi and Lorenzo Monaco.

The Black king generally appeared somewhat later than the African servant. In Germany, a Black king may have been portrayed in sculpture at the church in Thann as early as 1355, and by the early 1400s, Stefan Lochner included African kings in paintings of the *Adoration*. Hans Multscher's Wurzach Altarpiece of 1437 also contains a Black king. Lochner's compositions do not single out Africans for special attention. This may be interpreted as consistent with the earlier medieval and scholastic attitude, which saw the different human races as equally worthy in the eyes of the Creator.[16]

Italy lagged in adopting the new iconography, which only became common there during the last two decades of the *quattrocento*. In the Low Countries the new motif became prevalent by about 1470, just about at the time that Africans appeared in northern Europe in increasing numbers, as a result of the start of regular sea voyages to West Africa.

Several important Northern representations of the Black king appear in the work of Hugo van der Goes. In Hugo's Monforte altarpiece the African king, here of evident Moorish or North African heritage and rather light in complexion, is portrayed as a proud and handsome young man.

In Venice during the last two decades of the fifteenth century, Black servants were far from unknown. They were, in fact, frequently used to row gondolas. Several works by Gentile Bellini and Carpaccio's *Heron Hunt in the Lagoon* show Black servants. The latter work portrays two African boatmen. These paintings may be presumed to represent the actual activities engaged in by at least a part of Venice's small Black population at the time.

Elsewhere in Northern Italy, in Ferrara and Mantua, there was considerable interest among the wealthy classes in servants of African heritage, who were prized at least in part because of their rarity. In Mantua, Isabella d'Este had a predilection for such servants and she took pains to procure Blacks for her Court. Her mother had even imported an entire family to the Court at Ferrara. This was primarily an example of wealthy individuals desiring the exotic and the unusual.

Among North Italian artists, Andrea Mantegna reflected an interest in Black servants, at least in part as exotica, in his ceiling frescoes for the ducal palace in Mantua. He, not surprisingly, was also among the earliest Italian artists to depict one of the Three Kings as an African.

In view of the interest shown by the Mantuan Court in unusual physical types, it is reasonable to assume that efforts would have been made there to obtain an African servant as soon as one was available on the Venetian market. Yet, as late as the 1470s, Mantegna's dark-complexioned figures are modeled after North Africans or Moors of mixed ethnic heritage. When he painted the Camera degli Sposi in 1472–74, he included, silhouetted against the trompe l'oeil opening painted on the ceiling, a dark servant woman who is clearly not a Black African. Had the court entourage included a darker African, Mantegna would most probably have displayed that individual along with the dwarf and other attendants who do appear in the composition. This suggests that no African servants had yet been brought to the Mantuan court. By 1491, however, Isabella Gonzaga had acquired a young Black servant and, thereafter, she was able to indulge her interest in Blacks as exotic others, by acquiring additional Black servants.[17]

Iconographically, Africans appear in a limited range of roles in Early Renaissance painting. The fact that Blacks were depicted primarily in prescribed roles such as St. Maurice or the youngest of the Three Kings did limit the artists' latitude to interpret their subject. It also diminished the room afforded them to portray such "ethnographic" details as African

XV. "Julian the Apostate Ordering the Bones of Saint John to be Burned," from a group of panel paintings entitled "The Story of the Remains of Saint John the Baptist," Dutch, ca. 1490. On the right among the bystanders is a Black figure with his back turned to the viewer. His flowing robes and sparkling jewels show him to be above the common rank. Kunsthistorisches Museum, Vienna.

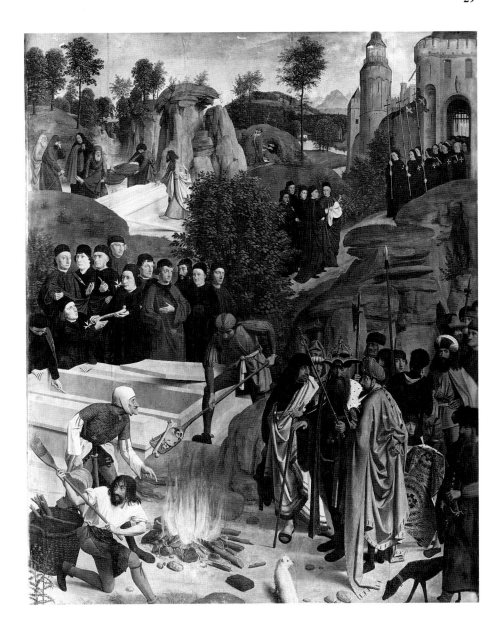

clothing, coiffure, or jewelry, so that even if any of these cultural elements were to be found in Europe, they do not show up, at least not clearly, in fifteenth century painting.

There are a small number of instances where Blacks appear, if not in spontaneous pose and their actual garb, at least somewhat outside of the usually prescribed subjects. One important example is in Geeraert van Sint Jans' painting of "Julian the Apostate Ordering the Bones of Saint John to be Burned," in which an African appears who may be dressed in African clothing. It is not possible, however, to identify even this figure as to specific geographical origin, for the painting offers little useful information for the ethnologist. In general, late fifteenth and early sixteenth century painting offers no more ethnographic information than is found in this work.

What appears in these paintings is, of course, a variety of physical types, some approaching portraiture. One thinks both of Hugo van der Goes' Monforte altarpiece and of Dürer's portrayals of the Adoration of the Kings. Dürer's (1508) portrait sketch depicting the head of a Black man, now in the Albertina, stands out as one of the first individual portraits of an African in European art. Here, the artist's response to his subject is apparent. It is, in fact, almost a cliché to speak of the dignity inherent in the noble features of the sitter. With this positive image, it is appropriate to conclude the present brief survey of images of Blacks in European art before the Atlantic slave trade.

The earliest depictions of an unfamiliar subject reflect the effort to translate that subject into a familiar idiom. Although Blacks were not unknown prior to the Portuguese sea explorations of 1444–1500, Africans were still exotic to most Europeans. At the same time, however, they already had an established role in existing Christian iconography.

In the fifteenth century, the discovery of new worlds—the Americas in particular but also, to a lesser extent, Africa—and of the inhabitants of those continents, challenged Europeans' accustomed conceptualization of the world. The process of assimilating these "others" into preexisting European intellectual structures (including established Christian iconography) was nothing less than an attempt to reassert order and to avoid an ontological abyss.

By fitting the African into an existing Christian iconography, European artists were incorporating the Black man into their familiar view of the world. Nevertheless, the discovery of distant lands and other cultures was one of the factors which, over the course of the subsequent three centuries, would cause the collapse of that essentially hermetic, Eurocentric world.

Pictorial representations of non-Europeans from the Age of Exploration provide significant evidence about the ways in which Europeans responded to the challenge, "How do we understand these others?" That question was to become increasingly important with the establishment of sustained contact with Africa and the New World. Ultimately, the European response would be founded increasingly on physical force, but during the Early Renaissance, relations of power had not yet come to dominate either European dealings with, or their conceptions of, Africans.

By the end of the 1600s, European attitudes toward African culture tended to equate European customs with civilization while defining indigenous African institutions as barbarous. Those Africans who, through extensive commercial contact, had adopted European manners or dress were considered more civilized than their countrymen who retained local customs. In the era of the Atlantic slave trade, very few Europeans could transcend this ethnocentric bias. Even fewer could share the uncommon sensitivity that Michel de Montaigne had expressed when, in 1580, he wrote, "Each man calls barbarism whatever is not his own practice."

NOTES

1. See Iris Origo, in *Speculum*, 1955.

2. See John Mandeville, p. 145.

3. See R. Hess, in *Journal of African History*, 1965, p. 16.

4. See Richard Jobson, p. 149.

5. See Carlo Ginzburg, 1983.

6. See Adam Jones, 184–185.

7. See Philip Ziegler, p. 85.

8. See Daniel Defoe, pp. 34, 35

9. Ibid. p. 41.

10. See Philip Beaver, p. 324.

11. See Defoe, pp. 48, 49

12. See Jobson, p. 84.

13. See Peter Mark, in *African Studies Review*, xxii, pp. 2, 91.

14. See Jones, p. 22.

15. See Kaplan, 1982.

16. See Peter Mark, 1974, p. 11.

17. See Mark, 1974, p. 88; Kaplan, 1982, xxi, parts 1 and 2.

BIBLIOGRAPHY

Beaver, Philip. *African Memorandum relative to an attempt to establish a British settlement on the island of Bulama on the western coast of Africa in the year 1792*. London, 1805.

Crawford, O. *Ethiopian Itineraries 1400–1524*. Cambridge, 1958.

Defoe, Daniel. *A Journal of the Plague Year*. Reprint. London, George Routledge and Sons, 1896.

Devisse, Jean. *The Image of the Black in Western Art*. Harvard University Press, 1976.

Ginzburg, Carlo. *Night Battles, Witchcraft and Agrarian Cults in the sixteenth and seventeenth Centuries*. New York, 1983.

Hess, R. "The Itinerary of Benjamin of Tudela: A Twelfth Century Jewish Description of Northeast Africa," *Journal of African History*, 1965, vi, 1.

Jobson, Richard. *The Golden Trade*. 162. Reprint. New York, 1968.

Jones, Adam. *From Slaves to Palm Kernels, A History of the Galinhas Country West Africa 1730–1890*. Wiesbaden, 1983.

Kaplan, Paul. "Titian's 'Laura Dianti' and the Origins of the Motif of the Black Page in Portraiture." *Antichita Viva*, 1982, xxi, parts 1, 2.

————. *The Rise of the Black Magus in Western Art*. Ann Arbor, 1985.

Kehrer, Hugo. *Die Heiligen drei Königen in der Legende und Kunst*. Strassbourg, 1904.

Lull, Raymon. *Blanquerna*. London, 1925.

Luzio, Alessandro. "Buffoni, nani e schiavi dei Gonzaga ai tempi d'Isabella d'Este." *Nuova Antologia*, 1890, xxxiv.

Male, Emile. *The Gothic Image*. New York, 1958.

Mandeville, John. *Mandeville's Travels*. Reprint. New York, 1960.

Mark, Peter. *Africans in European Eyes: The Portrayal of Black Africans in 14th and 15th Century Europe*. Syracuse, 1974.

————. "Fetishers, 'Marybuckes' and the Christian Norm: European Images of Senegambians and their Religions, 1550–1760." *African Studies Review*, Los Angeles, 1980, xxii, 2, 91.

al-Naqar, Umar. "Takrur, the History of a Name," *Journal of African History*, 1969, x, 3.

Origo, Iris. "The Domestic Enemy: The Eastern Slaves in Tuscany in the 14th and 15th Centuries," *Speculum*, 1955.

Ziegler, Philip. *The Black Death*. New York, 1969.

EDITORS' NOTE

Illustrations are numbered; objects appearing in the catalogue raisonne are identified by a number in parentheses at the end of the caption. For alternate views and references consult the catalogue raisonne.

XVI. "*Effigies ampli Regni auriferi Guineae in Africa*" Engraved by Baptista van Doetechem who worked ca. 1588–1633; published in Amsterdam by Carel Allard, ca. 1690. The map is based on a manuscript attributed to Luis Teixeira (1564–1604), a Portuguese Jesuit who was cartographer to the Spanish crown. It was probably originally engraved at the close of the sixteenth century; this is a late seventeenth century reimpression by Carel Allard. Both Sierra Leone (Sierra Liona) and Benin, the two main sources for the Afro-Portuguese ivories, are indicated on this map. The manner of riding horses in Benin is illustrated in the upper right-hand corner. A community festival is depicted to the left. The accompanying caption describes three types of fabric worn by the musicians and dancers. The carefully rendered instruments include a drum, hand and ankle bells, a gong, and even a harp. Cities, mountains and rivers fill much of the interior. Ink and original color on paper, 63.2 cm. x 53.2 cm. W. Graham Arader III Gallery, New York.

Commune Guincarum chorea quibus summo pere delectatur, hoc modo sunt, in brachys et cruribus quam plurimes habet vel eres, vel stamos, vel thurnes aut inube, quarum plureg, tintinabulis munit sunt, vorum ex motu edetes sonitum. Instrumenta quibus canut sunt peluis, tympana, trunci feretis cavati, nole vacariae, quaedam nostris tystabini similia facte cychare quarum chorde ex certis arundinibus, aut setis caude Elephantinae compesstae sunt, quorum sonus no inua cundes est. Bin plerumque saltant, alterno pede terram quatientes, diversis gestibus, astronomicis intermpetis, Inuiti choreas praesentibus extraneis agunt.

Mos est Nobilibus aulicis in Regia urbe Benin, aulam aditurus, equitare trans versum faeminarum nostratum more sedsculis loco ephippiorum insidentes, pendulis pedibus, et duobus famulis utrinque suffulci, plurimis comitati famulis, quorum unus umbraculum adversus puncturam solis, supra caput gestat, alij sequntur canetes tibiis, tympanis ferreis tubulis quos pulsant, atque ita Regiam ingrediuntur, Magnates utuntur rebus suntana bulis plenis, quae a famulis pulsantur. Rex suo more magno apparatu et pompa utitur.

CHAPTER 1
THE LEGACY OF THE NAVIGATOR

The primary impetus for the great European voyages of discovery to Africa, the Far East and the Americas, was the spread of the Islamic presence throughout the Mediterranean world. Although Islam posed a military and political threat to Christian Europe, it simultaneously brought with it the diffusion of Arab science throughout Western culture. Europe profited greatly from Islamic achievements in mathematics, astronomy, and geography, fields in which the Arabs inherited and preserved the cultural tradition of the classical world. Without this infusion of scientific knowledge into the Christian West from the Islamic East—one need only mention the astrolabe—the great voyages would probably never even have been dreamed of, let alone undertaken and successfully carried through.

Although Islam had dominated the Iberian Peninsula militarily since the eighth century, it was the Crusades, beginning in the eleventh, that put Europe into direct contact with the Islamic world. The great Italian maritime powers, whose fleets had ferried the Crusader armies to the Holy Land (and in doing so reaped immense profits for themselves) became the masters of the Mediterranean. This accomplished, they began placing commercial agents throughout the Near East and North Africa in order to foster and extend trade.

The Venetians rapidly secured a monopoly on imports from the Near East while the Pisans, the Florentines and, more importantly, the Genoese conducted trade in western Mediterranean markets. Because commerce there was poorer than in the east, the Genoese soon began to consider sending expeditions to Black Africa. They knew that the rulers of North Africa would never grant passage through their lands to infidel European merchants. The Atlantic was their only route.

Two galleys, the Allegranza and Sant'Antonio of the Vivaldi brothers, set out in 1291 from Genoa on an ill-fated voyage to Africa. Their goal was to reach the mythical kingdom of Prester John, to them Christian Ethiopia, which had maintained intermittent relations with Rome, and in so doing, they also hoped to bypass their Venetian rivals by opening up an alternate trade route to the Orient. This ambitious project to circumnavigate Africa two centuries before the voyage of Bartolomeo Dias ended tragically. Legend has it that one of the two ships did reach Ethiopia, where members of the crew passed the rest of their lives.

The broadening of geographic horizons created a demand for new navigational instruments. New maps were especially needed, maps that would take account of the knowledge passed down by Antiquity, and would include the latest (though often imprecise) information gathered by navigators and merchants. To meet this demand, important schools of map making were established in the fourteenth century, in which scholars, who were for the most part Jewish, drew up the first precious geographical maps, known as the *Portolani*. Genoa, Venice and Pisa were the first important cartographic centers, but later activity was concentrated at Majorca in the Balearic Islands. On these new maps, the outlines of the coast of Africa began to take shape, while in the immense blank spaces of the interior appeared rivers whose sources were unknown, mountains and lakes whose location was often pure fantasy, and the first cities. A Genoese who lived in Sidjilmasa made a map in 1320 that plotted the route

1. Armillary sphere, 1543. A sort of skeletal celestial globe, this is an astronomical instrument whose metal rings represent the tropics and celestial orbits; the central globe revolves upon its axis within a horizon divided into degrees. As the exploration of the world became a national project, a demand for new navigational instruments arose. Wood, metal, and leather. National Museum of Denmark, Copenhagen.

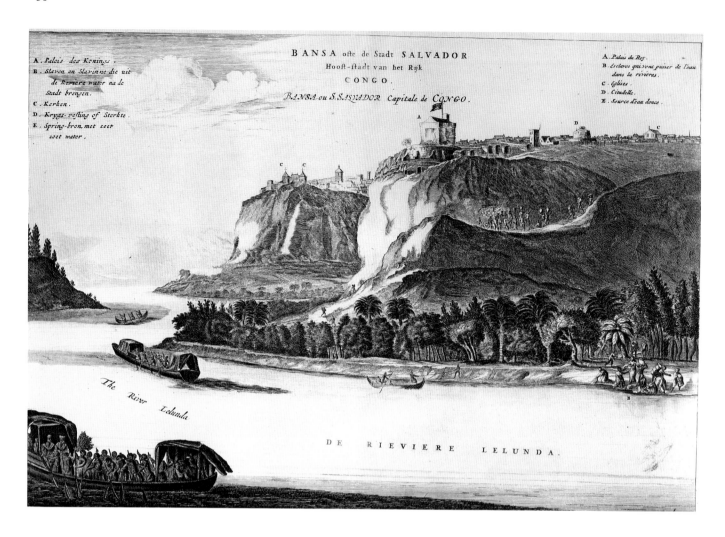

A .Palais des Koninys .
B .Slaven en Slavinne die uit
de Reviere water na de
Stadt brengen .
C .Kerken .
D .Krygs-vesting of Sterkte .
E .Spring-bron met zeet
zoet water .

BANSA ofte de Stadt SALVADOR
Hooft-ftadt van het Rijk
CONGO.
BANSA ou S.SASVADOR Capitale de CONGO .

A .Palais du Roy .
B .Esclaves qui vont puiser de l'eau
dans la rivieres .
C .Eglises .
D .Citadelle .
E .Source d'eau douce .

The River Lelunda

DE RIEVIERE LELUNDA .

of the forty day journey from Tafilalet to Walata.[1] Mali appears for the first time in 1339 on the map by Angelino Dulcert of Majorca, and the ancient cities of Gao and Timbuctoo are already correctly located on the *Atlas Catalan,* a map made in 1375 for Charles V of France by another Majorcan, Abraham Cresques.

The failed voyages of the Vivaldi brothers and those of other Italian and Catalan navigators revealed the unsuitability of their Mediterranean ships for ocean navigation. These ships were fragile, powered by oars and difficult to maneuver; the Italian galleys were far inferior to the hardier Iberian ships, which, furnished with lateen sails invented by the Arabs, were easily maneuverable on the high seas. Realizing that they had to acquire direct experience of sailing the ocean if their voyages of exploration were to have any chance of success, Genoese admirals, captains, pilots and commercial agents transferred their activities to the Atlantic coast of the Iberian peninsula.

As a result, between 1310 and 1339, an expedition commanded by a Genoese, Lanzarotto Malocello, discovered the Canary Islands and gave the name Lançarota to one of the islands. A second expedition in 1341, led by another Genoese, Niccoloso da Recco, along with the Florentine Angiolino del Tegglia dei Corbizzi, reached the Azores. The great Florentine writer Giovanni Boccaccio wrote an account of this voyage, apparently based on information given by Niccoloso da Recco himself to some Florentine sailors in Seville.[2]

The Black Death and the demographic and economic crisis it precipitated in mid-fourteenth century Europe put an end to attempts by any

2. "City of San Salvador, capital of the Kongo Kingdom," from O. Dapper, *Description de l'Afrique,* Amsterdam, 1687. In 1482, the caravels of Diogo Cão entered the mouth of the river Congo and established contact with the Kongo kingdom. Engraving, 258 x 342 mm. Fondation Dapper collection, Paris.

3. Portrait of Prince Henry of Portugal (1394–1460), known as Henry the Navigator, from the *Cronica de Gomes Eanes de Azurara.* It was he who directed the endeavors which, in the course of half a century, culminated in the circumnavigation of Africa by Portuguese vessels and opened the way to the fabulous riches of the Indies. Bibliothèque Nationale, Cabinet des Manuscrits, Paris.

4. Boats of the first expedition to India, pictured in the *Livros das Armadas,* 1497. During the second half of the fifteenth century the caravel was the main vessel of Portuguese ocean voyages. Equipped with heavy cannon, it represented a great advance over earlier ships. Academia das Ciencias, Lisbon.

Mediterranean state to establish itself as a commercial power in the Atlantic. This left the field of activity open to the countries of the Iberian peninsula, above all, to Portugal.

At the beginning of the fifteenth century, Portugal was a poor, sparsely populated country of roughly a million inhabitants, but it enjoyed advantages which Spain, for instance, still lacked—a national identity and well-defined borders. The Portuguese had already liberated themselves from Moslem rule by 1257, and they were engaged in the Western Crusade to conquer the lands of North Africa across from the Iberian peninsula. Since the routes linking the Mediterranean to the North Atlantic crossed Portugal, Portuguese culture was enriched by contacts with other civilizations. For although Portugal shared a common heritage and religion with the rest of Europe, her borders looked out onto the world of the "others," the pagan world that still aroused great terror and curiosity.

A small country on the edge of the Christian world, Portugal had a close relationship with the Atlantic—on which sailed her oceanic fishing fleets, and her mercantile ships carrying wine, leather, salt and fish to Flanders and England. These factors put her in a unique position as the age of new explorations began.

The Portuguese conquest of the fortified Moroccan city of Ceuta in 1415 opened a new chapter in Portugal's history. The possession of even this small piece of Moroccan territory granted to the Portuguese something that was unavailable to the rest of Europe: first-hand information on trans-Saharan commerce and news from the lands beyond the desert.

Prince Henry of Portugal (1394–1460), the son of the first king of the Aviz dynasty, participated in the taking of Ceuta. Henry was also the Grand Master of the Military Order of Christ—an order whose special mission was to fight the Moors—and he used the Order's funds to finance expeditions in the Atlantic. He personally accompanied some of these voyages, thus earning the name of Henry the Navigator.

For the first time in Portugal, sailors and men of science worked together to create new tools for world exploration. As Jaime Cortesão wrote of this period, "for the first time the idea of the exploration of the world became a project for a nation, took the form of a method, with a clear scientific character."[3] The legendary "School of Sagres" in the most southwestern part of Europe, where new maps and new instruments were believed to have been prepared, never existed in a proper sense. Nevertheless, sailors, geographers, astronomers and cartographers worked together under the orders of the Infante Henrique. Winds and currents were studied, new methods of astronomical observation to determine latitude were developed and the main vessel of the discoveries, the caravel, sailed from the ports of Lagos and Lisbon. All the pilots returning from ocean voyages had to take their log books to the "Casa da Mina" (later "Casa da India") in Lisbon so that the cartographers could adjust the standard map or "Carta Padrão." After every voyage the old, fantastical maps became more accurate. The Portuguese also revealed a true genius in the production of firearms; even in the fifteenth century their ships were armed with heavy cannon.

Until 1434, Cape Bojador, located on the northwest coast of Africa at the same latitude as the Canary Islands, lashed by ocean currents and wrapped in fog, had been a barrier beyond which the Portuguese were unable to sail, either technically or psychologically. Around 1445 a route was found which, following an arc on the high seas near the Azores, allowed the ships to return to Portugal without having to counter the southern winds that blow off the African coast.

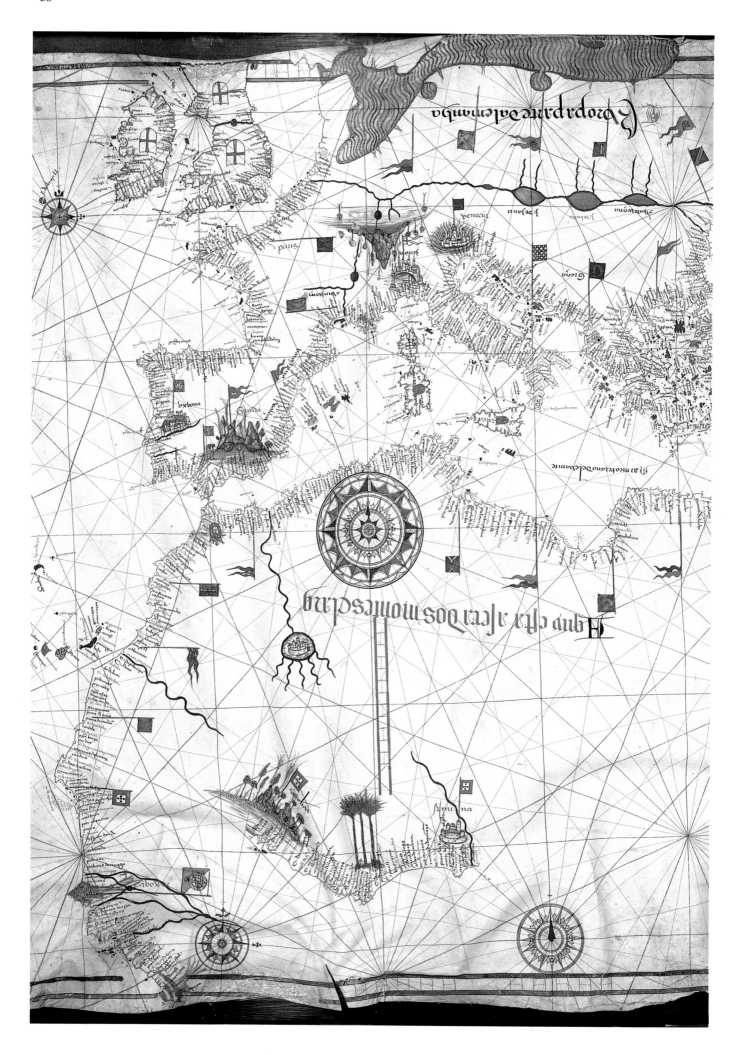

Once Cape Bojador had been passed, Portuguese caravels pushed farther south quickly, reaching the Gulf of Guinea and the Cape Verde Islands in 1455–1456. The report of this discovery, written by the Venetian Alvise da Mosto, is among the most interesting documents in the whole history of fifteenth century discoveries.[4] Pero da Sintra discovered Sierra Leone in 1460, but in that same year Prince Henry died, and activity was sharply curtailed.

At this time, trade with the newly discovered lands, especially in spices and ivory, was highly profitable. One company, for instance, operating from the Portuguese port of Lagos on the Algarve, took in profits at the rate of six hundred percent between 1450 and 1451, despite an appalling death rate among the sailors. Greed for the lucrative trade soon prompted a resurgence of exploration. This time, private entrepreneurs took charge and the voyages intensified.

Thus it came about that in 1469, Fernão Gomes, a rich merchant in Lisbon, obtained a royal concession to conduct trade in the regions beyond Sierra Leone on the condition, however, that his ships explore one hundred leagues of new coastline each year until 1475. In 1471, Gomes' captains reached what is now Ghana; the next year they discovered the islands of São Tomé and Principe and arrived on the marshy coasts of what is now Nigeria. Sailing up the Benin River to Gwato (Ughoton) in 1472, the Portuguese made contact with the *oba* of Benin through intermediaries.

Ten years later the caravels of Diogo Cão entered the mouth of the river Congo, and on its southern bank the captain raised the "Padrão" of St. George, a stone emblazoned with the royal arms, as testimony of this feat. The Portuguese returned to the Nigerian area in 1486, with a more substantial presence than the first time; they set up a permanent settlement and established friendly relations with Benin. A mission led by João Afonso d'Aveiro visited the city and was received by the *oba*. The king showed so lively an interest in trading with the Portuguese that he dispatched an ambassador to Lisbon.

Finally, in the same year, Bartolomeo Dias reached the Cape of Storms, rechristened the Cape of Good Hope, and entered the Indian Ocean. In so doing, he opened the route to the Orient to Vasco da Gama, who reached Calcutta in 1498. In less than half a century Prince Henry's great plan had been achieved. The orientation of European trade with Africa and the East shifted from the Mediterranean to the Atlantic.

In practical terms, the Portuguese had no rivals. The only possible competitors were Spanish sailors and merchants. But at this time the resources of Castile and Aragon, unified since the marriage of Ferdinand and Isabella in 1469, were fully occupied with the war of reconquest against the Moors, which continued until the fall of Granada in 1492.

The treaty of Alcaçòvas drawn up in 1479 pledged the renunciation of the Spanish crown to "all the traffics, commerces and land of Guinea with the gold mines, or to any other land, yet discovered or still to be discovered," in exchange for the final renunciation of Portugal's claim to the Canary Islands. In 1492, the discovery of America provided a new sphere for the maritime power of Spain and opened up a whole continent to her colonial ambitions.

The great voyages of discovery were far beyond the economic resources of little Portugal, which could not sustain the enormous costs occasioned by the opening of the new routes. These voyages were made possible by broader European resources: technical knowledge, commercial capacities and, above all, by capital. The marshalling of these resources came about through the close ties between the Portuguese crown and the great merchant banks of Italy and Germany: the Marchionni, Frescobaldi,

5. Detail of *Europe and Africa* drawn by Jorge de Aguiar in 1492, the oldest known Portuguese map of Africa. It is meant to be read from all four sides. Part of the West African coast that today runs from Sierra Leone to Ghana is shown in an inset above the area. Important cities have been indicated by drawings of buildings: Venice, Genoa, Avignon (upside down), Grenada, and "Lixbona" (Lisbon). Two areas in Africa merited detailed drawings: Elmina in what is now Ghana, and "Seralioa" on the Sierra Leone coast. The fanciful city in a lake in the western Sahara is a sign of how little penetration into the interior had taken place, and how poorly the interior of the continent was known. Parchment, 77 x 103 cm. overall. Yale University Library, New Haven.

and Medici of Florence, and the Rotts and Fuggers of Augsburg, to cite some of the more famous names involved.

One of the principal objectives of the Portuguese explorations in Africa, although never explicitly stated, was to control the gold trade from West Africa. Formerly, gold had reached Europe by caravan routes along the Mediterranean coasts. But in 1471, the ships of João de Santarem discovered the coastal region of present-day Ghana in the area of the river Pra. The place was renamed "Mina" because of the hoards of gold that were found in the surrounding regions. Returning to this area ten years later, Diogo d'Azambuja, the commander of the Portuguese expedition, acting on orders from King João II, built a fort on land seized by force from the local king. The fort was named São Jorge da Mina, at present-day Elmina.

For a time, the building of the fortress was a state secret. Stones, bricks, chalk, timber and ironware were shipped, as recounted by the fifteenth century chronicler Garcia de Resende, in old ships that were sunk after being unloaded in order to convince the competing maritime powers that the strong currents made it impossible to sail back to Europe from that region. Three other forts were built later at Axim, Shama, and at what is now Accra to store the gold and the goods exchanged for it, to house soldiers, functionaries and merchants, and to ward off the ships of other competing nations.[5]

Much less was realized from the gold trade at Monomotapa, in the Zambezi region of south-eastern Africa. Despite the conquest of the cities of Kilwa, Mombasa and Sofala, the quantity of gold that the Portuguese obtained from the Moslem merchants who controlled the interior—and who were hostile to the newcomers—was insufficient to cover the maintenance of the forts and the protection of the trade routes. Nor was the situation improved by Portuguese attempts to take over the sources of production. These endeavors culminated in the second half of the sixteenth century with a treaty with the ruler of Monomotapa, according to which the Moslems would be expelled so that the Portuguese could enjoy complete commercial freedom.

For a long time, the gold monopoly in Western Africa constituted an important source of income for the Portuguese. It provided them with the means to finance their expeditions as well as their commercial enterprises. At first two of the most important were ivory and pepper, products that were highly esteemed in Europe but extremely expensive when obtained via the Near East and Venice. African pepper, which came primarily from the Benin kingdom, was regarded as inferior in quality to Indian

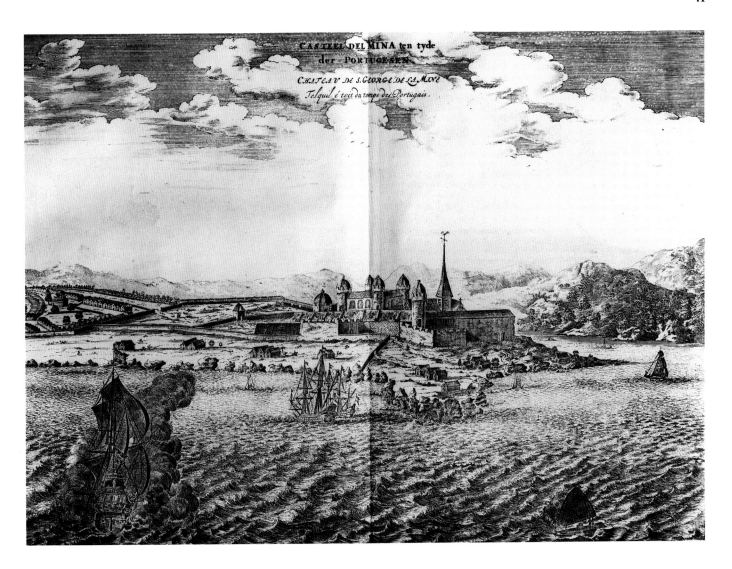

6. "The Castle of Elmina," from O. Dapper, *Description de l'Afrique,* Amsterdam, 1687. The ships of Fernão Gomes, a rich Portuguese merchant from Lisbon, reached present-day Ghana in 1471. The coastal region surrounding the river Pra was named "Mina" because of the hoards of gold found there. In 1481, Diogo d'Azambuja, the commander of the Portuguese expedition, acting on orders from King João II, built a fort on land seized from the local king. The fort was named São Jorge da Mina, today called Elmina. Fondation Dapper collection, Paris.

7. Peoples of the world from Guinea to greater India are illustrated in this woodcut from five blocks entitled *The King of Cochin* by Hans Burgkmair, Nuremberg, post 1500. Vasco da Gama, traveling around the Cape of Good Hope, reached Calcutta by 1498, thereby shifting the orientation of European trade with Africa and the East from the Mediterranean to the Atlantic.

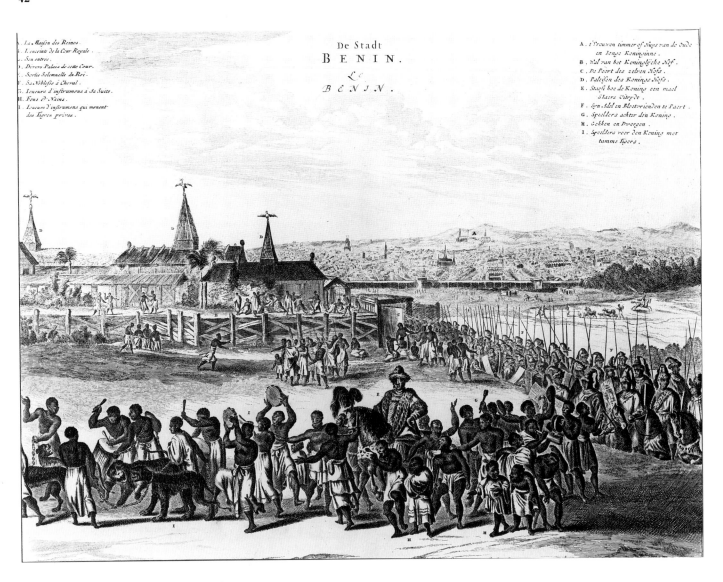

De Stadt
BENIN.
Le
BENIN.

pepper and therefore realized a lower price on the European market. Its importation collapsed at the beginning of the sixteenth century with the opening of the route to India. The storehouse at Gwato on the Benin River was closed in 1507 because it had become unprofitable, and because the *oba* wished to impose his own trading rules.

Ivory, on the other hand, became ever more scarce as the slaughter of elephants was vigorously pursued in West African coastal regions to satisfy European demand. In due course, ivory, spices and even gold progressively lost their importance compared with the much more profitable trade in slaves. In the early years exported mainly to Portuguese settlements in Africa, particularly to the Gold Coast and the islands of São Tomé and Principe, slaves were later shipped to the plantations of Brazil and other colonies of the New World. Although the institution of slavery was known to African society, the trading of slaves was introduced by Europeans. The numbers computed by Philip D. Curtin, after an analysis of the literature on the slave trade, show: 76,000 Africans were shipped to Europe in the period from 1415 to 1525; 74,000 between 1526–1600; and 125,000 were exported to America in the same years.[6] These huge figures become modest when compared to those of successive years—over 9 million between 1601 and 1870—but they are horrific when one remembers that the merchandise was human beings.

In this second period of intense activity the Portuguese played but a secondary role. The slave trade, like the gold trade, passed first into the hands of the Dutch and then into those of the English.[7] Nevertheless, for

8. "The city of Benin," from O. Dapper, *Description de l'Afrique,* Amsterdam, 1687. In the background is the palace with its tall spires topped by bronze birds as shown on the box to the right. The European and the Bini depictions of this building agree. The city of Benin was described in the seventeenth century by Olfert Dapper as being larger than the Dutch town of Haarlem with which it was favorably compared. This engraving shows a procession of the *oba,* or king, of Benin with his retinue of attendants, warriors, dwarves, leopards, and musicians. Fondation Dapper collection, Paris.

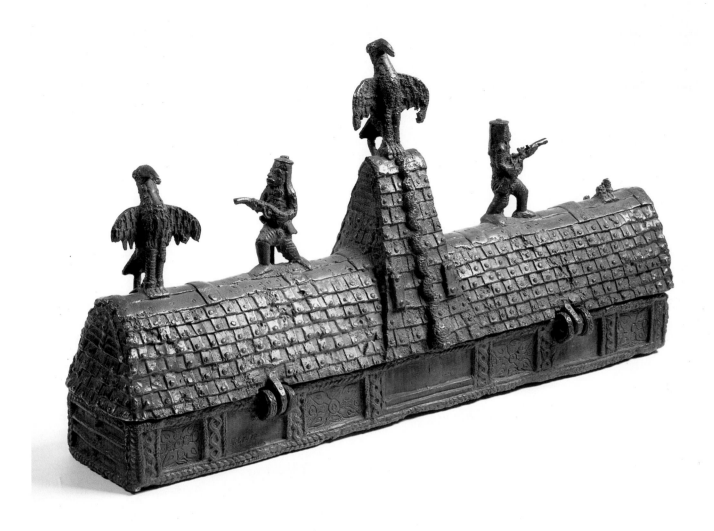

9. Bronze box made in Benin. Nigeria, 17th century. Cast by the lost wax method by the guild of royal bronze-casters, this box depicts the gabled palace entrance as it appeared in the seventeenth century, surmounted by a monumental bronze bird and a serpent. The presence of two Portuguese musketeers on the roof metaphorically expresses their military support of Benin's king. Bronze, 60 cm. Museum für Völkerkunde, Berlin.

about a century, Portugal, the small kingdom at the edge of the continent, was the greatest commercial power of Europe, and Lisbon was the emporium of the world.

The position assumed by Portugal as a world power was sanctioned by treaties. In 1494, the treaty of Tordesillas settled the territorial competition between Spain and Portugal. On August 23, 1499, Pope Sixtus VI bestowed on the young King Emanuel I the patronage over all African lands that had either already been discovered or would be discovered in the future. This *patronatus* was meant to be understood as a religious responsibility to convert the heathen, but it was taken as a kind of political authority which the Portuguese used to ban the ships of all other countries from African waters. This was particularly applied, of course, to trading vessels.

In the name of the patronage, Emanuel I in 1512 sent a *regimento* (rule) to the newly converted king of the Kongo. This was a document that regulated relations between Portuguese and Africans and provided a plan for organizing the state on the model of a Christian kingdom.[8]

One of the most conspicuous results of the European presence, the conversion of the Africans, was more often in name than in fact. Traditional African religious practices continued to hold sway even after the more or less enduring conversions of various local rulers. After the sincere conversion of King Afonso I of the Kongo, images of the Crucifix, the

10. Three crucifixes. Kongo, Zaire, 17th–18th century. After the conversion of King Afonso I of the Kongo, in 1512, images of the crucifix, the Virgin Mary, and of St. Anthony were created in bronze by Kongolese artists after Portuguese originals. In time, the people returned to their original religion and the images lost their Christian meaning. They became integrated into the African tradition as emblems of power or as instruments of Kongo religious ritual and remained in use into the twentieth century. Wood, bronze. 37, 42, 28 cm. Museo Etnografico Missionario, Città del Vaticano.

Virgin Mary, and of St. Anthony were cast in bronze by Kongolese artists after Portuguese originals, but in time, the images lost their original meaning and were integrated into the African tradition as emblems of power or as instruments of religious ritual. Furthermore, the oft-proclaimed desire of the Portuguese kings to convert Africans to the true faith had more than a religious motivation. They also wished to win the favor of the Papacy which carried with it concrete commercial advantages.

The Portuguese presence in Africa during the fifteenth and sixteenth centuries was largely limited to some of the coastal regions, where their outposts had varying lifespans. In her original grand plan, Portugal had never foreseen the creation of new commercial activities, nor manufacturing in the newly discovered countries. Nor had Portugal ever intended to set up real colonies— with the possible exception of those on the islands in the Gulf of Guinea. Rather, the Portuguese intended only to redirect existing economic activities and political systems to their own advantage.

This policy was modified over the course of time; Portugal, the first European nation to set up a great colonial empire, was also the last to dismantle it. The influence, therefore, of the Portuguese over the structure of the African societies with which they came in contact, was quite varied, and depended not so much on the Portuguese themselves as on the type of culture and social structure they administered.

The fifteenth century Sapi, for instance, who are the ancestors of the present-day Bulom (Sherbo), Temne, Kissi and some smaller peoples of Sierra Leone, lived in relatively small communities led by a local chieftain who in turn was a vassal of a paramount chief or king. Theirs was a very localized, stateless political structure unlike the more centrally organized political states of Benin and the Kongo.

The city of Benin was described in the seventeenth century by Olfert Dapper as being larger than the Dutch town of Haarlem. It was a city-state where strongly centralized power was wielded by a divine king, the *oba,* assisted by a council of chiefs. The ordinary people, however, were

11. "Homage of the Portuguese ambassadors to the king of Kongo in 1491," engraving by T. and J. de Bry from the Latin edition of *Relazione del Reame di Congo. . . ,* by F. Pigafetta, Frankfurt, 1598. A richly dressed Portuguese is shown paying homage to the Kongo king who sits on an elevated platform. At his feet lie European objects including a chalice and a crucifix, both likely to have been gifts from the visitor. Though there are no known Kongo versions of the chalice, and no Kongo-Portuguese saltcellars, the crucifix was copied by Kongo artists.

12. "Costumes of the Nobleman and of the Servant," from F. Pigafetta, *Relazione del Reame di Congo. . . ,* Rome, 1591. When the Portuguese arrived at the mouth of the Congo river in present-day Zaire, they encountered the vast Kongo kingdom with sophisticated social and administrative structures which included a territorial organization, an efficient trading network, a monetary system and a rigid hierarchy at whose head sat the king, the *manicongo.*

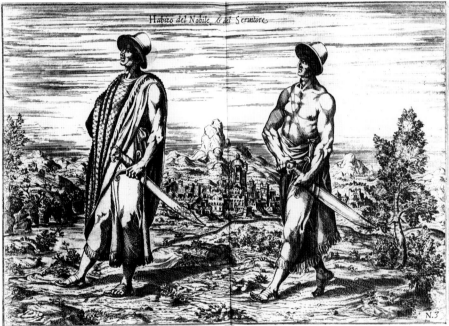

organized in a system of village communities, which was the original structure apparently overlaid by the Yoruba dynasty and bureaucracy of the kingdom.

The Kongo was a vast kingdom with tested and proven social and administrative structures which included a territorial organization, an efficient trading network, a monetary system and a rigid hierarchy at whose head sat the king, the *manicongo.* These monarchs of Benin and of the Kongo were of quite a different order from the local chieftains in Sierra Leone or even from rulers of the warring kingdoms of the Gold Coast.

During the early periods of contact, the kings of Benin and the Kongo were, at least on the surface, treated as equals by the king of Portugal, who referred to them as "brother." In the *Regimento* of 1512, Emanuel I called upon the Manicongo Afonso, a Christian convert, to send a mission to Rome to make an act of obedience to the Pope "as do all Christian

13. Oliphant. Kongo, Zaire, 16th century. This hunting horn was one of the first African objects to enter a European collection. Listed in an inventory of 1553, it is one of the three oliphants that belonged to Cosimo I de Medici, Grand Duke of Tuscany. 57.5 cm. Museo degli Argenti, Florence (no. 182).

14. Woven raffia cloth. Kongo, Zaire, or Angola, 17th century. Kongolese cloth with a pile similar to velvet, and with geometric designs in low relief, was exported to Europe in great numbers during the fifteenth and sixteenth centuries. In 1507, only twenty years after the arrival of Diogo Cão, Kongo textiles were listed as among the goods of the deceased Alvaro Borges, a Portuguese colonist in São Tomé. Raffia, 57 x 48 cm. National Museum of Denmark, Copenhagen.

15. Woven raffia hat. Kongo, Zaire, or Angola, 17th century. The Kongo made hats for their own use. The technique and motifs were similar to those on the cloths made for export and local use. Raffia, 18 cm. National Museum of Denmark, Copenhagen.

16. Detail of oliphant. Central Africa (?), Zaire (?). This oliphant is partly covered with leather embossed with the arms of the Houses of Toledo and the Medici. The combination of these heraldic markings indicates that the hunting horn was acquired at the time of the marriage between Cosimo I de Medici and the Spanish princess, Eleonora of Toledo, daughter of the Viceroy of Naples, which occurred in 1539. Ivory and leather, 114.5 cm. Museo di Antropologia e Etnologia, Florence.

princes and sovereigns." The Pope, on his own, was in contact with the *manicongo* and called him "our most beloved son." In 1518, the Pope named the *manicongo's* son, Henry, as the first bishop of Black Africa. Henry had been educated in Lisbon with the sons of other African nobles.[9] Black ambassadors were sent to Lisbon where they were received at court with great pomp. In Europe they must have presented an image of Africans quite different from the one presented later by the thousands of slaves engaged in manual labor.

The technological disparity between preindustrial Europe and Africa, which was not yet so great, did not at first seem to play a dominant role. The two great premises for the voyages of discovery, one of which was idealistic—the "civilizing" mission of the West, while the other was materialistic—trade, soon manifested their contradictory natures. In only a few decades, commerce had degenerated into the brutality of the slave trade, a denial of all humanity to the Africans. These mixed motives are revealed in the above-mentioned *Regimento,* sent to the king of the Kongo in 1512, which stated that the goal of the Portuguese is not "material gain," but only that of the propagation of the faith. Nonetheless, it recommended that ships returning to Europe be "as heavily laden as possible with slaves as well as with copper and ivory" *(asy descrauvos como de cobre e marfim)* in order to repay the high expenses incurred in the Christianization of the country.[10]

Ivory and cloths were listed among the gifts brought back by Diogo Cão from his voyage to the Kongo. In fact, Ruy de Pina, one of the first chroniclers of the Portuguese expeditions, wrote that "the gift of the king of the Kongo to the king [of Portugal] was elephant tusks, and worked ivory pieces and many raphia cloths well-woven and of fine colors."[11] In the following years the shipments continued.

Among the first African objects to enter a European collection that we can identify today (if we interpret the rather summary documents correctly) are the three oliphants belonging to Cosimo I, Grand Duke of Tuscany, which are listed in an inventory of 1553. These objects are now in the Museo degli Argenti (nos. 181 and 182) and the Museum of Anthropology and Ethnology, both in Florence. One of the trumpets has been partly covered with leather, embossed with the arms of the Houses of Medici and Toledo. These heraldic markings inform us that the trumpet was acquired at the time of the marriage of Cosimo and the Spanish princess, Eleonora of Toledo, the daughter of the Viceroy of Naples, in 1539.[12]

Kongolese pile cloth similar to velvet, woven with beautiful geometric designs in relief, are the most numerous of centuries-old African artifacts in European collections. Although the first secure reference we have for an identifiable cloth appears only in 1659 (a piece from the collection of the merchant Christof Weickmann now in Ulm), these textiles are repeatedly mentioned in sixteenth century chronicles about the Kongo.[13] Already in 1507, only twenty years after the arrival of Diogo Cão—"two pillows of the *manicongo,*" "another pillow of the *manicongo,*" and "a half-cloth and two decorated fabrics all of the *manicongo*" are listed as among the goods of the deceased Alvaro Borges, a Portuguese colonist in São Tomé.[14] The "pillows" almost certainly had covers consisting of decorated cloths sewn together, as recounted in later chronicles, and as confirmed by the tasselled double fabrics now in the National Museum of Denmark in Copenhagen, and in the Museo Pigorini in Rome.

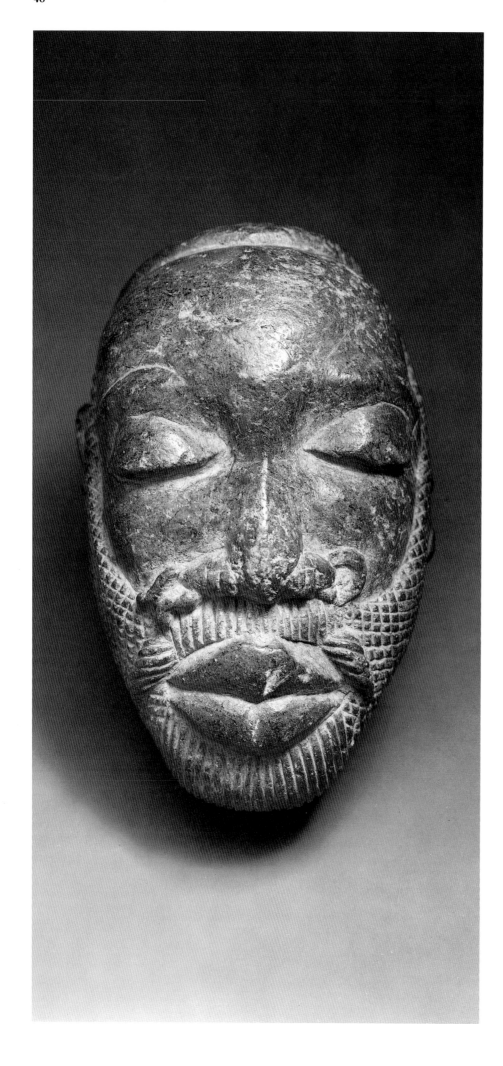

17. Stone head (*maha yafa*). Sapi, Sierra Leone, 15th-16th century. The stone sculptures found in Sierra Leone and Guinea today can be taken as representative of the art style that preexisted the Portuguese arrival on the coast. Stone, 20.3 cm. The Paul and Ruth Tishman Collection of African Art, Walt Disney Co., Los Angeles.

18. Seated figure (*nomoli*). Sapi, Sierra Leone, 15th-16th century. This style of stone work, often attributed to the Sherbro, most closely resembles that of the Afro-Portuguese ivories. Soapstone sculptures are found in the earth today by the present inhabitants of Sierra Leone and Guinea, who use them in ancestral rituals. We have no information on their original use or meaning, but it is clear that their style formed the basis for the Sapi works in ivory carved for the Portuguese. Stone, approx. 15 cm. Francesco Pellizzi collection.

19. Figure (*pomdo*). Sierra Leone, 15th-16th century. This style of stone sculpture, though found on the Sierra Leone coast, does not have much in common with the Afro-Portuguese ivories. Stone, 17 cm. Carlo Monzino collection.

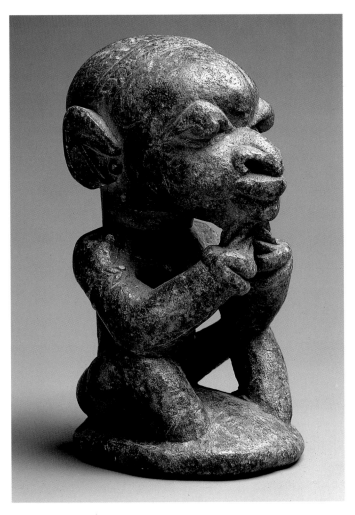

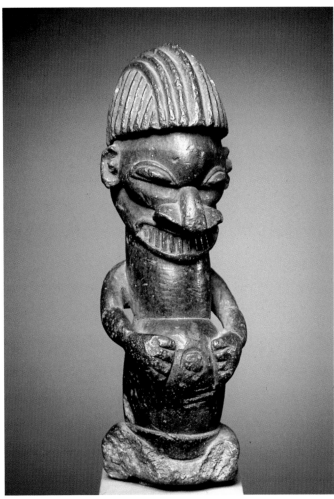

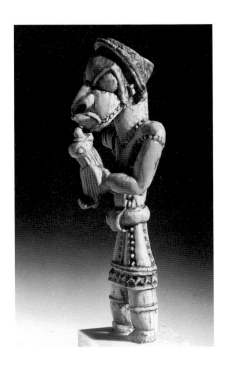

20. Ivory figure from a Sapi-Portuguese saltcellar, ca. 1490-1530. The similarity in style to the soapstone figures from Sierra Leone is marked. The roundness of the eye, the broad nose treated as three separate parts, and the horizontal thrust of the chin are shared characteristics. Approx. 7 cm. F. Rieser collection (no. 54).

The only works of art or artifacts from Sierra Leone and Benin to appear in older European collections are works commissioned by Europeans from African artists for export to Europe, namely the Afro-Portuguese ivories that form the nucleus of this exhibition. Though no works have survived, the peoples of these regions clearly had their own artistic traditions that preexisted their first contacts with the Portuguese. Numerous artistic traditions flourished, as will be demonstrated below.

Hundreds of sculptures in soapstone have been found in the regions of Sierra Leone now inhabited by the Sapi (Bulom, Temne, and Kissi peoples) and by the Mani (Mende) who arrived in that area in about 1540–1560. These sculptures of human figures and animals are reliably dated by scholars to at least the first half of the sixteenth century. The figures are called: *nomolisia* (sing. *nomoli*), *mahey yafeisia* (sing. *maha yafa*) and *pomtan* (sing. *pomdo*). The first two terms refer to works characterized by voluptuously rounded volumes and by an abundance of detail that are usually assigned to the Bulom. The figures called *pomtan,* often with ferocious features, are attributed to the Kissi. Aside from their intrinsic artistic worth, these stone figures are important to this investigation because of their similarities to the ivory sculpture from Sierra Leone, similarities to be examined in the following chapter.

The stone sculptures are almost certainly by the Sapi (rather than the Mani) the linguistic ancestors of the present-day Bulom, Temne and Kissi. The Mani, Manding warriors, and ancestors of the Mende, invaded the Sapi area in the mid-sixteenth century. According to the late Walter Rodney: "one of the most disastrous results of the Mani invasion was the destruction of the skills of the Sapes."[15] He echoes a judgment expressed by Manuel Alvares in 1611: "It is the fault of the foreign kings [of the

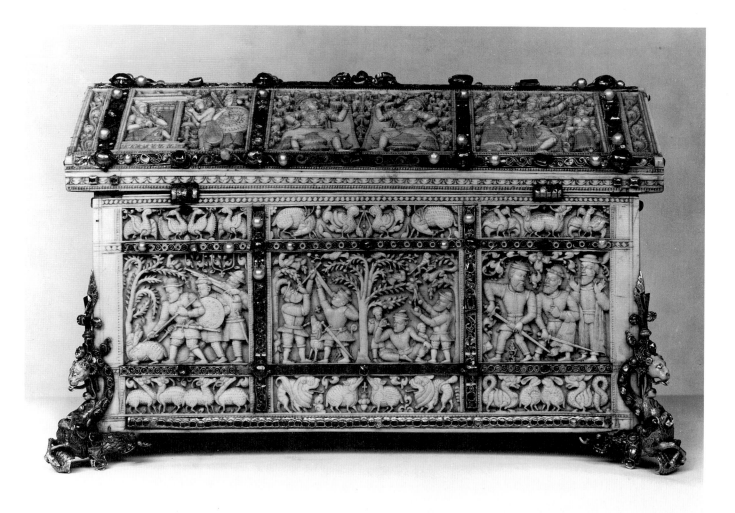

Mani] that the country is so poor, because they have captured so many master craftsmen, and . . . have committed so many vexations on the indigenous people that these latter have become less and less concerned and have given up the exercise of their arts."[16]

The Nigerian city-state of Benin, approximately fourteen hundred miles further along the Guinea Coast, is the richest source, at least numerically, for ancient African art. The immense corpus (more than two thousand sculptures in wood, ivory, and bronze) that reached Europe in 1897 following the occupation of Benin by British troops, was received with amazement and admiration.

21. Box. Ceylon, 1540. The Afro-Portuguese ivories and this Ceylono-Portuguese box have a similar mixed origin, and come from the same historical period. They also have certain stylistic traits in common such as the use of the beaded line seen here especially in the frames of the panels. Narrative scenes such as those seen here, however, are alien to African art, and occur rarely in the Afro-Portuguese works. Ivory, metal, and jewels. Schatzkammer der Residenz, Munich.

The discoveries in Africa and Asia increased the riches and extended the influence of Portugal beyond her own borders, and enhanced her prestige. The most powerful nations treated her as an equal and desired her as an ally. A series of marriages strengthened the alliances of the Aviz dynasty with the monarchies of Europe, particularly the Habsburgs of Spain. These latter ties were pursued so closely as to produce a "dangerous consanguinity," but the dream of unifying the Iberian peninsula under the House of Aviz was destined never to be realized.

Princesses and princes came and went from Lisbon accompanied by vast retinues of retainers, and by baggage trains filled to the brim with jewels, clothing and precious objects. These exchanges reduced the distance between Portugal and Europe; customs were modified, and objects up to then unknown and strange became familiar. Above all, new ideas circulated among the privileged classes and eventually modified the everyday life of the entire Portuguese nation.

22. Pitcher. China, Fukien (?), Ming Dynasty (1506-1521). The armillary sphere depicted here is a frequent subject of the Afro-Portuguese ivories. As Portugal became ever richer and more powerful, a taste for luxury characteristic of Renaissance Europe spread through the upper levels of Portuguese society. Contact with far away lands inspired an interest in the exotic and resulted in the commissioning of innumerable works of art. White porcelain, 26 cm. Fundaçao Madeiros e Almeida, Lisbon.

23. Powder flask. Japan, Muromachi-Momoyama period, late 16th century. The Portuguese visitor depicted here is wearing clothing similar to that seen on Portuguese figures in African art such as the seated figure from Benin illustrated on page 167. Lacquered wood, 30 cm. Museu Nacional de Arte Antiga, Lisbon.

Thus, between the end of the fifteenth century and the middle of the sixteenth, Portugal found herself in the role of intermediary between Europe and the newly discovered lands, the transmitter of the values of Western civilization, values which came back strengthened from the confrontation with alien cultures and enriched by contacts with those cultures. Hence, in the assimilation of these diverse experiences, Portugal paved the way for Europeans to acquire an understanding of the diversity of the human family.

As Portugal became ever richer and more powerful, a greater taste for luxury spread throughout the upper levels of Portuguese society, a taste that was characteristic of the Renaissance in Europe. Innumerable works of art were commissioned by the Portuguese in Italy, Flanders and Germany: paintings, sculptures, objects of gold and silver, tapestries and furniture. Contact with the newly discovered lands developed an interest in the exotic. It was in this context and cultural climate that the Portuguese commissioned works of art from African and Oriental artists. Even these works, however, betray a desire to conform to the prevailing model of "European taste." The Afro-Portuguese ivories are a perfect example of these crosscurrents.

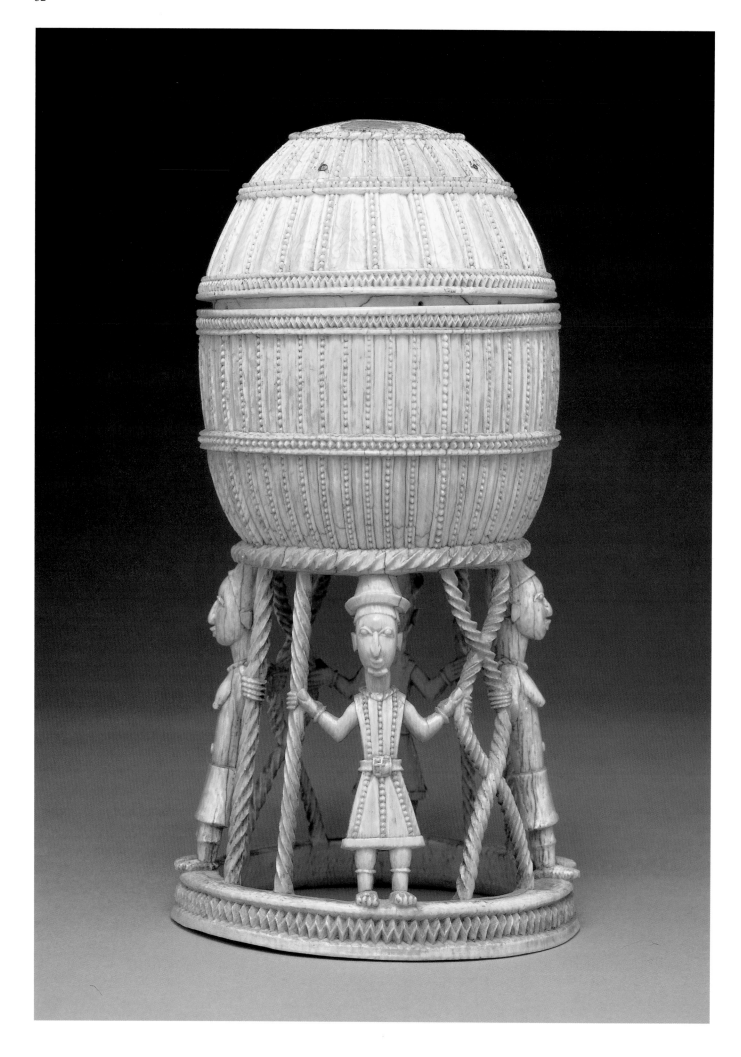

CHAPTER 2
THE AFRO-PORTUGUESE IVORIES

The neologism, "Afro-Portuguese ivories," was first used as a critical term in 1959 by one of us (W.B.F.) to designate a group of ivory sculptures in the British Museum.[17] Generically attributed to African artists, these ivories are adorned with motifs derived from European sources—in particular, heraldic devices that refer to the court of Lisbon, such as the arms of the ruling House of Aviz, the Cross of Beja (arms of the Military Order of Christ) and the Armillary Sphere.[18]

These ivory objects are covered cups (saltcellars and pyxes), spoons, forks, handles for daggers or knives, and oliphants (horns) all created for export to Europe. During the Renaissance some of these sculptures, not put to utilitarian use, entered famous art collections, such as those of the Medici of Florence, the Elector of Saxony in Dresden, and the Archduke Ferdinand of Tyrol in Ambras. References to these objects, though often erroneous, can be found in old inventories. For example, two oliphants that belonged to the Grand Dukes of Tuscany are minutely described and illustrated in a book by the Danish scholar, Olaus Worm, published in 1643. Worm even includes the purpose of the horns (hunting) and attributes the references on them to the royal House of Portugal.

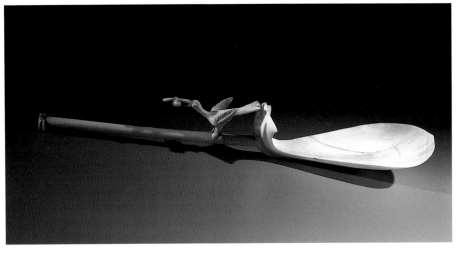

24. Saltcellar. Sapi-Portuguese, ca. 1490-1530. Customs records for the financial year 1504-1505, made by the treasurer of the House of Guiné, state that eighteen times that year saltcellars and spoons (*saleiros* and *colhares*) brought to Portugal from Africa were taxed *ad valorem*. This suggests that by the first years of the sixteenth century a substantial number of Afro-Portuguese ivories were already being imported. 19.5 cm. Private collection, Lisbon (no. 33).

25. Spoon. Bini-Portuguese, ca. 1525-1600. The first description of ivory spoons from Benin was written in 1588 by James Welsh, chief master of the sailing ship *Richard of Arundel*. He described these objects as "spoons of elephants teeth very curiously wrought with divers proportions of fowles and beasts made upon them." 22.4 cm. Museum für Völkerkunde, Vienna (no. 155).

Albrecht Dürer most probably acquired two Afro-Portuguese saltcellars during his trip to the Netherlands in 1520–1521. The great German painter notes in his diary, under the month of February, 1521, that he "paid three florins for two salt-cellars from Calicut."[19] His ivories have been lost, and thus their provenance cannot be ascertained. Nevertheless, we have no knowledge of Indian "salt-cellars" from that period made for European export. The terms "Indian" or "Turkish" are frequently used in older references to indicate objects that are in fact Afro-Portuguese, perhaps because Africans were considered unable to produce such refined work.

The coining of the term "Afro-Portuguese" in 1959 was of fundamental importance because it introduced a new stylistic category within the study of African art. The term, used without any prejudgment as to the dating or the provenance of the objects themselves, has since been adopted, sometimes acritically, by scholars in the field. (For those ivories

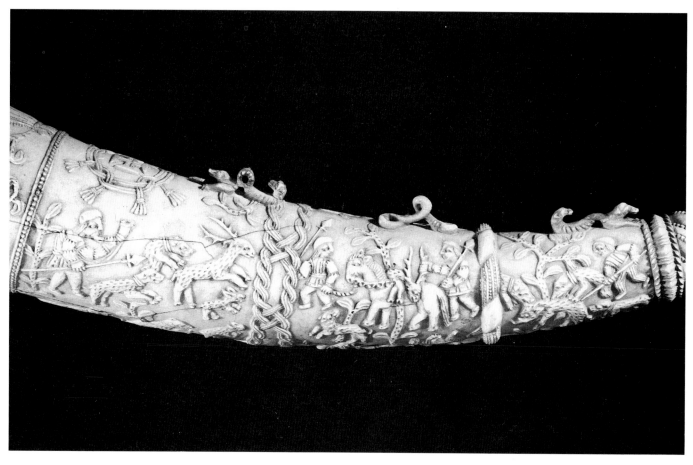

26. Engraving of a Sapi-Portuguese oliphant in the collection of the Grand Dukes of Tuscany, Florence, from *Monumentorum Danicorum,* by Olaus Worm, Copenhagen, 1643. This is a roll-out drawing of the entire horn seen from the convex side. Even the animal head at the mouthpiece is included—recognizable mainly by its teeth. This horn, extant today, is illustrated below.

27. Detail of a Sapi-Portuguese oliphant. This hunting horn, formerly in the collection of the Grand Dukes of Tuscany, Florence, is the horn in the 1643 engraving illustrated above. 48.5 cm. Musée de Cluny, Paris (no. 88).

28. Saltcellar. Sapi-Portuguese, ca. 1490-1530. Though this is typical in style, it is a unique composition; this lidded vessel is supported by a stem, not by the ring of figures as in other examples. 23.5 cm. Museum of Mankind, London (no. 32).

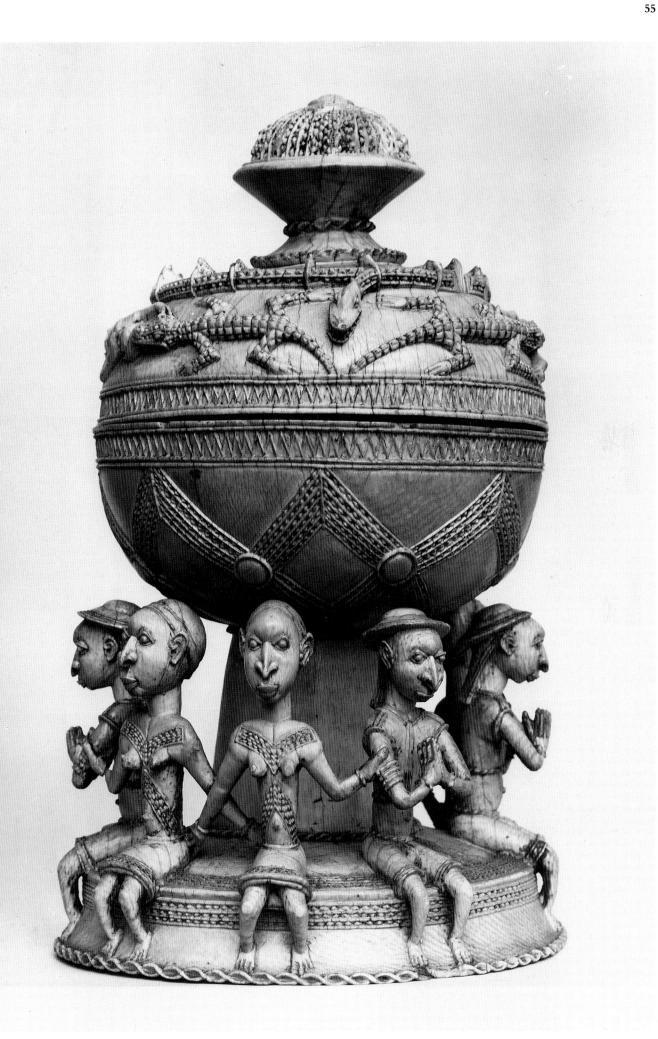

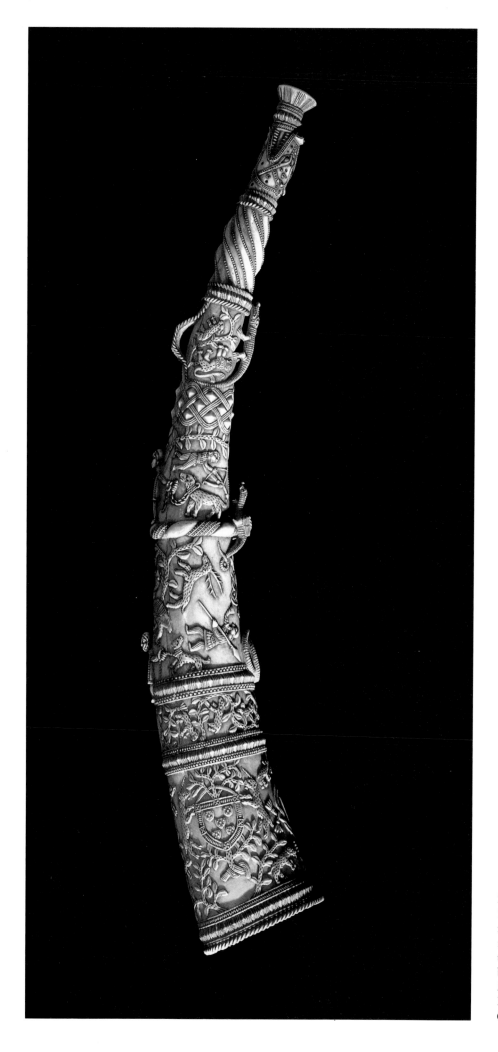

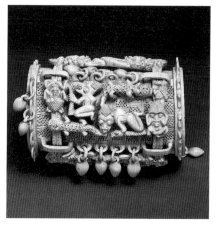

30. Bracelet or cuff from the Yoruba kingdom of Owo, Nigeria. Probably 16th century. This tour de force, double cylinder, ivory carving with its interlocking movable parts typifies the virtuoso skills of African ivory carvers. The professional skill of indigenous artists paired with the abundance and low cost of African ivory at the time of the early explorations apparently encouraged the Europeans to commission ivory objects for their own use. Ivory, 14 cm. The Paul and Ruth Tishman Collection of African Art, Walt Disney Co., Los Angeles.

29. Oliphant. Sapi-Portuguese, ca. 1490–1530. This horn, one of the most magnificent of those known, is now in the royal armory of Turin. It may have come to Italy as a consequence of the marriage between Beatrize, daughter of King Manuel I of Portugal, and Charles III, Duke of Savoy, which occurred in 1521. 63 cm. Armeria Reale, Turin (no. 81).

that do not sufficiently meet the requirements, we have given the name "Afro-Portuguese apocrypha," covered in a later chapter).

More recent discoveries by experts from various disciplines, now allow us to furnish answers to questions first raised twenty-five years ago. These questions concern the dating and provenance of the ivories, the relative autonomy or dependence of their makers on European models, and the nature of such dependence. Inasmuch as these problems have up to now been considered in a fragmentary manner, we will attempt to give an overall picture.

One preliminary observation is in order. The Afro-Portuguese ivories, made by African artists for European patrons and meant to be exported to Europe, are "hybrids." This term applies to objects that as the result of cultural interaction, combine iconographic and stylistic elements of two or more cultures. They differ from those produced in either of the two interacting cultures, yet refer to both, being simultaneously inside and outside the two cultures.

The European presence in Africa during the colonial period brought about the production of artifacts with purely commercial ends: the so-called "tourist art" which is another kind of hybrid. The term "hybrid" generally carries a negative connotation—justified perhaps when referring to African art objects of the last century in which a European influence and a mass market destination is readily visible. This tourist art is characterized by its repetitiveness, its summary execution, and frequently by the use of strange proportions to give the piece a touch of "primitiveness" to conform to the expectations of the buyers.

None of these qualities is present in the Afro-Portuguese ivories which, with very few exceptions, were made with the greatest of care. Hence, the term "turistenkunst" with which they have in the past been labeled in certain German museums, is inapplicable even though they were made according to European models expressly for export. Nor can the term "hybrid" be used pejoratively in respect to the ivories, any more than it can be applied to Ghandaran art.

The Portuguese commissioned ivories from African artists because of the abundance and low cost of African ivory at the time of the first contact, and probably more importantly, because they encountered artists of considerable talent and professional skill on the African coast, already experts in carving ivory. It is inconceivable that objects of such high formal quality and refined elegance resulted solely from an alien demand or contact with European culture. Nevertheless, the forms of these sculptures generally correspond to European objects, and the decorative motifs on some of the saltcellars and those on most of the trumpets are predominantly of European origin.

At the beginning of the twentieth century, the German scholar Wilhelm Foy formulated the hypothesis that the Afro-Portuguese ivories were made by African artists in Portugal. Foy was led to this conclusion because the themes encountered on the ivories are for the most part European and because he found their rendering faultless (although this is in fact not always the case).[20] We disagree with his conclusions because a whole series of documents and printed works testifies to the importation of ivory artifacts from Africa during the sixteenth century while not one document or publication dealing with the presence of Blacks in Portugal ever mentions sculptors of ivory.

These importation documents are in a single account book kept by the treasurer of the House of Guiné (a type of Customs house) which survived the great earthquake of 1755 in Lisbon. For the financial year

58

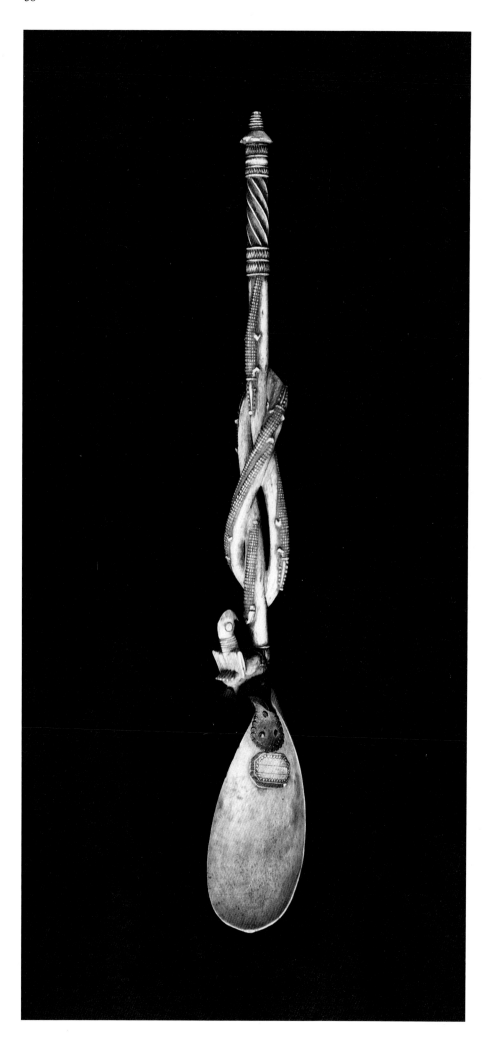

31. Spoon. Sapi-Portuguese, ca. 1490–1530. Duarte Pacheco Pereira, once the governor of the fort of São Jorge da Mina on the Gold Coast, writing of Sierra Leone reported that "the most beautiful ivory spoons are made here worked more highly than anywhere else . . ." 25.25 cm. Museo de America, Madrid (no. 67).

32. Engraving of a Sapi-Portuguese oliphant from F. Bonanni, *Musaeum Kircherianum. . .*, Rome, 1709. This oliphant was formerly in the Museo Kircheriano, Rome (no. 93).

33. Oliphant. Sapi-Portuguese, ca. 1490–1530. This is the instrument in the engraving. This horn, which bears the coats of arms of the Portuguese royal house, was described in 1709 by a Jesuit priest as "an ivory horn brought from Africa (*ex Africa allatum*) with various figures carved most elegantly." 43 cm. Museo Preistorico e Etnografico, Rome (no. 93).

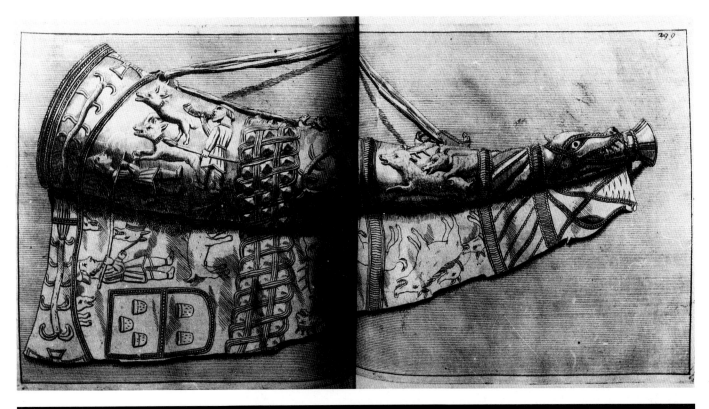

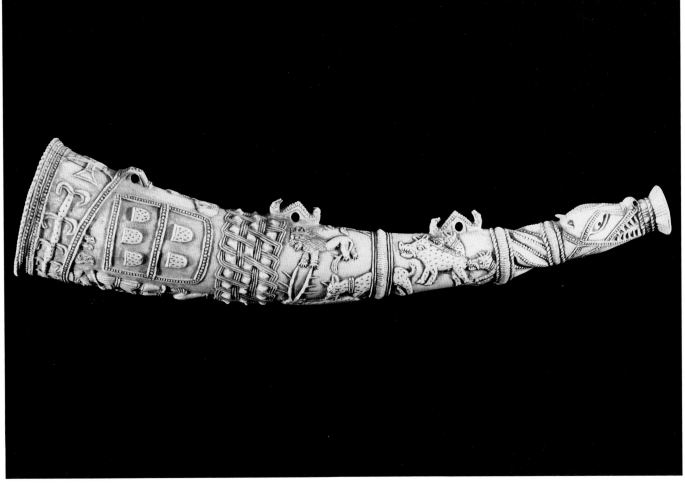

from September 1504 to September 1505, it is recorded that eighteen times a tax *ad valorem* equivalent to a quarter of the value of the total cargo was placed upon saltcellars and spoons (*saleiros* and *colhares*) brought to Portugal from Africa.[21]

Alan Ryder and Avelino Teixeira da Mota, the two scholars who discovered and published these customs documents, have noted that at the time ivory artifacts were always and only present in the baggage of sailors whose ships carried cargoes of rice as well as other goods. They concluded, therefore, that the spoons and saltcellars must have come from a region where rice was cultivated.[22] Ryder and Teixeira have identified this region as Sierra Leone basing this conclusion on the sixteenth century chronicler Duarte Pacheco Pereira, once the governor of the fort of São Jorge da Mina on the Gold Coast. It was here, reports Pacheco Pereira, that "the most beautiful ivory spoons are made, here worked more highly than anywhere else, as are also very beautiful palm mats."[23]

A more detailed account was given by Valentim Fernandes, a Moravian scholar resident in Portugal, who wrote in 1506–1510 that "in Sierra Leone the men are very ingenious and they make ivory objects that are wonderful to see, namely, saltcellars, spoons and dagger-hilts."[24] Damião de Gois, in his *Hispania* published in 1542, tells us that "ivory also comes from the land of the Blacks (vases and images that are made with a certain art)."[25]

As for ivories that come from the ancient Kingdom of the Kongo, we have only the vague testimony found in chronicles of the discoveries. Ruy de Pina, in his *Chronica del Rey D. Joao II* of the first half of the sixteenth century, writes that the king of the Kongo sent the king of Portugal "elephant tusks and worked ivory pieces." Nearly the same words are used by the other contemporary chroniclers: Garcia de Resende and Jeronimo Osorio.[26]

References to ivories from Benin are later, more summary and less frequent. The first comes in 1588 from the chronicle of James Welsh, chief master of the sailing ship *Richard of Arundel,* who says that in the great city of Nigeria one can obtain "pretie fine mats and baskets that they make, and spoons of elephant teeth very curiously wrought with divers proportions of fowles and beasts made upon them."[27] The same information appears in the 1621 chronicle by Garcia Mendes Castelo Branco that "very curious ivory spoons made by the natives and elegant bed covers made from raphia can be found in Benin."[28]

The objection could be made that all the sources we have cited contain only generic statements, that not one of them refers to a specific object that can be safely identified as one of our Afro–Portuguese ivories. But a specific reference does exist, although it dates from the beginning of the eighteenth century. This source refers to an oliphant that bears the coat of arms of the Portuguese royal House. It was formerly in the Jesuit Museum in Rome, and now is in the Pigorini Museum in Rome. In the 1709 catalogue of the Jesuit museum, written by the director, Father Filippo Bonanni, the hunting horn is fully illustrated and described as "An ivory horn brought from Africa *(ex Africa allatum)* with various figures carved most elegantly."[29] This affirmation, which one must presume was based on the museum's information, leaves no doubt as to the African provenance of the ivory.

CHAPTER 3
AN ART OF STILLNESS AND BEAUTY · THE SAPI-PORTUGUESE IVORIES

The approximately one hundred Afro-Portuguese ivories from Sierra Leone are the most fully documented and the most numerous: fifty-six saltcellars and fragments of saltcellars, three pyxes, eight spoons, three forks, two dagger or knife handles, and thirty-three oliphants or fragments of oliphants. To these can be added two horns that have been cited in documents and publications, but not identified. Similarities in both the form and style of these works, especially in their decorative elements, allow us to attribute them to a small number of workshops active for a limited period of time.

Keeping in mind the historical vicissitudes of Sierra Leone, to which we referred in the introduction, we can safely assume that the ivories produced in this region were made by artists of the Sapi peoples—the ancestors of today's Bulom, Temne, and other peoples. These are the same people who produced the soapstone sculpture, referred to above.[30] Documentary sources and formal similarities between the ivories and stone sculptures in the Sapi style, allow us to locate the production of the ivories in Sierra Leone. The stylistic analogies are closest in the treatment of the head with its typical forward thrust, globular, protruding eyes, curved nose with dilated nostrils, a consistent stylization of the ear, the beard rendered as though it were a twisted rope that runs from the chin to the ears, and well articulated dorsal muscles. There are also similarities between the scarification on the chests of some of the stone statues (especially London's beautiful reclining figure), and figures on ivory saltcellars. In 1564 the Englishman John Sparke, who took part in John Hawkins' voyage to Sierra Leone, wrote that the "Sapies . . . do jag their flesh, both legs arms and bodies, as workmanlike as a jerkinmaker with us pinketh a jerkin."[31] For these reasons we would like to designate these objects as the Sapi-Portuguese ivories.

34. Reclining Woman (*nomoli*). Sapi, Sierra Leone, 15th-16th century. Stone, 36.2 cm. Museum of Mankind, London.

35. Detail of a Sapi-Portuguese saltcellar (no. 32) showing ornamental scarification on the torso similar to that on the stone sculpture. (For full view, see page 55.) Museum of Mankind, London.

In the course of our investigation, we identified similar objects depicted on the ivories and the stone sculptures. The most cogent or striking of these is the tripod chair that is carved on certain *nomoli*[32] as well as on the lid of the saltcellars in Seattle (no. 48) and Modena (no. 27). Wooden chairs with a similar form have recently been collected in Liberia where they are still in use.[33]

We shall discuss the dating of these ivories after we have examined the formal, heraldic, and decorative elements that characterize the entire group of works. Let us begin with the Sapi saltcellars.

THE SALTCELLARS

The term "salt" was first applied to these works by Sir Augustus Wollaston Franks, who, in 1860–1890, almost single-handedly, formed the Afro-Portuguese collection of the British Museum. This term was thought preferable to the generic "pedestal cup" or, even worse, "chalice," terms that can be ruled out on iconographical grounds along with the theory that these objects were used as liturgical vessels. (A possible exception is no. 19.) A.W. Frank's intuition was later confirmed by documents that refer explicitly to "salts." As was often the case in the Renaissance, objects such as these were probably ornamental rather than functional. The term "saltcellar" for receptacles for salt came into use during the nineteenth century.[34]

The Sapi-Portuguese saltcellars can be divided into two basic types. The first includes those in which a more or less spherical container, is supported on a flat-topped conical base; the base is either plain or decorated by figures of men and animals both in relief and in the round. The second type features an openwork cylindrical base with figures and architectural motifs carved in the round. There are, of course, examples that fit into neither type—to be examined as they arise.

36. Seated figure (*nomoli*). Sapi, Sierra Leone, 15th-16th century. This figure is shown on a tripod chair that resembles the one on the Afro-Portuguese ivory opposite. Stone, 23 cm. Carlo Monzino collection.

37. Tripod chair. Mano, Liberia, 20th century (collected in 1927). Such chairs have remained in use to this day. Wood and fibers, 55.9 cm. Peabody Museum, Harvard.

38. Detail of the lid of a Sapi-Portuguese saltcellar (no.48). The figure is seated on a tripod chair like those known from the Sierra Leone and Liberia coasts. The center back leg is broken and missing. (For full view, see page 82.) Seattle Art Museum.

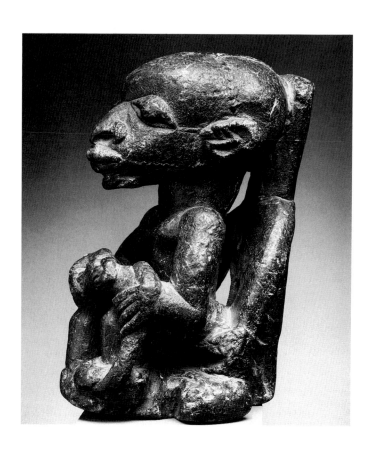

In commissioning works of art from African carvers, European patrons did not limit their suggestions to the decoration but occasionally suggested the shape of the piece as well. The saltcellars with conical bases correspond to covered cups, usually in precious metals, in use in Europe during the fifteenth and sixteenth centuries. They are especially close to those made by German goldsmiths in Nuremberg and Augsburg. Other possible prototypes are containers made of diverse materials such as hard stone, rock crystal, or even ostrich eggs.[35] Covered cups in metal with a gadrooned spiral decoration are often depicted as containers of the gifts offered to the Infant Christ by the Magi in fifteenth and sixteenth century art.[36] Dürer in 1501–1502 engraved his disquieting image of Nemesis, poised in the air above an Alpine landscape, holding a covered cup in her right hand; a nude woman with a lidded cup of this type was a frequent subject for early German engravers.

It is unlikely that valuable objects such as European cups in precious metals were sent to Africa to serve as models for African artists, but it would have been practical to send drawings or prints. At the beginning of the sixteenth century, prints with illustrations of covered cups were quite common. The most important of these were made by German artists.[37]

The cups which appear in the engravings are similar to the Sapi-Portuguese saltcellars with conical bases: they have the same overall structure, gadrooned surface, pillowlike element and spherical container (the sphere is somewhat flatter than the Sapi-Portuguese examples). In a famous drawing of a chalice by Paolo Uccello[38] one can see an element in the form of a reversed cup, placed between the conical base and the container as in saltcellars nos. 19-22.

With few exceptions, illustrations show European cups decorated exclusively with geometric motifs. While it is possible that European drawings served as models for the overall form, the embellishment with human and animal figures on the Afro-Portuguese salts is of African origin. In some cases African artists may have been given themes to carry out, if not to copy. Elements clearly identifiable as European in some of the ivories are religious, biblical, and heraldic motifs, certain fantastic creatures such as the dragon and the wyvern, and people in European dress.

Most of the ivory saltcellars with a conical base are fundamentally alike in their decorative schemes except for the groups of figures carved in the round on the tops of the lids. The true base is often partly gadrooned and decorated with rows of beads. On the sides, three or more carved human figures, alternate with squatting animals such as barking dogs; serpents with menacing jaws wind their way down from a round, pillowlike form, which usually tops the base. The women are either nude or wear a short skirt or a belt; the men wear trousers, striped stockings and sometimes a short-sleeved shirt. This apparel may indicate Africans of high rank who, according to Valentim Fernandes, wore "cotton shirts and trousers."[39] The upper section of the base and the surface of the pillowlike form are frequently carved in low relief. In some the receptacle rests on a second pillow, which in other examples is replaced by a hemispherical element.

The spherical container, in all surviving cases, is divided exactly in half, gadrooned, and decorated with rows of beads, as the base normally is. The rims of the two hemispheres are carved so that the upper half dovetails exactly with the lower half, and the place where they join is marked by horizontal beaded rows or zigzag lines.

The human figures carved on the bases have pronounced features,

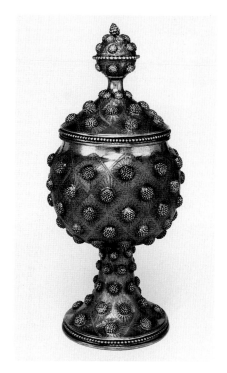

39. Covered cup. Portuguese (?), first quarter of the 16th century. The decoration of pearled bosses with a trellis pattern of wriggle work is typical of the largely nonfigurative decoration on European covered cups. Silver, 28 cm. Victoria & Albert Museum, London.

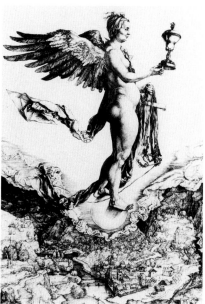

40. Nemesis, by Albrecht Dürer. German, 1501-1502. A nude female figure holding a covered cup was a frequent subject in German engravings. The cup seen here is of the kind that may have provided a model for the Sapi-Portuguese saltcellars. Engraving, 33.4 x 22.1 cm.

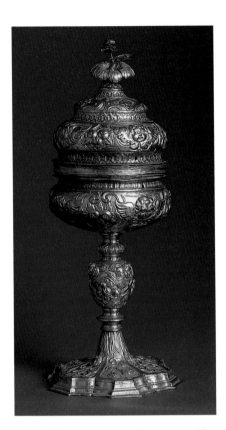

41. Chalice. German, 16th century. The articulation of this European covered vessel is repeated in the Afro-Portuguese ones: a domed lid with elaborated handle (here, a rose), deep vessel, stem with incident in the upper third, and a flaring base. Gilded bronze, 28 cm. Ruth Blumka collection.

42. Saltcellar. Sapi-Portuguese, ca. 1490–1530. One of the two basic configurations found in the Sapi-Portuguese salts consists of a roughly spherical container supported on a flat-topped conical base. No two are alike; the sculptures on the tops of the lids are especially varied. The lifelike entwined snakes seen here occur nowhere else, though serpents are a common motif. 27.4 cm. Museum für Völkerkunde, Berlin (no. 18).

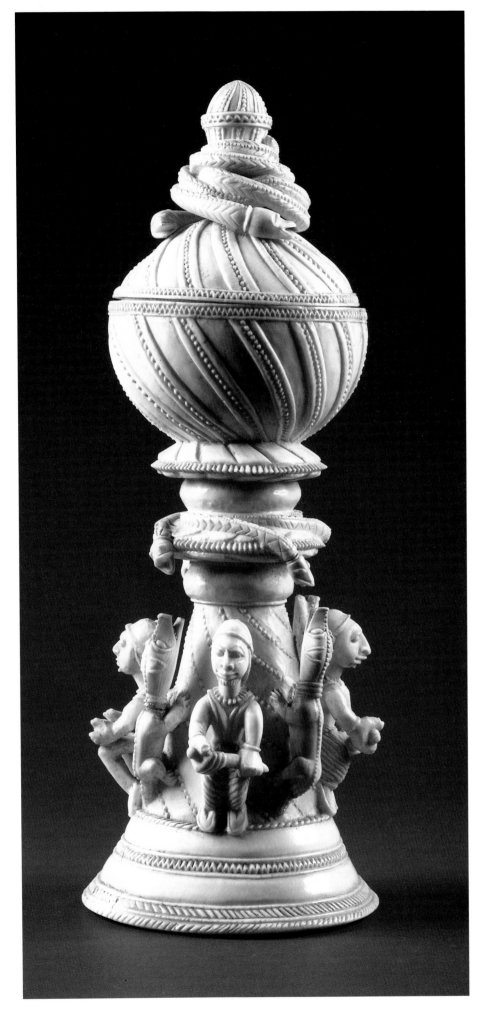

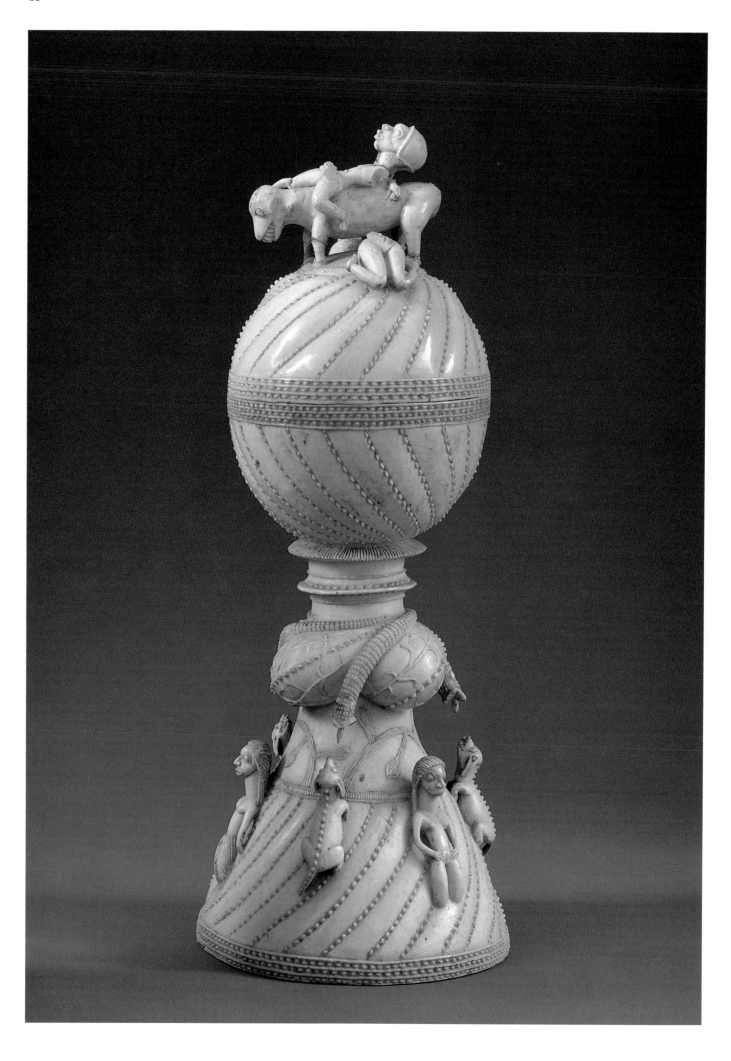

43. Saltcellar. Sapi-Portuguese, ca. 1490-1530. The spherical container and the pillowlike element on the stem of this saltcellar are particularly clear. The enigmatic subject on the lid will be discussed on page 72. 24 cm. Museo Civico Medievale, Bologna (no. 8).

44. Drawing of a chalice by Paolo Uccello. Italian, 15th century. The flaring element immediately below the container of the chalice drawn here is typical of the Sapi-Portuguese saltcellars. 34 x 34 cm. Uffizi, Florence.

45. Saltcellar. Sapi-Portuguese, ca. 1490-1530. The use of the human figure as the principal element of decoration is characteristically African; the European models for the saltcellars have decoration that is predominantly nonfigurative. Gadrooning, the spiraled decoration with lines of beading between bulging areas, is a purely European element used extensively here. 24.3 cm. Museum für Völkerkunde, Vienna (no. 10).

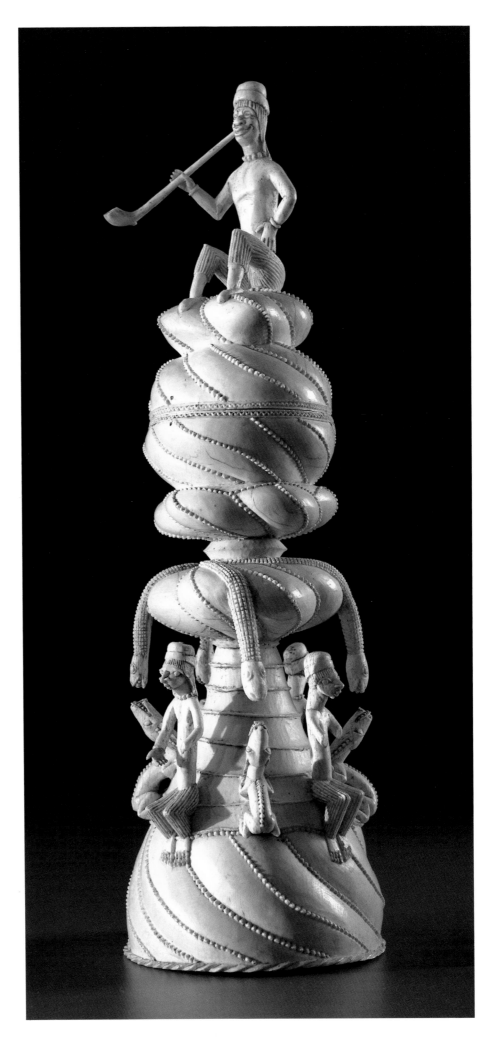

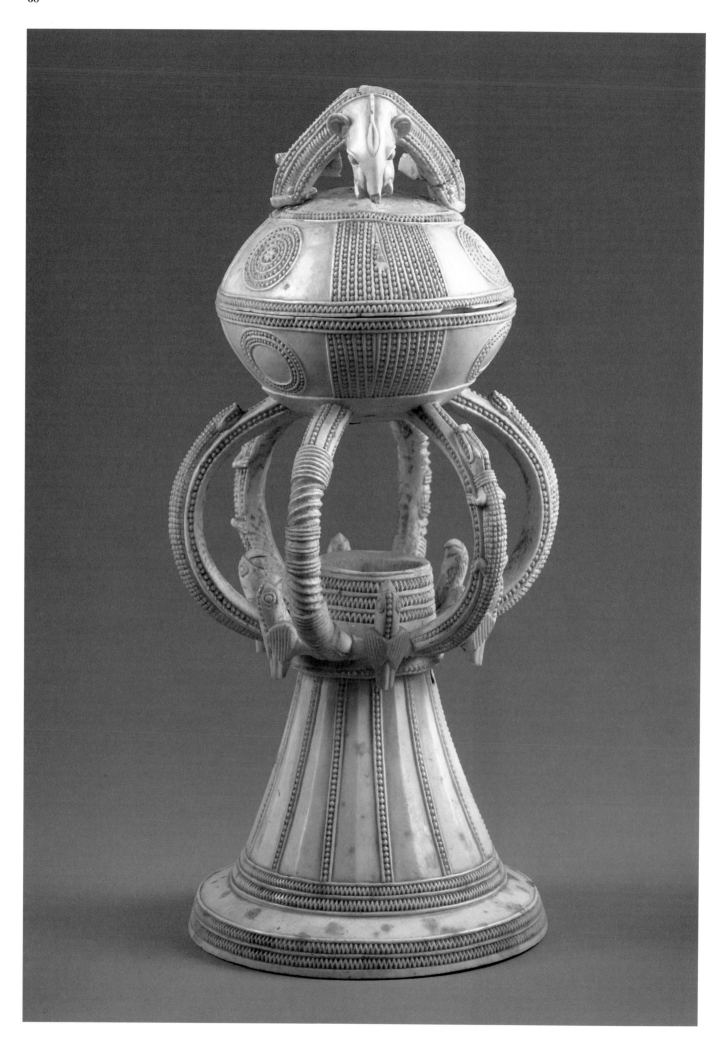

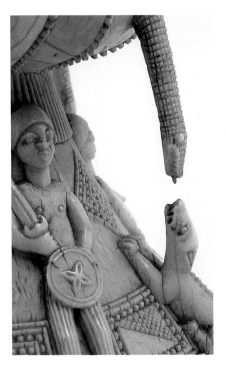

47. Detail of the base of Sapi-Portuguese saltcellar (no. 21). The pillowlike element on the stem often has serpents confronting dogs, as here. The Sapi artists seem to have taken pleasure in carving fine, undercut elements that are both fragile and difficult to execute. These traits immediately place the saltcellars outside the realm of ordinary objects and contribute to their quality of preciousness. (For full view, see page 128.) The Paul and Ruth Tishman Collection of African Art, Walt Disney Co., Los Angeles.

46. Saltcellar. Sapi-Portuguese, ca. 1490-1530. A group of four salts have this extraordinary almost architectural configuration: the simplified conical base is joined to the nearly spherical container by a series of arcing supports, here with crocodiles on them. The join between the lid and the vessel is the only one in this object: the entire lower part is carved of a single piece of ivory in the tradition of African craftsmanship. This not only required virtuoso carving, but produced objects of extraordinary luxury because it is a very wasteful way to work the precious material. A great volume of ivory had to be cut away from an unusually large tusk to produce this lacy work. The conical bases of the saltcellars are hollow, but the walls are surprisingly thick. 29 cm. Galleria Estense, Modena (no. 27).

and their relatively high degree of relief often approaches sculpture in the round. Variations in decoration are many: parrots stand in for two of the humans on saltcellar no. 17; birds are substituted for the dogs; in others there are no human figures. In still others only dogs or birds appear, as in a particularly elegant piece, no. 13, (missing the lid).[40]

In saltcellars nos. 27-30 (only one is nearly intact) the decoration of the conical base is extremely simplified and the container rests on a kind of spherical cage made up of a series of curvilinear elements. Parrots carved in the round alternate with these curvilinear forms.

The saltcellars with virtually cylindrical, openwork bases generally have three, but more often four, figures carved in the round, seated on the edge of the base holding three or four architectural forms (twisted columns, crosses, types of knots). These forms, and sometimes the heads of the figures as well, support a thin disk on which the spherical receptacle rests. The containers of this group are not gadrooned and often have large bands of parallel lines of beads, alternating with smooth areas. These areas sometimes show crocodiles in low relief, also seen on the containers of several saltcellars with conical bases. A unique composition distinguishes salt no. 32. The container rests on a smooth cylindrical central support of relatively small diameter, while on the edge of the base are seated alternating pairs of men and women.[41]

The African elements we see on the Afro-Portuguese ivories, having been integrated into objects designed to be used in an alien cultural context that did not share African symbols and values, lost their original symbolic value and became mere decoration. After almost five centuries and in the absence of surviving evidence, it is impossible for us to attach even a hypothetical meaning to those motifs which are not in some way tied to European culture.

In describing the figures on the bases of the saltcellars we have deduced their African identity only from their nudity, or the clothes they wear, or from their jewelry or scarification marks.[42] The facial features of Africans and Europeans are identically rendered. Naturally this complicates interpretation. We have, unfortunately, not succeeded in decoding the meaning of the combination, number or arrangement of the figures of African men, women and animals. The representation of animals fighting snakes (usually dogs, sometimes parrots) a subject that occurs fourteen times, cannot be accidental or coincidental, but we do not know what it means. Equally enigmatic is the meaning of the man with a child in his lap (on the base of saltcellar no. 49), a theme seldom treated in African or European sculpture. Nor do we know the significance of the crocodiles attacking or eating men shown on many ivories.

The figures and groups carved in the round on the lids of the saltcellars present similar difficulties of analysis. The saltcellars with conical bases, compared to those with cylindrical bases, have lids with decorations of greater thematic variety and wider origins: their motifs present characteristics that are European and perhaps even Oriental as well as African: a tangle of serpents wound tightly around the knob (no. 18); a man smoking a long pipe and seated on a gadrooned cushion (no. 10)[43]; a kneeling woman whose features and body conform to Indian sculptural traditions— thin waist, large breasts, broad pelvis (no. 12).

A question arises over figures that could represent maternity, a theme common in African sculpture, but rare in the stone sculpture of Sierra Leone. The lids of two saltcellars, nos. 1 and 9, are decorated with women holding children in their arms. One woman wears a sleeveless blouse, a belt, and a long veil. The other woman is nude and is in an unusual po-

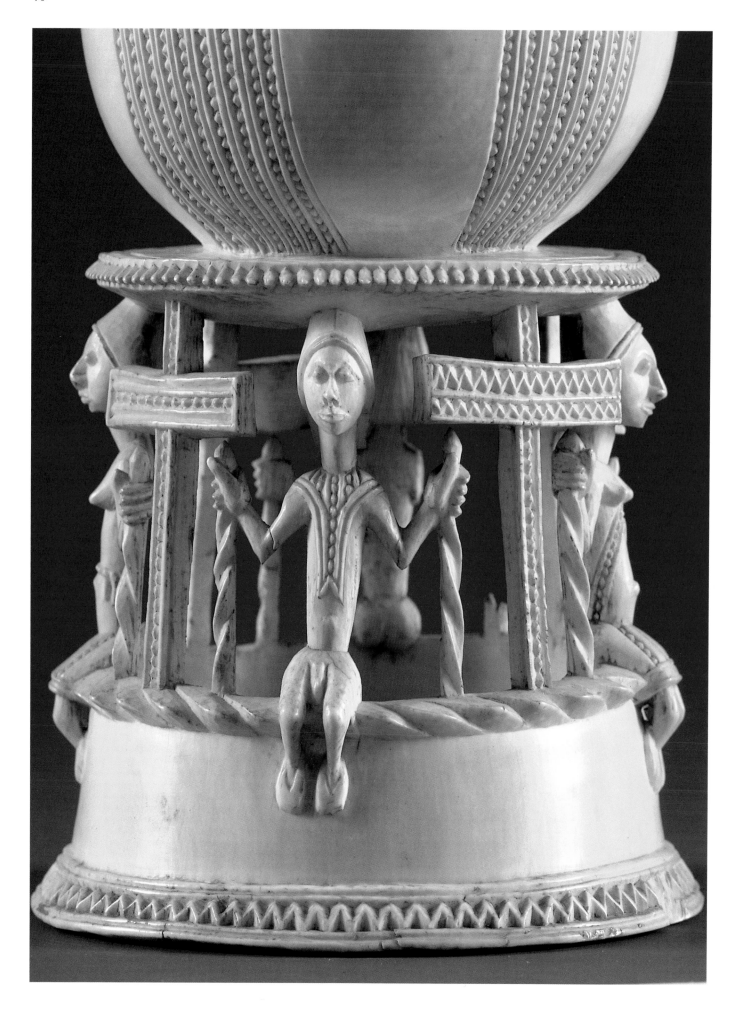

48 and 49. Detail and full view of a salt-cellar. Sapi-Portuguese, ca. 1490-1530. The second type of Sapi salts has a nearly cylindrical base, usually consisting of figures carved in the round holding architectural elements in their hands. This example, one of the most perfectly executed, has a bit of throw-away virtuosity: the vertical elements held by the figures do not quite touch the arms of the crosses above them. There are no hidden supports or braces; the bottom of the base is an open cylinder, and all the elements of the stand have been cleanly separated from each other. 24.5 cm. Museo Preistorico e Etnografico, Rome (no. 41).

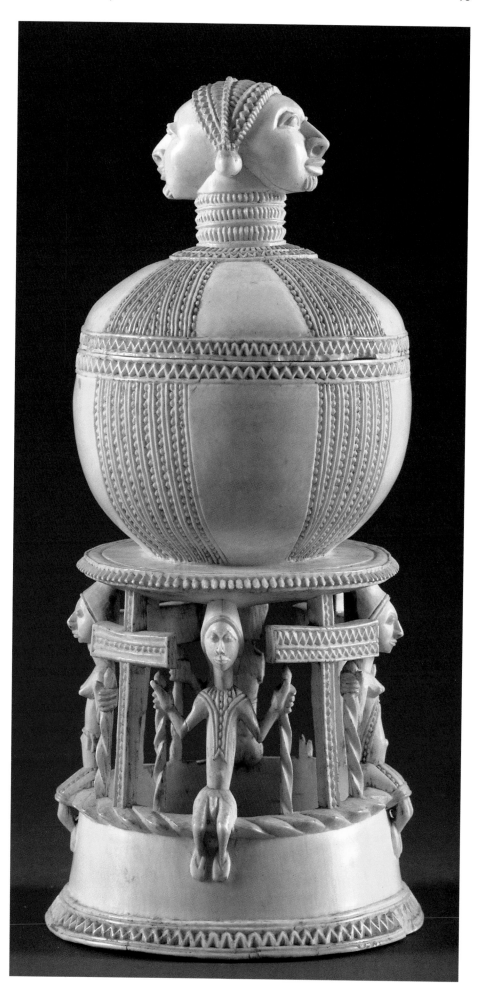

sition. While they do not conform to known African models, it is also very difficult to accept them as images of the Madonna and Child, because they are so distant from European models.[44]

A key work for our study is saltcellar no. 19, because its decoration is entirely composed of European motifs, with the exception of the usual four serpents, dangling from the pillowlike form of the base. On the surface are depicted: Daniel in the lions' den, a dog with a collar, two sirens, fish, a butterfly, stylized torches, plant forms, knots and braids, the arms of the House of Aviz and the Cross of Beja. The finial is in the form of a female figure, carved in the round, richly dressed, her head covered by a thick veil. She holds in her arms a naked child wearing a cross around his neck. Considering the context, it is most probably a representation of the Madonna and Child. Below them carved in high relief are three nude youths with elongated proportions, holding hands and flanked by two dogs. One of the youths holds a cross in his hand. The three youths may represent the three Old Testament figures, Shadrach, Meshach and Abednego, suggested by the the appearance of Daniel in the lions' den carved on the base.[45]

The preeminence of Christian motifs on saltcellar no. 19 suggests a liturgical use, possibly as a cyborium, although its shape is the same as that of the containers we believe to be saltcellars. Its overall appearance has a decidedly Renaissance feel to it, though the Madonna in her heavy, rigid costume recalls medieval prototypes.[46] A Romanesque, or Hispano-Moorish aspect characterizes saltcellar no. 26. Three tangles of serpents descend from above and rest their heads, with ferocious fangs, on the necks of three seated lions, creating a powerful composition. The low relief decoration of the container is in the Renaissance style: in addition to birds and plant forms, it is composed of narrow vertical and horizontal bands, crossing at right angles, plus a transversal on which the motto *Espera in Deo* is written. The bands make the receptacle resemble an armillary sphere.

Both European and African elements appear on saltcellar no. 23. One of the figures in high relief on the base is probably a representation of the Madonna and Child. The Child is wrapped in a blanket through which can be seen the shape of His body, while the Madonna wears a long, stiff dress and a heavy bonnet. An African element is introduced by a woman with bare breasts wearing a cap. Two coats of arms of the reigning house of Portugal and two "Manueline Knots" are carved in low relief between the figures of two praying Portuguese men.[47]

An interesting challenge is presented by saltcellar no. 8, described in a sixteenth century catalogue as "a figurated, antique chalice of ivory with its lid."[48] While seemingly decorated with typically African elements, close examination indicates that it too may possibly have a European source. On the base are the customary dogs and serpents alternating with human beings: a man and two nude women, their hands held near their genitals—those of one woman are clearly shown.

The partially damaged group in the round at the top of the lid features a woman, nude, except for a smooth cap. She lies astride a goat with an open snout revealing sharp teeth. The facial features and pose of the woman, and the volumes of the animal's body resemble carvings in soft stone.[49] The woman's arms are broken off at the shoulders, but a fragment of the arm, still attached to one of the thighs, seems to indicate that her hands were over her genitals. At the sides of this group are the traces of two human figures, though only their lower legs survive.

The meaning of the group in an African culture remains obscure. The

50. Detail of the base of Sapi-Portuguese saltcellar (no. 49). The subject of a man with a child in his lap is seldom found in African art. Its meaning here is unknown. (For full view, see catalogue raisonne.) Museum für Völkerkunde, Basel.

51. Detail of Sapi-Portuguese saltcellar (no. 19). It shows Daniel in the Lions' Den. The kneeling prophet appears between two importunate lions who touch him with their paws. (See full view, page 74.) Museum of Mankind, London.

52. Capital representing Daniel in the Lions' Den. Italian, unknown artist, 13th century. The subject in Christian iconography is often reduced to its simplest elements, a man between two lions, which is an oriental motif seen, for example, in Assyrian reliefs. The Duomo, Fidenza.

53. Detail of Sapi-Portuguese saltcellar (no. 19). The three nude figures represent another Biblical scene: Shadrach, Meshach, and Abednego in the fiery furnace. The textured area partly covering their heads represents a veil. (See full view, page 74.) Museum of Mankind, London.

54. Capital representing Shadrach, Meshach and Abednego in the fiery furnace by Gislebertus. French, ca. 1150. An angel holds a veil over their heads to protect them from the flames. Cathedral of St. Lazare, Autun.

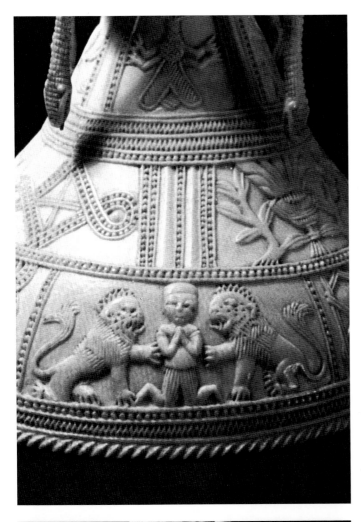

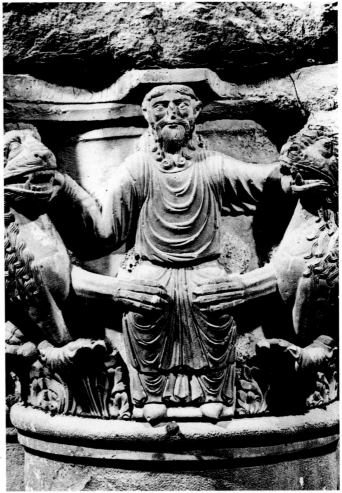

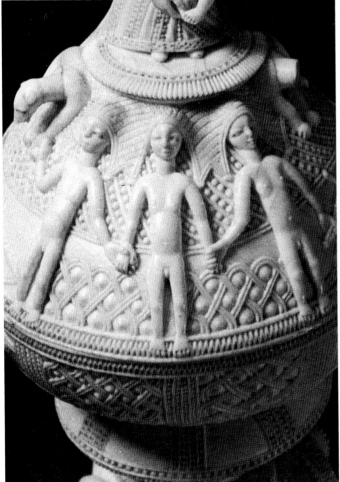

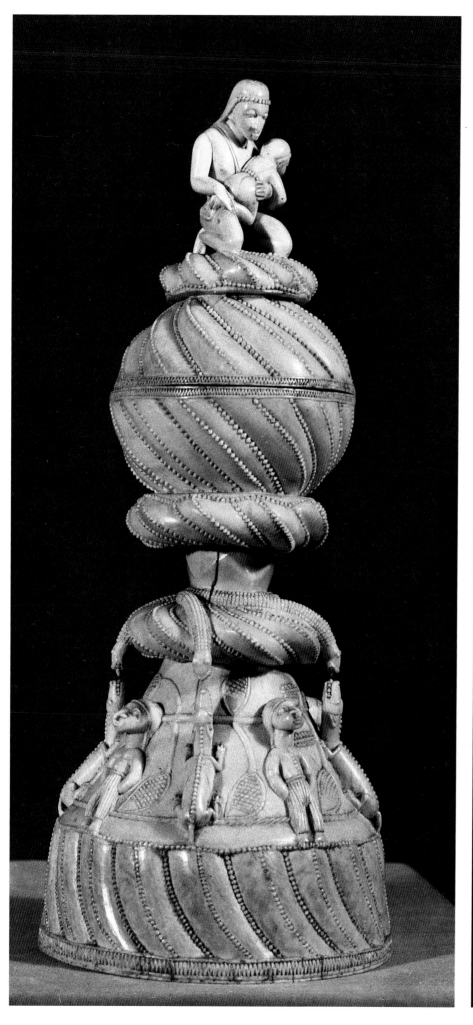
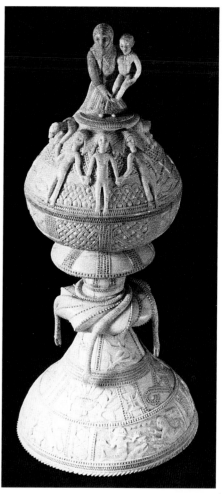
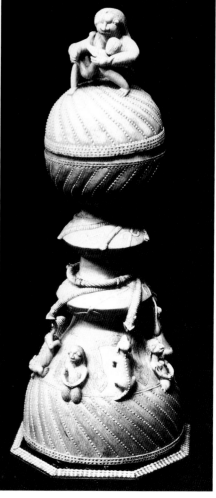

58. Fragment of a saltcellar. Sapi-Portuguese, ca. 1490-1530. The hooded figure on the base is the Virgin holding the Child in front of her. The coat of arms is that of Portugal .10 cm. Rijksmuseum voor Völkerkunde, Leiden (no. 23).

55. Saltcellar. Sapi-Portuguese, ca. 1490-1530. Three salts have lids decorated with women holding children. Though maternity is a common theme in African art, the figures here correspond neither to African prototypes, nor to European representations of the Virgin and Child. The object has been restored, and one scholar asserts that the group on the lid is a replacement, though that view is disputed. 37.5 cm. Allen Memorial Art Museum, Oberlin (no. 1).

56. Saltcellar. Sapi-Portuguese, ca. 1490-1530. All the motifs on this salt are European except for the four serpents in the middle. On the lid is the Madonna and Child. In addition to the two biblical scenes illustrated on page 73, the decoration includes a dog, two sirens, a fish, a butterfly, the arms of the House of Aviz, and the Cross of Beja. 30.5 cm. Museum of Mankind, London (no. 19).

57. Saltcellar. Sapi-Portuguese, ca. 1490-1530. The mother and child here do not correspond to African or European prototypes. Whereabouts unknown (no. 9).

representation of nude women with their hands touching the genitals (also on saltcellar no. 11), and even more the subject of a woman riding a goat, suggests a magical-erotic ritual which, as far as we know, does not occur in African culture. Despite its African figurative style, it may derive from Europe.

At the time the saltcellar was probably made, around 1500, belief in witchcraft was widespread in Europe, nourished by the Church itself, as testified by numerous treatises of the time, and trial records of the Inquisition.[50] One of the sins to which accused people confessed under torture and also by auto-suggestion was "carnal intercourse with the Devil," which took place during the Witches' Sabbath. To this nocturnal meeting participants were transported magically on the back of the Devil himself in the form of a goat, which was one of his most frequent incarnations in both religious and popular iconography.

The theme of a witch riding a goat appears in three illustrations datable to 1506–1510. A drawing in the Louvre attributed to Albrecht Altdorfer shows a cortege of naked witches in flight on the backs of goats, greeted by four other witches on the ground. A print by Albrecht Dürer and one by Hans Baldung Grien[51] shows a witch flying in the air on the back of a goat, with the body of the woman leaning backwards like the ivory figure. Dürer's print shows four little putti on the ground while Baldung's has four witches wreathed in smoke preparing some deadly brew. These suggest that a European print or drawing was the model for the saltcellar.

An almost universal motif, the Janus head appears with a long neck on four saltcellars (nos. 40–43) and on one independent lid (no. 44) plus a fragment on a *cinquedea* in Glasgow (no. 46). Another Janus head appears as a finial on a saltcellar with a cylindrical base and an egg-shaped container (no. 45) in an annotated drawing in the nineteenth century notebook by Sir A.W. Franks, kept in the archives of the Museum of Mankind, London.[52] A seventh Janus head (no. 47) rests on the back of a quadruped whose long snout bears human features and whose body is covered by a kind of armor made of closely set rows of beads. The Janus motif is rare in the ancient stone sculpture of Sierra Leone, but not absent. The European forms of Janus are commonly contrasting, i.e. male/female, old/young, unlike the ones we have on the saltcellars and stones, (though the bodies of the *nomoli* are those of male and female). It seems likely that the Sapi Janus heads originated on the Guinea Coast where Janiform masks are still carved.[53]

More specifically African themes appear on two saltcellars with cylindrical bases which have survived intact. They are crowned respectively by a warrior riding on an elephant (no. 35) and by an executioner, in the act of decapitating a victim (no. 31). Both of these figures are probably African. Although they have trousers with vertical stripes, they are bare-chested, wear brimmed hats, and carry round shields, like two *nomoli* that show warriors with similar round shields, and headgear with rigid brims.[54] Since elephants were never domesticated in Sierra Leone, the warrior riding an elephant is probably a symbolic representation of a chief, a metaphor for authority which occurs in sculpture in soft stone.[55]

The complex execution scene carved on saltcellar no. 31 is the largest sculpture group and certainly one of the most extraordinary in terms of quality. Unfortunately, the ivory has been restored: part of the staff held in the left hand is missing; the executioner's right hand, the axe, and the head of his victim have been refashioned. The axe was a complete invention of the restorer, as there is no evidence of axes in this form in old sculpture or documents of Sierra Leone. The executioner and the two men carved

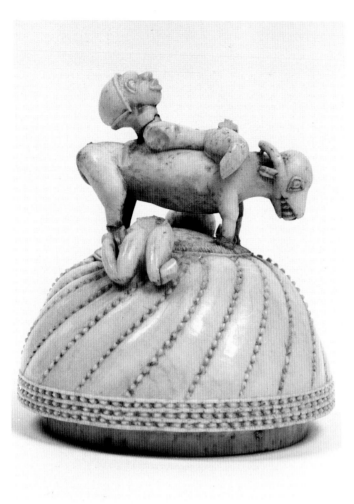

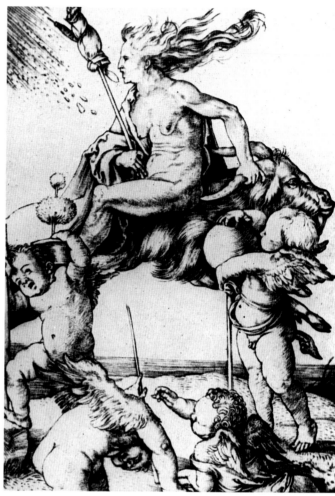

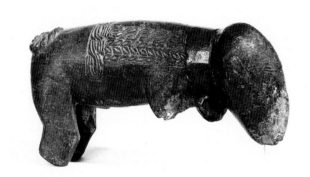

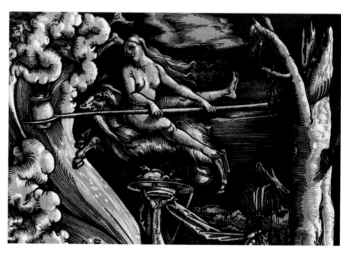

59. Lid of a saltcellar. Sapi-Portuguese, ca. 1490-1530. The female rider is unusual in African art, and the reclining posture unprecedented. (See full view, page 66.) Museo Civico Medievale, Bologna (no. 8).

60. Witch riding a ram, by Albrecht Dürer. German, 1506-1510. Superstitious beliefs including the idea that witches existed in the physical world prevailed throughout much of Renaissance Europe. Engraving, 11.5 x 7.2 cm.

61. Quadruped (nomoli). Sapi, Sierra Leone, 15th-16th century. Stone, 31 cm. Museum für Völkerkunde, Munich.

62. Witches' Sabbath, by Hans Baldung Grien. German, 1506-1510. This print shows a naked witch flying in the air on the back of a goat. Engraving, 37.4 x 25.7 cm.

63. Top of a saltcellar. Sapi-Portuguese, ca. 1490-1530. The lower section is missing. 17.1 cm. Museum of Mankind, London (no. 43).

64. Lid of a saltcellar. Sapi-Portuguese, ca. 1490-1530. We see here the tail and hind legs of a quadruped with Janus heads on its back. 11.6 cm. Museum of Mankind, London (no. 47).

65. Janus figure (nomoli). Sapi, Sierra Leone, 15th-16th century. The Janus motif is rare in the ancient stone sculpture of Sierra Leone but it is not absent as this nomoli makes evident. Stone, 23.5 cm. Meneghini collection, Palm Harbor.

66. Detail of dagger with Sapi-Portuguese finial. (For full view, see page 88.) The Janus head on the handle may have come from a broken saltcellar such as that in ill. 63. 5.5 cm. (finial). Glasgow Museum and Art Galleries, Glasgow (no. 46).

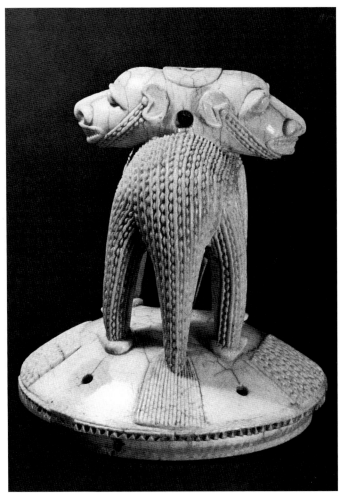

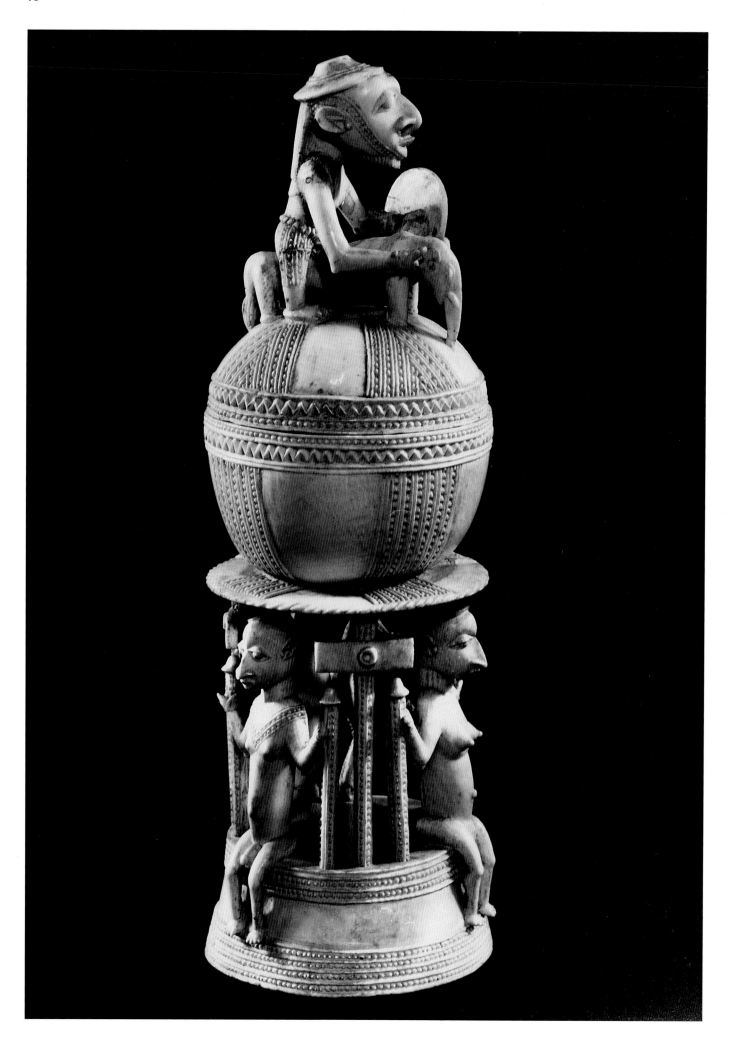

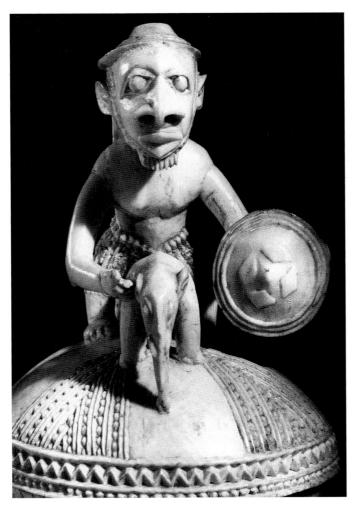

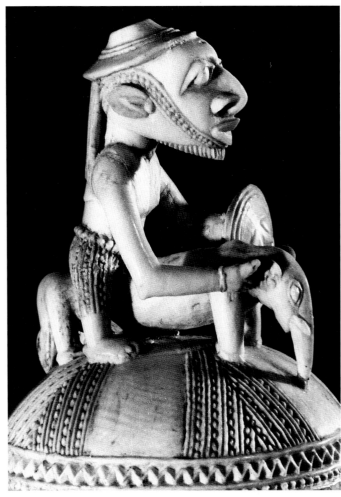

67, 68 and 69. Saltcellar, full view and details of lid. Sapi-Portuguese, ca. 1490-1530. The figure of a bare-chested man carrying a shield and riding an elephant, probably represents an African. The nude figures on the base are likely also to be Africans. Though elephants were never domesticated in Africa, figures riding or standing on elephants occur in African art as a metaphor for power. The diminutive size of the elephant in relation to the man is a further comment on his importance. The beard seen here, treated as a band of texture, occurs frequently in the stone sculptures from the region. The stylization of the ear is also typical of the stones (see illus. 19 and 72). 22.5 cm. Museum für Völkerkunde, Vienna (no. 35).

70. Man riding an elephant (*nomoli*). Sapi, Sierra Leone, 15th-16th century. The vertical element above the animal's head is the man's braided beard. Riders are an infrequent subject in *nomoli* which usually portray single seated or crouching figures. Stone, 22.5 cm. Museum of Mankind, London.

on the base wear codpieces, the padded cloths worn by European soldiers during the Renaissance to protect their genitals.

The scene seems to illustrate an execution, as described in the chronicle of Alvarez de Almada in the seventeenth century: "This is how they mete out justice . . . they cut off the heads and throw the bodies to the wild animals."[56] The gigantic size of the executioner compared with the victim suggests a symbolic representation of the great chief endowed with the power of life and death, as do the shield and the exotic codpiece which would surely not be attributes of an executioner.

Warriors who rest on or are surrounded by severed heads are also represented in *nomoli*. The hypothesis of a symbolic representation of a great warrior is corroborated by another statement by Alvarez de Almada that Sapi warriors quarreled over the heads of their enemies, and that warriors "who have not had this honor buy cheaply persons sentenced to death, kill them and are highly honored."[57] The bottom of saltcellar no. 48 is lost, but we can deduce from the decoration of rows of closely-set beads that alternate with smooth areas on the container that it must have had a cylindrical base. A man is carved on its lid, seated on a tripod chair similar to one seen on some *nomoli* (the back of the chair has lost its central support); we have already noted the importance of this element in respect to locating the origin of the ivories in Sierra Leone.[58]

From the preceding comparisons we find it most likely that the salts with conical bases are derived from European models. The second group of salts with cylindrical openwork bases seems, on the contrary, to bear no relation to European prototypes of the same period. As Susan Vogel argues above, we must consider an African origin.

Lidded vessels, made of wood or gourds, in many shapes and sizes, are common in Africa today and appear in the archaeological record. Gourds might have suggested the nearly perfect spherical shape of the container in most of the African saltcellars, compared with the European models, which are rather flattened. Gourds and some spherical containers in terracotta often rest on an openwork stand, whose cylindrical cavity receives the round bottom of the container. These could have inspired the shape of the wooden bowls and could also be the models for the cylindrical openwork bases.

73. Detail of the lid of a Sapi-Portuguese saltcellar. This complex scene, surmounting one of the largest and most perfectly executed salts, depicts an executioner, his submissive victim seated before him, and six severed heads. Unfortunately, the executioner's right hand is restored along with the axe whose shape is probably an invention of the restorer. The head of the victim is also a restoration, albeit a more correct one. The hat and shield are similar to those seen on other salts. The crispness of the forms and the absolute freedom with which the artist has undercut the sculptural elements, freeing them from the original shape of the tusk is remarkable. The hypothesis is that this represents an important chief. (See full view, page 110.) Museo Preistorico e Etnografico, Rome (no. 31).

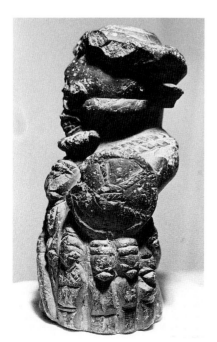

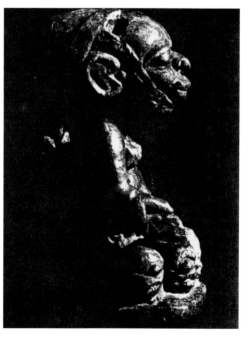

71. Warrior figure (*nomoli*). Sapi, Sierra Leone, 15th-16th century. The warrior is shown surrounded by small figures, perhaps prisoners. He carries a round shield like the one carved on the saltcellar on the previous page (ill. 67-69). Meneghini collection, Palm Harbor.

72. Seated man with skulls (*nomoli*). Sapi, Sierra Leone, 15th-16th century. Stone, 19 cm. F. Monti collection, Milan.

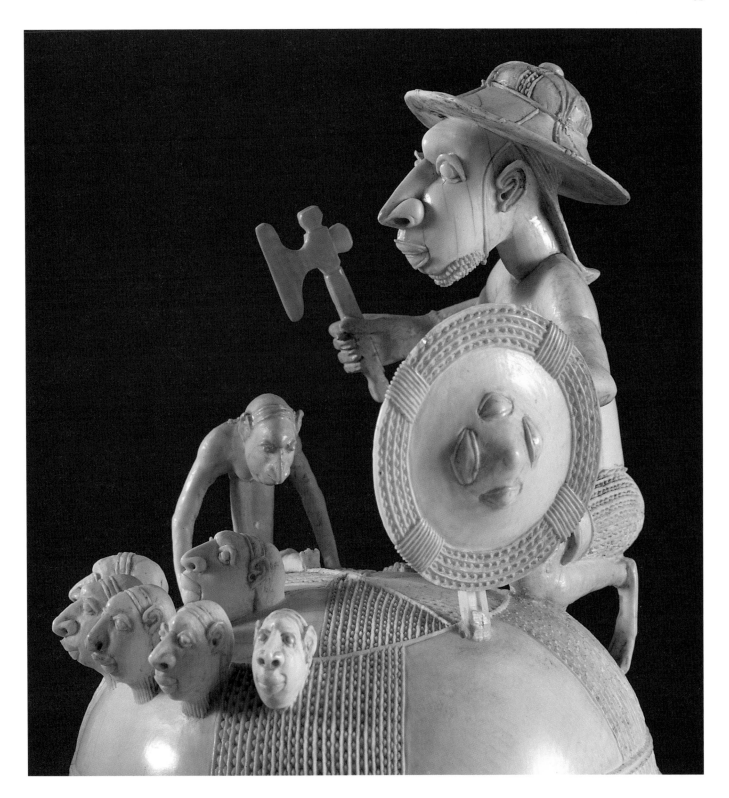

A few ivory bowls, carved by two Owo artists in Nigeria, are hemispherical containers enclosed in high, openwork bases of caryatids ranged in a circle. In the saltcellars under consideration the spherical container rests on a flat disk, while the lowest part of the base is a ring on which human figures stand or sit. The same design appears on stools found from Mali to Zaire. The Sapi carvers of the saltcellars probably had in mind the image of a gourd container resting on a stand, even if we cannot suggest a specific artifact from Sierra Leone as an actual model.

The hypothesis of the African origin of the shape of the saltcellars with a cylindrical base (never gadrooned) is reinforced by the fact that the sculptural groups on the lids apparently illustrate African themes only. The European figures carved on some of the bases could be Portuguese visitors to Sierra Leone.

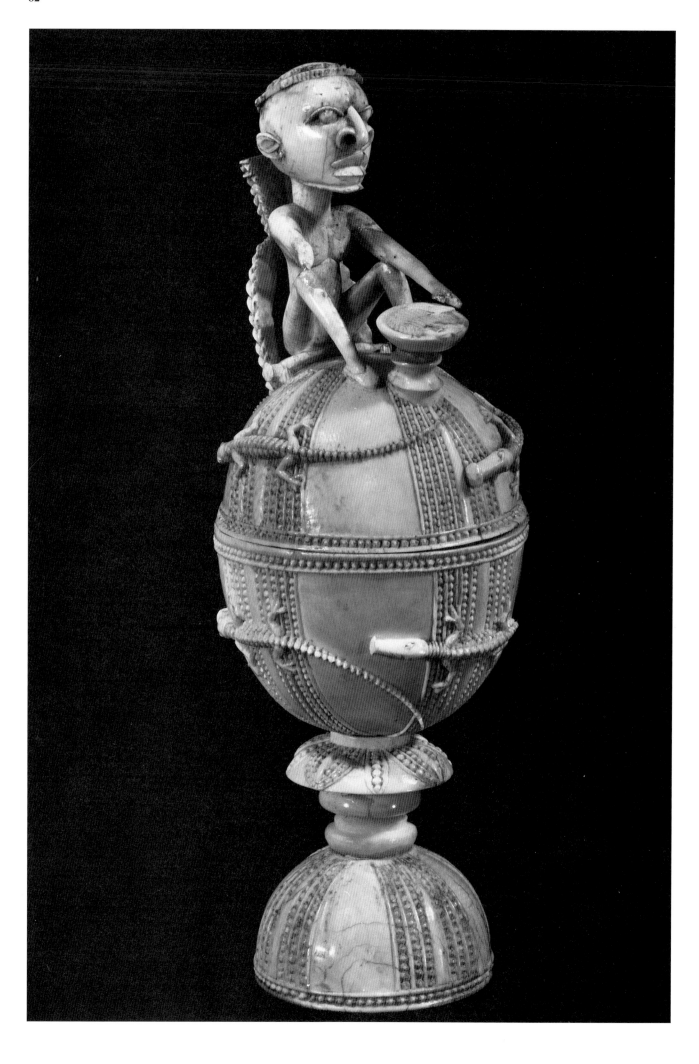

74. Saltcellar. Sapi-Portuguese, ca. 1490-1530. The figure on the lid is seated on a tripod chair typical of the Sierra Leone coastal area. The bottom of this salt is lost; the base is part of the container of another salt. 20.7 cm. Seattle Art Museum (no. 48).

75. Pyx. Sapi-Portuguese, ca. 1490-1530. Two scenes of The Crucifixion appear here with, on the right, The Descent From the Cross. This piece is incomplete, lacking its lid, and perhaps, feet in the shape of lions. 14.5 cm. Walters Art Gallery, Baltimore (no. 59).

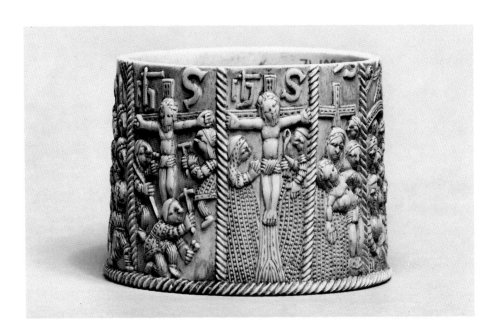

THE PYXES

Three containers (nos. 57, 58 and 59 which is missing its lid) seem to be the only surviving examples of Afro-Portuguese ivories meant for Christian liturgical use. They are quite certainly pyxes, vessels in which the consecrated bread was kept. The form of the three ivories corresponds to European liturgical vessels of the period. The cylindrical, rather low, lidded containers are supported by four lions, and the surface is entirely covered by scenes carved in low relief, with beaded, zig-zag and twisted lines. Motifs on these ivories are predominantly Christian, many consisting of whole scenes, unlike the separate figures on other vessels.[59]

Consistent with a liturgical purpose, two vessels, nos. 57 and 58, are decorated with scenes from the Life of the Virgin: The Tree of Jesse, The Annunciation, The Visitation, The Birth of Jesus, The Annunciation to the Shepherds and The Adoration of the Magi. In addition The Presentation of Jesus in the Temple and The Flight into Egypt appear on pyx no. 57. The scenes are quite similar on both examples: on no. 58 The Tree of Jesse shows the reclining Jesse, ancestor of the Virgin, from whom the tree originates; this figure is missing in pyx no. 57. On the lid of no. 57, a number of motifs are carved in low relief: the arms of the House of Aviz held up by two angels; the Cross of Beja, also flanked by two angels; the motto "*Ave Grasia P.*," two figures—perhaps martyrs—holding palms; two birds, the letter "S" and floral motifs. On the center are the remnants of three figures carved in the round, perhaps a Madonna on a cushion with two angels. The Portuguese scholar F. Russel Cortez wrote that the letter "S" on pyx no. 57 (which also appears on saltcellars nos. 20 and 51) might suggest the reign of Sebastian I (1557–1578); it was in fact used on the silver coins named *vintén de 11 dinheiros* minted in 1558.[60]

The group on the lid of the second pyx (no. 58) is less damaged than the previous one, and the central figure carved in the round is clearly a seated Madonna and Child, but three vestiges are unidentifiable. The decoration in low relief is simpler than on pyx no. 57, and the heraldic motifs are reduced to the Cross of Beja. The lions that support the container show the shields with the coat of arms of the House of Aviz, lacking on pyx no. 57.

Only the cylindrical vessel remains of the third example (no. 59); the lid and the supports are missing. The surface decoration consists of panels with scenes of The Passion of Christ, The Kiss of Judas, The Coronation with Thorns, The Ascent to Calvary, The Crucifixion and The Deposition.

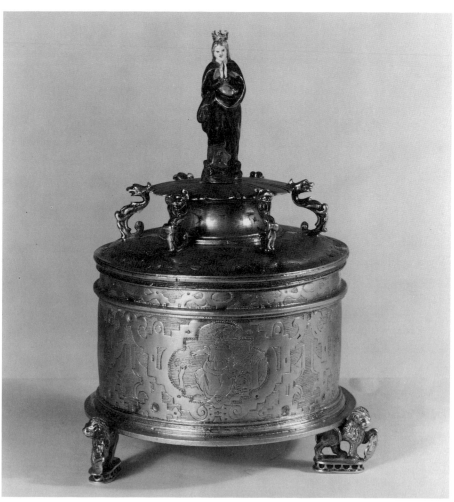

76. Pyx. Portuguese, 16th century. A pyx is a Catholic liturgical vessel in which consecrated hosts are kept. Silver gilt, 18 cm. Francisco de Barros e Sa collection. Museu Nacional de Arte Antiga, Lisbon.

77. Pyx. Sapi-Portuguese, ca. 1490–1530. On the front is The Tree of Jesse framed by columns. The Sapi-Portuguese pyxes have been carved with a dense, allover textured decoration that leaves virtually no plain areas (called *horror vacui*). 17 cm. Private collection (no. 58).

78. Pyx. Sapi-Portuguese, ca. 1490–1530. The scenes carved on this pyx illustrate the life of the Virgin Mary. The broken figure at the center of the lid probably also represented the Virgin. 14.5 cm. Museu de Grao Vasco, Viseu (no. 57).

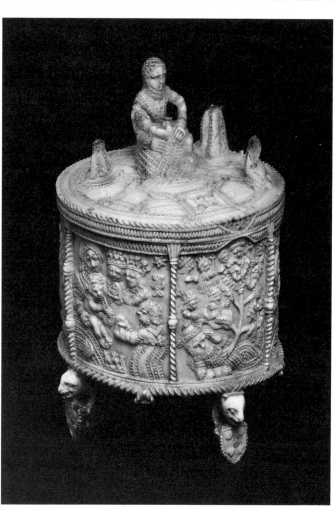

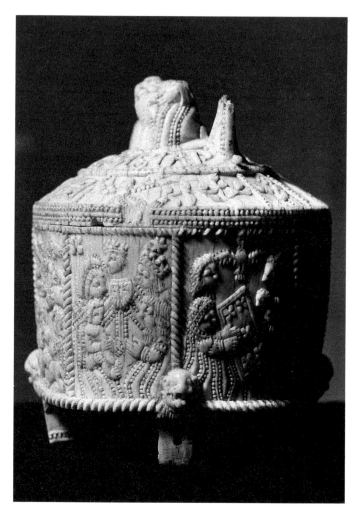

THE SPOONS, FORKS AND KNIFE HANDLES

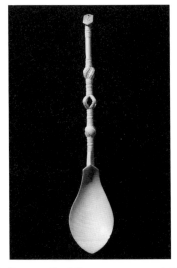

79. Spoon. Sapi-Portuguese, ca. 1490-1530. This spoon, typical in its long slender handle, and broad bowl conforms to European prototypes. The gadrooned and spiraled decoration is similar to that seen on the salts and oliphants. 21.2 cm. Museum of Mankind, London (no. 64).

80 and 81. *The Death of the Virgin* (full view and detail). Portuguese school, 16th century. The detail of this still life shows what is probably a Sapi-Portuguese ivory spoon being used to serve fruit. Oil on wood, 128 x 87 cm. Museu Nacional de Arte Antiga, Lisbon.

European sixteenth century metal spoons seem to have been the models for the ivory spoons, in the shape of the bowl and in the length and slenderness of the handle. It is possible that they may derive from an African leaf spoon or a ladle made from a small sectioned gourd with wooden handle attached. The shape of the forks also corresponds to that of European forks of the sixteenth century. The refined and complicated carvings that adorned the spoons and forks were the invention of the virtuoso African artists who made them.

Sapi-Portuguese spoons and forks are far less numerous than the salt-cellars; we know of only eight spoons and three forks even though spoons are frequently mentioned in inventories.[61] The spoons and forks, while of great refinement, are very fragile and were probably used more as decorative ornaments than as functional implements. However, *The Death of the Virgin,* by the Portuguese painter, Mestre do Paraiso (c. 1520–1530), shows a spoon which might be a Sapi-Portuguese ivory in a pot, implying everyday use for such objects.[62] Because of their fragility, few of these objects have come down to us,[63] but many of the ivory spoons for which an import tax was registered—as in the records of the Casa de Guiné—were probably simple, undecorated objects, not kept in collections or museums and thus have not survived. It is surprising that artifacts of such exquisite make were imported by simple sailors or cabin boys, as it appears in the records. However, they may have been carried for the captain or owner of the ship. In any case, the values of carved ivories as attributed by customs officials were not very high, and there were sizable differences in value among objects of similar description.[64]

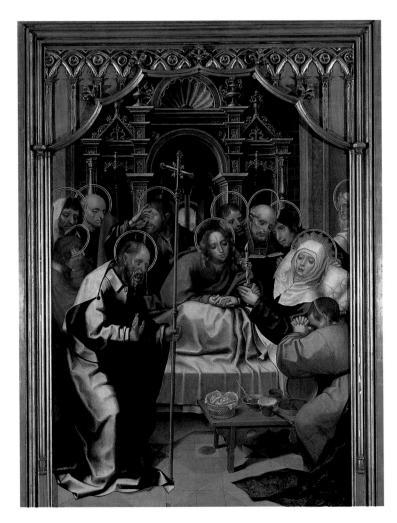

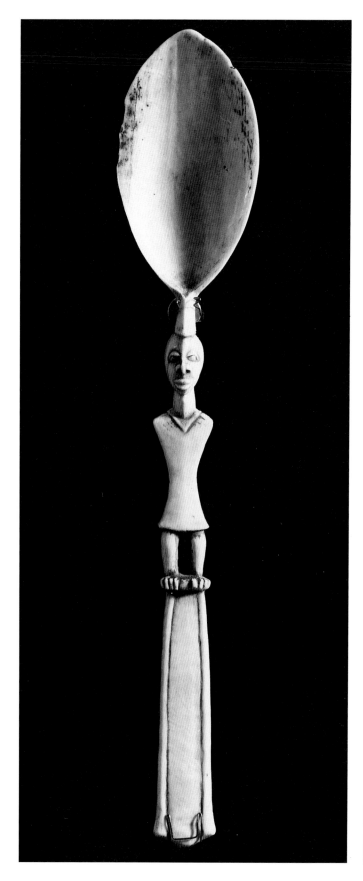

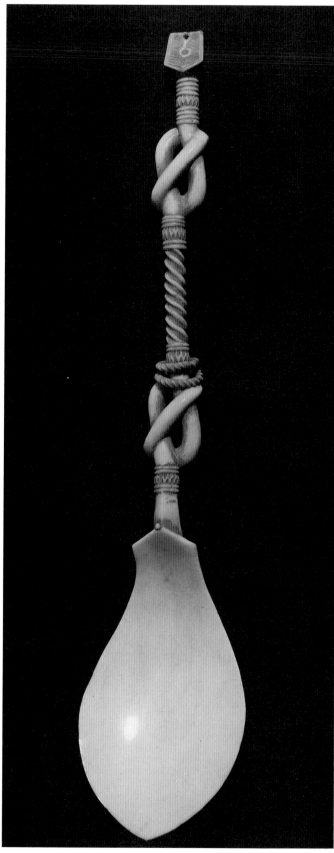

82. Spoon. Sapi-Portuguese, ca. 1490–1530. This is the only Sapi spoon with a figure on it. 23.3 cm. The Metropolitan Museum of Art, New York (no. 60).

83. Spoon. Sapi-Portuguese, ca. 1490–1530. The openwork knots are not the only tour de force carving here: the two small rings above the lower knot are carved free of the shaft, and move between the two larger elements. 23.6 cm. Musée de la Renaissance, Château d'Écouen (no. 66).

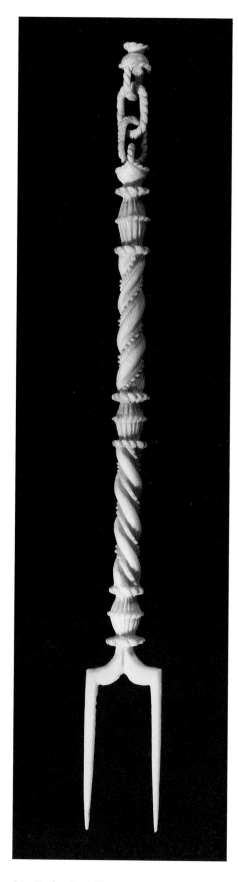

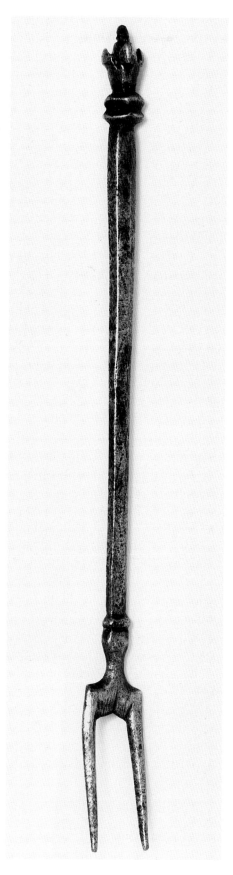

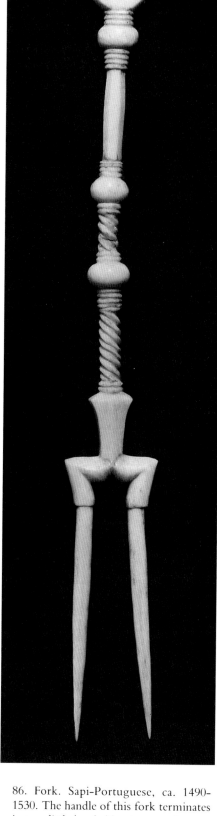

84. Fork. Sapi-Portuguese, ca. 1490–
1530. The Afro-Portuguese forks are
rare—but so are European ones of the
period. Forks were just coming into
general use in sixteenth century Europe,
where most people still ate with their
hands. 14.4 cm. Museum für Völker-
kunde, Vienna (no. 68).

85. European fork. English (?), 16th
century. Most of the European forks are
metal and are simpler and more utilitarian
than the Sapi-Portuguese ones. The
fragility of ivory, and the delicacy of the
carving of the latter suggests they served
more as prestige objects than as utensils.
Cast and engraved latten, 21 cm. Victoria
and Albert Museum, London.

86. Fork. Sapi-Portuguese, ca. 1490–
1530. The handle of this fork terminates
in two little heads like the ones that ap-
pear sculpted in the round on the oli-
phants. 20 cm. Musée de la Renaissance,
Château d'Écouen (no. 69).

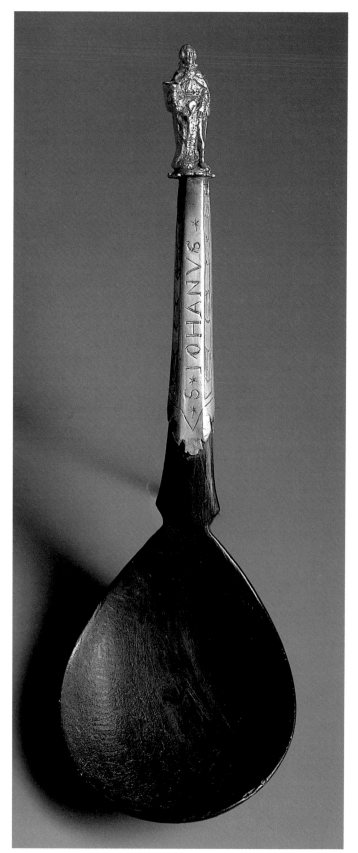

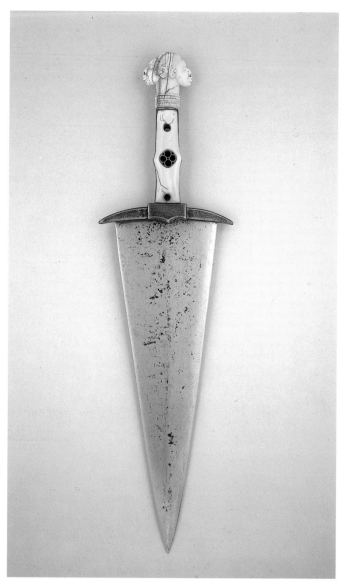

87. Spoon with fig shaped bowl. Southern Germany, late 15th century. The fig-shaped, shallow bowl of this spoon is typical of European spoons of the late fifteenth and early sixteenth centuries. Silver, horn, 15.2 cm. Ruth Blumka collection.

88. Dagger (*cinquedea*). Sapi-Portuguese finial, ca. 1490-1530. Dagger handles are cited in the old chronicle of Valentim Fernandes as among the works in ivory made by the Sapi. Ivory and metal, 47 cm. overall. Glasgow Museum and Art Galleries, Glasgow (no. 46).

89. Seated man, back view (*nomoli*). Sapi, Sierra Leone, 15th-16th century. The human/crocodile combination is frequently encountered in the stone sculpture of Sierra Leone. It recurs in the Sapi-Portuguese ivories, as illustrated in dagger no. 73. Stone, 25 cm. Mangió collection, Milan.

90. Dagger hilt, back view. Sapi-Portuguese, 1490-1530. The handle consists of a ferocious face on a powerful neck; the crocodile climbs the back of the head. We find its exact parallel in the *nomoli* here. 11.4 cm. Museum of Mankind, London (no. 73).

91. Handle of a *presentoir* or hunting knife. Italian or German, 16th century. Knives like this were used during the last moment of the hunt to pierce the animal's heart in a final coup de grâce. The handle is carved in the form of a ferocious looking, open mouthed lion; grotesque or monstrous faces often adorn objects of this type. Ivory and silver blade, 31.7 cm. overall. Ruth Blumka collection.

92. Dagger or knife handle. Sapi-Portuguese, ca. 1490-1530. The open-mouthed aggression of this ivory head might be related to the European hunting knife handles like the one illustrated here. 17.6 cm. Seattle Art Museum (no. 74).

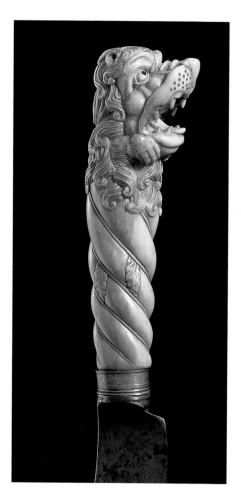 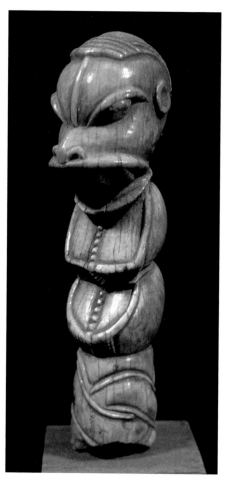

The bowls of all eight spoons known to us are large, fig-shaped and shallow. The handle begins on the back of the bowl on five of them, while on the other three the handle and bowl are continuous. The Sapi showed exquisite taste and impeccable craftsmanship in carving the handles, creating imaginative pieces with slim interlocking, movable parts and delicate openwork.[65]

The forks have two prongs, as did European forks of the period. In two of them (nos. 68 and 69) the handle bears a geometric decoration, which in the case of one (no. 69) terminates in two little heads such as appear on oliphants. A third (no. 70) shows a crocodile and a quadruped—perhaps a dog—biting the tail of a snake, all carved in the round.

Dagger handles are cited in the early chronicle of Valentim Fernandes as among the ivory artifacts made by the Sapi. This seems to be confirmed by the presence in the Glasgow Museum of a Renaissance dagger of the type called a *cinquedea* (no. 46) with a handle that terminates in a beautiful Janus head, surely Sapi-Portuguese. A careful examination of the *cinquedea,* especially of the differences in color between the ivory of the handle itself and that of the head, indicates that the head must be a fragment of a salt-cellar lid, reused to make the dagger handle more precious.

Two other ivories, nos. 73 and 74, probably are dagger handles that were never perforated or otherwise prepared for the insertion of the blade; this operation must have been meant to be carried out in Europe but never took place. They could also, however, have been intended for hunting knives and resemble ornate European knives of the Renaissance. The use in Africa of prestige weapons with handles in wood or ivory in the form of human heads suggests an African origin. The example no. 73 shows a monstrous head on a long neck, with a crocodile on its back. This human/crocodile combination is frequently encountered in the stone sculpture of Sierra Leone.[66]

THE OLIPHANTS

Oliphants had been known all over Europe since medieval times. The term derives from the word elephant, the source of the ivory which was invariably used. Ivory horns originally came from the Orient, or were made by Arab artists working in Sicily and in the Iberian Peninsula. One such instrument decorated with hunting scenes, fantastic animals, and scenes of combat, kept in the treasury of the cathedral of St. Guy in Prague, is said to be the famous horn sounded by Roland at Roncevalle.[67] Oliphants were widespread in Europe. The inventories of the Renaissance treasuries and armories record many trumpets in ivory, horn, metal and wood, used for signaling, hunting and war. They are not mentioned, however, among the ivory objects in the registers of the Casa de Guiné at the beginning of the sixteenth century.[68] A mention occurs in the 1507 inventory and bill of sale of the possessions of the deceased Alvaro Borges, where among other African objects, a "small ivory" (*bocyna pequena*) is listed. The price of 50 *reais* given for this bugle, about the same or even less than for a spoon, seems too low for a large, decorated hunting oliphant. Hence this "bugle" of unknown origin was probably small and undecorated.[69]

A second "ivory bugle" appears in the inventory of the possessions of André Marques, a navigator who died aboard the caravel *Santiago* during a voyage from São Tomé to Portugal.[70] In this case as well, we have too little information about the object in question to identify it as a Sapi-Portuguese ivory, nor does Valentim Fernandes cite trumpets as among the products of Sierra Leone. This absence is doubly surprising because ivory oliphants are among the most numerous, as well as the most conspicuous—considering their dimensions—of the objects carved by the artists of that region.

93 and 94. Hunting horn. Detail and full view. German, 16th century. This horn bears certain features characteristic of the Sapi oliphants designed for European export: the apical mouthpiece and the presence of lugs meant for a cord, chain or belt from which the instrument was suspended. The detail of the cast metal band which adorns the wide end of this oliphant shows a lion hunt. Ivory and gilded bronze, 97.8 cm. Ruth Blumka collection.

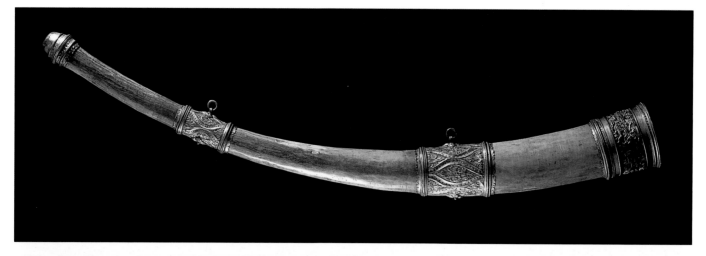

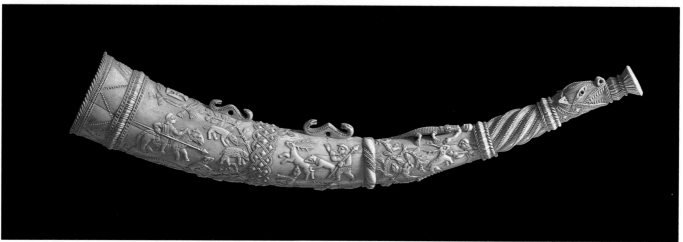

96. Oliphant. Sapi-Portuguese or Sapi, late 15th – early 16th century. The carved surfaces of the Sapi-Portuguese oliphants often display an interaction between indigenous and European forms and decorative motifs. On this horn, however, the only European elements are the gadrooned sections. The predominance of African forms and motifs makes this unique instrument more African than Afro-Portuguese. Perhaps it was meant for local use, probably as the regalia of a chief. 79 cm. Musée de l'Homme, Paris. (no. 201).

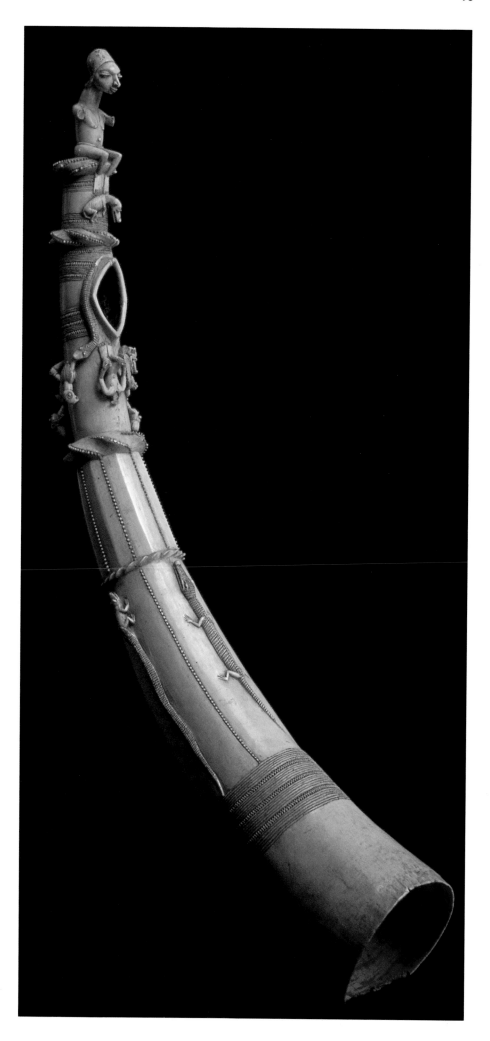

95. Oliphant. Sapi-Portuguese, ca. 1490–1530. This oliphant, like most other horns made for European export, is sounded through a mouthpiece on the tip of the tusk. Horns made for African use are generally transverse trumpets, meaning that the mouthpiece is set into the side part of the tusk. 49.5 cm. Private collection, New York (no. 84).

The typically African elements that characterize the saltcellars and knife-handles do not appear on the oliphants. The horns exported to Europe differ from those meant for African use chiefly in the way the sound is produced. The European horns are sounded through a mouthpiece on the tip of the tusk, while African horns are transverse trumpets with a lateral mouthpiece, smooth or in relief, usually set into the concave part of the tusk.[71]

Five oliphants with lateral mouthpieces on the concave section of the tusk, typical of African horns (nos. 101, 109, 201-203) are of special interest as they display the interaction between indigenous and European forms and decorative motifs. Although the lateral mouthpiece in the form of a lozenge on the first one (no. 101) would seem to distinguish it from those intended for export, the side mouthpiece may have been a liberty granted one of the most gifted carvers working for the Portuguese. Its extraordinarily high quality and its rich decoration, make it one of the most exemplary of art objects made for Europeans.

Instrument no. 109 has the African, lateral mouthpiece that is rounded, yet it also has a lug, a characteristic of the European horns.[72] The lug is placed immediately below the design in low relief surrounding the mouthpiece, which includes a crocodile, snakes, three figures in European dress and a small section of gadrooned surface.

The oliphants nos. 101 and 109 combine African and European elements, anomalous versions of the horns made specifically for export. This conclusion does not apply to the third trumpet no. 201 on which the European elements are marginal, and even less to the fourth and fifth trumpets, where we find no European motifs. We may, therefore, conclude that at least the last three instruments (nos. 201, 202 and 203) were meant for local use, probably as part of the regalia of a chief.

The oliphant no. 201 with lateral mouthpiece and no lugs is the most impressive of this group. The owner of this oliphant no. 201 must have been of particularly high social status, as implied by the size of the piece (79 cm.), and by the richness of its decoration. A human figure, carved

97. Oliphant. Islamic, 11th-12th century. Hunting horns were known all over Europe from medieval times, when they came from Byzantium or the Orient, or were made by artists active in Sicily and in the Iberian peninsula. Ivory and silver, 55.9 cm. Purchase, 1904. Rogers Fund, The Metropolitan Museum of Art (04.3.177).

98. Detail of an oliphant. Sapi-Portuguese or Sapi, late 15th - early 16th century. The lozenge-shaped lateral mouthpiece on the concave side of this oliphant

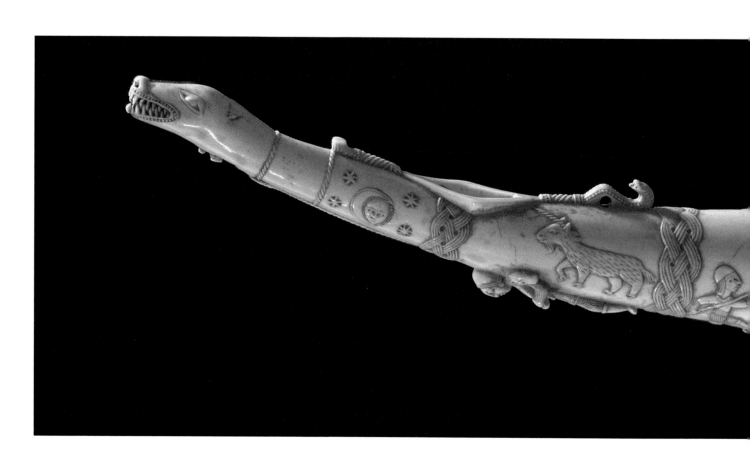

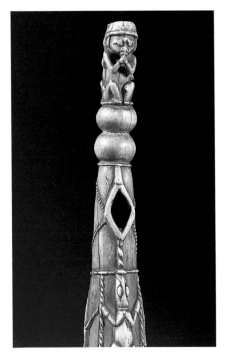

is typical of horns made for African use. 32 cm. Ernst Anspach collection (no. 203).

99. Oliphant. Sapi-Portuguese, ca. 1490-1530. The lateral mouthpiece in the form of a lozenge on this horn might suggest it was made for African use, but its rich relief decoration made up solely of European motifs—including the arms of the House of Aviz—shows it was destined for a Portuguese client. It is one of the most exquisite examples of the Afro-Portuguese art objects. 54 cm. Private collection (no. 101).

in the round, is seated at the end of the tusk on a circular platform. The volume of his large head dominates and contrasts with the thinness of his body (the arms are broken and lost). His facial features are similar to those found on the *nomoli*. An animal that looks like a dog lies at the man's feet. Beneath the mouthpiece, decorated with lozenges, appears a more complex sculptural group of three figures, and on the other side a serpent is seen eating a parrot. These figures are similar to the one at the top of the instrument, but are reversed in position. There is also a gadrooned section and, finally, two crocodiles and two snakes, devouring two small animals with smooth bodies.

Although there are similarities between the features of these figures and some sculptures in soft stone—taking into account the modifications that occur when a subject is treated in two different media—the similarities between oliphant no. 201 and the figures, animals and decorative motifs on the other Sapi-Portuguese ivories are even greater. The details of the figures correspond exactly to those carved on the saltcellars. The pose of the bodies, the angle of the knees, the shape of the feet, even the eyes of the birds rendered as two concentric circles are similar to those carved on the conical base of saltcellar no. 13, and on the handle of spoon no. 65. The subject of a bird attacked by a snake is treated frequently and in diverse manners.[73] The bands in relief that divide the surface of the horn are reminiscent of compositional devices found on the saltcellars.

A fourth transverse trumpet, no. 202, ends with four small heads that bear the unmistakable traits of Sapi sculpture. The decoration on the sides, not as rich as on no. 201, consists of two crocodiles and two snakes in the act of eating two animals with smooth bodies, pointed heads, and only two legs each. The relief is very shallow and the stylization so extreme, that the animals are not clearly identifiable.

The surviving apical part of a broken oliphant no. 203, the fifth in

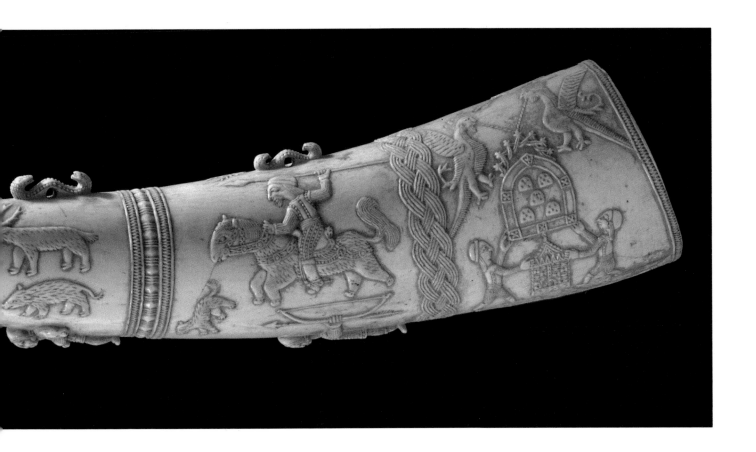

100. Detail of Sapi-Portuguese oliphant. The apical position of the mouthpiece and the animal head from whose fanged jaws the mouthpiece emerges indicate that this horn was created for export to Europe. (For full view, see page 90.) Private collection, New York (no. 84).

101. Marten head. German, late 16th century. Jeweled heads of ermine, marten, or sable made of gold or precious stones were attached to fur pieces to ward off fleas during the fifteenth and sixteenth centuries. The likeness between these heads and those on the ivories is striking. Even the bridle recalls the ivory carvings, which are often decorated with a reticulum of rows of beads studded with inlays. Rock crystal, 7 cm. Whereabouts unknown.

102. St. George and the dragon. Florentine, ca. 1495. Woodcut. Examples of incunabula such as this may have circulated among the Sapi-Portuguese ivory carvers. Wyverns or dragons figure prominently in fifteenth and sixteenth century literature, best known in the frequently illustrated legend of St. George. These and other fantastic creatures were also illustrated in bestiaries of the time.

103. Detail of Sapi-Portuguese oliphant. The decorative elements on this hunting horn confirm that it was made for a European destination. The wyvern, a large winged animal with two paws, which is carved in the round on the concave side of this horn, is a monster that frequently appears in European medieval sculpture. (For full view, see page 56.) Armeria Reale, Turin (no. 81).

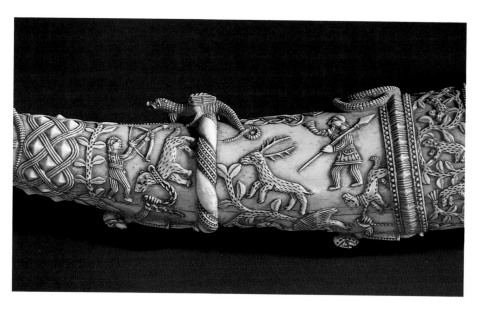

the group, terminates in a figure seated on two spheres. A crocodile climbs the back of the figure, while on the lower section of the surface two other reptiles are depicted in relief.

Since the shape of the oliphants was dictated by the shape of the tusk, the shape of the African instrument does not differ from the European one, except for the placement of the mouthpiece: lateral for Africans, apical for Europeans ones. In Sapi-Portuguese ivories, the mouthpiece emerges from the jaws of an animal with large teeth and small, pointed ears. The head of the animal is usually decorated with a reticulum of rows of beads and, in the more refined examples, sometimes with studs of precious metal. The animal head from whose fanged jaws the mouthpiece emerges is seen on certain early sixteenth-century firearms and is clearly a motif introduced by Europeans.[74]

Lugs meant for a cord, chain or belt from which the instrument was suspended are another feature distinctive of the oliphants designed for European export. These do not appear on the oliphants used by Africans. On trumpets meant for European export the lugs consist of elaborate geometric elements. Sometimes the lugs are in the shape of small animals perfectly integrated into the overall decoration. Even the form of the lugs, where the strap for the instrument was attached, is derived from European weapons. The lugs are related to the rings used to lift cannons, known as "dolphins." These lugs often took the form of a fish whose back is arched; more rarely, they were shaped as a wyvern.[75]

The apical position of the mouthpiece, the animal head from which the mouthpiece emerges, and the lugs for the attachment of straps are all elements that indicate such objects were commissioned by Europeans. Whether in high or low relief or in the round their decoration confirms this.

On the concave part of the instrument, at least in the larger and more finely executed examples, appear crocodiles and serpents carved in the round that are certainly African. Small, unidentifiable animals with slim bodies are probably African, but wyverns with shagreened bodies to indicate their scaly skin are certainly not in the African tradition.[76]

On the convex part of the oliphant appear hunters with spears and dogs on chains, carved in high relief. Sometimes they hold an animal by the nape of the neck or tail, or carry it on their shoulders. The man with

104. Seated male figure with crocodile (*nomoli*). Sapi, Sierra Leone, 15th-16th century. Confrontations between crocodiles and men frequently appear on the Sapi-Portuguese ivories. Stone, 18 cm. Carlo Monzino collection.

105. Gun signed "Maistre Denis." Detail. Flemish (?), 1535. The lugs on many Sapi-Portuguese oliphants are related to European Renaissance weapons. The non-functional sculpture in the round which adorns the sides of the Sapi-Portuguese horns corresponds to the form of "dolphins" on weapons, lugs which are often in the form of a fish with arched back. This richly decorated cannon sports a pair of wyverns functioning as lugs. Bronze, The Tower of London.

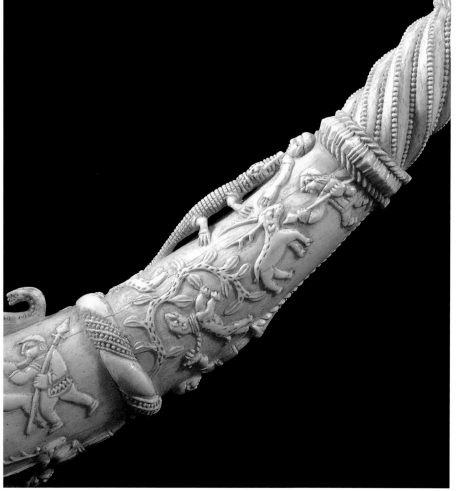

106. Detail of a Sapi-Portuguese oliphant. On the concave side of the instrument a crocodile appears devouring a human figure in the round. While this is a quintessential African motif, the hunt scenes carved in low relief on the sides of this horn are quintessentially European. Private collection, New York (no. 84).

107. Swivel gun, probably Flemish or German, ca. 1520. Similar to the mouthpieces on the oliphants, this cannon has a barrel protruding from the jaws of an animal with small pointed ears. Bronze, 143.5 cm. The Tower of London.

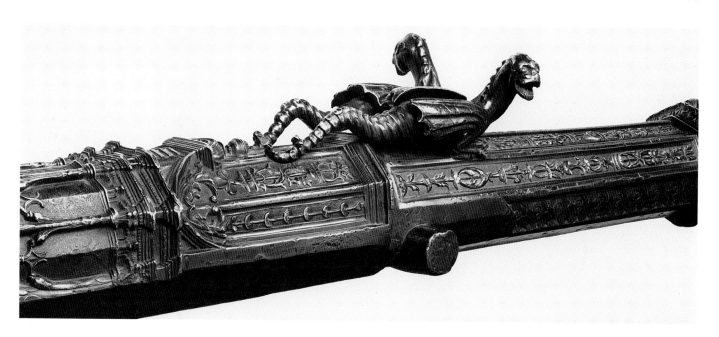

an animal across his shoulders is almost certainly inspired by a figure which was common in early Christian art, seen in frescoes in the Catacombs, mosaics and carvings on sarcophagi. It is the Good Shepherd, a metaphor for Christ, Shepherd of the Christian flock. This image also recurs in the Indo-Portuguese ivories made in Goa in the seventeenth century but there as a young man seated among the sheep. Despite the formal analogies, however, the meaning of the figure has been reversed on the African ivories because the animal carried across the shoulders is not the customary lamb but an animal that has been killed. On the convex side of oliphants nos. 86 and 91 a Madonna with Child replaces one of the figures.

The decoration in low relief is of European and sometimes Oriental derivation. On horns no. 86 and 87, pairs of Western knights armed with spears face each other. The romance of chivalry and the vogue for jousting and tourneys thrived in Portugal as in all Europe at the beginning of the sixteenth century.

The oliphants were probably commissioned to be used in hunting. The theme of the stag hunt appears most frequently on the horns and, less frequently, those of boars, bears, and birds. The stag hunt scenes illustrated are those that had been codified in Europe over the course of centuries for the *chasse à courre*. They are: the departure of the hunters both on horse and on foot with dogs; the signal of the discovery of the prey; the attack of the dogs; the sounding of the horn by the Master of the Hunt to announce the death of the prey; and the transport of the carcass to the castle.[77] These themes are the same as those in late Gothic miniatures and tapestries, especially those of the Franco-Flemish school from the late fifteenth and early sixteenth centuries. One can see such miniatures in the French manuscript *Le Livre de la Chasse du Roy Modus* of the late fourteenth century by Gaston de Foix who was called Gaston Phoebus,[78] and in the *Très Riches Heures du Duc de Berry* illuminated by the Limbourg brothers, in the first half of the fifteenth century.[79]

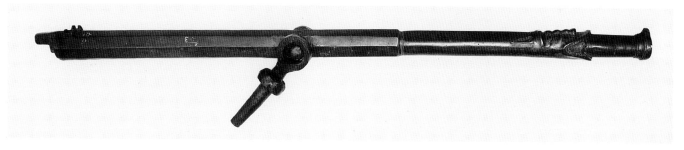

108. The Start of the Hunt. Tapestry from the series *The Hunt of the Unicorn.* Franco-Flemish, ca. 1500. The scenes illustrated in low relief on the sides of many of the hunting horns are those that had been codified in Europe over the course of centuries for the *chasse à courre:* the discovery of the prey by the Master of the hunt, who announces it through his curved horn with its apical mouthpiece; the attack of the dogs; the *hallali du cerf;* the sounding of the horn to announce the death of the animal; and the transport of the carcass to the castle. Wool and silk with metal threads, 3.66 x 3.88 m. The Metropolitan Museum of Art, The Cloisters Collection, Gift of John D. Rockeller, Jr., 1937.

109. Detail of Sapi-Portuguese oliphant. On the convex part of this oliphant, the human figure with an animal around his shoulders carved in high relief is almost certainly styled after the figure of the Good Shepherd. The carver of this ivory replaced the image of the rescued lamb which rested on Christ's shoulders with the kill from the hunt. (For full view, see page 107.) The Paul and Ruth Tishman Collection of African Art, Walt Disney Co., Los Angeles (no. 76).

110. The Good Shepherd (detail of a sarcophagus). The theme of the Good Shepherd, a metaphor for Christ as Shepherd of the Christian flock, was common in Paleo-Christian art. The theme inspired certain Indo-Portuguese ivories carved in Goa in the seventeenth century. In the Sapi-Portuguese ivories the theme took a slightly altered form, as illustrated above. Museo Vaticano.

111. Fluted oliphant. Afro-Portuguese (?), West Africa (?). Fluted horns similar to this horn are worn by three of the figures in the tapestry illustrated here. 66 cm. The Danish National Museum, Copenhagen (no. 192).

In manuscripts from the end of the fifteenth or the beginning of the sixteenth century, the theme of the hunt is not as central as it is in the book by Gaston Phoebus (the only example we know), but it is sometimes used as a decorative element in the margins of pages in devotional books.[80]

The theme of the hunt is most frequently treated in Renaissance tapestries. One need only visit certain great collections such as the Burrell collection in Glasgow, the Metropolitan Museum in New York, or the Victoria and Albert Museum in London in order to see the importance given this theme by the master weavers of the period.[81]

The analogies between the hunting scenes carved on the horns and those woven on the tapestries are not only thematic: the hunters are shown in the same moments of the hunt and are depicted in the same way. Take, for instance, the scenes of the hunter sounding his horn while the dogs attack the stag, and of the killing of the animal. In the tapestry from the *Hunt of the Unicorn* in the Cloisters in New York the unicorn is carried on the back of a horse, and the hunter grasps the antler of the killed animal. This situation is presented almost identically in scenes of the carrying off of a stag carved on many oliphants. Even certain clothes and weapons are alike.[82]

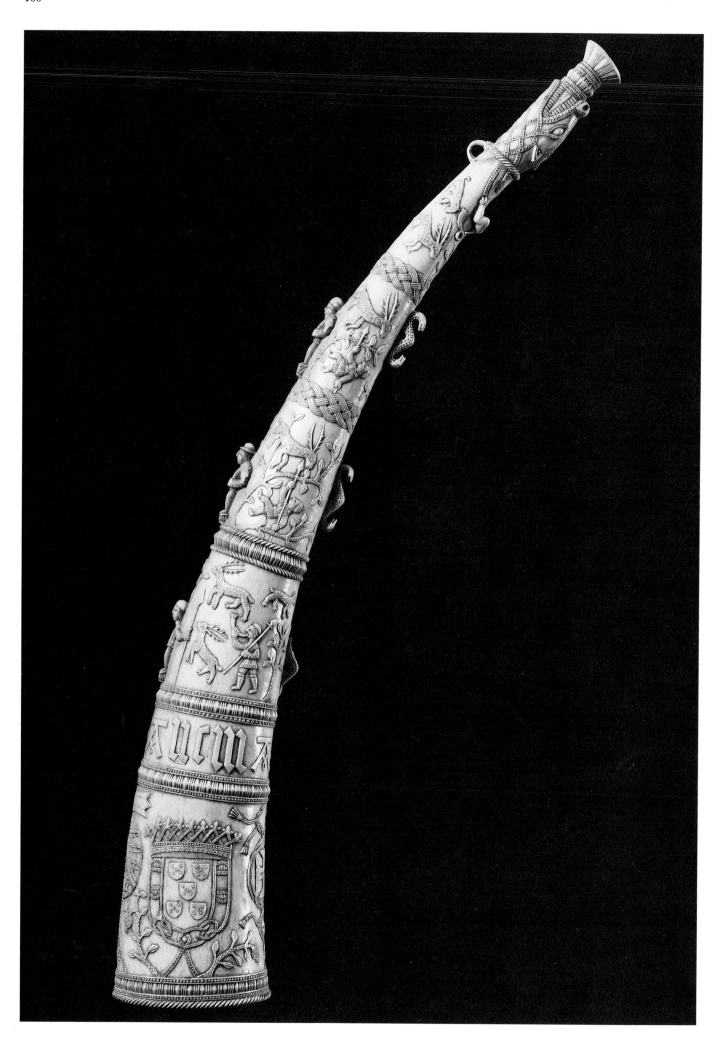

112. Oliphant. Sapi-Portuguese, ca. 1490-1530. The hunt scenes depicted in low relief on this Sapi-Portuguese oliphant and those illustrated in the margins of the late fifteenth century Book of Hours shown here are so closely parallel that the two could almost be superimposed. 68.5 cm. Australian National Museum, Canberra (no. 75).

113. Hunter blowing his horn. Detail from a page of the *Horae Beatae Mariae Virginis,* French, by Philippe Pigouchet for Simon Vostre, Paris, 1498. The analogies between the hunt scenes carved on the African oliphants and illustrated in European works are more than thematic; the hunters are shown in the same moments of the hunt and are depicted in the same way.

114. Hunter blowing his horn. Detail of a Sapi-Portuguese oliphant. Compare the pose of the hunter blowing his horn carved by a Sapi artist to that of the hunter from the margin of the French Book of Hours. The African artist even included a tree, whose leafy branches, although more symmetrically conceived, resemble the European artist's rather schematic representation of thick forest growth. Australian National Museum, Canberra (no. 75).

115. The killing of the stag. Detail of a Sapi-Portuguese oliphant. The hunter's long straight hair identifies him as a European. The scene itself, a stag hunt, is also of European derivation, since narrative scenes were not part of the West African artist's repertoire. The weapon being used to kill the stag in this scene is a "winged spear"—a European hunting weapon of the late fifteenth and early sixteenth centuries—so called because of the wings which kept the blade from penetrating more than a certain depth. Australian National Museum, Canberra (no. 75).

116. The killing of the stag. Detail from a page of the *Horae Beatae Mariae Virginis,* French, by Philippe Pigouchet for Simon Vostre, Paris, 1498. The African artists carving the Sapi-Portuguese ivories copied very precisely certain details of the models supplied by their European patrons. Compare the antlers of this stag to those on the oliphant. Other details were executed with greater freedom. The African artist's more hesitant hunter is separated from his prey by the stray branches of a tree which sweeps in from the lower right, stripping the scene of any reference to foreground or background.

Firearms are seen neither on the tapestries nor on the horns. Claude Blair has stated that matchlock guns were too loud and too slow to load to be suited for hunting. Wheelocks, on the other hand, were made only after 1520 and were used for hunting only after 1530. Thus, the absence of firearms permits a more precise dating of the Sapi-Portuguese oliphants.[83] Other motifs are interspersed among the hunting scenes, the sun

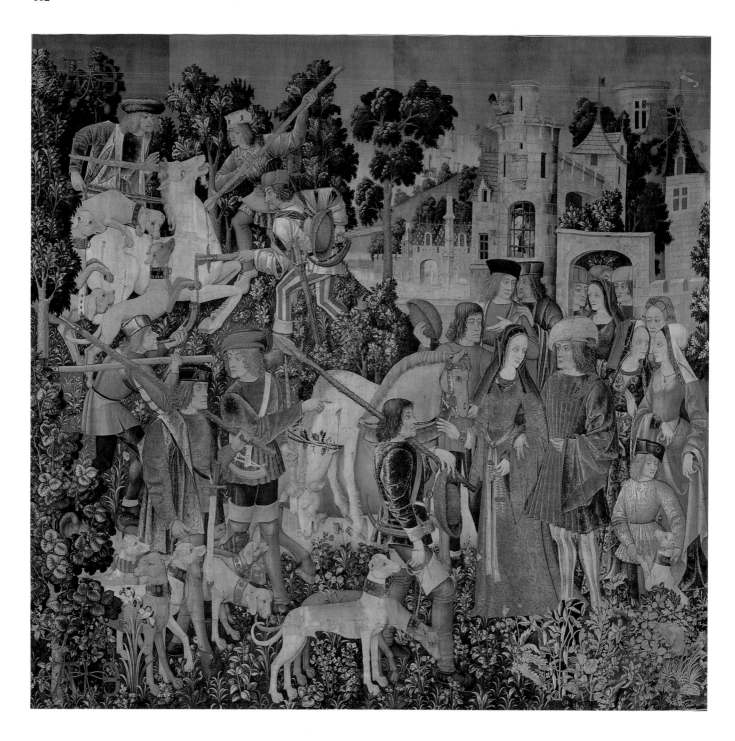

and moon, and fantastic animals and monsters derived from European sources: unicorns, harpies, wyverns, griffins, basilisks, and centaurs. On two oliphants, nos. 100 and 101, are large birds, perhaps ostriches, holding horseshoes in their beaks. On another two, nos. 81 and 83, are birds with monstrous heads whose long necks are intertwined. Like these pairs of birds, lions often appear, sometimes with crowns, rendered according to the Renaissance canons of European heraldry.[84]

Few animals are seen on the oliphants except for dogs, the game seen in the hunting scenes, crocodiles, and serpents. An ape appears on oliphant no. 103, and no. 101 has a hedgehog and a goat with short, spiral horns and a beard; another goat appears on oliphants nos. 78, 81, 85 and 100. An elephant, a rhinoceros, and a lion or lioness with an entirely smooth, powerful-looking body also appear on no. 85.

The elephant represented on horns nos. 81 and 85 is an Asiatic elephant, recognizable by the small ears. Another three elephants are carved on horns nos. 82, 103 and 105. The first two carry howdahs on their

117. The Unicorn is brought to the Castle. Tapestry from the series *The Hunt of the Unicorn,* Franco-Flemish, from the Château of Verteuil, late 15th century. This splendid work demonstrates how important the theme of the hunt was during the late fifteenth century. The taste which gave rise to the creation of this work, broadly speaking, also inspired the commissioning of the intricately carved Sapi-Portuguese ivory hunting horns. Both reflect a taste for luxurious but useful items, and an appreciation for the consummate achievements of specialized craftsmen, European and African. Wool and silk with metal threads. 3.66 x 3.88 m. The Metropolitan Museum of Art, The Cloisters Collection. Gift of John D. Rockefeller, Jr.

118. Transport of the killed stag. Detail from a page of the *Horae Beatae Mariae Virginis,* French, by Philippe Pigouchet for Simon Vostre, Paris, 1498. Compare the way the front figure leads the horse bearing the stag here with the similar African version of this scene. Both figures carry "winged spears" over their shoulders.

119. Transport of the killed stag. Detail of a Sapi-Portuguese oliphant. The castle and the dogs included in the European scene are missing in the ivory version. Australian National Museum, Canberra (no. 75).

120. Page of the book *Horae Beatae Mariae Virginis,* French, by Philippe Pigouchet for Simon Vostre, Paris, 1498. This book may have provided a source for many of the hunt scenes on the Sapi-Portuguese oliphants. The details of hunt scenes illustrated here and on page 101 were taken from the margins of this work. 22.9 x 15.2 cm.

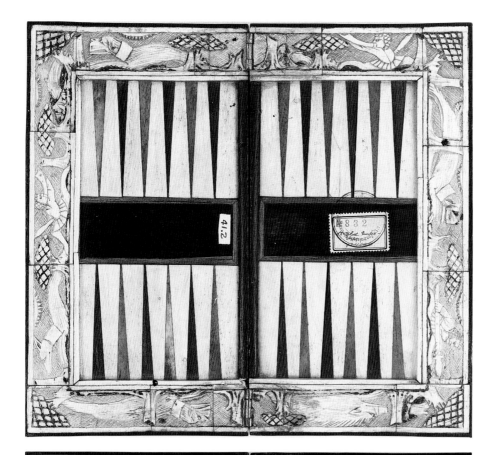

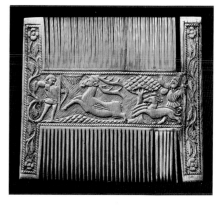

121 and 122. Gameboard. German, 1440-1470. The hunters, hounds, and the hunted prey—here, a boar—dash behind tree trunks which cut the border of this gameboard into horizontal frames. This artist's interest in layering elements to create a scene with spatial depth provides an interesting comparison to the hunt scenes carved by the Sapi-Portuguese artists who generally ignore such European conventions. Both this border and some of the framing bands on the Sapi horns cut across figures in an almost photographic way. Ivory inlaid with wood, 27.62 x 24.77 cm. Detroit Institute of Arts. Gift of William Clay.

backs, the third is ridden by a man who holds a hooked baton, while a servant holds the animal's chain. Since elephants were never domesticated in Africa, these must be representations of Indian elephants, which served as beasts of burden. The image could have been supplied by an oriental miniature or by an engraving or drawing by a Western artist. Harnessed or mounted elephants are not the only figurative elements that could be of oriental origin. The motif of birds with intertwined necks, mentioned

123. Comb. French, 16th century. Precious utilitarian objects, such as this comb, were carved of ivory and adorned with hunt scenes during the Renaissance. Ivory. Victoria and Albert Museum, London.

124. The hunt of the birds with the crossbow. From Petrus de Crescentis, *In commodum ruralium,* Spira, 1490. Woodcut.

125. Detail of a Sapi-Portuguese oliphant. The crossbow which this hunter aims towards the bird perched above is a European weapon. The artist who carved this ivory may have copied the image of the crossbowman from the bird hunt illustrated in the woodcut to the left. Náprstkovo Museum, Prague (no. 104).

above, which could be of Sassanian origin, also appears on ivories made in Ceylon for the Portuguese. India and Persia had maintained relations with Europe ever since Antiquity via land routes and the Mediterranean long before the Atlantic Ocean routes were opened. These motifs could also have been transmitted by the Arabs.[85]

There are several other motifs which may be of Islamic derivation. The mounted hunter with a spear on oliphant no. 101 might represent a Moorish figure, seen in Spain. The manner in which he grasps the spear with his arm held behind corresponds to images in Iranian works of art.[86] The kinship is further underlined by the similarity of the horses to certain Fatimid bronzes of the eighth to ninth centuries.[87] The depiction of the horses' tails, terminating in two tufts, is also the solution adopted for the tails of the centaurs on this horn and those on nos. 100 and 102.

126. Plate. Iranian, 7th-8th century. There is a marked similarity between the horseman on this plate and one on the Sapi-Portuguese horn pictured on pages 92 and 106. Note the way the horseman holds the spear above and beyond his shoulder, and the way the horse's tail is divided into two tufts.

127. Centaur/archer. Detail from a page of the *Horae Beatae Mariae Virginis,* French, by Philippe Pigouchet for Simon Vostre, Paris, 1498.

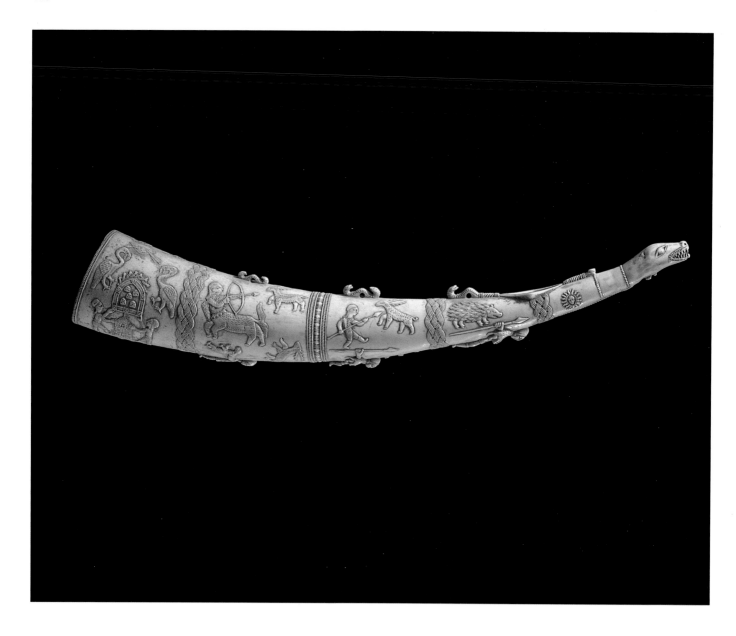

Coats of arms, heraldic devices and mottoes of European, indeed Portuguese, origin constitute yet another series of decorative motifs that characterize certain oliphants, some saltcellars and pyxes. It was precisely these elements that originally inspired the term "Afro-Portuguese." With few exceptions all are of a Christian nature, written in Latin in late Gothic script. They include the mottoes: "*Ave Marya*" (Hail Mary), "*Ave Grasia P.*" and "*Ave Grasia Plena*" (Hail full of grace), "*Da Pacem Domyne in Dieb(us) n(os)tris* (Grant peace in our time, O Lord).

"*Espera in Deo*" (Hope in God), carved on the saltcellar in the form of an armillary sphere no. 26 was the device of Emanuel I, king of Portugal (1495–1521), while "*Spes Mea in Deo Meo*" (Hope in My God), carved on the oliphant no. 85, was that of his son King John III (1521–1557). "*Imfamte Dom Luis*," carved on oliphant no. 87 was already identified by Olaus Worm as the second son of Dom Manuel, who lived from 1505 to 1555.[88] "*Aleo*," carved on oliphant no. 78, was the battle cry of the Portuguese at the conquest of Ceuta and the motto of Dom Pedro de Menezes, Count of Villa Real and Governor of the conquered Moroccan city.[89]

These emblems are largely those of the House of Aviz, which ruled Portugal from 1385 to 1580. The armillary sphere and the Cross of Beja refer to the Portuguese sovereigns and in particular Dom Manuel "the Fortunate," who reigned as King Emanuel I from 1495 to 1521; during his reign the last great discoveries in Africa and Asia were achieved.[90]

128. Oliphant. Sapi-Portuguese, ca. 1490-1530. This centaur/archer is a typically European subject. Note, however, the double tufted tail as in the Iranian plate illustrated on p. 105. Another image on this horn, the hunter spearing a stag, resembles one on the French print on page 101. Private collection (no. 101).

129. Oliphant. Sapi-Portuguese, ca. 1492-1516. This oliphant bears the arms of the House of Aviz and Ferdinand V of Castile and Aragon, as well as Ferdinand's motto: "*Tanto Monta.*" 63.5 cm. The Paul and Ruth Tishman Collection of African Art, Walt Disney Co., Los Angeles (no. 76).

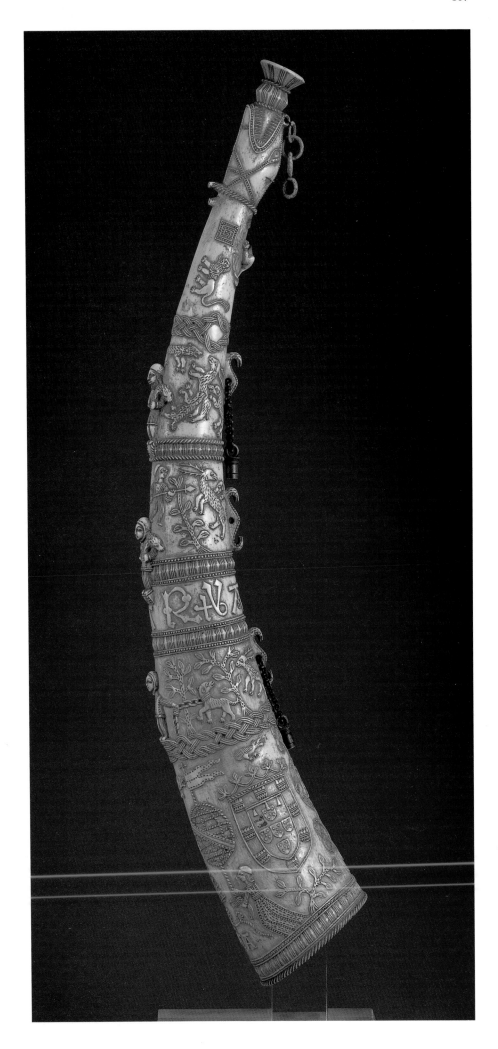

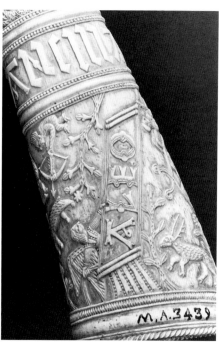

130. Arms of Ferdinand and Isabella of Castile and Aragon. Relations between the Portuguese king, Emanuel I, who was married to one of their daughters, and Ferdinand and Isabella, were particularly close between 1490 and Ferdinand's death in 1516. Woodcut, 1498.

131. Detail of capital of the portal of the church of Batalha. Portuguese, late 15th to the early 16th century. Features characteristic of Manueline architecture such as these appear in the nonfigurative decoration on the Afro-Portuguese ivories: the gadrooned surfaces with rectilinear or spiral bands, the subdivision by means of rows of beads, and the braided and twisted elements that transversally subdivide the surface.

132. Tympanum of the facade of the convent of San João da Penitencia, Estremoz, Portugal. Here we see the emblem of the House of Aviz flanked by two armillary spheres. Gadrooned bands outline its rectangular divisions and the Cross of Beja is set in a circle above.

133. Detail of a Sapi-Portuguese oliphant. "*Aleo*" was the battle cry of the Portuguese at the conquest of Ceuta and the motto of Dom Pedro de Menezes, Count of Villa Real and Governor of the conquered Moroccan city. Museo Nacional de Artes Decorativas, Madrid (no. 78).

134. Tomb of Dom Pedro de Menezes, Count of Villa Real, in the church of the Grace, Santarem (Portugal). The motto and battle cry, "*Aleo,*" which is carved in low relief on the oliphant illustrated above also appears many times on the Count's marble tomb.

Three horns (nos. 75-77) and a powder horn fashioned from the fragment of a fourth (no. 79), exhibit elements that allow us to date them more precisely than any other Afro-Portuguese ivories. These are the arms of the House of Aviz and Ferdinand V of Castile & Aragon, as well as Ferdinand's motto: "*Tanto Monta*." The coat of arms of Ferdinand and Isabella here also sports the pomegranate, emblem of the Kingdom of Grenada, the area of southern Spain recaptured from the Arabs in 1492. Thus we can place the commissioning of this group of oliphants between 1492 and the death of Ferdinand in 1516.

The relations between John II and, later, Emanuel I with the "Catholic Sovereigns," Ferdinand and Isabella, were particularly close from 1490 to 1516. The alliance was reinforced by the marriages of two Spanish princesses with two Portuguese kings, as well as by the Treaty of Tordesillas in 1494, which sanctioned the division of the world between the two Iberian powers. It is most likely, therefore, that either John or, more probably Emanuel, presented his father-in-law and powerful ally with these hunting horns made by artists in Sierra Leone, over whom he ruled by virtue of the Patronatus.

The nonfigurative decoration on the ivories requires close examination. It consists of gadrooned surfaces with either rectilinear or spiral bands, rows of beads and braided and twisted elements that subdivide the surface transversally. All of these features are found in, and are characteristic of, Manueline architecture, which flourished in Portugal at the end of the fifteenth century and beginning of sixteenth, taking its name from King Emanuel I.

In the cloister and church of the Mosteiro dos Jerónimos in Lisbon, a whole complex of these elements can be seen, mainly on the pillars of the church: floral motifs, stylized torches, and monsters like those on the saltcellars and oliphants. On the pilasters and on the keystones, the arms of the House of Aviz appear frequently, in one case held up by two griffins. A huge armillary sphere is affixed to the tribune of the church. The examples could be infinitely multiplied."[91]

CHAPTER 4
SOURCES FOR THE SAPI–PORTUGUESE IVORIES

At this point, before attempting to attribute these works to artists or to specific workshops, we should also consider the problem of possible models that may have been furnished to the sculptors by their patrons. Neither the range nor extent of the European themes and patterns is very wide compared to the African ones. On the oliphants, for example, the scenes are almost always the same, with few variations. We have already ruled out the possibility that European cups, pyxes, or horns in precious metal were sent to Africa to serve as models for the ivories. Nor can we imagine that ivories or miniatures, which are also precious, or tapestries, which are too large, would have been sent to serve as models. This possibility does not even exist for the architectural motifs.

The solution must lie with European objects, not too large and not too valuable, but easily transportable. Prints, which at the end of the fifteenth and beginning of the sixteenth centuries were already quite common throughout Europe, are the likeliest possibility. Except for the sources of models which we have already discussed, which came to light in a wide-ranging though not exhaustive search, our references are limited to prints. Most of these, however, are contained in books which, after Gutenburg's invention of the printing press, replaced manuscripts.

These incunabula and sixteenth century printed books reproduced writings of various kinds, from the Bible and devotional books to the works of the ancient authors. The books were frequently adorned with illustrations, either large scale or in the margins usually unrelated to the text, imitating the illuminations found in the original manuscripts. The woodblocks made by the better engravers circulated among the various European publishers of the time and were frequently reused or copied with the result that identical or very similar images turned up in books of diverse subjects by different authors, publishers and editors.

Even these printed books, however, were themselves relatively costly and rare. It seems quite probable that whole images or details from the margins were copied by able draftsmen—not themselves necessarily creative artists—and sent to Africa to be used as models. If this was the case, the same presumably applies to the decorative motifs, especially those derived from architectural models, and to coats of arms, frequently reproduced on the frontispieces of contemporary books, and to subjects not illustrated in printed books. This hypothesis would seem to be confirmed by Valentim Fernandes when he states that "the men of the country [Sierra Leone] are black and very talented in making things, that is ivory salts and spoons; whatever sort of object is drawn for them, they can carve in ivory."[92]

There seems to be no possiblity of finding in Africa today the traces of models or sketches sent there five hundred years ago. We can, however, suggest which European prints, both separate and contained in books or copied in drawings, could have been used as models in Africa. In discussing the saltcellars we proposed prints showing witches on the back of a goat as a possible source for the image on the saltcellar no. 8.

There are many possible sources for the themes carved on the pyxes, which are episodes from the life of the Virgin, and the passion of Christ—frequently treated during the late fifteenth and early sixteenth centuries.[93]

135. Saltcellar. Sapi-Portuguese, ca. 1490-1530. One of the great masterpieces of Sapi-Portuguese art, this salt is carved with a precision and invention not seen on the others. The slender rods that support the vessel and the elongated figures between them are both elegant and cunningly integrated into the overall design. The artist's brilliant use of two areas of plain surface with clean linear decoration alternating with two areas of sculptural incident is the mark of a master. 43 cm. Museo Preistorico e Etnografico, Rome (no. 31).

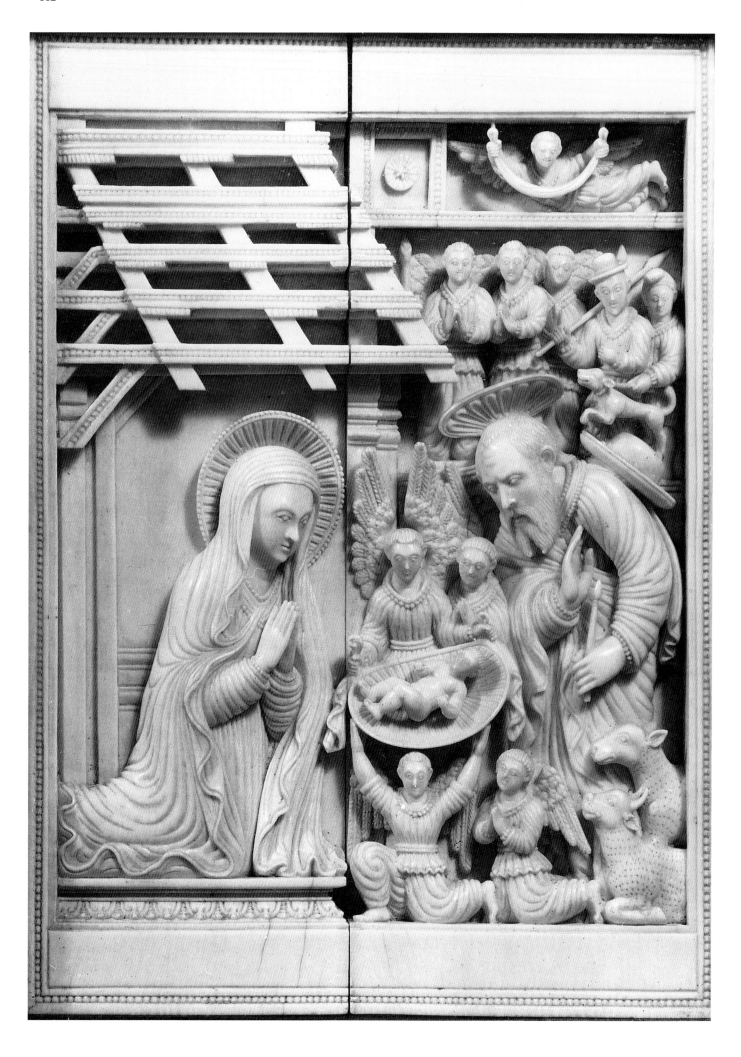

136. The Nativity. Ceylon-Portuguese, 17th century. Engravings by Dürer and Schongauer seem to have served as models for the ivory carving from Ceylon. In a similar way, European prints, which at the end of the fifteenth and beginning of the sixteenth centuries were already common throughout Europe, probably served as models for images seen on the Sapi-Portuguese ivories. Ivory, 18.2 x 12.8 cm. Museu Nacional de Arte Antiga, Lisbon.

137. Pyx. Sapi-Portuguese, ca. 1490-1530. Scenes from The Passion appear here: The Kiss of Judas and The Deposition. Illustrations, mainly from Books of Hours, provided the models for scenes on the Sapi-Portuguese pyxes. The Walters Art Gallery, Baltimore (no. 59).

138. The Kiss of Judas. Print from the *Horae Beatae Mariae Virginis,* French, by Philippe Pigouchet for Simon Vostre, Paris, 1498. Compare this scene with that on the pyx above. The low arch crowned by a spire in the marginal illustrations of this Book of Hours also reappears in the scene of The Deposition.

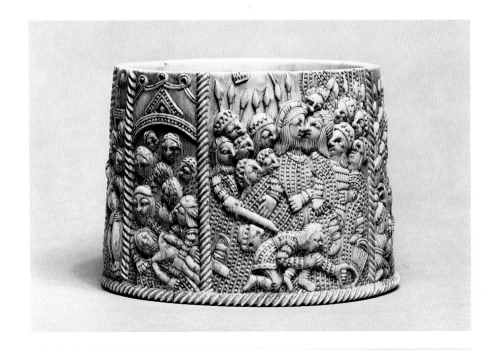

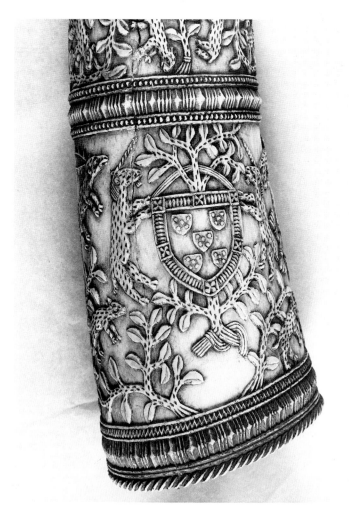

139. Detail of Sapi-Portuguese oliphant with the coat of arms of the King of Portugal. The presentation of the coats of arms on this oliphant resembles that in sixteenth century printed books (for full view see page 56). Armeria Reale, Turin (no. 81).

140. Mark of the printer Thielman Kerver, Paris, late 15th century. Woodcut. Thielman Kerver, a Parisian printer, who called his shop "At the Sign of the Unicorn," illustrated his mark hanging from the branch of a leafy tree flanked by unicorns, just as the arms of the House of Aviz are presented on oliphant no. 81.

141. Detail of Sapi-Portuguese pyx with The Tree of Jesse. Compare the image of The Tree of Jesse, a metaphor for the militant and triumphant Church, carved in ivory on this pyx, to the version seen in a late fifteenth century print (ill. 142). Private collection (no. 58).

142. The Tree of Jesse. Print from the *Horae Beatae Mariae Virginis*, French, by Philippe Pigouchet for Simon Vostre, Paris, 1498.

The models for scenes on the pyxes, however, seem to be taken from book illustrations, above all from Books of Hours. These were personal prayer books of the laity, combining sacred and secular elements, widely in use in Italy and France, containing numerous illustrations often placed in the margins of the pages.

Compare, for example, The Tree of Jesse, a metaphor for the militant and triumphant Church, or The Visitation carved on pyx no. 58 with the illustrations from the *Horae Beatae Mariae Virginis,* printed in Paris in 1498 by Philippe Pigouchet for Simon Vostre. Examine the scenes of The Annunciation and The Annunciation to the Shepherds in the margins of this volume or in editions of later years. Even more convincing is a comparison of the engravings in this same book with the scenes of The Passion on pyx no. 59, especially The Kiss of Judas. The Deposition on this pyx shows the same architectural element of a low arch crowned by a spire as appears in the marginal illustrations of the *Horae Beatae Mariae Virginis* referred to above.[94]

The coats of arms, not surprisingly, of the reigning house of Portugal, especially the armillary sphere, appear in many sixteenth century printed books, as do those of Ferdinand and Isabella of Spain. The presentation of the arms on some oliphants resembles the way they are presented in many prints. On the frontispiece of the book published by Antoine Verard of Paris (1485–1512), two angels bear the arms of the lilies of France. On powderhorn no. 79 the arms of the House of Aviz are supported in the same way. Two angels are also shown supporting the Holy Grail on the frontispiece of a volume published by the workshop of Philippe Pigouchet in 1498, also in Paris. Thielman Kerver, a Parisian printer, who called his shop "At the Sign of the Unicorn," hung his mark like a handbag from the branch of a leafy tree flanked by unicorns on their hind legs, just as the arms of the House of Aviz are presented on oliphant no. 81.[95]

It is the stag hunting scenes, however, that unequivocally reveal their European matrix. As stated in previous references to the tapestries, illustrations of the stag hunt correspond to a uniform iconography that existed all over Europe. All of the main moments of the hunt, depicted on the ivory horns and on the tapestries, can also be found on the small marginal scenes of the *Book of Hours* of Philippe Pigouchet for Simon Vostre, already cited.[96] Formal analogies are even more marked than the expected thematic ones; hunters and animals are rendered in attitudes and positions so similar that they could be superimposed.[97]

The boar hunt was often used to illustrate the Meleager story for Ovid's *Metamorphoses,* frequently published in this period. The scene on oliphants nos. 88, 91, 93, 94, 100 and 101 can be compared with an illustration from a book printed in Parma in 1505 by Francesco Marzalis.[98]

For the source of scenes of the bear hunt that appears on oliphant no. 85, we find the example of a bear being torn apart by dogs in the margin of the *Libro della Ventura (The Book of Fortune)* by Lorenzo Spirito printed in Milan in 1500. The bird hunted by crossbowmen carved on oliphant no. 104 finds a corresponding illustration in the incunabulum of Petrus de Crescentis, *In Commodum Ruralium,* printed at Spira about 1490. Archers hunting birds, seen on the horns nos. 100 and 104 appear as the printer's mark of Jean de la Garde of Paris (1514–1526).

A centaur throwing arrows appears in many astronomical books as the sign of Sagittarius in the zodiac. One with his torso turned backwards (nos. 82, 88, 100, 101, 103 and 105) represents the month of November in the *Book of Hours* of Philippe Pigouchet from 1498.[99] In his same book knights are depicted wearing plumed hats such as those carved on the

143. Powder flask cut from an oliphant. Sapi-Portuguese, ca. 1492-1516. On this flask two angels support the arms of the Portuguese House of Aviz. Fashioned at some later date from the end of a hunting horn, this flask (and flask no. 80 made from the same horn; and horn no. 76) can be dated more precisely than any other Afro-Portuguese ivories. They display the Portuguese arms as well as those of Ferdinand and Isabella of Castile and Aragon. Relations between the Spanish house and the house of Aviz under kings John II and his brother Emanuel I were particularly close before the death of Ferdinand in 1516. These horns were probably a gift from Emanuel to Ferdinand, his father-in-law and powerful ally, sometime after 1499 when Emanuel began to rule Sierra Leone by virtue of the *patronatus* which the Pope had bestowed on him. 10.5 cm. Instituto Valencia de Don Juan, Madrid (no. 79).

144. Mark of the printer Antoine Verard, Paris 1485-1512. Woodcut. Two angels bear a shield with the fleur-de-lys of France in a manner similar to the angels on the Sapi-Portuguese oliphants.

145. Bear attacked by dogs. Margin of a page of the *Libro della ventura* by Lorenzo Spirito, Milan, 1500. Woodcut.

146. Oliphant. Sapi-Portuguese, ca. 1490-1530. The bear attacked by dogs in the woodcut illustrated here may have served as a model for the scene of the bear hunt carved in the left section on this hunting horn. Notice the small elephant in the middle section. 43.5 cm. Hermitage, Leningrad (no. 85).

hunting horns in Turin and Leningrad (nos. 81, 85 and 87).[100]

The elephant with a howdah, carved on oliphants nos. 103 and 105, is typically Indian. Although a miniature may have been its model, no miniatures predating 1600 with this subject have been found, even though the subject was represented in Europe at least a century earlier. The Rhenish painter Martin Schongauer engraved a beautiful scene of an elephant with a howdah between 1480 and 1490. Another elephant supporting a castle appears as the mark of the editor Zuan Battista Pederzano in a book from 1524.[101]

Representations of knights confronting each other in duels or tourneys could derive from chivalric literature, but they also appear in the *Mer des Hystoires* printed by Pierre le Rouge for Vincent Commin in 1488.[102] In the margins of this book, still other subjects carved on the oliphants are illustrated: the hunter sounding his horn, the sun and the moon, wyverns and two monsters with entwined necks. Although the latter are stubby and wingless, their poses recall the monstrous birds on the oliphant no. 81. The sun and the moon are depicted in the monumental *Liber Chronicarum* (*The Nuremberg Chronicle*) by Hartman Schedel, with woodcuts by M. Wohlgemuth, printed in Nuremburg in 1493 by Anton Kolerberg in a manner strikingly similar to those on horns nos. 100-102.[103] The wyvern appears, not only in the margins of many incunabula and sixteenth century printed books, but also in the numerous depictions of St. George killing the dragon. Other mythological beings such as harpies and sirens frequently appear in decorative margins of books of the period.[104]

African artists followed their models, particularly of hunting scenes, with absolute faithfulness to the iconographic content, but allowed themselves absolute liberty in the distribution of motifs over the surface of the oliphants. Perhaps for decorative effect, they have positioned men and animals either horizontally or perpendicularly—without heed to the narrative sequence. The manner is such, however, that the whole, scanned along transverse reliefs, forms a balanced composition.

The comparisons we have brought to light leave no doubt that African artists worked from European models supplied by their patrons. This influence, almost total in the case of pyxes and oliphants, is far less apparent in respect to the saltcellars.

Considering that saltcellars, pyxes and oliphants were probably made in the same workshop, and that the models were, therefore, under the eyes of all the artists, greater freedom must have been allowed in the decoration of the saltcellars. Except where commissions appear to have been specific, the choice of subjects or motifs to be carved would thus have been made by the artists, who may have favored traditional, even familial motifs. They may have carved some oliphants to have in stock, once the hunting horns had acquired features suitable for a European clientele: the shapes or forms, the coat of arms, and the hunting scenes. They could have sold their works to occasional clients, or buyers interested more in the quality than in the subject of the work.

147. Mark of the publisher Zuan Battista Pederzano, 1524. Woodcut. An elephant supporting a castle provides the backdrop for the mark of this publisher.

148. Elephant with a Howdah. Rhenish, by Martin Schongauer, 1480–1490. Engraving.

149. Oliphant. Sapi-Portuguese, ca. 1490–1530. The elephant with the howdah that appears near the wide end is typically Indian. No Indian miniatures predating 1600 with this subject have been found, even though the subject was represented in Europe at least a century earlier. Possible European models include Schongauer's Elephant with a Howdah, or the mark of the publisher Zuan Battista Pederzano. 56 cm. Kugel collection, Paris (no. 105).

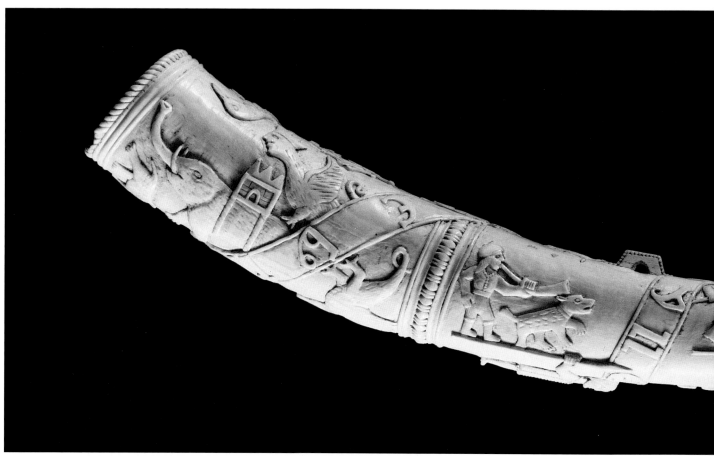

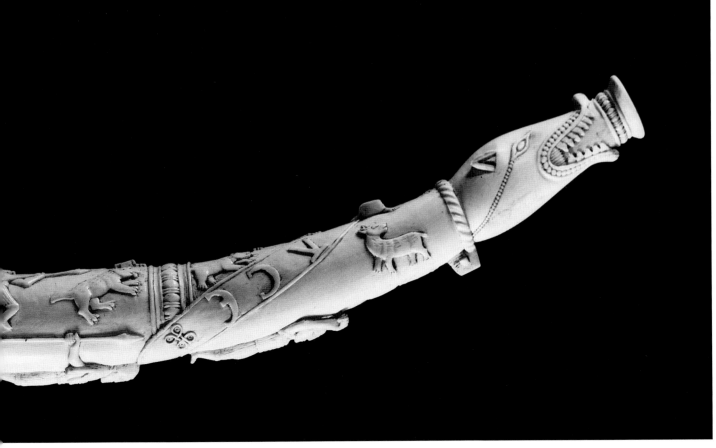

150. The sun and the moon. Detail from a page of the *Liber Chronicarum* by Hartmann Schedel. Nuremberg, 1493. Woodcut. The sun and moon depicted here are strikingly similar to those carved on the horn, although the African artist has altered the image. He gave both heavenly bodies faces, as in the European woodcut, but he separated the sun and the moon, carving them on opposite sides of the horn, and turned the moon's profile into a frontal face. An inkling of how the European imagery may have been communicated to the ivory carver comes from Valentim Fernandes who reported that "the men of the country [Sierra Leone] are black and very talented in making things, that is, ivory salts and spoons; whatever sort of object is drawn for them, they can carve in ivory."

151, 152. Detail of opposite sides of a Sapi-Portuguese oliphant. For full view see pages 92, 93 and 106. Private collection (no. 101).

153. The Arms of Miron. Tapestry, Franco-Flemish, early 16th century. Images of coats of arms or armillary spheres borne by angels are encountered in Franco-Flemish tapestries from the beginning of the 16th century. The Burrell Collection, Glasgow.

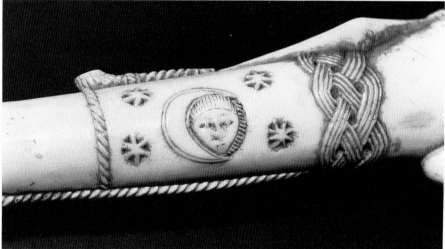

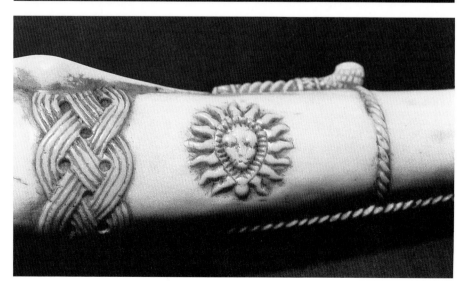

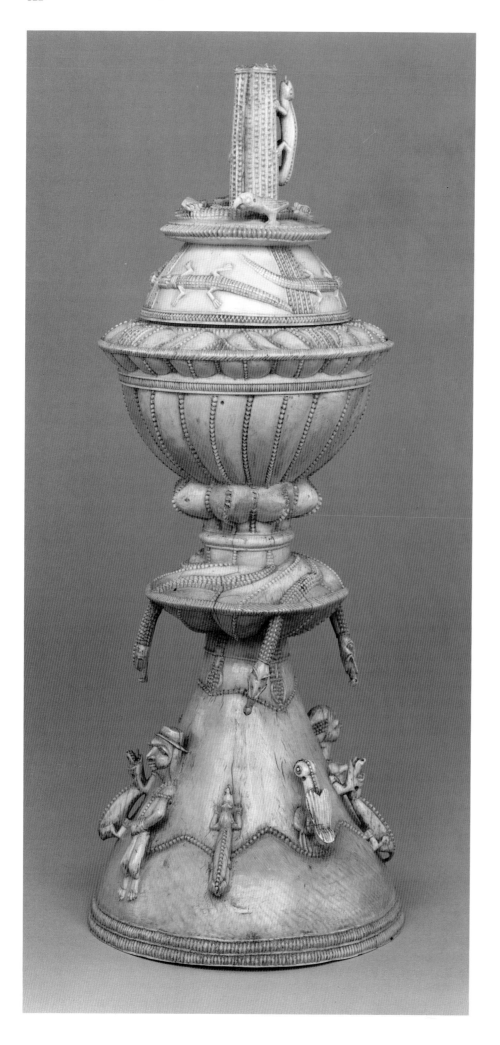

154. Saltcellar. Sapi-Portuguese, ca. 1490-1530. This salt was probably created in a workshop which specialized in the production of saltcellars with conical bases. Of the fourteen artists we can distinguish in this workshop the one who carved this object developed a particularly strong personal style. The form of the lid, the complexity of the finial (now a fragment), and the presence of both humans and a menagerie of dogs, birds, snakes, crocodiles and a chameleon make this work unique. 33 cm. Royal Scottish Museum, Edinburgh (no. 17).

155. Drawing of a Sapi-Portuguese saltcellar. By comparing this drawing, executed before the finial was damaged, to the photograph of the same saltcellar here, we can see that the original composition on the lid shows a man scaling the pillar which had a bird on it. Royal Scottish Museum, Edinburgh (no. 17).

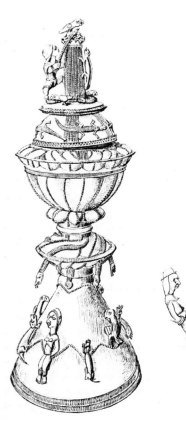

CHAPTER 5
SAPI WORKSHOPS AND ARTISTS

It is very difficult to assign the ivories to workshops or to individual artists; there are no records of where the ancient ivories were collected. Using thematic and formal elements as clues to attributions, however, it is possible to hypothesize three or four workshops. Presumably, the majority of the saltcellars with conical bases (nos. 1-17) were carved in the first of these workshops, an hypothesis based on the following shared characteristics: the distribution of volumes, the partial gadrooning of the base, the shape of the pillow-like element below the container, plant forms in low relief, and the presence of dogs and snakes confronting each other, alternating with human figures.

In this workshop, which we will call workshop A, we may distinguish the work of fourteen artists. The work of three of them can be recognized in sculptures with obvious stylistic consistencies of structure and form, in the placement and pose of both human figures and dogs, in the rendering of plant forms, and in some of the other decorative elements. Examples of marked similarity can be observed in three pairs of saltcellars implying that each pair was the work of a particular artist: nos. 1 and 2, nos. 4 and 5, and nos. 8 and 9.

The carvers of saltcellars nos. 17 and 18, while operating within the workshop's overall scheme, nonetheless adopted quite personal formal solutions. Saltcellar no. 17 has several unique features: the form of the lid, the complexity of the finial, the concomitant presence of humans, dogs and birds, the representation of snakes slithering across the pillow, and crocodiles in low relief. A distinctive personal style is also apparent on saltcellar no. 18. The human figures seated on the base are carved practically in the round, and the gadrooning around the cup is replaced with a decoration of spiral bands in relief.

A second workshop which we may provisionally call workshop B. may have created a third group of salts nos. 19-26 (no. 22 is known only from an old illustration). The saltcellars take the form of spheres on conical bases with predominantly European figurative elements. As far as we can tell from the surviving parts, the surface gadrooning is limited to a reduced portion of the base. Six of the salts could have been made by a single artist, although the survival of such a high number of works from the same hand would be quite exceptional. Nonetheless, this is suggested by the series of similar features that reappear on different objects.

All of these saltcellars have the same structure, and those which are intact have two horizontal elements between the base and the container in the form of a pillow or a reversed cup or disk. The human figures, in very low relief on the bases of nos. 21-24 and on the lid of no. 19, lean full length against their support, and have the same regular lineaments and similar hands and feet. Even their dress with its rows of beads and straight vertical lines set closely together is the same. These similarities are also present in the Madonna and Child, carved in the round, crowning saltcellar no. 19.

The rendering of the snakes on saltcellars nos. 19-21 is similar, even the part of their bodies that hangs off into space is the same size. The dogs

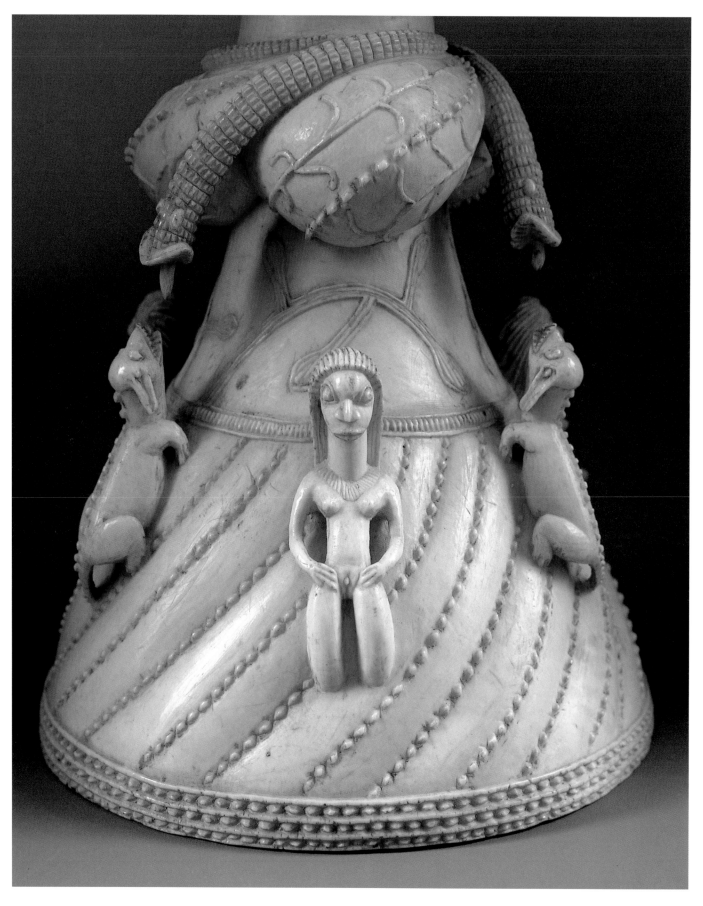

156. Detail of a Sapi-Portuguese saltcellar. (For full view, see page 66.) Snakes dangle from the mid-section of nearly all conical based Sapi-Portuguese saltcellars. In this exceptionally elegant example, snakes confront small dogs whose tails and spines are traced with a beaded line.

These short beaded lines follow the curve of longer beaded lines which swirl across the saltcellar's overall form. This little flourish reveals the playful nature of this artist's character. Museo Civico Medievale, Bologna (no. 8).

157. Base of a saltcellar. Sapi-Portuguese, ca. 1490-1530. The top has been cut off. The artist who created this work is probably also responsible for saltcellar no. 5, illustrated on page 127. 14.4 cm. Danish National Museum, Copenhagen. (no. 4).

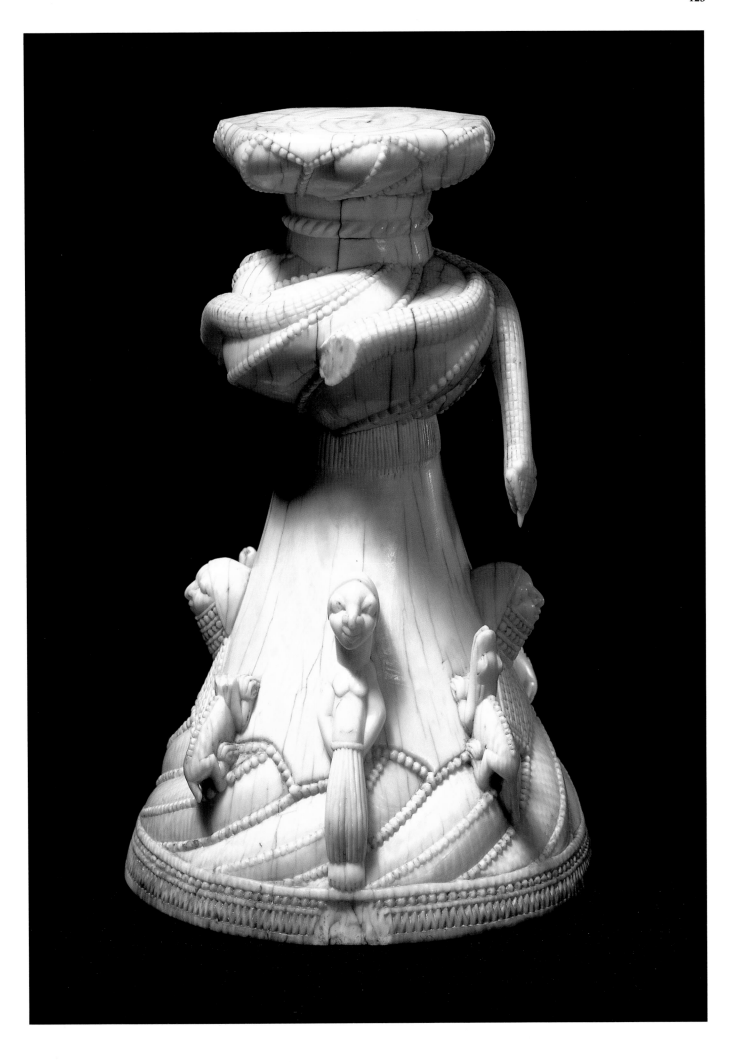

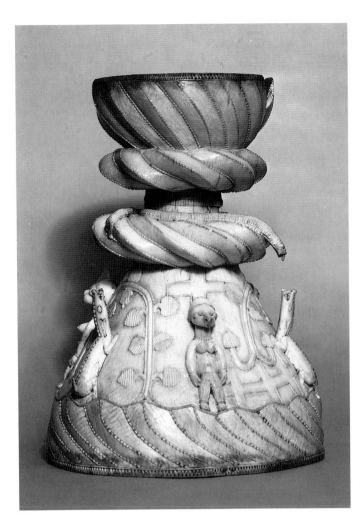

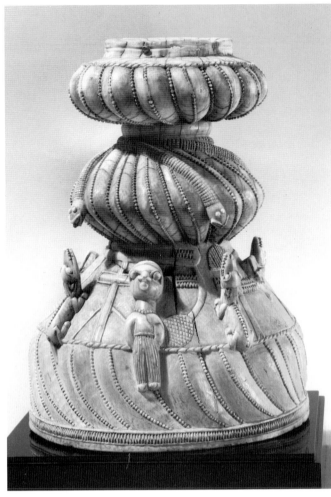

on nos. 21, 22, and 24 are also very much alike. On the pillow-like form of no. 23 one can observe traces of the claws of four birds, which are fully visible on no. 20. Decorative elements in low relief also recur: the floral decoration on the lids of nos. 19 and 20 and on the disk and base of nos. 20 and 23; and the plaited motif on nos. 20 and 21. Saltcellars nos. 19 and 20 also share the flattened volume of the container and the decoration on the upper disk of the lid. The reversed cups of nos. 19, 21, and 22 are also identical in shape and similar in decoration. These six ivories share many details.

Fragments nos. 24 and 25 are similar in the reduced size of the gadrooned zones and in the bands of vertical lines below the pillowlike form. The dogs on no. 25 are replaced on no. 24 by crouching lions, rendered according to European convention; between them a crowned lion, two unicorns, two stags and plant forms are carved in low relief.

Finally, saltcellar no. 26, the only one of its kind among Sapi-Portuguese salts, presents a daring solution. The inspired, ingenious artist disregarded rules to fashion an original and highly personal work. This splendid saltcellar manifests an extraordinarily balanced combination of European and African elements, although the European prevail. The container is ornamented in relief, with the decoration set in horizontal bands, and a transversely placed motto, *Espera in Deo,* which gives this saltcellar the aspect of an armillary sphere. On the base, are shields with the arms of the reigning house of Portugal, supported by three lions (as on the pyxes). The lions crouch under an elegant platform of twisted and plaited cords which recall Manueline architectural motifs. In spite of its originality, similarities exist between various features on this saltcellar and other examples.[105]

158. Saltcellar, missing lid. Sapi-Portuguese, ca. 1490–1530. This work was created by the same artist who made saltcellar no. 1, illustrated on page 74. 19 cm. Museum of Mankind, London (no. 2).

159. Base of a saltcellar. Sapi-Portuguese, ca. 1490–1530. The top has been cut off. Of the two workshops which produced conical based saltcellars, this fragment came from the one which created salts whose bases have human figures alternating with animals. 16 cm. Private collection (no. 7).

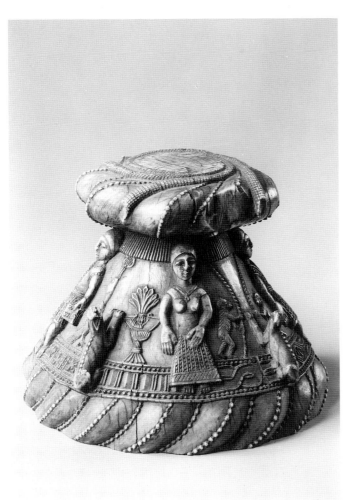

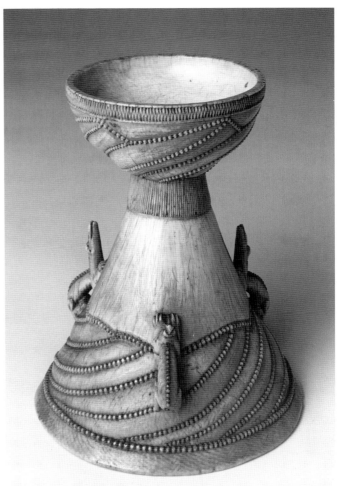

160. Base of a saltcellar. Sapi-Portuguese, ca. 1490-1530. The top has been cut off. At least three, or possibly five other saltcellars may be attributed to this artist. The low relief human figures which appear to lie back on the bases of this and salts nos. 21-23 identify these works as by the same hand. Figurative elements taken from European sources predominate in ivories produced by the workshop where this artist probably worked. (See salt no. 21 on page 128.) 8.7 cm. Museum für Völkerkunde, Berlin (no. 24).

161. Saltcellar, missing lid. Sapi-Portuguese, ca. 1490-1530. The marked similarity between this and the base of saltcellar no. 4, illustrated on the previous page, suggests that both works were created by the same artist. 12.6 cm. Royal Scottish Museum, Edinburgh (no. 5).

In the case of saltcellars nos. 27, 28 and the base of no. 29 we seem to be confronting not a workshop but rather a particular artist who uses positive and negative spaces with originality and great mastery. In the two most complete examples, the rather flattened container is held up by semicircular elements, which form a spherical openwork cage. Several parrots alternate on the supports of saltcellar no. 27, while two snakes and two crocodiles appear in low relief. Other motifs in common are vertical beading and crocodiles, seen on nos. 27-29. The two pairs of stylized fleur-de-lis on nos. 28 and 29 seem to imply a particular patron and destination, perhaps a member of the reigning house of France.

The base of no. 30 may also be from the hand of this original artist. Its heavier appearance is due to its higher plinth, thicker decoration, and the weight of the four human figures in high relief, leaning against the side. These rather stocky figures in bulky European dress have regular features which recall the heads on no. 4. The two pairs of crocodiles on the horizontal level of the plinth, however, are like those on saltcellar no. 29.

The unmistakable way of representing the crocodiles on nos. 27 and 30, with thick, blunt tails, and bands around the neck, is the same as that on saltcellar no. 17. On the latter, the hemispherical part of the lid features a decoration of closely set, beaded rows and two pairs of crocodiles facing each other; an identical composition recurs on saltcellar no. 28. A logical conjecture is that saltcellar no. 17 was also carved by this very gifted artist. He probably also carved the elegant spoon no. 63, which has a crocodile with typical morphological characteristics. Perhaps fork no. 70 is also by this artist. The presence of parrots, similar to those on saltcellars nos. 17, 27 and 28, reinforces this hypothesis.

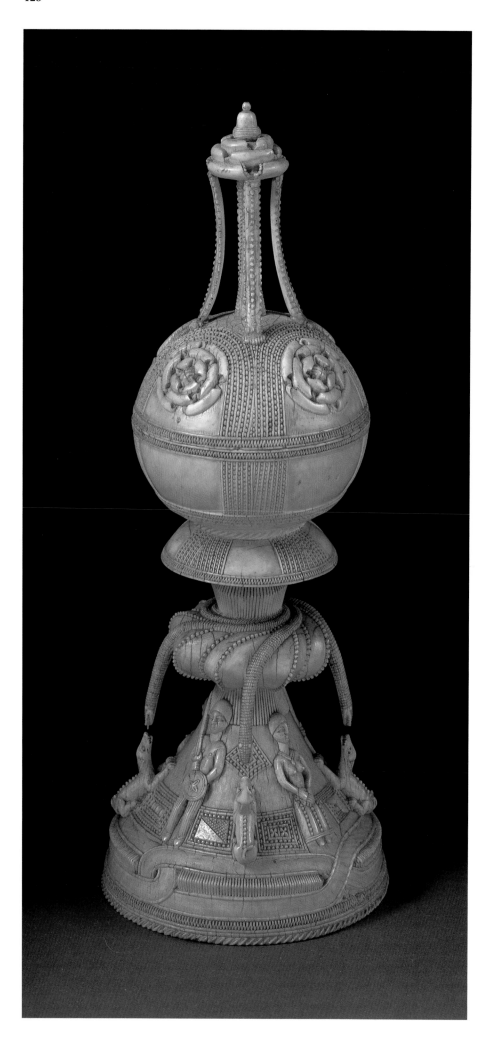

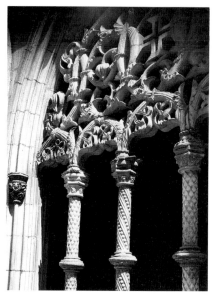

162. Saltcellar. Sapi-Portuguese, ca. 1490-1530. This saltcellar was probably carved by the same artist who created the lost salt no. 22, known only from an eighteenth century illustration (see catalogue raisonne). Their basic structure is remarkably similar: the two horizontal elements between the conical base and the spherical container are almost identical in form. 29.8 cm. The Paul and Ruth Tishman Collection of African Art, Walt Disney Co., Los Angeles (no. 21).

163. Royal cloister of Batalha, Portugal, early 16th century. The lacey openwork of interlocking forms surrounding the Cross of Beja in this tympanum is typical of Manueline architecture. The beaded and spiral colonettes also reflect royal taste in early sixteenth century Portugal, an artistic sensibility which, to a certain degree, influenced the decoration of the Sapi-Portuguese ivories.

164. Saltcellar. Sapi-Portuguese, ca. 1490-1530. This uniquely conceived salt reveals the influence of a European Renaissance aesthetic. Its plaited and twisted forms recall Renaissance architectural conventions, especially those of Manueline Portugal. The presence of crouching lions surmounted by what resemble elaborately ornamented colonettes reflect a European influence. At first glance one might not realize that these spiraling forms are actually intertwined snakes performing an architectonic function. The motto *"Espera in Deo"* encircles the spherical container above making it resemble an armillary sphere. Shields with the arms of the House of Aviz are held between the lions' paws. 21 cm. Museum für Völkerkunde, Berlin (no. 26).

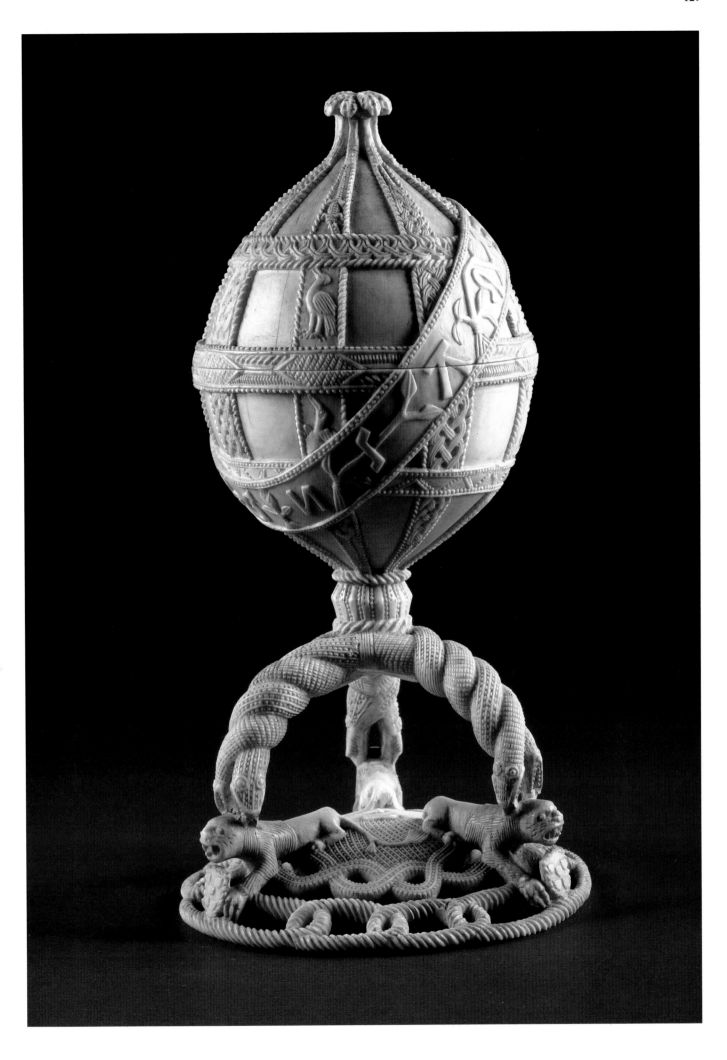

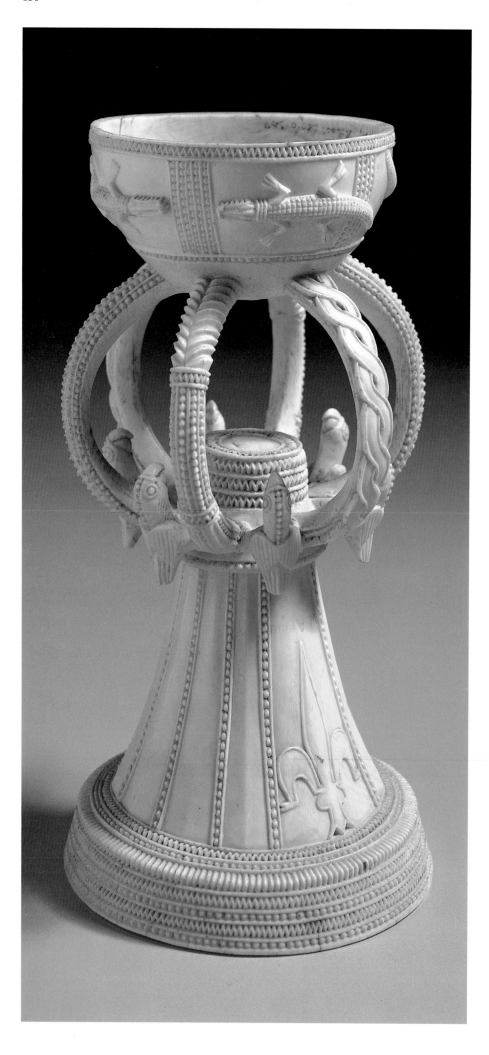

165. Saltcellar. Sapi-Portuguese, ca. 1490-1530. The artist who created this and salt no. 27 masterfully combined positive and negative spaces to create these highly original works. 20.2 cm. Pitt Rivers Museum, University of Oxford (no. 28).

166. Detail of a saltcellar. The marked similarity between this and salt no. 28 overshadows differences between the two. Notice how the snakes and crocodiles which cling to the curved supports of this salt are replaced with ornamentation of a more purely European style in the salt on the opposite page. Galleria Estense, Modena (no. 27).

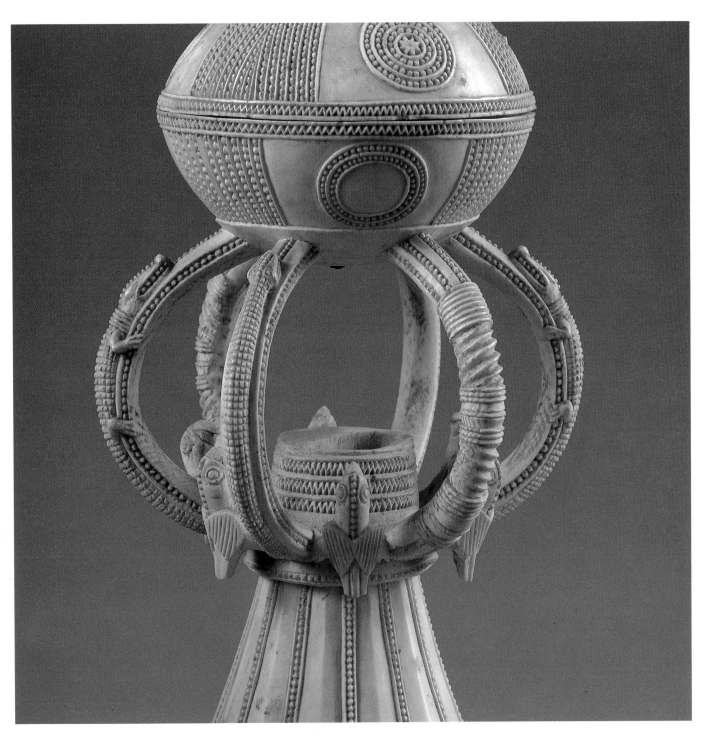

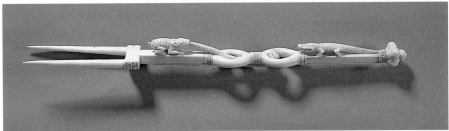

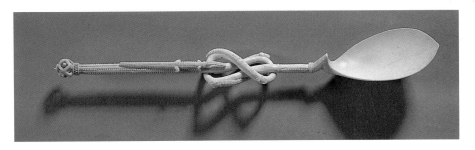

167 and 168. Fork and spoon. Sapi-Portuguese, ca. 1490–1530. The unmistakably similar way of representing the blunt-tailed crocodiles which slither across surfaces on these and the two salts suggest that they all have a common author. The same artist may also have created saltcellar no. 17, illustrated on page 122. 24.5 and 24 cm. Museum of Mankind, London (no. 63 and 70).

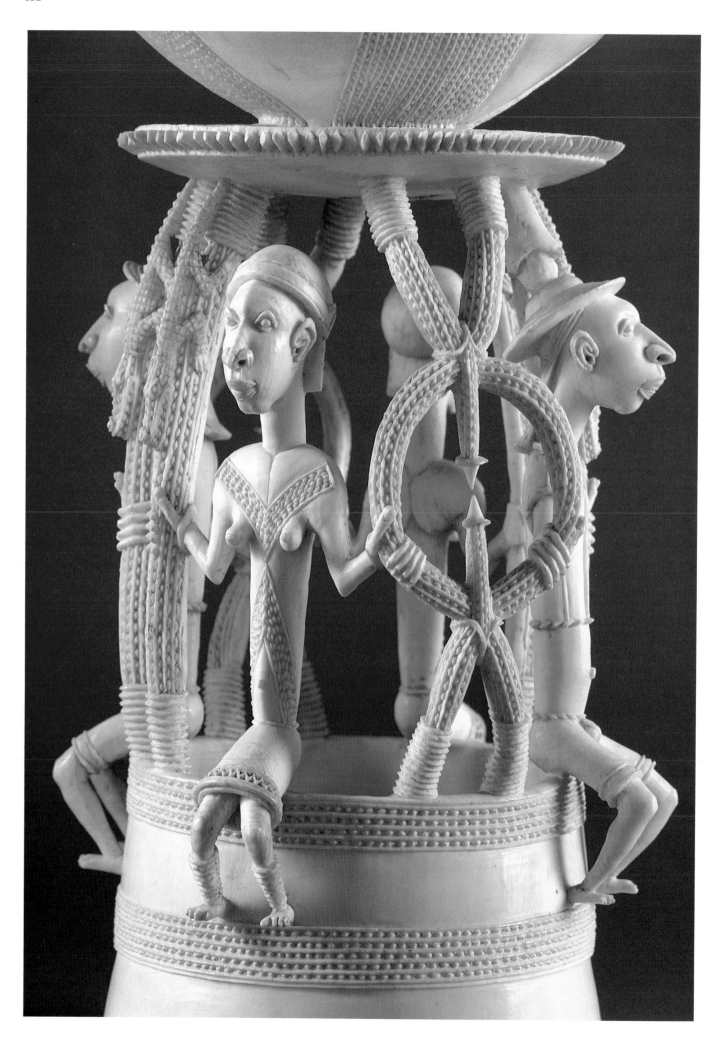

169. Detail of the base of a Sapi-Portuguese saltcellar. This saltcellar was probably created in what we call workshop C, which specialized in the production of saltcellars with cylindrical bases embellished with an openwork of human figures, crocodiles and architectural elements. Out of a corpus of twenty-two objects which share this common structure, only two pairs seem attributable to the same artist. This saltcellar is from the hand of the same master who created salt no. 32, illustrated on page 55. (For full view, see page 110.) Museo Preistorico e Etnografico, Rome (no. 31).

170. Saltcellar. Sapi-Portuguese, ca. 1490-1530. Dense ornamentation circles the long neck of this Janus head. Although several saltcellars have a finial in the form of a Janus head, the varying form of their containers and the differing proportions of the figures which encircle their bases seem to indicate that no two are by the same hand. Compare the concentric circles filled with zigzag and beaded lines which decorate the egg-shaped container of this salt to those on salt no. 27, illustrated on page 68. 30.4 cm. Seattle Art Museum (no. 40).

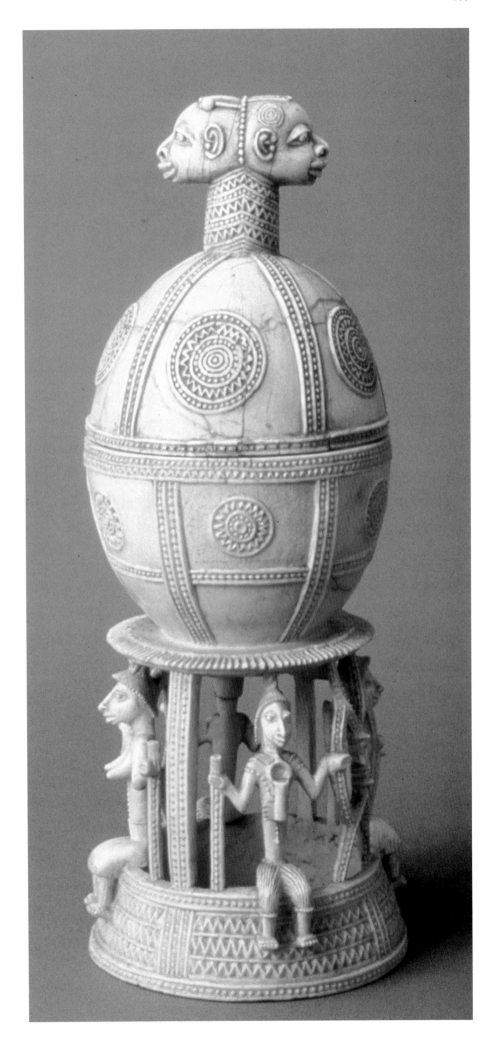

134

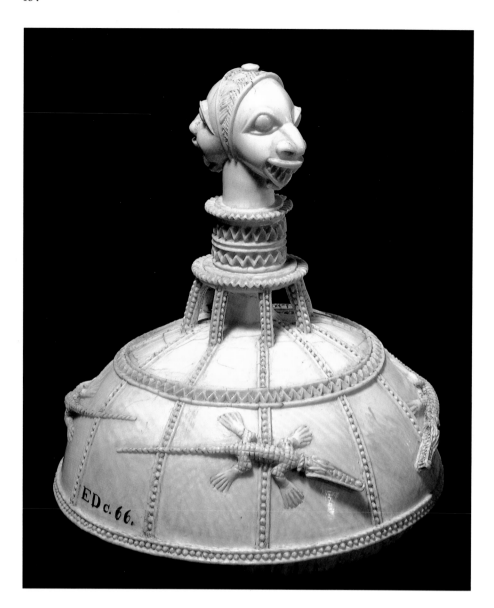

171. Saltcellar lid. Sapi-Portuguese, ca. 1490-1530. Crocodiles in low relief appear on the receptacles of several salts, see, for example, no. 17 (page 122), no. 28 (page 130) and no. 48 (page 82). The crocodiles on the lid of saltcellar no. 32 (page 55) devour human figures, while the crocodiles here simply bare their teeth. 15 cm. Danish National Museum (no. 44).

From the third workshop, which we will call C, come twenty-two saltcellars or fragments of saltcellars (nos. 31-50). With one exception these works share a common structure: a more or less cylindrical base, carved in openwork with human figures, crocodiles and architectural elements in the round, supporting a platform on which the container rests. Only two pairs of these ivories seem attributable to the same artist. All the others display differences in shape, and marked dissimilarities in the distribution of the volumes, the proportions of the figures and their anatomical details, the rendering of facial features, and the treatment of the animals. They clearly lack sufficient affinities to postulate a common author, except for saltcellars nos. 31 and 32; 33 and 34.

Curiously, the structures of nos. 31 and 32 are totally different though there would seem to be no doubt that these two saltcellars are by the same hand. The cup of saltcellar no. 31 rests on a central support, while the other intact pieces of this group rest on a disk held up by geometric elements or by human figures. The human figures, nevertheless, all conform to the same rigorous canon: elongated and cylindrical torsos, arms and legs; well-defined facial features; distinctively formed ears; the x-shaped scarification marks on the women's torsos; and the dress of both men and women. The low-lying crocodiles on the lid of no. 32 and on the supports of saltcellar no. 31 are much alike.

We can consider this carver one of the greatest of the Sapi artists,

172. Fragment, base of a saltcellar. Sapi-Portuguese, ca. 1490-1530. Curiously, the wrists of all four of the alternating male and female figures are bound to the vertical supports. Their torsos are bare except for neck and breast ornaments of large (glass?) beads. The male figures wear trousers with deep folds and the female figures wear skirts with three rings around the hips and multiple anklets. 9.2 cm. Museum für Völkerkunde, Munich (no. 37).

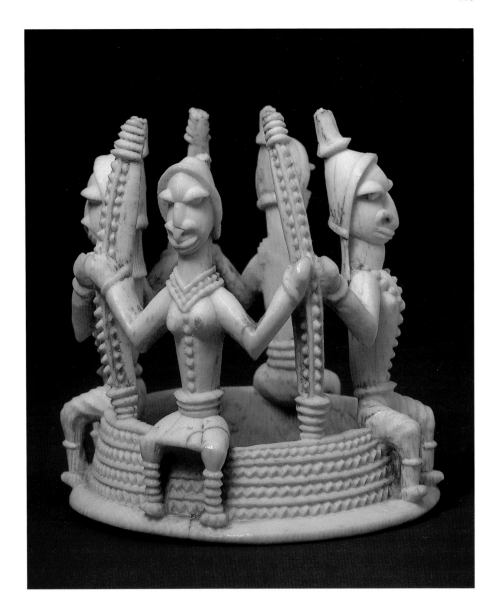

both for innovative, highly imaginative style and for the refinement of his workmanship. We shall dub him "Master of the Symbolic Execution," because of the uniqueness of the subject depicted on the lid of saltcellar no. 31.

The other pair of salts probably by a single original artist are nos. 33 and 34. The structure and shape of both are the same, particularly in the egg-shaped container covered entirely by vertical lines of very closely set beads, a form, one would assume, also originally present on no. 34. This artist has adopted an original solution for the base placing upright, standing human figures between the supports instead of seated ones as on all the other saltcellars. The slim, short-legged bodies have similar proportions. We cannot compare the facial features, however, since on no. 34 these are almost completely worn away. Its smoothly worn, darkened surface indicates that this particular saltcellar was kept and used in Africa for a long time and underwent the usual treatment for ivories—it was repeatedly handled, rubbed, and coated with red palm oil.

The other saltcellars, or their remaining bases and lids (nos. 35-51), although surely belonging to the same basic family, seem to be by various artists who shared a common tradition, but each work is marked with a particular artist's personal style.[106] Consider the heads on no. 37 with bulging eyebrows, like a menacing visor, that give the figures a ferocious expression in contrast with the serenity of the figures on saltcellar no. 38, with their calm volumes and rounded outlines.

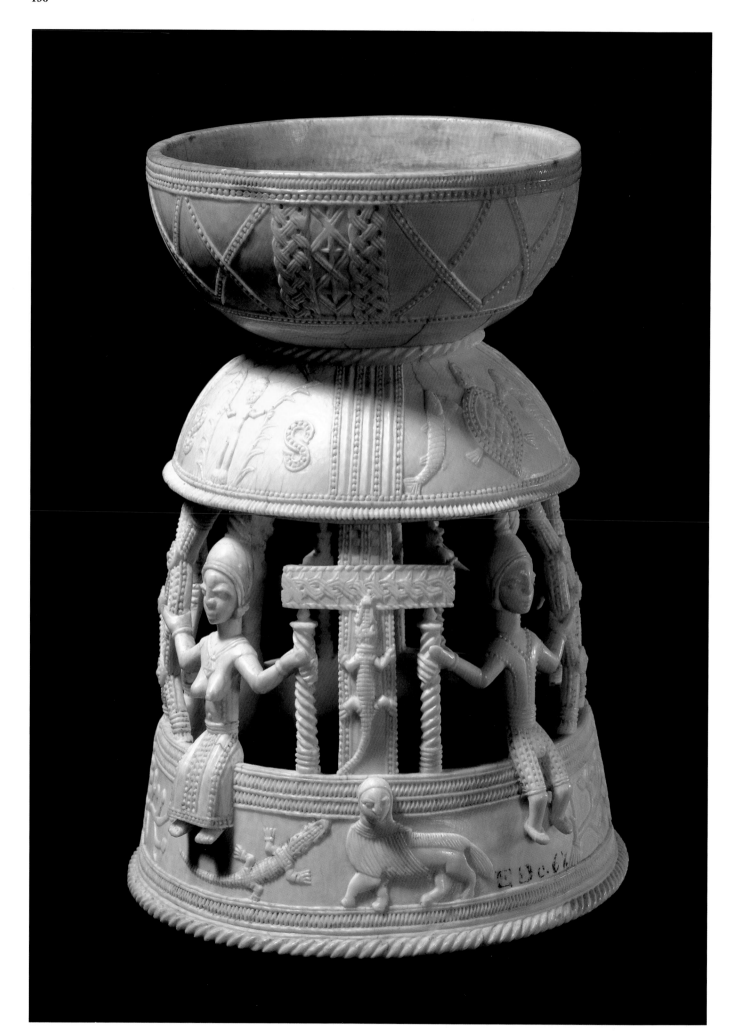

173. Saltcellar, lid missing. Sapi-Portuguese, ca. 1490-1530. Formal and thematic similarities between this saltcellar and nos. 19-26 suggest that all were carved either by the same artist or within the same workshop. European motifs predominate in these works. Non-African motifs on this salt include a walking sphinx and a mermaid (see catalogue raisonne for a view of the opposite side of this salt). 16 cm. Danish National Museum Copenhagen (no. 51).

174. Saltcellar. Sapi-Portuguese, ca. 1490-1530. The broad brimmed hat seen here—its only appearance on a Janus head—occurs on many of the Sapi salts. Its most detailed rendition is on the executioner (no. 31, page 81); its source is unclear. 28 cm. Museum of Mankind, London (no. 42).

175. Saltcellar, lid missing. Sapi-Portuguese, ca. 1490-1530. The rather awkward form of this work betrays the hand of a less sophisticated artist. Nevertheless, it is interesting for the way it reveals its basic shape. The clearly visible upper and lower sections resemble what may have been the African prototype for cylindrical based saltcellars—a round-bottomed container resting upon an openwork stand made of ceramic, gourd or wood. 16.8 cm. Stadtisches Museum, Braunschweig (no. 38).

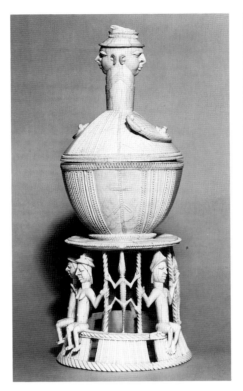
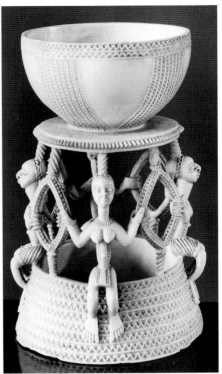

A Janus head appears as a finial on the lids of saltcellars nos. 40-44. Each head is carefully rendered and none are alike. The varying forms of the containers—the beautiful oval (no. 40), the sphere (nos. 41 and 43) and a hemisphere with a conical lid (no. 42), and the differing proportions and features of the figures on the bases, also seem to indicate different hands.

The carver of the Janus head resting on an animal's back, a motif seen on the cover of saltcellar no. 47, reminds us that expressive and compositional needs, rather than any depiction of reality, probably occasioned the unnatural elongation of volumes and other unique features. The author of saltcellar no. 49 has created unusual proportions between the height of the container and the diameter of the base, and has also carved on the base elements usually depicted upon the lids. Saltcellar no. 50 which we know only from a photograph is the only known piece where the openwork base is predominantly geometric, the only figural elements being the crocodiles carved in relief on the vertical supports. They harmonize completely with the elegant, rhythmical play of straight and curvilinear elements in the composition.

The base of saltcellar no. 51 is not only an example of exquisite workmanship, but it is also the only cylindrical, openwork base that features a series of European iconographic motifs similar to those carved in low relief on salts nos. 19-26.

The receptacles of saltcellars nos. 18, 20 and 21 are held up by a hemispherical form decorated by vertical beaded lines. Such a form, enriched by other motifs and enlarged to the size of the receptacle itself, also characterizes salt no. 51. In four other saltcellars, furthermore, the joint between support and receptacle is decorated with a ropelike motif.

Finally, the figures in the round on no. 51 bear a striking resemblance to those in high relief on the bases of the salts nos. 20-24. They share the same regular features and the same delicate modeling, which is further enhanced by their being carved in the round. The presence of both formal and thematic similarities leads us to believe that this saltcellar, with a cylindrical base, is also by the same artist who made the pieces with conical bases that bear European motifs, nos. 19-26.

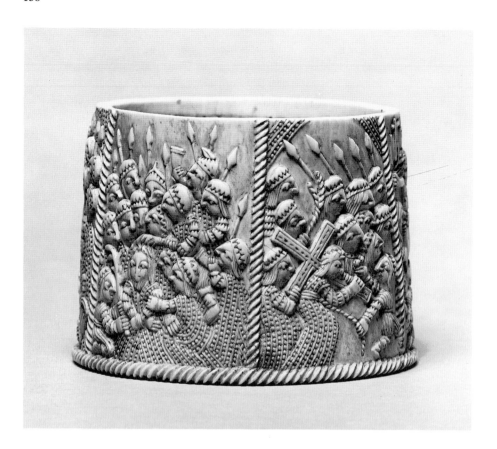

176. Pyx, missing lid. Sapi-Portuguese, ca. 1490-1530. The artist who carved this pyx followed the models provided to him by his patrons very faithfully. Two other pyxes (nos. 57 and 58), by the same hand, are extant today. 5.8 cm. Walters Art Gallery (no. 59).

Of significant interest is fragment no. 52, which, although limited to its spherical container, almost certainly belongs to the group of saltcellars with openwork bases, as indicated by its geometric decoration. In the remains of the figures once crowning the cover, we see spatulalike feet with comblike toes (all of the same length), identical to those of the figures carved on saltcellar no. 15. The latter piece is of the conical-base type, although somewhat atypical in having two containers instead of one.

Beyond these analogies, note the presence of similar decorative motifs on salts belonging to different types. Concentric circles carved in low relief are present on the containers of salts nos. 27, 40 and 52, while crocodiles in low relief appear on the receptacles of salts nos. 17, 29, 30, 36, 43, 44 and 48.

Three pyxes (nos. 57-59) can be assigned to a single carver who seems to have faithfully followed the imagery furnished him by his patrons. His work is characterized by an almost obsessive use of rows of beads, to represent clothes as well as architectural motifs. He tends to fashion crowded scenes, perhaps in order to concentrate the greatest possible number of episodes in the limited space at his disposal. On the pyx that bears scenes from The Passion this crowding betrays a true *horror vacui*.

It is impossible to attribute the spoons and forks to individual artists because of the very small size of their sculptural decoration.[107] The same difficulties arise with the attribution of pieces nos. 73 and 74, probably hilts, which are unique objects to the best of our knowledge. Nonetheless, it is probable that the sculptors of the hilts, spoons and forks, as well as of some of the individual saltcellars, also created salts and oliphants though we have not been able to identify any common motifs that would justify specific attributions for these works.

It is unthinkable, however, that African artists of such considerable skills would have made but a single work, or that, even considering their fragility, only one of a group of fairly numerous objects, exported to

177. Detail of a Sapi-Portuguese oliphant showing the Arms of Castile and Aragon. This artist may be referred to as the "Master of the Arms of Castile and Aragon" since the insignia and motto of King Ferdinand V of Castile and Aragon join the insignia of Emanuel I (the arms of the House of Aviz, the Cross of Beja and the Armillary Sphere) on these works. The same artist carved oliphants nos. 76, 77 and 78 and powder flasks nos. 79 and 80. (For full view see page 100.) National Museum, Canberra (no. 75).

178. Detail of a Sapi-Portuguese oliphant. Elements which characterize the work of the "Master of the Arms of Castile and Aragon" include: transverse elements that divide the low relief hunt scenes into narrative bands; human figures carved in the high relief that punctuate the convex side of the horn, and a consistent way of depicting coats of arms, stag hunts and plant forms. (For full view, see page 107.) The Paul and Ruth Tishman Collection of African Art, Walt Disney Co., Los Angeles. (no. 76).

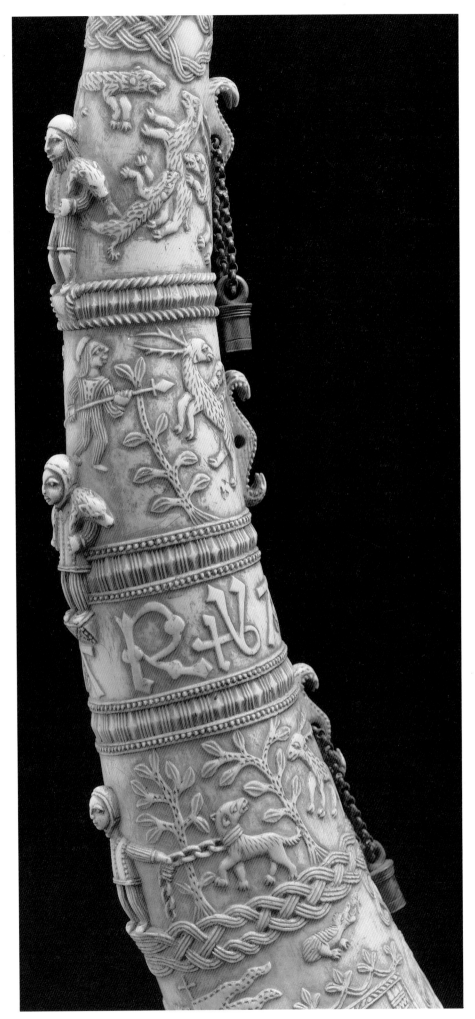

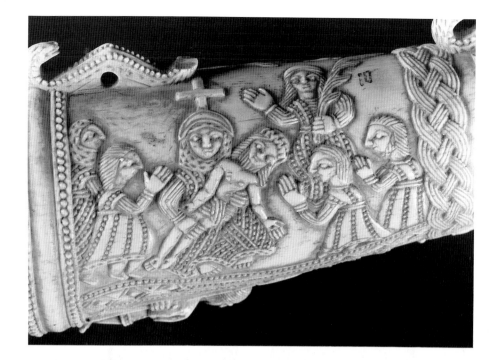

179 and 180. Oliphant. Sapi-Portuguese, ca. 1490-1530. Detail and full view. This hunting horn may also be by the "Master of the Arms of Castile and Aragon" even though only the arms of the House of Aviz and the motto *"Aleo"* appear here. The similarity between The Deposition scene on this horn and the scenes represented on the pyxes suggests a common authorship or at least a close association between the artists who created these works. 61 cm. Museo Nacional de Artes Decorativas, Madrid (no. 78).

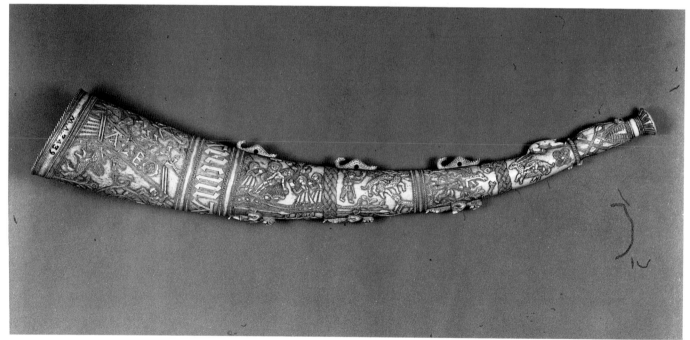

Europe, should have survived up to the present time. We know that these objects were removed from everyday use soon after they appeared in Europe and were transferred to private collections and museums, where they were carefully preserved.

The oliphants decorated with hunting scenes pose a different problem. Even though the number of surviving examples is large, the richness of their decoration indicates that these horns were created in a single workshop. Their fidelity to the European models such as coats of arms, heraldic motifs and hunting scenes makes the attribution of hands most uncertain.

A group composed of three horns (nos. 75-77) and two powder flasks (nos. 79 and 80) carved from the fragments of a fourth horn may possibly be by one author. These ivories are marked by the insignia of Emanuel I (the arms of the House of Aviz, the Cross of Beja and the Armillary Sphere) as well as by the arms and the motto—*"Tanto Monta"*—of King Ferdinand of Castile and Aragon.

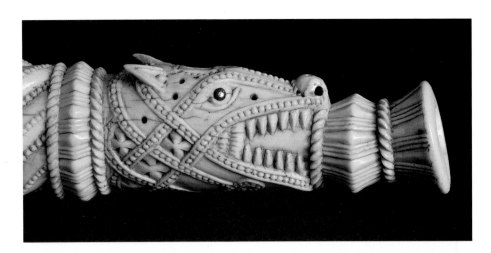

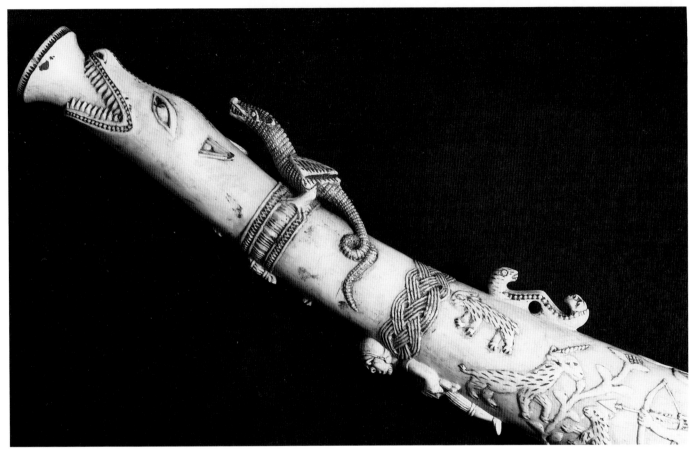

181. Detail of a Sapi-Portuguese oliphant. A motif which can be considered a virtual artist's "signature" is the small quatrefoil carved in the interstices of the ribbonlike decoration on the animal head at the mouthpiece. Since this motif also appears on oliphants nos. 87 and 88, these works can also be attributed to the same hand. (For full view see catalogue raisonne.) Private collection (no. 89).

182. Detail of a Sapi-Portuguese oliphant. The polished nudity of the ferocious looking animal forming the mouthpiece of this horn makes it possible to identify this and four others as the work of a single artist. Oliphants nos. 100-104 all have similar mouthpieces (see no. 101 on page 93). (For full view of this horn see catalogue raisonne.) 57.2cm. Merseyside County Museum, Liverpool (no. 100).

These ivories (nos. 75-77, 79 and 80) show the same transverse elements in relief which divide the surface into narrative registers. They have similarly depicted coats of arms, stag hunts and plant forms. The rendering of the hunters and animals is sure and elegant, while the composition is harmonious. The heads of the animals from which the mouthpieces emerge are similar, often lavishly adorned with a kind of bridle with ivory rings dangling from a rope collar carved in low relief around their necks. On the convex side three closely similar men, in high relief, stand upright on a small platform, carrying animals on their shoulders or leading dogs on chains.[108] In the case of powderhorn no. 79 the similarities are limited to the coats of arms, the inscriptions, and to one of the figures in high relief typical of the style. Powderhorn no. 80 displays the same hunting scenes, the braidlike motif marking the subdivisions and the two figures in high relief typical of the style of this sculptor, whom we shall designate "Master of the Arms of Castile and Aragon," since this is the characteristic element of the series.

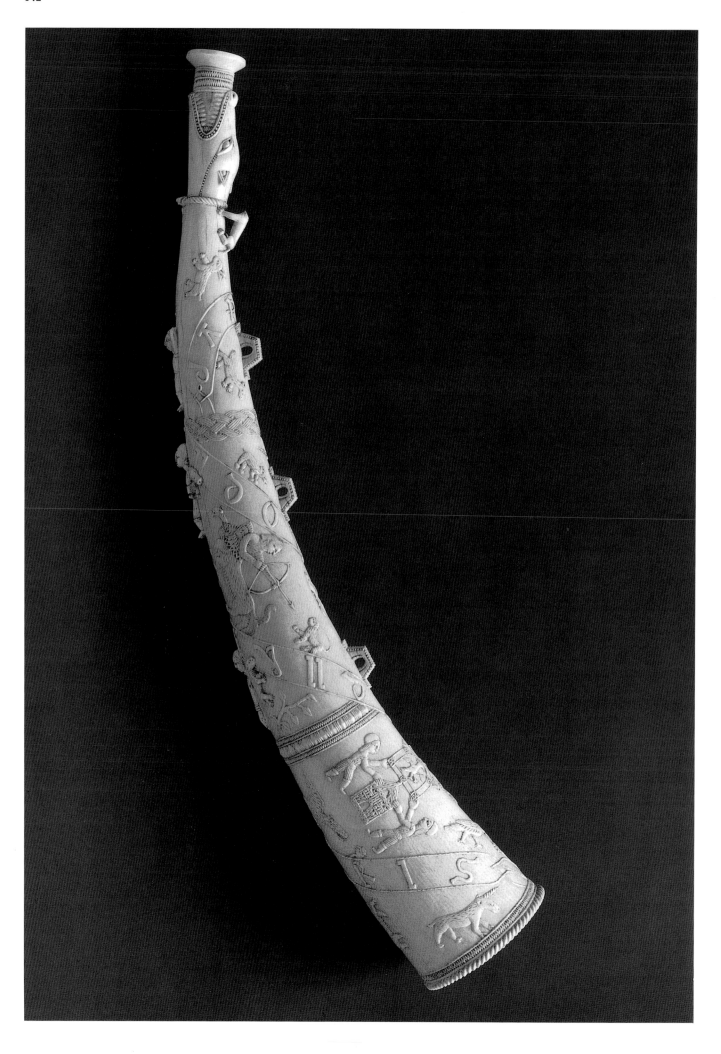

183. Oliphant. Sapi-Portuguese, ca. 1490-1530. By a single artist are the horns identifiable by common iconographic elements, and by the polished nudity of the ferocious animal which forms their mouthpieces (as described in the previous caption). These shared elements in low relief include: a coat of arms which rests on a castlelike structure held up by two figures, the sun and moon (see nos. 101 and 102) and centaur archers. Compare the centaur archer which appears here to the one pictured on page 106. The decoration of oliphant no. 105, illustrated on page 118, its spiral bands and its inscriptions exactly duplicate the decoration of this horn. 60 cm. Historisches Museum, Dresden (no. 103).

Oliphant no. 78 is probably another work by the "Master of the Arms of Castile and Aragon," even though it does not present the whole group of coats of arms of Portugal and Spain, having only the arms of the House of Aviz and the inscription "*Aleo.*" Nevertheless the human figures and the animals in the hunting scenes are in the characteristic style. The relief element that divides the space, the lugs and the inscription "*Ave Maria*" are the same; a small quadruped in high relief appears near the mouthpiece, as in the previous examples. The scene of the Deposition on this oliphant, however, is close to the scenes on the pyxes, suggesting, if not an identity, at least a close association between the author of the pyxes and of these oliphants.

The oliphants nos. 81-91, although similar to those of the "Master of the Arms of Castile and Aragon" in terms of the low relief decoration, present other features which allow them to be treated as a separate group, characterized by gadrooned and spiral decoration on the portion of the horn immediately above the head. Between the divisions of the various narrative registers appear two common elements: the first is composed of two twisted bands, one smooth and the other decorated with rows of beads; the second is a plaited and rusticated form. There are only two carved figures on the convex side of the horn (those on nos. 82, 83, and 88 have been lost). On the concave side are crocodiles and snakes in high relief and in the round (nos. 81, 83, 86 and 87), crouching animals (nos. 87, 89 and 91) and a wyvern (no. 81).

The decoration in low relief is richer and more fantastic than on the oliphants previously considered. One sees a stag hunt, a boar hunt and a bear hunt; hunters on foot, and horsemen with gay plumed hats and knights fighting duels. Wild animals appear on some of the pieces—an elephant, a rhinoceros, a lioness, besides the usual crowned lions and a goat. In addition there are domestic animals like the mounted elephant held by a chain (no. 82), and even fantastical animals such as the centaur, the unicorn and birds with dragon heads on twisted necks.

Three of these oliphants (nos. 87-89) can be attributed to a single artist since, beyond the characteristics mentioned above, they possess a common decorative motif which all the other oliphants lack: a small quatrefoil is carved in the interstices of the ribbonlike decoration on the animal head which forms the mouthpiece. This motif can be considered a virtual "signature" of the artist.[109]

A marker for a different hand is an elegant vine branch that decorates the register nearest the bottom of oliphants nos. 86, 88 and 89. A simplified version of the same motif appears on four other examples, nos. 91-93, 95 and 96. These latter horns also share the characteristic elements that divide up the space, but the decoration of the hunting scenes in low relief is not as rich, the figures are somewhat clumsy, and the animals are less elegantly rendered, even crudely depicted in some cases. The arms of the House of Aviz on horns nos. 92, 93, and 95 are similarly and rather summarily rendered. The lugs are in the simple form of triangles with small serpents' heads.

The carver of four small oliphants nos. 96-99 (which have relatively thick walls) takes up the themes and motifs which characterize the group of horns that we have just examined. Although these have been executed in a less accomplished manner, they are not without their own effects.

Five oliphants, nos. 100-104, are also the work of a single artist, although they seem quite distinct from each other at first sight. Note the heads of the animals, quite ferocious in their polished nudity, the figures carved in high relief on the convex side and, lastly, the decoration in low relief. With regard to nos. 100 and 101, the rendering of the animals, the plant forms and the humans is, without a doubt, by the same hand.

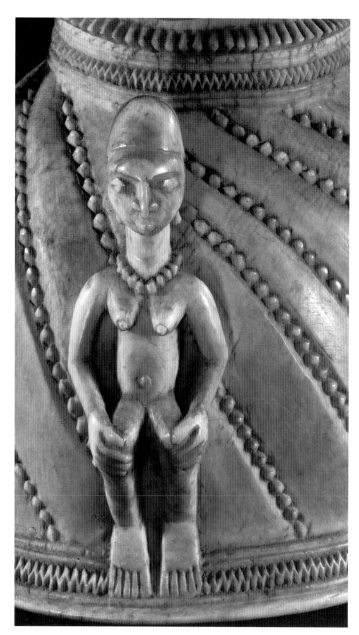

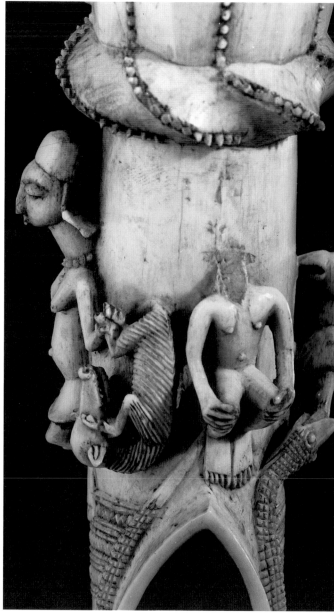

Common iconographic elements also appear on this group of ivories: the way in which the coats of arms rest on a castlelike form held up by two figures (nos. 102 and 103); the way of representing the sun (nos. 101 and 102); and the bearded centaurs with long manes and tails that flare into two tufts (nos. 100–103). Horn no. 104, attributed to this artist, lacks the animal heads from which the mouthpiece emerges, as well as the coats of arms. Its bands carved in low relief imitate the metal rings which often circle European horns. If one compares the bird-hunting scene on this piece to the scene carved on no. 100, the likeness is apparent. Furthermore, the small boar carved in the round near the mouthpiece recalls the dog (now missing its head) on example no. 103.

A sixth oliphant, no. 105, exactly repeats the decoration of horn no. 103. It includes the bands and inscription, but the rather rigid execution of the decoration identifies it as the work of a related but different artist.

Beyond the similarities already mentioned, the lions carved in low relief on many of the oliphants resemble the two lions on saltcellar no. 19, which illustrates Daniel in the lions' den. The rendering of the mane and the double tufted tails is handled in the same way on all of these pieces.

184. Detail of a Sapi-Portuguese saltcellar. The way in which the figures clasp their bent knees on this salt and on oliphant no. 201, to the right, suggests that both works are by the same artist. Further evidence for this assumption lies in the fact that their feet are also similarly represented flat. (For full view, see catalogue raisonne.) Museum für Völkerkunde, Vienna (no. 15).

185. Detail of a Sapi-Portuguese oliphant. The artist who carved this oliphant appears to have had African as well as Portuguese clients, since this horn was probably part of the regalia of a local ruler, while salts nos. 15, 16 and 52 also by his hand, were no doubt made for European export. (For full view see page 91.) Musée de l'Homme (no. 201).

186. Saltcellar, missing lid. Sapi-Portuguese, ca. 1490-1530. The man holds a shield, the woman touches its tip while an animal with a long curled tail mounts the stem of the vessel. The poses of the figures on this salt show movement, a feature rarely seen in the Sapi-Portuguese ivories. 12.9 cm. Bowes Museum, Durham (no. 16).

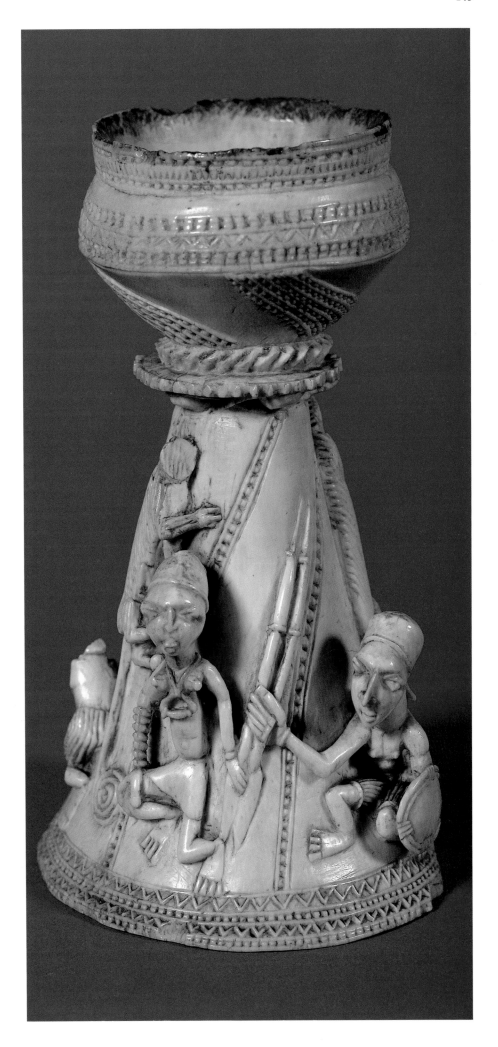

The same hand produced not only salts nos. 15, 16 and 52—and spoon no. 61, but also the oliphant no. 201, which was probably created for African use. The female figures carved on the saltcellars nos. 15 and 16 resemble those on horn no. 201: the volume of the head and neck, the shape of the headgear, the facial features, the tubular arms and legs, the necklace of beads, the figures' hands clasping their bent knees (nos. 15, 201) the large feet resting flat against the base, and the comblike fingers and toes. The gadrooned elements are also identical, as are the rows of beads, as well as the disk-shaped platform which separates the upper sections of all three works. We can also compare the smooth-bodied animals carved on spoon no. 61 and on horn no. 201. On the spoon this animal faces a snake, while on the horn the snake bites the small animal.

CHAPTER 6
CONCLUSIONS ON THE SAPI-PORTUGUESE IVORIES

This conjunction of similar motifs and figurative elements on unlike object types must be significant. If we also take into consideration thematic and morphological resemblances between the ivories and the ancient indigenous stone sculpture of Sierra Leone, the datable European iconographical sources, the coats of arms and mottoes, the overall picture becomes more legible and allows us to draw some tentative conclusions.

The presence of common motifs and similar formal solutions on objects of different types establishes the fact that in one instance a particular African artist made both saltcellars and spoons for export, while producing horns for indigenous use. Thus after 1490, any single workshop may have continued to serve African patrons, as it had prior to the arrival of the Europeans, while simultaneously producing works for the new patrons. The demand created by the latter undoubtedly led to an enlargement of the workshops and an increase in the number of ivory carvers.

Shared motifs and formal solutions also suggest an environment fertile for exchange and experimentation. European models and individual artists may have passed from workshop to workshop. Perhaps there was not a single working place, but rather an entire community where ivories were produced and where the models were stored (since drawings and prints are extremely fragile and perishable). In this community there could have been a group of artists who specialized in the carving of various kinds of objects meant for local consumption as well as for export. The artists would have had access to a small pool of models and could have been inspired by each others' work.

The European iconographic elements can all be dated to the last quarter of the fifteenth century and the first quarter of the sixteenth, allowing us to conclude that the Sapi-Portuguese ivories were made during a period of forty years, from c. 1490 to 1530. The brevity of the period would explain the small number of artists and of European patrons involved. The number of artists is certainly less than the forty previously suggested; it is most likely that further research will assign single works from different categories to the same artist. The limited period of time would also explain the relative homogeneity of the style and iconography of the Sapi-Portuguese ivories.

187. Spoon. Sapi-Portuguese, ca. 1490-1530. The artist who carved salts nos. 15, 16 and 52, and oliphant no. 201, probably also carved this spoon. The smooth-bodied animal confronting the snake on the stem of this spoon has been attacked from the rear on oliphant no. 201. 22 cm. Danish National Museum, Copenhagen (no. 61).

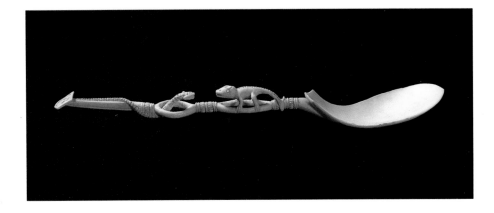

CHAPTER 7
THE BINI-PORTUGUESE IVORIES: ENTER MOVEMENT

The exciting discovery of an entirely new phenomenon, the Bini-Portuguese ivories, seems to have made little or no splash in the artistic firmament. It seems nobody noticed when the venue from which the Afro-Portuguese ivories issued changed from the mountains of Sierra Leone to the low-lying swamps of Great Benin—a distance of some fourteen hundred miles. And we cannot even tell whether there was a hiatus in time or a period of overlap. During the change the ivories developed a severe case of *horror vacui*.

The most fundamental change of all lay in the fact that, whereas the Sapi-Portuguese production yielded only one or two doubtful cases of a human figure in motion (leaving out of account the hunting scenes copied

188. Plaque, king and attendants. Benin, Nigeria, 16th-17th century. The king, wearing his coral bead crown and regalia, is shown flanked by warriors with four small attendants: on the lower left one holds a box in the form of an antelope head; in the upper right an attendant is sounding a side-blown oliphant. Plaques such as this adorned columns of the palace at Benin, and were described by European visitors. They fell out of style so that when the British captured Benin at the end of the 19th century, they found some nine hundred plaques in storage in the palace. Bini art style is typically hieratic and static, presenting members of the court motionless in frieze-like tableaux. The incised decoration is dense and lush, leaving almost no untextured areas. Bronze, 47 cm. Private collection.

189. Saltcellar, midsection and lid. Bini-Portuguese, ca. 1525-1600. The asymmetrical poses and fluid gestures produced by Bini artists for their Portuguese clients departed radically from their own tradition. This was a double chambered saltcellar, perhaps for salt and pepper. It lacks its bottom section which formed the lower vessel and would have depicted the legs of the walking horses. 12 cm. Museum für Völkerkunde, Berlin (no. 126).

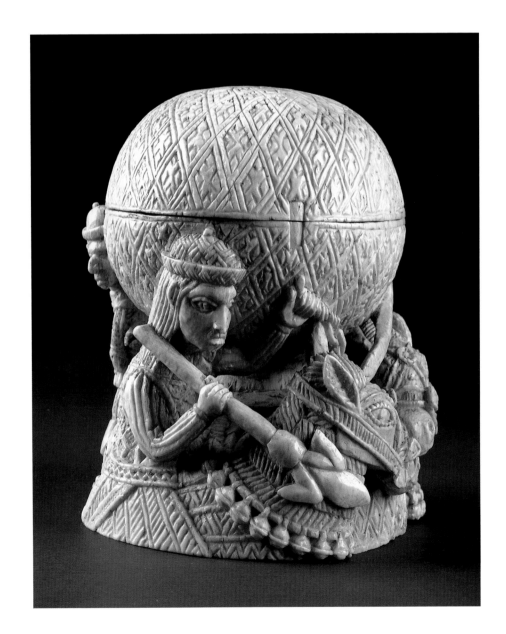

from engravings and the like), on the Bini-Portuguese pieces fifteen salt-cellars show no less than fifty-two figures in clearly defined movement against a mere twelve static figures. The detailed implications will be considered in the following pages.

Around 1950, one of us (W.B.F.) first separated the Afro-Portuguese ivories from other ivories in the Ethnographical Gallery of the British Museum. They were, however, still regarded as a single line of study until 1961–1962, when three objects from the Nigerian area were grouped independently from the Sierra Leone corpus (at the time known as Sherbro-Portuguese ivories but now more correctly called the Sapi-Portuguese, to include the Temne and possibly the Kissi). Finding analogies in style and subject matter with certain traditional works from Benin, he gave the second corpus of ivories the name "Bini-Portuguese."

To date, the corpus of Bini-Portuguese ivories existing in Western collections consists of three oliphants, fifteen double-chambered saltcellars, forty-eight spoons and two fragments. The absence of forks, daggers or knife handles, and religious implements, such as pyxes, suggests that these types either were not carved in the Nigerian area, or did not survive.

As stated in Chapter 2, the first unequivocal written reference to Nigerian ivories was made in 1588 by the English navigator, James Welsh, who accurately described Bini-Portuguese spoons in his journal, "In Benin they make . . . spoons of Elephant teeth very curiously wrought with diverse proportions of fowles and beasts made upon them."[110] But the first documented registration of a Bini-Portuguese ivory in Europe was in Florence in 1560, when five spoons were accessioned in the property of the Grand Duke of Tuscany, Cosimo I de Medici. This group was divided at the end of the nineteenth century, and three of the spoons (nos. 129-131) are now in the Ethnographic Museum in Florence, while two (nos. 132 and 133) are in the Pigorini Museum in Rome. A larger group of a dozen spoons was acquired in 1590 in Leipzig by the Grand Duke of Saxony (nos. 134-148).[111] A third set of six spoons (nos. 149-154) was registered in an inventory made in 1596, after the death of their owner, the Grand Duke of Tyrol, Ferdinand of Habsburg, in the Castle of Ambras; they are now in the Museum für Völkerkunde in Vienna. There are no references at all to Bini-Portuguese oliphants, and the first documentation of a saltcellar in Europe was in 1674 when one, no. 128, now in the Copenhagen Museum, was registered in the Kunstkammer of the king of Denmark.

All three sets of spoons suffered errors in attribution. It is interesting that two of the sets—in Dresden and in Ambras—were described as Turkish: "twelve spoons in ivory made in Turkey were bought by the Grand Duke, Christian of Saxony in Leipzig"[112] and "six long spoons worked very thin with different motifs in the Turkish manner."[113] The spoons in the Florentine inventory were described as of mother-of-pearl, rather than of ivory. However, one of them is described as being broken (indeed it is), and the form of another is accurately described in a subsequent inventory of the Medici family (1640), which leaves no doubt that the objects in question were the Bini-Portuguese ivories.[114] If the Florentine registration in 1560 is correctly interpreted, the Bini spoons are the first identifiable Afro-Portuguese ivories still in existence mentioned in European documents. We are inclined to think that the carving of ivories for export began later in the Nigerian area than in Sierra Leone, and that there was a whole new atelier producing Afro-Portuguese works of art in or near Benin. This might have started in the second quarter of the sixteenth century, after production ceased or diminished in Sierra Leone.

190. Sceptre or flywhisk handle. Benin, Nigeria, 18th century. Though the horse's trappings are similar to those on the Afro-Portuguese ivories, the motionless pose and the stiffly erect rider are markedly different. Ivory, 41.5 cm. Pitt Rivers Museum, University of Oxford.

191. Aegis pendant. Benin, Nigeria, 18th century. For many years after their departure, the Portuguese continued to figure in Benin art. It is interesting that the depiction of movement in Benin art is largely restricted to the figures of foreigners. Here a mounted Portuguese, recognizable by his long straight hair and knee pants, rides a small horse. The textured background pattern is the one conventionally used in Benin art to portray leopard skin, a symbol of power and royalty. Bronze, 23 cm. Private collection.

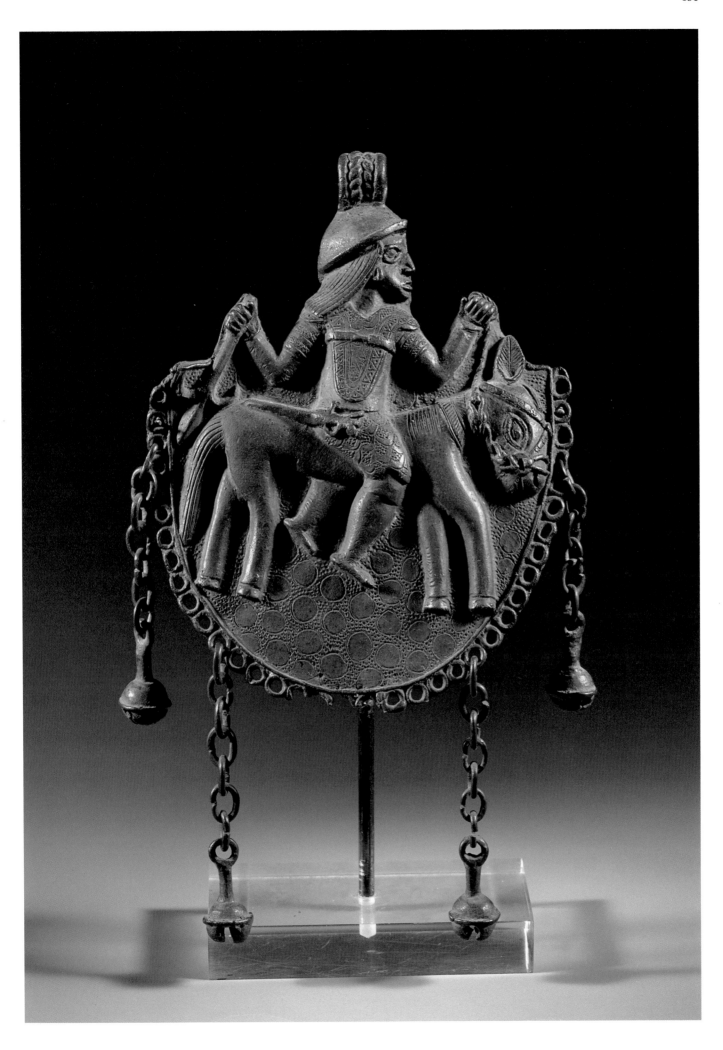

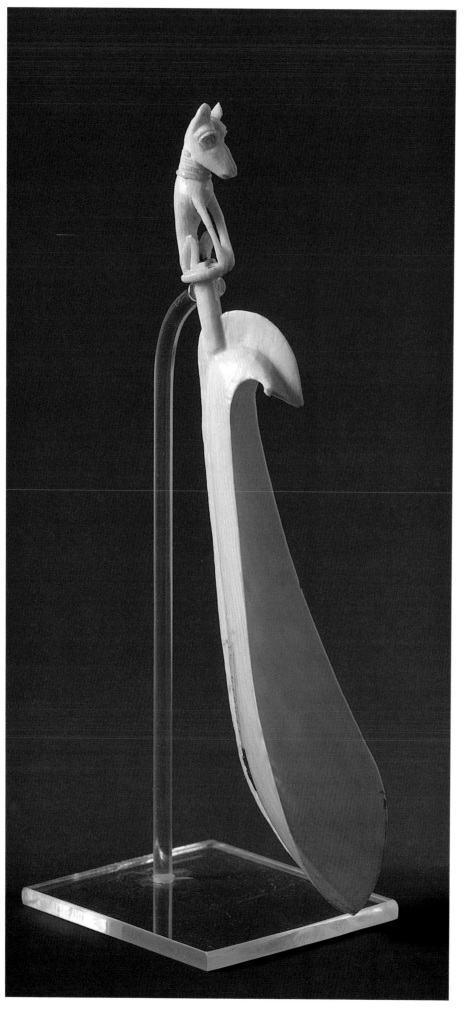

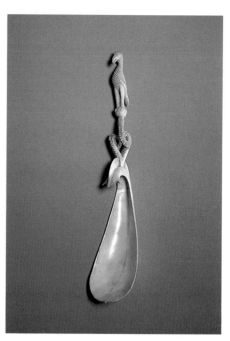

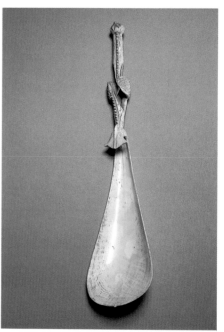

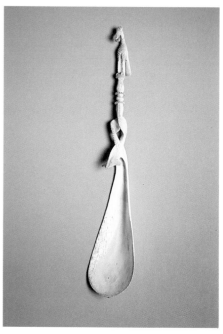

192. Spoon. Bini-Portuguese, ca. 1525-1600. In 1560, Cosimo I de Medici, Grand Duke of Tuscany, acquired five Bini-Portuguese spoons including this one. They were at the time described as made of mother–of–pearl. The broad, elongated bowl, more like a scoop than a spoon, and the prominent hook where the handle meets the bowl, are features that distinguish the Bini from the Sapi spoons. 24.8 cm. Museo Preistorico e Etnografico, Rome (no. 133).

193. Spoon. Bini-Portuguese, ca. 1525-1600. The English navigator, James Welsh, described Bini-Portuguese spoons in his journal in 1588: "In Benin they make . . . spoons of Elephant teeth very curiously wrought with diverse proportions of fowles and beasts made upon them." 26 cm. Ulmer Museum, Ulm (no. 159).

194. Spoon. Bini-Portuguese, ca. 1525-1600. When they were first brought to Europe and for a long time thereafter, the Afro-Portuguese spoons were believed to be Turkish rather than African. 22.4 cm. Ulmer Museum, Ulm (no. 160).

195. Spoon. Bini-Portuguese, ca. 1525-1600. To date, the corpus of Bini-Portuguese spoons numbers forty-eight complete spoons and two fragments; there are no forks known from Benin. 17.9 cm. Ulmer Museum, Ulm (no. 158).

196. Saltcellar. Bini-Portuguese, ca. 1525-1600. This is the most elaborate of all the Bini salts, and the one with the greatest sense of movement. One scholar has suggested that it was carved in Europe after an African model. If the artist was European then, we feel, he must have been working in Africa, and was most probably the commissioner and instigator of all the ivories. When this salt was registered in the Kunstkammer of the king of Denmark in 1674, it became the first documented in Europe. 27.5 cm. Danish National Museum, Copenhagen (no. 128).

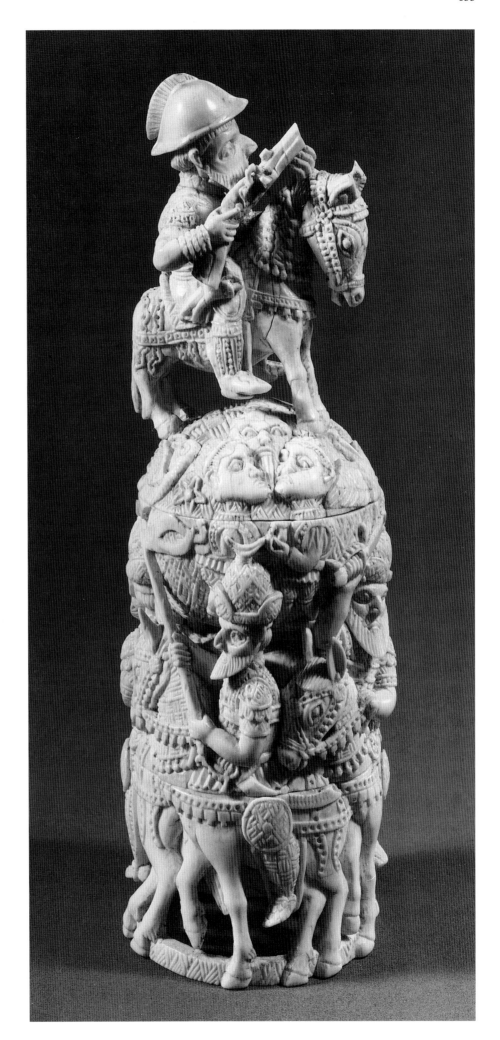

197. Belt mask. Benin, Nigeria, 16th century. Ivory carvers working for the king, or *oba*, of Benin made a series of similar masks shortly after the arrival of the Portuguese. They were probably worn at the hip as pendants by the king during commemorative rites for his deceased mother. This refined, naturalistic style is typical of the early period of Benin art. Ivory, coral, 19.5 cm. Lindenmuseum, Stuttgart.

THE GUILD OF IVORY CARVERS

While the Bini-Portuguese ivories are less well documented than those of Sierra Leone, the traditional artistic context of Benin is much more fully understood. Traditional Bini works in ivory, and other materials as well, can of course be found in museums throughout the world. Furthermore, oral tradition reveals valuable information about the commissioning and creation of works in ivory. It is known, for example, that ivory carvers were organized in a guild called the *igbesamwan* and that they lived and worked together on a special street. While their first obligation was to the *oba,* the king of Benin, they sometimes carved works for other patrons with his consent. Ivory for these commissions was supplied by elephant hunters who were required to give one tusk of every elephant to the *oba,* and the *oba* also had the right to buy the second one. An examination of the corpus of Benin ivories suggests that artists from other ethnic groups worked in ivory occasionally at Benin, as they did in other materials such as bronze.

198. Pendant. Yoruba, Owo, Nigeria, before 1800. The Yoruba kingdom of Owo, 80 miles north of Benin, used regalia similar to Benin's. There was much mutual artistic influence, and it seems possible that Owo artists even worked at the court of Benin. Owo art, in which the ram is a frequent subject, is often bolder and less cluttered than Benin art. Ivory, 15 cm. Private collection.

199. Bracelet. Benin, Nigeria, 16th century. Worn by the *oba,* this bracelet and its mate depict the king wearing full regalia, flanked by two Portuguese standing in rather awkward postures. The use of a multitude of textured patterns and the density of the decoration are typical of Benin art, whether made for the Portuguese or for Bini clients. The number of ivory carvings made by Bini artists for the use of their own king and court greatly exceeds the number of Bini-Portuguese works. Ivory, 13 cm. Carlo Monzino collection.

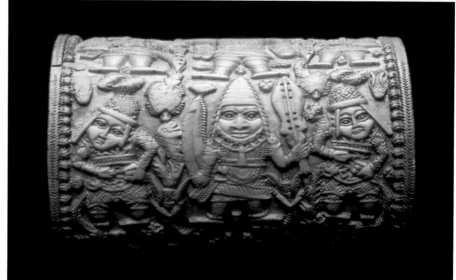

THE BINI-PORTUGUESE OLIPHANTS

Of all Bini-Portuguese ivories, the oliphants (nos. 111-113) constitute the smallest group. Of the three examples known, two are complete, nos. 111, 113, while the third, no. 112, is but a fragment, albeit a substantial one, in the British Museum. Like the Sapi oliphants, these conform to the natural curve of the tusk, and their surfaces are carved with both geometric patterns and figurative scenes in low relief that fill every space. All three oliphants have a flat rectangular mouthpiece placed on the convex side of the tusk, which, among the Bini, was and still is the invariable practice. The two surviving finials take the form of an animal head with bared teeth, resembling both European and Sapi-Portuguese oliphants, though the lack of a mouthpiece emerging from the animal's mouth reduces the Bini-Portuguese finials to purely decorative, rather than functional, elements.

Because of the explicit way in which Portuguese and Bini motifs are combined, these oliphants deserve—more than any other group of works—to be called "Bini-Portuguese." Among the traditional motifs the most obvious are the basket weave, lozenge, and guilloche patterns interspersed across the surface.[115] But the most important Bini motif for the definitive attribution of the ivories is the step pattern, a border design consisting of a single line of steps, that frames an armillary sphere on two of the three oliphants (nos. 111 and 112); since this pattern appears nowhere in Africa but Benin, it is a characteristic pointer to Benin workmanship. These motifs, combined with the traditional placement of the mouthpiece on the convex side of the tusk and the *horror vacui* typical of Bini art, confirm our belief that these horns were carved by artists trained in the *igbesamwan* guild at Benin.

Combined with these Bini motifs are others of purely European origin. Among them are the Portuguese coat of arms, the armillary sphere, hunting scenes and the depiction of a European man blowing a long straight horn (no. 112). While oliphant no. 113 has no coat of arms, it does have two hunting scenes and winged dragons or wyverns, typically European in content and form. With regard to possible sources for these motifs, the commissioner might have supplied the carver with books, drawings, engravings, prayer books or coins for the coat of arms and armillary sphere, as were supplied to the Sapi-Portuguese carvers.[116] It is also possible that the hunting scenes were copied from playing cards, because the two hunters, one in profile and armed with a spear, the other depicted frontally with a dagger, are highly reminiscent of the figures found on playing cards.

The prominence of traditional Bini motifs on the oliphants contrasts with the Sapi oliphants that are more strictly European. This might lead one to speculate that the oliphants were not made for export, but for the use of Bini royalty, who might have commissioned the artist to include European motifs for their prestige or exoticism. A more likely explanation, however, is that the strict academic training of the *igbesamwan* guild required artists to abide by certain artistic canons, even when working for foreign patrons. The rectangular mouthpiece and its placement on the outer curve of the horn, for example, were formal rules for Bini carving. In other words, the artist may have been obliged to refuse to put the mouthpiece on the end at the commissioner's request. We postulate that these Bini-Portuguese oliphants were made for export but under constraint of the *oba's* authority, or that of the *igbesamwan.*

Striking similarities in the form and the decoration—both traditional and European—and its distribution in superimposed registers, suggest that the three existing Bini-Portuguese oliphants are the work of a single artist.

200 and 201. Oliphant, full view and detail. Bini-Portuguese, ca. 1525-1600. The armillary sphere and the coat of arms are strictly European motifs as is the striding figure blowing a horn, but the geometric patterns are typically Bini, in particular the step pattern that fills a band just above the armillary sphere. The shallow carving here—practically incised drawing—contrasts with the full relief sculpture on the Sapi oliphants. Oliphants made by the Sapi and the Bini for their own use show a corresponding difference. 39.4 cm. Museum of Mankind, London (no. 112).

202. Detail of Bini-Portuguese oliphant. This horn has the animal head finial seen in the Sapi-Portuguese examples, but treated in a Bini style. The horn is side-blown in the African manner rather than end-blown in the European fashion, though it would appear to have been made for the Portuguese. (See full view, next page.) Rautenstrauch-Joest Museum, Cologne (no. 111).

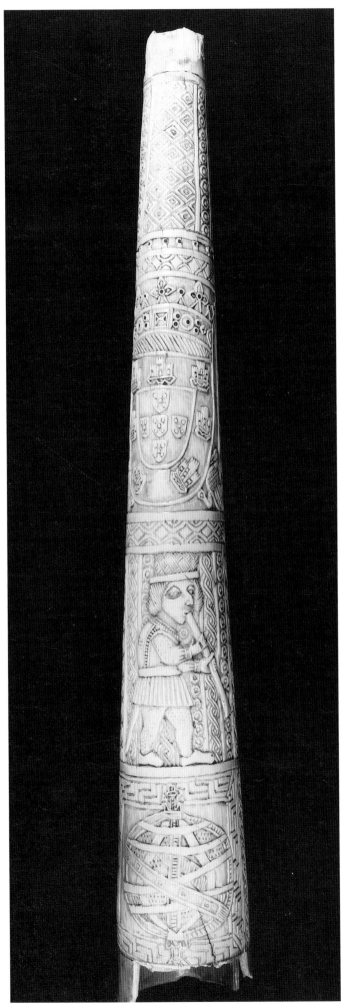

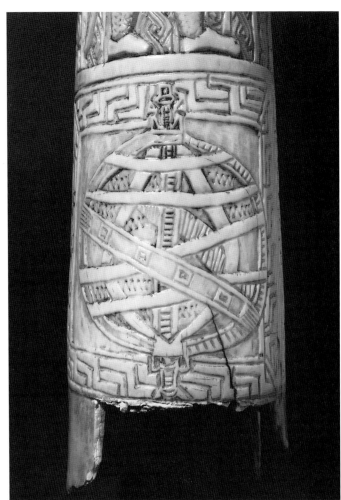

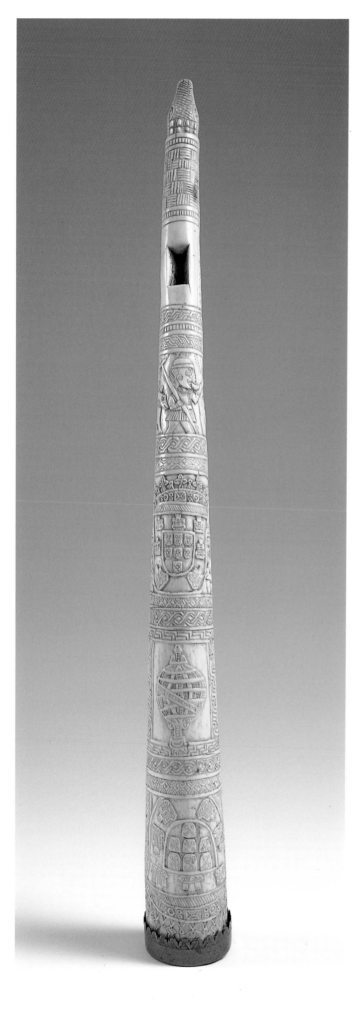

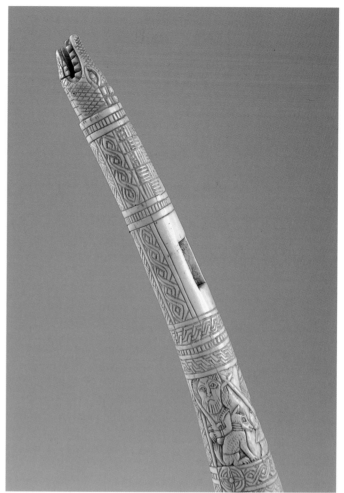

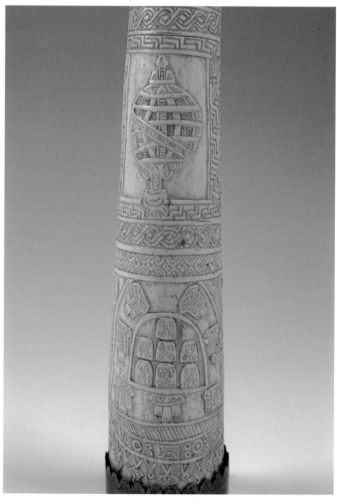

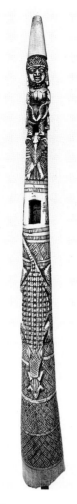

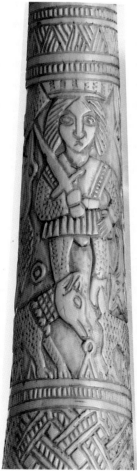

203, 204 and 205. Oliphant, full view and details. Bini-Portuguese ca. 1525-1600. Only three Bini-Portuguese oliphants are known, all similar in style and very likely all by the same artist. All three also have the mouthpiece on the outer side of the tusk. This feature helps place them in Benin since it is characteristic of Bini oliphants. African horns from Sierra Leone and the rest of the west coast of Africa typically have the mouthpiece on the inner side of the tusk. 57 cm. Rau - tenstrauch-Joest Museum, Cologne (no. 111).

206. Oliphant. Benin, Nigeria, 16th century. Surely made for an African pa- tron, this oliphant is so close in style to the Bini-Portuguese ones that it may well be of the same period. At the apex is pic- tured the *oba* riding on an elephant. This is a metaphoric and symbolic image as are the frontal bird with outstretched

wings, and the crocodile devouring a frog. Ivory, 54.5 cm. Museum für Völkerkunde, Vienna.

207. Miniature from the *Livro Carmesin,* Portuguese, 16th century. The coat of arms of the king of Portugal is shown here supported by angels. At the top are the arms of the House of Aviz, below is the armillary sphere, symbolic of Eman- uel I's interest in exploration. Ms. 37, Arquivo Historico da Câmara Municipal, Lisbon.

208. Detail of Bini-Portuguese oliphant. Though the hunter and his dog are pic- tured, the Bini artist has produced a much more static composition than the Sapi artists' versions of this theme. True to his extensive training, he has also en- tirely filled the space of his composition with decorative incident, and the single large figure of the hunter. Collection unknown (no. 113).

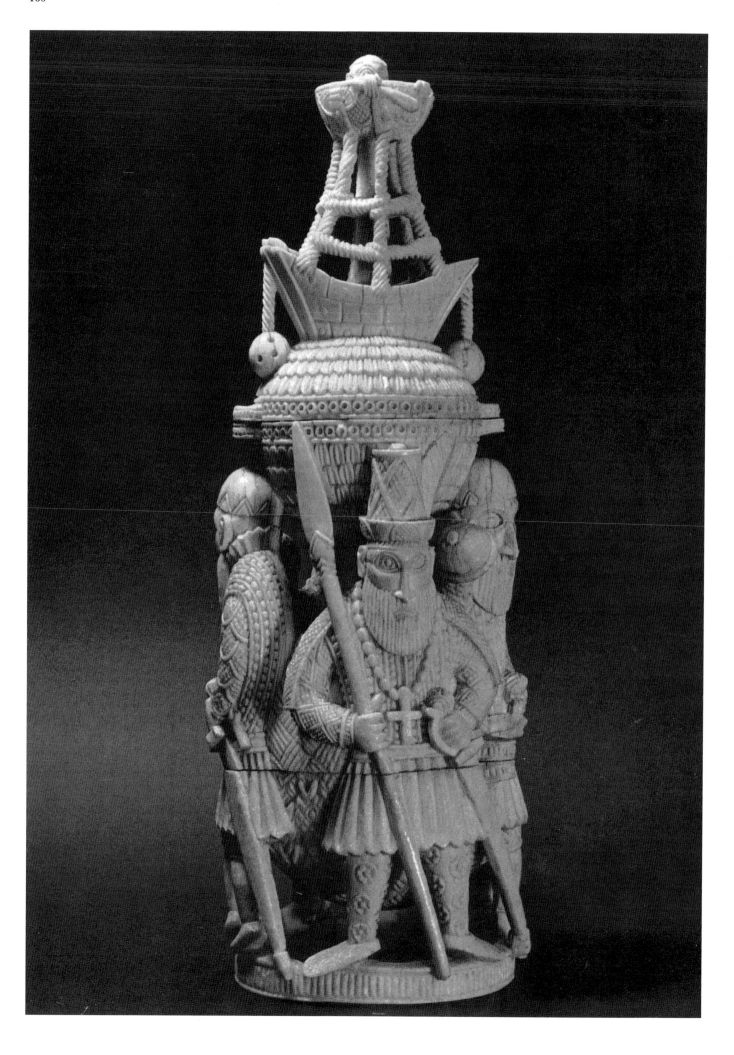

THE BINI-PORTUGUESE SALTS

A larger, and still more problematic group of Bini-Portuguese ivories are saltcellars, of which a total of fifteen are known. Of these, only three are complete, two lack their lower sections, four are missing their lids, and of six only the middle section has survived. Unlike the Sapi-Portuguese salts all Bini-Portuguese examples are double-chambered, with two spherical containers, one above the other, connected by a central stem. Each of the two containers is divided horizontally in half, creating a tri-partite structure, of which the middle section is usually the largest. This basic structure is enveloped by a frieze of figures in European costume. The lids are sometimes surmounted by a figure carved in the round, and are held in place by a rim on the lower section of that container. Generally, saltcellars are of two basic types, one with mainly standing figures of Portuguese, the other with Portuguese on horseback, accompanied by a winged figure.

Both types of Bini-Portuguese saltcellars incorporate two distinct themes. In general, one theme envelops the two lower registers, while a second theme adorns the uppermost register. Separating these two themes is a band in relief on the upper container where the second and third registers join. This band is not a rigid dividing line, but an area in which a certain amount of overlapping is permissible in order to avoid discontinuity between the two themes. With this sculptural device, a skilled artist both conceals the junction of the container with the base and effects the transition between the themes. Only in one instance (no. 127) does the figural group of the uppermost register intrude upon the lower sections. This case will be discussed later.

While a balanced integration of European and African motifs characterizes the oliphants, European imagery predominates on the saltcellars. The figures are dressed in rich European costume including jerkins, trousers and capes with plain or decorated stockings and shoes, and high-crowned feathered hats, skull caps or helmets. All standing figures wear "brigandines," jackets lined with metal plates fixed with rivets, popular in Europe during the second half of the fifteenth and first half of the sixteenth century.[117] All equestrian figures, in contrast, wear what appear to be quilted jackets, used in Europe at the time.

The frontal standing figures also wear pectoral crosses and the standing figures in three-quarter view wear keys at their belts. The horses are richly caparisoned; their trappings are ornamented with *crotals* (small metal rattles) and some have saddle blankets. It is noteworthy that the costumes in the Bini-Portuguese saltcellars are much more richly rendered than in the representation of Portuguese on Bini brass plaques cast in the same period.

Certain weapons depicted on these saltcellars indicate datable links with Europe and the Far East. Some of the equestrian figures (nos. 123-127), hold a matchlock gun in both hands. This weapon was in common use in Europe until 1520–1530, when it was replaced by the more effective wheel gun. On other saltcellars figures grasp sword hilts surmounted by a spherical knob, typical of European rapiers in the first half of the sixteenth century.

Daggers, and spears in which the blade emerges from an animal's mouth, are thought to be of Eastern derivation. Claude Blair, formerly the Keeper of the Metalwork Department of the Victoria and Albert Museum in London, has noted that these weapons may be of Indian origin because of the way the spear blades are attached to the shafts, and because the dagger hilts resemble those of Indian daggers.[118] The Portuguese, having opened the oceanic route to the East at the end of the fifteenth century and having controlled Eastern trade, could have acquired weapons on commercial voyages to India. Moreover, since the Portuguese ships trav-

209. Saltcellar. Bini-Portuguese, ca. 1525-1600. Four stern Portuguese ring the vessel while on the lid a small ship lies at anchor, a face peering out of its crow's nest. Of the fifteen Bini-Portuguese salts we know today, this is one of only three that are still complete. Like all the others, it is double chambered, and made in three parts: the lower third is the container of the bottom vessel; the midsection is the lid of the lower vessel, and the container of the upper one; the top is the lid of the upper vessel. The contours of the nearly spherical upper vessel are visible, only partly hidden behind the figures' heads. The lower vessel, also spherical, is partly masked by the figures. The boldly carved figures, and especially the strong diagonal lines of their lances here cunningly distract the eye from the clean horizontal cut that marks the join between the bottom and the midsection of the object. The successful use of this device creates a unified composition. 29.2 cm. Museum of Mankind, London (no. 114).

O GOVERNADOR·AFFONÇO·DE·ALBOQVERQVE·SVÇEDEO·NA·JNDIA
A·DOM·FRANCÍSCO·DE·ALMEDO········IDA·EMNOVEMBRO·DE
509·TOMOV·DVAS·VEZE·S·········A·CDADE·DE·GOA·E·A·SE·DE·MALA
E·TE·ORVZ·E·FEZ·A·FORTALEZ········A·DE·CALECVTE·FOI·A·PERCIA·E·AO
ESTRETO·DE·ORMVZ·E········MAR·ROXO

210. Portrait of Afonso de Albuquerque, second Governor of the Indies. Goan, 16th century. The distant land governed by Dom Afonso, which included Goa and the Straits of Hormuz, was reached by sailing around the African continent. Except for the hat, the costume he wears is extraordinarily close to those on the salts. His long straight beard and authoritative bearing—even his posture, one hand on his sword, the other on a staff—echo the ivories so closely one wonders if they might not be based on a similar portrait. Mixed technique on wood, 182 x 108 cm. Museu Nacional de Arte Antiga, Lisbon.

211. Saltcellar, missing the lid. Bini-Portuguese, ca. 1525-1600. The figures on this salt bear a striking resemblance to richly dressed Portuguese men of the same period. The African artists have captured not only details of clothing and physiognomy, but of demeanor as well. They seem to have been particularly struck by the long, straight-haired beards worn by the Europeans. 18.1 cm. The Metropolitan Museum of Art, Louis V. Bell and Rogers Fund, 1972 (no. 117).

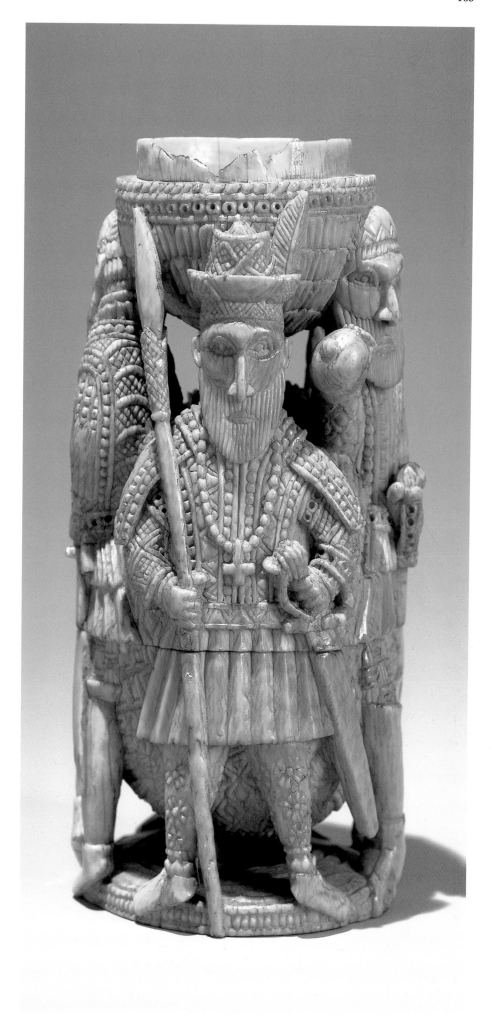

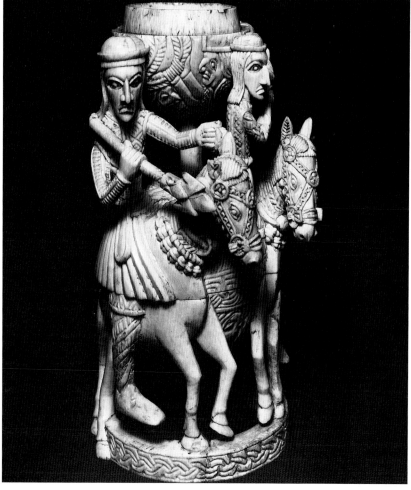

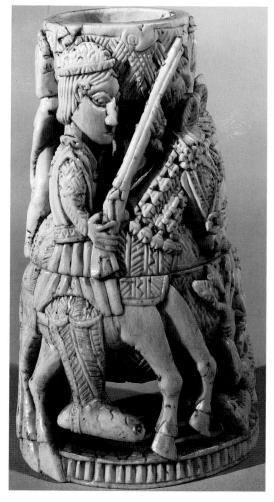

212. Brigandine. Italian, 16th century. The brigandine was a sleeveless jacket lined with metal plates fixed with rivets. The pattern produced by the studs is carefully rendered on many of the Afro-Portuguese ivories. The Metropolitan Museum of Art, Gift of William H. Riggs, 1931.

213. Detail of the *Paneis de St. Vicente de Fora*. Portuguese, Nuno Gonçalves, ca. 1460. The man in this painting is wearing a brigandine over a chain mail tunic. Museu Nacional de Arte Antiga, Lisbon.

214. Saltcellar, missing the lid. Bini-Portuguese, ca. 1525-1600. The long implement carried by the riders may be a mule goad. Horses rarely survived long on the coast of West Africa where they were very vulnerable to disease borne by the tsetse fly. This made them rare, highly prized animals. 18.3 cm. Royal Scottish Museum, Edinburgh (no. 120).

215. Saltcellar, missing the lid. Bini-Portuguese, ca. 1525-1600. The equestrian here carries a matchlock gun, a weapon that was in common use in Europe until 1520-1530 when it was replaced by the more effective wheel gun. 14 cm. Museum voor Volkenkunde, Leiden (no. 124).

eling to and from India customarily called at African ports for food and water, these Indian weapons could have been seen or even acquired by Africans.

Finally, the equestrian figures on several saltcellars (nos. 123-126) hold an implement that could be either a staff of office or a goad (a prod to use on mules). If it is a goad, then the animals depicted may, in fact, be mules and not horses. This is a likely hypothesis since horses rarely survived in south western Nigeria, where they were plagued by the tsetse fly.

If the European elements manifest themselves primarily in the representation of people, costumes and weaponry, traditional Bini elements can be seen in the decorative motifs. As in the oliphants, the artists of the saltcellars frequently used the basket-weave and lozenge patterns, associated with the *igbesamwan* guild, to fill in the surface decoration of the containers and on the costumes. Particularly on the costumes of the standing figures, these prevailingly Bini patterns are combined in a highly inventive way with a European pattern of beaded lines that is much more common in Sapi-Portuguese ivories. Finally, the leaf-shaped ears of the Bini-Portuguese mounts (whether horses or mules), can be found in all traditional Bini arts in the representation of animals, including leopards and rams in both ivory and bronze. We can observe similarities in the treatment of details in both the ivories and the bronze plaques, but it would be unwise at this stage to draw any definite conclusions.

To date, no counterpart of the double-chambered saltcellar has been found in the corpus of Bini traditional artifacts, nor is the use of this type of implement in Bini society mentioned in the written or oral records. Double-chambered saltcellars, furthermore, were not very popular in Europe in the fifteenth and sixteenth centuries. Few examples of this type exist compared with the great number of single-chambered containers; moreover, those that do exist bear little resemblance to Bini-Portuguese salts. They have a completely different distribution of volumes, and a simpler decoration.[119]

In addition to the lack of a likely European model for the structure of the saltcellars, we also lack any printed models in books or engravings for the images of standing and mounted Portuguese, mounts, angels, and the heraldic vessel. This is very different from the wealth of possible models for the imagery in Sapi-Portuguese ivories. Nonetheless, the sources must be European since some of the imagery on the Bini-Portuguese saltcellars is alien to the Bini thematic repertoire, and the overall rendering of the images (with the exception of the Bini details mentioned above) has little in common with Bini art.

The absence of models, and the unlikelihood that Bini carvers could have invented imagery so thoroughly European, leads us to postulate that the commissioner of these ivories must have supplied the carvers with his own sketches. These sketches need not have been more than outlines, since the details of weaponry and costume could have been derived from actual models. The Portuguese undoubtedly took with them to Africa finery to impress local dignitaries during official ceremonies of state, in this case at the court of Benin. What details of clothing the Bini carvers did not observe firsthand, they filled in with decorative patterns from the *igbesamwan* repertoire—basket-weave and lozenge patterns.

The more or less incomplete sketches, nevertheless, had to convey a clear idea of how the figures should look, not only in static poses, but

also in movement, for the curvature of the figures around the vessel is highly unusual in African art. Likewise, the dramatic torsion of some of the figures, especially the angels, is rarely seen in African sculpture, where figures are usually depicted in frontal, static poses. An exception to this rule is a handful of Bini, cast bronze, Portuguese crossbowmen and *arquebusiers* (musketeers) remarkable for their spiral stance, also probably influenced by Europeans. These non-African artistic conventions must have been taught to the artists of the ivories by the commissioner. Furthermore, the image of the angel could have been conveyed only through illustrations, since angels are not part of our visible reality, and are not present in Bini religious thought. Yet, the angels on the saltcellars differ from those in European iconography, especially in the explicit representation of gender, which never appears in European art. This also supports the hypothesis that the commissioner provided his own drawings to the artists.

The evidence suggests that the commissioner of the saltcellars— and, no doubt, of the oliphants as well—was a Portuguese official who held a position for some years in one of the Portuguese factories (warehouses) located in the Benin region. This individual would have been an artist himself, with the ability not only to sketch the desired motifs (for drawings could have been imported from Europe), but also to teach the carvers of the saltcellars how to read the drawings and to carve from them. Strong resemblance among the Portuguese depicted on the saltcellars by different hands might further support the theory of a single commissioner/teacher, instructing the African artists in European artistic conventions. The return to Europe, or the death of this instigator might explain the seemingly abrupt cessation of the carving of salts.

216. Plaque. Benin, Nigeria, 16th-17th century. A Portuguese man and a youth are depicted on this plaque made to be fixed to one of the columns around a courtyard in the palace at Benin. When the Bini portray Portuguese figures for Portuguese clients, they show them wearing sumptuous costumes: in depictions made by the Bini for their own use, the Portuguese are more simply dressed. Bronze, 52 cm. Private collection.

217. Saltcellar. European, 16th century. Like the Bini-Portuguese salts, this is a double chambered vessel. Its form and decoration are, however, totally different from the African ones. No close prototype has been found in either Europe or Africa for the configuration and decoration of the Bini-Portuguese salts. Silver, mother–of–pearl, 19.7 cm. The Lee Collection, on loan to the Royal Ontario Museum, Toronto, from the Massey Foundation.

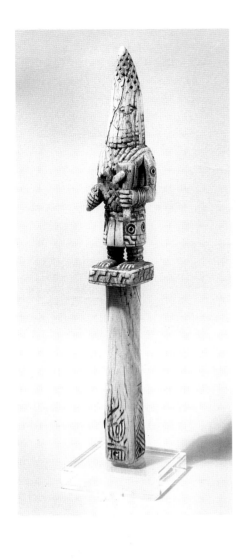

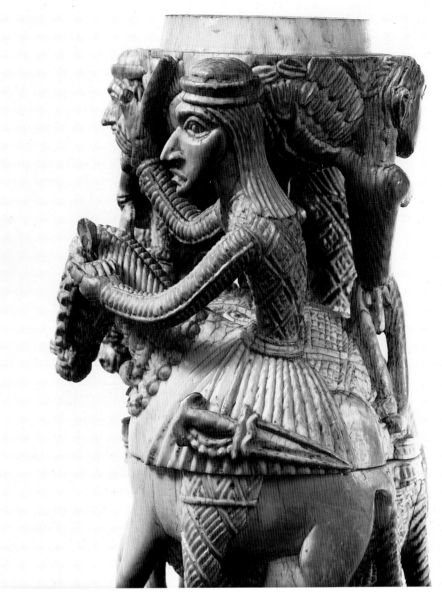

218. Whisk handle. Benin, 16th-17th century. The figure is shown striking a gong. The rigid posture is characteristic of Benin art. Note the step pattern on the waist and hem of the skirt, and on the platform below. It is typical of work by the *igbesamwan*, the guild of ivory carvers in Benin. Ivory, 30.5 cm. Private collection.

219. Saltcellar, missing the lid. Bini-Portuguese, ca. 1525-1600. The artful way in which the figures are integrated with the cylindrical form of the vessel can be seen here. The striking torsion of the small nude angel facing the viewer

with his head averted is unlike anything seen in art made by the Bini for their own people. 18.2 cm. Museum of Mankind, London (no. 119).

220. Seated figure. Benin, Nigeria, 17th - 18th century. Made by the lost wax method like all Bini bronzes, the original use and meaning of this figure is unclear. It is probably part of a larger work. The details of European clothing are carefully observed and depicted. The Portuguese certainly brought their finery with them to Africa and wore it during state occasions. Bronze, 12 cm. Private collection.

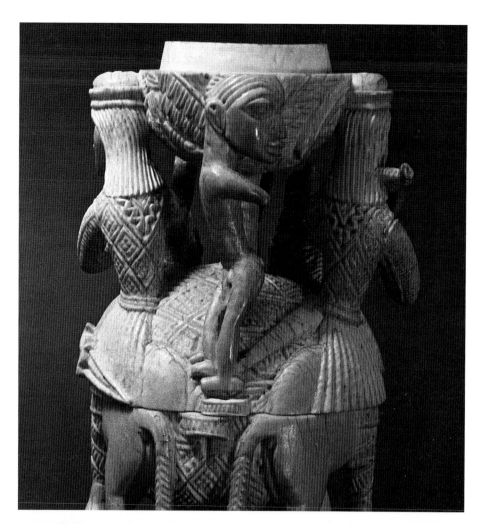

221. Back view of a Bini-Portuguese saltcellar. The small nude angel here crystallizes the hybrid nature of the Afro-Portuguese ivories. The angel is a European motif, but the nude portrayal of him is not. The active, asymmetrical stance and the total lack of frontality is far from the African tradition. A lug (unpierced in this case) on which the angel is perched is typical of Bini work and would have served to align the lid and vessel correctly. (In this photo they are slightly out of line.) Museum of Mankind, London (no. 119).

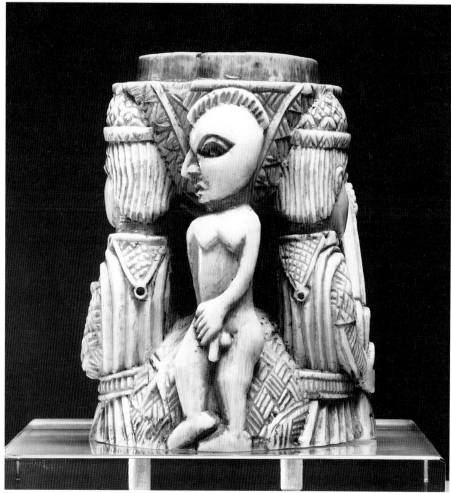

222. Midsection of saltcellar. Bini-Portuguese, ca. 1525-1600. A small nude angel is seen on the center back of another salt. On either side stand two Portuguese, their hoods and straight hair clearly rendered. 9.1 cm. National Museum, Canberra (no. 125).

223. Seal of the city of Straslund, 1301. This simplified medieval depiction of a ship corresponds in general form and some details to the finial on saltcellar no. 114 carved in the form of a ship.

If the commissioner was a European, the artists of the saltcellars and oliphants were Bini. The *horror vacui* and the presence on the surface of the ivories of many motifs used by the *igbesamwan* (motifs isolated, for example, by one of us—W.B.F.), leave no doubt about the Bini origins of the artists and their training in the *igbesamwan*. Undoubtedly, the members of the royal guild would have been required to obtain permission from the *oba* to carve for foreigners. Unless, of course, these artists were beyond the jurisdiction of the *oba*. This would have been more likely if the workshop was located outside of the kingdom of Benin.

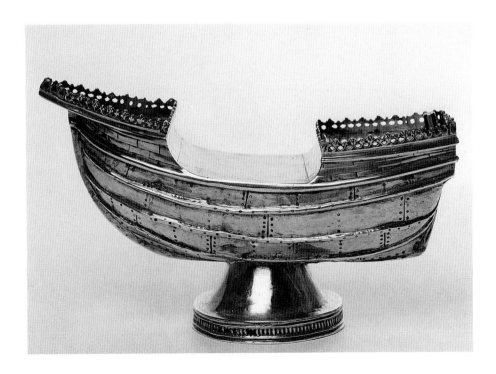

224. Saltcellar (?) in the form of a ship. Portuguese, 15th century. Silver, 10.8 cm. Museu Nacional de Arte Antiga, Lisbon.

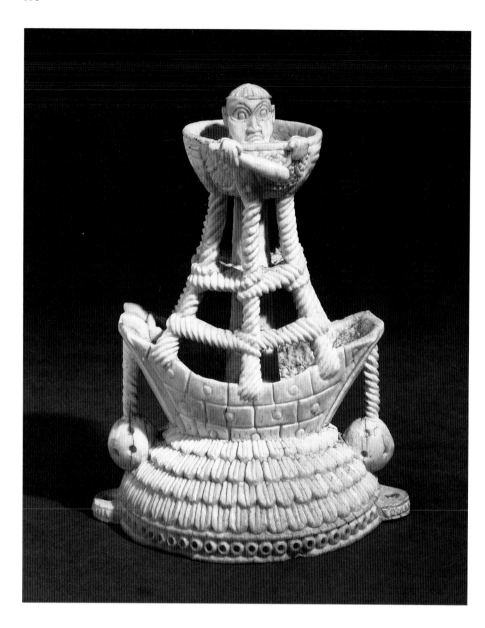

225. Lid of a Bini-Portuguese saltcellar. Every saltcellar has a different subject on the lid. This singular example shows a European ship with a lookout in the crow's nest. He is shown grasping a megaphone—telescopes were not invented until the beginning of the 17th century. The ship is riding at anchor, but the artist has depicted sheet anchors, in reality flat discs, as prominent balls. (See full view, page 160.) Museum of Mankind, London (no. 114).

226. Spoon, Bini-Portuguese, ca. 1525-1600. Forty-eight spoons are known of which this is one of the most baroquely decorated. Though animal and bird figures are the principal subjects carved on the spoons, the dense and interlocking way they are presented here is exceptional. 26.5 cm. Städtisches Museum, Braunschweig (no. 165).

The possible geographical location of this workshop is suggested by the presence of a ship on one of the three complete saltcellars (no. 114). The representation of this ship is reduced to its essentials: a hull, two sheet anchors, the rigging descending from the mast, crowned by a crow's nest from which a sailor looks out (no sails are visible).

The striking resemblance of the Bini-Portuguese ship to the medieval examples, and not to caravels used in the sixteenth century, suggests that the Bini carver was provided with an archaic rendering, perhaps in the form of a drawing or a woodcut.[120] It is highly improbable that the Bini artist would otherwise have reached precisely the same stylized solution to this representation as had European artists of the fourteenth century.[121] On the other hand the man in the crow's nest, rendered in an anecdotal manner—unlike the imposing figures on the lower registers of the saltcellars—might have been a humorous addition by the Bini carver. Perhaps he saw a real vessel topped by a crow's nest with a man in it, and the sight impressed him to the extent that he emphasized this detail. (The instrument held by the sailor is not a telescope, not yet invented, but probably a hailer). If this speculation has any validity, then the workshop to which the artist belonged must have been in close proximity to one of the harbors where Portuguese ships used to call, though no more than three or four ships a year.

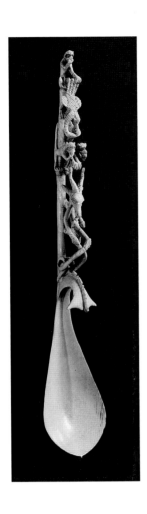

THE BINI-PORTUGUESE SPOONS

Among the most elegant of all Bini-Portuguese ivories are finely decorated spoons. To date forty-eight (nos. 129-176) have been discovered in Europe and America, making them the largest group of Bini-Portuguese artifacts. They differ from Sapi-Portuguese spoons primarily in the beauty and refinement of the bowl which stands out as the main feature. An elongated, streamlined form, it tapers toward the junction of the stem and then curves outward, creating a tripartite hook. A thin central rib runs along the total length of the back of the bowl. The bowls are so finely worked and so smoothly finished that many are actually translucent; this may be the reason for the misidentification of five spoons as mother-of-pearl in the Florentine inventories of 1560.

On the stem are various combinations of animal figures carved in the round; in only one case is the subject a human figure. These zoomorphs either surmount a thin, straight stem, or are interconnected in such a way as to create the stem itself. Usually the groupings tastefully combine plain, uncarved surfaces with decorated areas and figural groups with one exception (no. 165), in which the superimposition of animals is so dense and complex that it may be described as *horror vacui*.

In the repertoire of figural motifs, birds predominate, though some spoons also incorporate dogs, crocodiles, snakes, antelopes, leopards, monkeys, cocks, a pangolin, a hand with two extended fingers, and a young man in Portuguese costume. Snakes and crocodiles are usually shown consuming smaller animals, including fish, snails, and birds, while antelopes are always shown eating leaves.

At this stage of our research, it is not possible to assign fixed meanings to these animals and the recurrent pairing of some of them. We know, however, that birds, snakes, crocodiles, fish, and leopards belong to the traditional Bini iconographical repertoire. All of these animals are present in the bronze plaques that adorned the pillars in the courts of the *oba's* palace, and some are represented by sculptures in the round. Most significantly, certain of these animals were used to embellish architectural structures: both a bronze plaque and a bronze box now in Berlin[122] and another plaque in London[123] depict the palace of the *oba* surmounted by figures of birds and snakes. Great bronze pythons forty feet long were mounted on the gate towers. This architectural feature is confirmed in Dapper's famous engraving, which shows the palace crowned with birds and snakes. The representation of a bird with open wings may well relate to the "Bird of Disaster," the prophetic bird who warned Oba Esigye of impending disaster in the early sixteenth century. In spite of these connections, it is more likely that the animals, except for the "Bird of Disaster," were devoid of specific references, and were merely decorative elements intended to render the spoons even more precious to the European eye.

It is the bowl, however, that is the real achievement of the artists of these spoons. Because the shape does not correspond to the form of European spoons, and there is no evidence for the use of spoons in Bini traditional culture, we must postulate that the artists invented the shape after the first Portuguese commissioner provided them with a model. The shape of the bowl, with the spinal rib and curvature at the stem, seems to have been inspired by a leaf. While leaves do not appear much in Bini art (only on a few plaques with trees), they play a significant role in Owo imagery. Some of the terracotta fragments excavated in Owo in the last several years and dated by thermoluminescence to the fifteenth century, show the leaves of the *akoko* sacred tree.[124] The representation of leaves

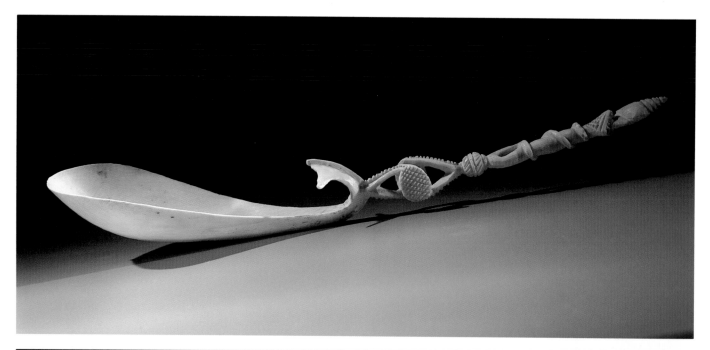

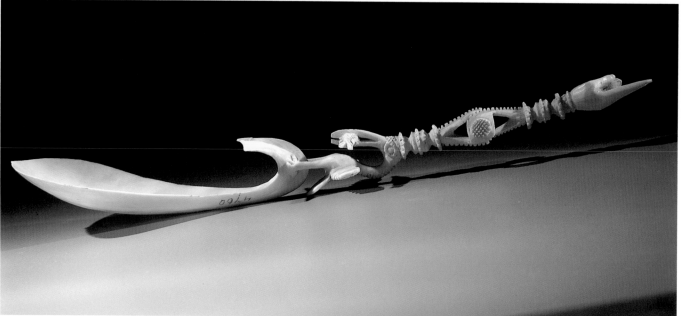

also appears frequently in ancient ivories attributed to Owo, including bracelets and lidded bowls. In these works, the leaves are often being eaten by antelopes, a strictly Owo motif that we also find on the spoons. The presence and treatment of the leaf form, together with the notable absence of *horror vacui* in the spoons lead us to postulate that the artists of these spoons were not Bini, but rather Owo.[125]

We previously stated that Owo artists worked for the *oba* of Benin in the *igbesamwan* guild along with Bini carvers. It is not clear whether they were full or only honorary members, in which case they may not have been as strictly controlled by the *oba* as were the Bini members.[126] This greater freedom might have permitted the carvers to work outside Benin City, near the coast where the Portuguese established their factories. This area might not have been far from the center where the saltcellars were carved, for on spoon no. 171 appears the only human figure carved on a spoon, a young man with bare feet in Portuguese costume, perhaps a page boy, iconographically and stylistically related to the Portuguese figures carved on the saltcellars. It especially resembles a small figure carved in profile on the back of saltcellar no. 126.

227 and 228. Two spoons. Bini-Portuguese, ca. 1525-1600. The Bini or Owo artists who carved these spoons found numerous ways of shaping them into thin struts and strange openings. They seem to have willfully made them fragile, and breakable, perhaps as a statement of virtuosity. 25 cm. Museum für Völkerkunde, Vienna (nos. 150, 154).

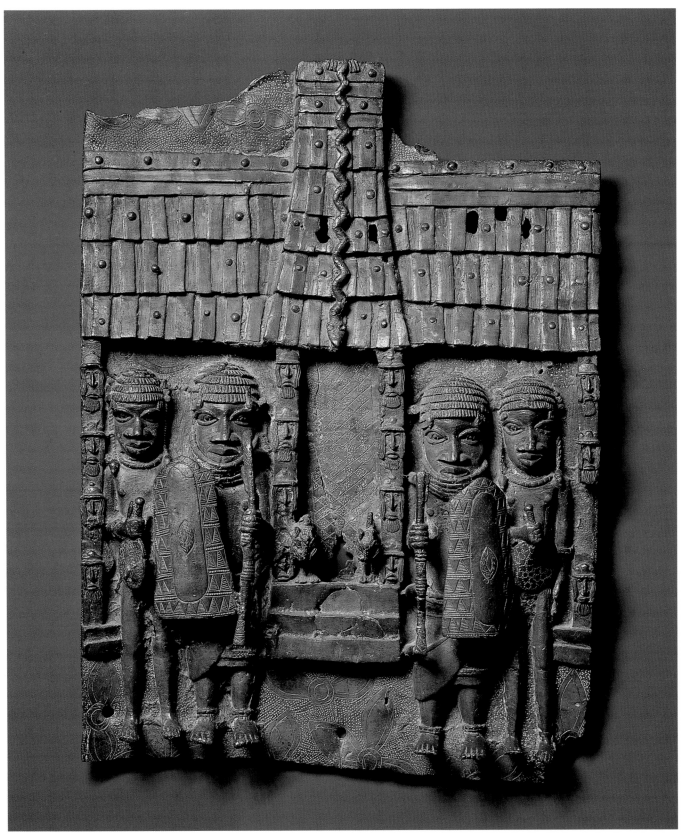

229. Plaque. Benin, Nigeria, early 17th century. This plaque depicts a palace entrance with plaques on the columns, and a bronze serpent descending from the roof. The earliest European written description of the palace at Benin was based on early 17th century Dutch reports. It states: "The king's court is square, and stands at the right hand side when entering the town by the gate of Gotton [Ughoton] and is certainly as large as the town of Haarlem, and entirely surrounded by a special wall like that which encircles the town. It is divided into many magnificent palaces, houses, and apartments of the courtiers, and comprises beautiful and long square galleries, about as large as the Exchange at Amsterdam, but one larger than another, resting on wooden pillars, from top to bottom covered with cast copper, on which are engraved the pictures of their war exploits and battles, and are kept very clean. Most palaces and the houses of the king are covered with palm leaves instead of square pieces of wood, and every roof is decorated with a small turret ending in a point, on which birds are standing, birds cast in copper with outspread wings, cleverly made after living models." Bronze, 40 x 52 cm. Museum für Völkerkunde, Berlin.

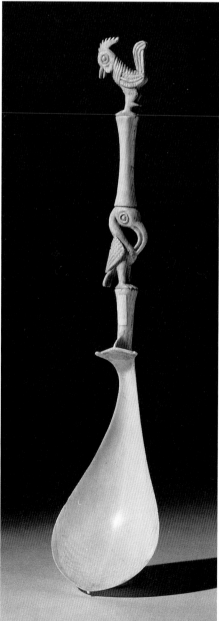

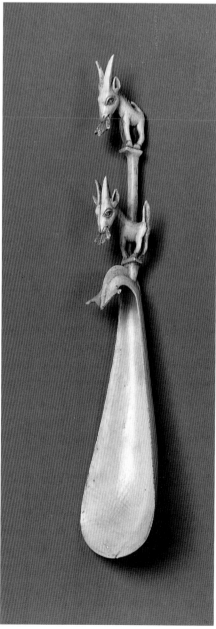

230. Colossal python head. Benin, Nigeria, 16th - 17th century. A Dutch visitor to the court of Benin published this description in 1702: "On top of the last [gate] is a wooden turret, like a chimney, about sixty or seventy foot high. A large copper snake is attached to its top, its head dangling downwards. This snake is so neatly cast with all its curves and everything, that I can say that this is the finest thing I have seen in Benin . . ." Several similar bronze snake heads exist as well as a few sections of the undulating body. 41.4 cm. University of Pennsylvania Museum, Philadelphia.

231. Spoon. Bini-Portuguese, ca. 1525-1600. Birds figure prominently and meaningfully in Benin iconography though their use on the spoons seems to have been simply decorative. Here is a rooster, associated with the queen mother; on other spoons we find the standing bird with outspread wings that appeared on the turrets of the palace. 23.9 cm. National Museum, Historical Division, Prague (no. l69).

232. Spoon. Bini-Portuguese, ca. 1525-1600. The antelope, a central motif in Owo art, is frequently shown eating three leaves. Here a spoon made for the Europeans shows two antelopes in the Owo manner. 16.5 cm. Ulmer Museum, Ulm (no. 156).

233. Detail of Bini-Portuguese spoon. These antelopes eating leaves are among the most charming and skillfully carved of all the figures on the Bini-Portuguese spoons. Ulmer Museum, Ulm (no. 156).

234. Box. Benin, Nigeria, l8th-l9th century. Plant motifs, which rarely figure in African art, are sometimes cast or carved on Benin works such as this lidded box. The leaves shown here are clearly not *akoko,* the leaf typical of Owo art, since they alternate on the branch instead of being paired. Ivory, approx. 15 cm. Private collection.

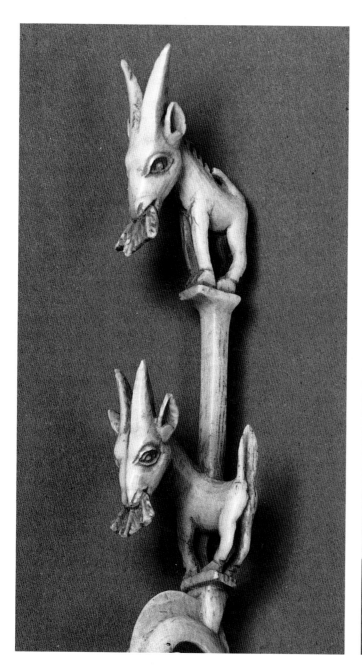

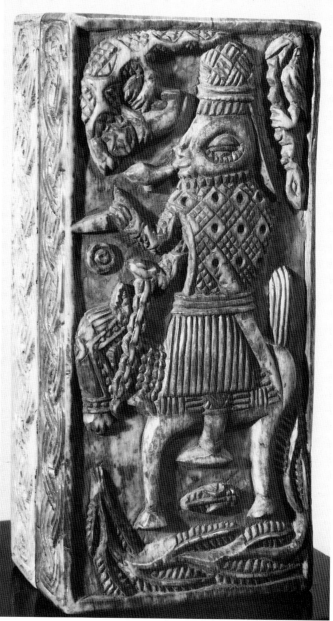

The maker of this spoon could conceivably have been a Bini artist in the saltcellar workshop who departed, at least temporarily, from Bini artistic canons, in particular from the characteristic *horror vacui,* to create this spoon. However, considering the absolute perfection of the bowl and the absence of *horror vacui,* it is far more likely that it was made by an Owo artist who adopted the rendering of the figure from the Bini saltcellars. If so, then these two groups were not only working simultaneously, but were also in close geographical proximity.

We will not attempt to distinguish the individual hands who carved the Bini-Portuguese spoons, a question more difficult than for the saltcellars. Not only are the formal elements reduced both in size and number, but artists used the same formal conventions to depict many of the animals: snakes coiled around the stem, crocodiles rendered only by their heads, and dogs perched high on platforms. Only if the entire corpus were studied simultaneously would it be possible to detect the minute details that distinguish each artist.

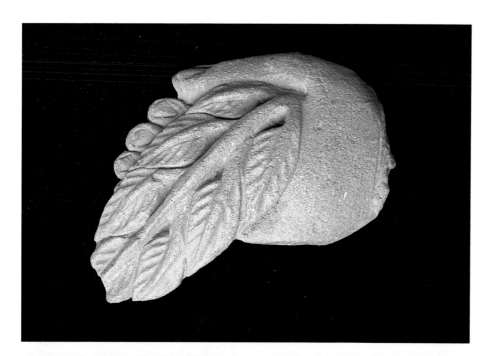

235. Hand holding an *akoko* leaf. Owo, Nigeria, 15th century. Leaves were used in rituals and appear frequently in Owo art. Here on an archaeological fragment is an *akoko* frond, recognizable from the pairs of leaves that spring from a central rib. Terracotta, 11 cm. National Museum, Lagos.

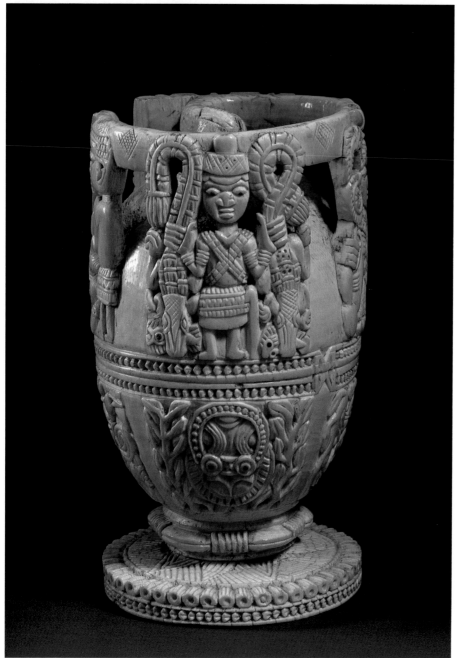

236. Lidded vessel. Owo, Nigeria, before 1800. *Akoko* leaves spring from the jaws of the skull-like face in the lower register. Above, a figure grasps a crocodile in each hand while they in turn each bite a round-eyed fish. A notch in the line of beading that marks the separation between vessel and lid indicates the proper alignment of the two. This feature, and the domed shape of the lid are characteristics that African artists repeated in the works they carved for foreigners. It seems likely that the "Bini-Portuguese" ivories were created by both Bini and Owo artists who worked for the *oba,* and belonged to the *igbesamwan* guild in Benin. Ivory, 21 cm. Private collection.

237. Spoon. Bini-Portuguese, ca. 1525–1600. The only human figure carved on a spoon is this barefoot Portuguese boy. He is closely related to the figures of Portuguese carved on the saltcellars, especially the small figure on the back of salt no. 126. 19.7 cm. Museum of Mankind, London (no. 171).

238. Back view of Bini-Portuguese spoon. The rib down the center of the bowl is present on all the Bini spoons and many of the Sapi examples. The pure, streamlined form of the bowl is one of their outstanding features. Museum of Mankind, London (no. 171).

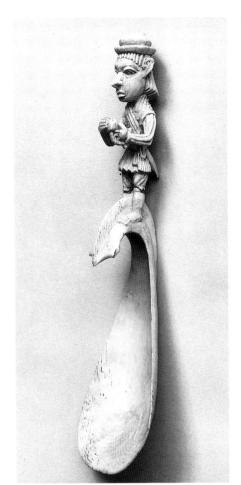

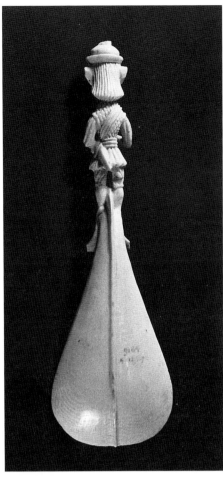

239. Detail of the Bini-Portuguese saltcellar. This figure, only a couple of inches high, is full of character. The artist has depicted him holding in his right hand a manilla, a metal crescent imported by the Portuguese that served as an element of currency. He holds it aloft in an oddly casual way. Despite the small size of the carving, the artist has captured all the details of the sleeveless tunic with its laced front and knotted sash. Museum für Völkerkunde, Berlin (no. 126).

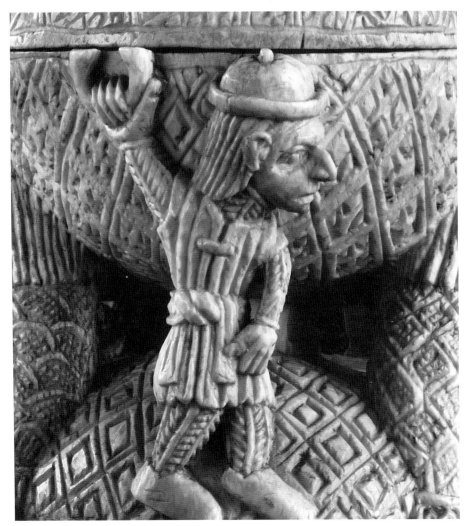

Though the saltcellar and spoon workshops were probably contemporaneous, the production period of the spoons seems to have spanned a longer period of time. We know that spoons were being made at least by the middle of the sixteenth century because five spoons were registered in Florence in 1560, and surely they were carved at least several years earlier. One spoon in fact in the first registry was already broken by the time it was described. Furthermore, James Welsh's quote of 1588 confirms that spoons were still being carved in Benin thirty years later.[127]

This extended period of production may be because less ivory was required for spoons. Furthermore, since the spoons did not have to conform to strict European requirements of form or subject matter, they may have been made for stock, after the first successful commission was sold to Portuguese visitors. A long period of production may also explain the large number of spoons as compared with the saltcellars or horns, which required more ivory, more time and a commissioner-teacher.

If we accept that both Bini and Owo artists created the corpus of ivories, the term "Bini-Portuguese" might seem restrictive. But since these Owo carvers might have worked for the *oba* of Benin, and with the *igbesamwan* guild of artists at Benin, we still maintain the term Bini-Portuguese to identify this group of Nigerian ivories.

CHAPTER 8
THE BINI-PORTUGUESE ARTISTS

ARTISTS I AND II

A stylistic examination of the corpus of Bini-Portuguese saltcellars, of which there are only fifteen examples, reveals that they were created in one workshop by no more than seven or eight artists.

Three salts (nos. 114-116) in the Bini-Portuguese corpus can be attributed to one artist, and because the lid of the only complete saltcellar in this group (no. 114) depicts a ship, as discussed above, we call the author of this group the "Master of the Heraldic Ship."

In all works by this master the main group of figures, which enclose the two lower registers, consists of four, standing, fully bearded Portuguese in elaborate costumes bearing swords and spears. In an extremely well-balanced composition, the artist alternates fully frontal figures in static poses with active figures in three-quarter view. He has given his more regal figures a contrasting stillness. This skillful juxtaposition serves to focus the eye upon the dominant frontal figures in the richest apparel.

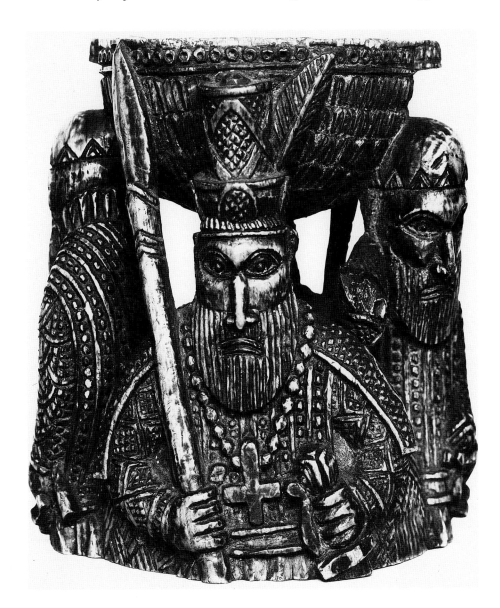

240. Midsection of a saltcellar by the Master of the Heraldic Ship. Bini-Portuguese, ca. 1525-1600. Four bearded Portuguese figures form the midsection of this well balanced composition. Fully frontal figures in static poses alternate with active figures in three quarter view. This skillful juxtaposition serves to focus the eye upon the dominant frontal figures in the richest apparel. 11.3 cm. Royal Scottish Museum, Edinburgh (no. 115).

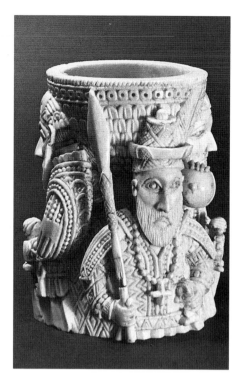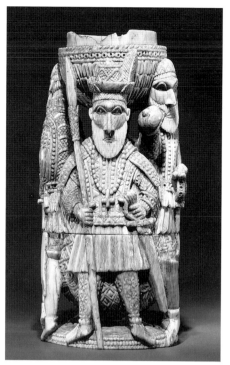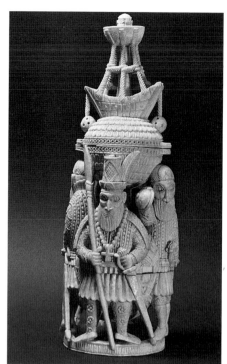

The saltcellars nos. 117 and 118 are practically identical to those by the Master of the Heraldic Ship, only differing in minute details such as facial features. This suggests they are the work of another artist, very close to the foregoing master and working after the same models.

The containers of the saltcellars nos. 114 and 117 that retain their lower sections are decorated with lozenge and basket-weave motifs, upon which four fish are carved in low relief. On the one complete saltcellar surmounted by the ship, the upper container is decorated with a pattern that seems to serve a dual purpose: on the lower half it represents the foliage of a tree, while on the upper half it provides water on which the ship sails. To mark the transition from plant to water, the junction between the two parts of the container is decorated with a double row of rings. This motif is actually more characteristic of Owo than Bini art. In addition, the works by the Master of the Heraldic Ship incorporate, more than any others, the Manueline motif of beaded lines to embellish the costumes. Together with the basket-weave pattern, these elements are so well integrated that certain parts of the figures seem to merge with the bowl itself.

ARTIST III

A single master is the carver of two salts (nos. 119 and 120) both of which depict two mounted, clean-shaven Portuguese alternating with an attendant on the front and an angel on the back. Compared with those of the Master of the Heraldic Ship, these figures are slenderer and are characterized by a greater sense of movement, which reaches its maximum in the completely and unnaturally contorted angel figure. The converging lines formed by the heads and legs of the mounts, the equestrian's weapon and the attendant's arm show this artist's formal sophistication. It is also revealed in the juxtaposition of solids and voids; in the way the angel is theatrically staged, by creating a background out of the decorative patterns of the Portuguese heads and costumes; and in the equal importance accorded to both front and back. These design elements are not haphazard, but conscious artistic choices, and serve to create an open, well-balanced composition.

241. Midsection of a saltcellar. Bini-Portuguese, ca. 1525-1600. In a style similar to the Master of the Heraldic Ship, this artist has set four rigidly posed figures around the bowl. The close attention to detail typical of Bini-Portuguese salts can be seen in the Manueline motif of beaded lines that embellish the costumes. Even the small detail of dress, the crucifix worn by one of the Portuguese figures, is rendered with care. Lozenge motifs cover the bowl. 9.1 cm. Museum of Mankind, London (no. 118).

242. Saltcellar. Bini-Portuguese, ca. 1525-1600. This saltcellar is practically identical to those by the Master of the Heraldic Ship, down to the flowered leggings. It differs in details such as facial features, and is probably the work of another artist very close to the foregoing Master working after the same models. 18.1 cm. The Metropolitan Museum of Art, New York (no. 117).

243. Saltcellar by the Master of the Heraldic Ship. Bini-Portuguese, ca. 1525-1600. This is the only complete saltcellar of three that form the Bini-Portuguese corpus created by the artist identified as the Master of the Heraldic Ship. We can assume that he also authored a purely Bini corpus. The artist's skill in maintaining the unity of the overall design is particularly striking in this example. The upper container is decorated with a pattern that seems to serve a dual purpose: on the lower half it represents the foliage of a tree, while on the upper half it provides water on which the ship sails. 29.2 cm. Museum of Mankind, London (no. 114).

244. Saltcellar (lid replaced). Bini-Portuguese, ca. 1525-1600. Artist III. Slender figures and a greater sense of movement characterize the work of this artist. The converging lines formed by the heads and legs of the mounts, the equestrian's weapon and the attendant's arm show the artist's formal sophistication. 18.2 cm. Museum of Mankind, London (no. 119).

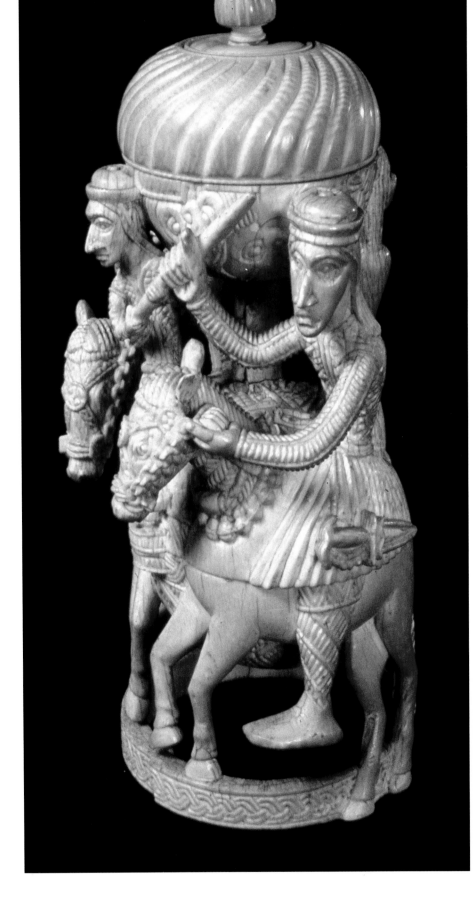

ARTIST IV

Of this artist's work only the middle section of one saltcellar (no. 121) remains, on which two angels carved in relief are coupled with two standing Portuguese figures in the round. Secondary Portuguese figures are carved in low relief over the surface of the bowl as though emerging from the geometric patterns. The angel whose legs clearly continue into the missing lower section (the only case where this occurs) has the face turned, but not the extreme torsion of the body seen in nos. 119 and 120. This angel's form also has more naturalistic proportions, and his wings are more clearly delineated in higher relief.

ARTIST V

As in the case of the previous artist, only the middle section of a single saltcellar (no. 122) by this carver has survived. Here, the main figural group consists of two mounted Portuguese and one angel portrayed in a lively walking position, with the head turned as in the previous example. The wings in this case, however, are almost fused totally with the decoration of the bowl. While similarities can be found between this saltcellar and those of Masters III and IV, this artist leaves less space between the figures. The result is a tighter, more compact, composition.

ARTIST VI

Three saltcellars (nos. 123-125, one mostly complete except for a possible restoration on the lid, one missing a lid, and one middle section) document the work of this artist. In all three examples the main figural group portrays an angel and two mounted Portuguese, one of whom is armed with a matchlock gun. The central attendant figure between the horses is absent, and a seated figure holding a branch is carved in the round between the front legs of the horses. The shift in weight from top to bottom and the compression of the human and animal figures in the upper section, give these saltcellars a unique, conical form.

ARTIST VII

The work by the carver of this single middle section and lid (no. 126), missing the crowning figure group, differs from the others in its overall structure. Most notable is the spacing of the upper and lower containers in closer relation to one another, with the result that the heads of the mounts and the riders become integrated with the salt as a whole. Moreover a charming young man in Portuguese costume is substituted for the angel at the back.

ARTIST VIII

For this artist, we are again forced to limit our discussion to a single work, a middle section with a lid surmounted by an equestrian figure (no. 127). This is the only example in the corpus of Bini-Portuguese saltcellars in which figures, both mounted and standing, bearded and clean-shaven, are combined. In spite of the curious and unnatural proportions of the figures, the artist shows a high level of inventiveness in the way he uses the volume of the lid to build up the gigantic man and his tiny mount. If we ignore for a moment the long legs extending into the lower register, the figure on the lid resembles a medieval chess piece. This distinctive saltcellar has the largest zone of transition of all the saltcellars, since the imagery of the lid intrudes upon that of the middle section. Futhermore,

245 and 246. Midsection of a saltcellar. Bini-Portuguese, ca. 1525-1600. Artist IV. Fluid contours form the angel and create a lively composition. The pose here is unusual, as the Portuguese grasps his sword with one hand, while turning and reaching backward to hold a bare branch proffered by the angel. The wings are almost totally fused with the decoration of the bowl; secondary Portuguese figures carved in low relief seem to emerge from the geometric patterns. In the alternate view the skillful execution of this complex design is revealed in the juxtaposition of solids and voids. Two angels carved in relief are paired with two Portuguese figures in the round. 8.3 cm. The Paul and Ruth Tishman Collection of African Art, The Walt Disney Co., Los Angeles (no. 121).

247 and 248. Midsection and lid of a saltcellar. Bini-Portuguese, ca. 1525-1600. Artist VIII. This is the only example in the corpus of Bini-Portuguese saltcellars which combines figures both mounted and standing, bearded and clean-shaven. Despite the curious and unnatural proportions of the figures, the artist shows a high level of inventiveness in the way he uses the volume of the lid to build the gigantic man and his tiny mount. A great sense of movement pervades the lower register: the mounts with extended necks and bared teeth appear to be whinnying and have a strange likeness to crocodiles or Picasso's horse in "Guernica." The mount on the lid contrasts sharply with those on the lower registers; not only do they wear different trappings, but the agitated horses of the lower register toss their heads, bare their teeth and raise their tails. This saltcellar is unique in the way the imagery of the lid intrudes upon the midsection. 19.2 cm. Museu Nacional de Arte Antiga, Lisbon (no. 127).

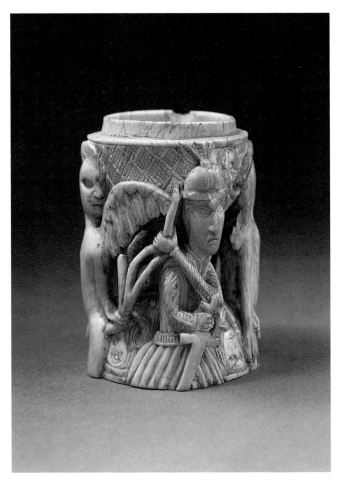

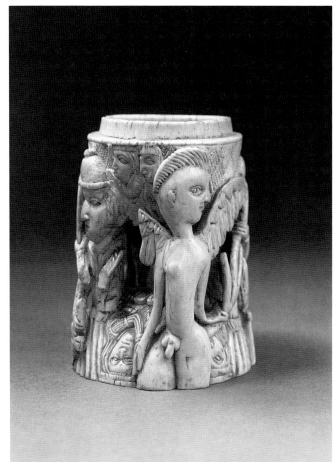

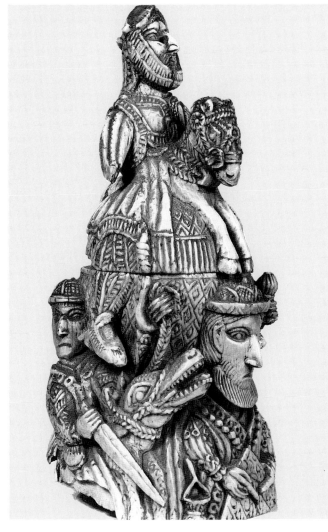

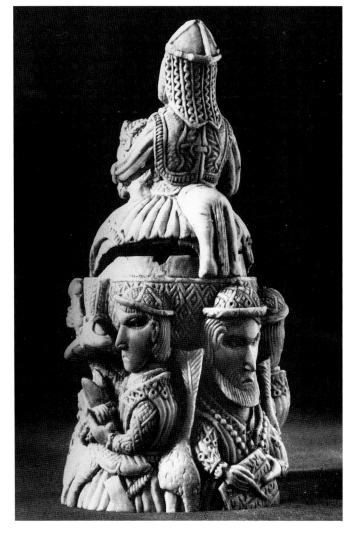

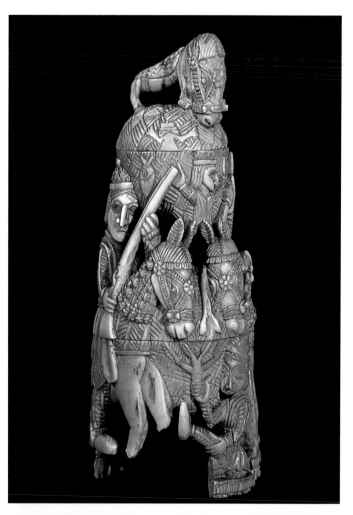

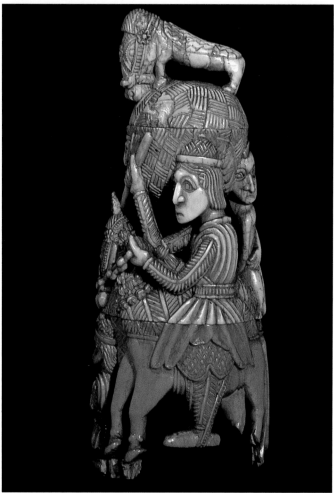

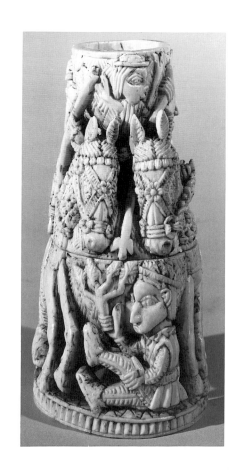

249 and 250. Saltcellar. Bini-Portuguese, ca. 1525-1600. Artist VI. The shift in weight from top to bottom and the compression of the human and animal figures in the upper section, give this saltcellar its unique conical form. In this compact and tight composition, the main figural group portrays an angel and two mounted Portuguese, one of whom is armed with a matchlock gun. The central attendant figure between the horses is absent, and a seated figure holding a branch is carved in the round between the front legs of the horses. 19.2 cm. Etnografisch Museum, Antwerp (no. 123).

251. Bottom and midsection of a salt-cellar. Bini-Portuguese, ca. 1525-1600. Artist VI. The mounted figure and the horse are built into the conical shape of this salt. The figure's upper torso is carved close to the bowl, while the lower registers that form the horse are carved more fully in the round. 14 cm. Rijksmuseum voor Volkenkunde, Leiden (no. 124).

252. Saltcellar. Bini-Portuguese, ca. 1525-1600. Master of the Mounted Throng. This elaborate saltcellar crystalizes the best Bini-Portuguese ivories and summarizes in many ways their achievements. The figural groups, both in the round and in relief, are skillfully integrated into the overall structure. A great sense of movement pervades the lowest register. Other figures are carved in a fluid, low relief style on the surface of the container. The greatest emphasis is placed on the lid which is adorned by a mounted Portuguese embracing a matchlock gun, and wearing a feathered helmet. By underplaying the sub-structure to focus attention on the main subject on the lid, the artist has given this small ivory a monumental presence, and revealed his great skill. 24.5 cm. Danish National Museum, Copenhagen (no.128).

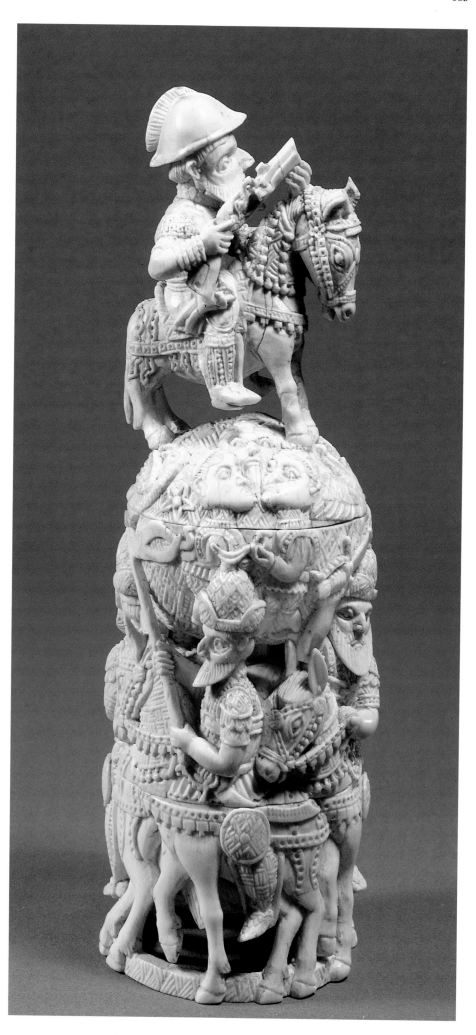

there is a great disparity between the rendering of the mounts on the lid and those of the lower registers; not only do they wear different trappings, but those of the lower registers—with extended necks and bared teeth—appear to be whinnying, and have a strange likeness to crocodiles or Picasso's horse in "Guernica".

ARTIST IX

The carver of the saltcellar no. 128 has the most intriguing personality. He might be the artist who, more than any other, succeeded in fulfilling the requirements of the commissioner/teacher. In fact, his single surviving work, the most elaborate of all the saltcellars, summarizes in many ways the stylistic achievements of all the carvers in this workshop. The work is surely the most European in the group, in terms of movement, gesture and proportion.

The figural groups, both in the round and in relief, are not only the most complex, but also the most skillfully integrated into the overall structure. The costumes of the four equestrians on the lower registers are more precisely rendered in terms of their European elements though the basket-weave and lozenge patterns are still present. A great sense of movement pervades the lowest register in a way that is characteristic of European equestrian representations, while various figures, carved in a fluid, low-relief style on the surface of the containers, almost obscure the geometric decoration.

The greatest emphasis is placed upon the figural group of the lid, a mounted Portuguese embracing a matchlock gun, and wearing a feathered helmet. We can imagine a troop of cavalry, jostling each other and making a clatter far more than the actual numbers; hence we would name this artist the "Master of the Mounted Throng." By underplaying the substructure to focus attention on the main subject on the lid, the artist has given this small ivory a monumental presence, and revealed his great skill. His work crystalizes the best Bini-Portuguese ivories.

One scholar has suggested that the saltcellar was carved in Europe after an African model.[128] The hypothesis should be seriously considered, but in our opinion, even if the author was a European, the ivory must have been carved in Africa. It is unlikely that a European would have copied an African model, and, above all, that he would have used the traditional Bini basket-weave and lozenge motifs, or the Manueline beaded lines, not only to decorate the surface of the containers, but also to represent parts of the costumes in exactly the same way as had the African artists. If we have to postulate that this saltcellar is the work of a European artist, then we must conclude that he was the same man as the teacher/commissioner of the Bini carvers, and that, working closely with them, he absorbed Bini decorative conventions and the way of working with them.

CHAPTER 9
A CONJECTURAL DIGRESSION AMONG THE BRONZE CASTERS

L et us take up again the tale of the hypothetical commissioner and teacher whom we have resurrected from the sixteenth century in order to account for the revolutionary qualities of the Bini–Portuguese ivories. He is a shadowy figure indeed, but one who seems to detach himself from the fabric of history with a quirky human presence. His tuition and advice when carried into action were seen to take direct sculptural forms in ivory—not, let it be noted, in the indigenous ivory production, but only in his workshops at the "factory."

Now let us see how he fares when he leaves his own métier between 1550 and 1570 and goes on a (hypothetical) visit to the *iguneromwon* or guild of the bronze casters, to whom he would have been introduced by the *oba* after presenting his obeisances. His visit might have been at about the very time of Esigye's death when the possibility was being considered of setting up one or more bronze figures on the ancestral altar and tomb in commemoration of the occasion when a detachment of Portuguese soldiers marched with Oba Esigye's victorious army against the Ata of Idah. Indeed, the likeliest date for his visit would be shortly after the death of Esigye, ca. 1550, when it would be incumbent upon his successor and son, Orhogbua, to make the arrangements for the erection of a tomb and the sculptures which would ornament it.

We need not detail with what skill he would have shown how the whole of Benin statuary, without exception, relied on rigidity for strength, and how he would have told them the way to put life into their figures and make them simulate movement. Then probably, as now, the members or brothers of the guild specialized in particular productions, so that, for instance, all aquamaniles would be made in one compound in the Street of the Bronze Casters, whose household head would have had a virtual copyright on the "properties," allotted by the *oba,* no doubt on the chief *ineniguneromwon's* advice.

In this hypothetical case one of the senior smiths of figures in the round would be given the job, and we have no means of knowing how many attempts were made before success was achieved; yet, if we are right in attributing to the Early or Middle Period only three Benin free standing figures (the remainder falling into the Late Period), then these three can be arranged in a very persuasive order: first, one in the Museum of Mankind in London is *sui generis* and seems to sum up the message which our commissioner might have recommended; secondly, two identical figures, one also in the Museum of Mankind, the other in the Nigerian Museum, despite a good spirality, show a weakness in the legs, which the commissioner might have advised precautions against.[129]

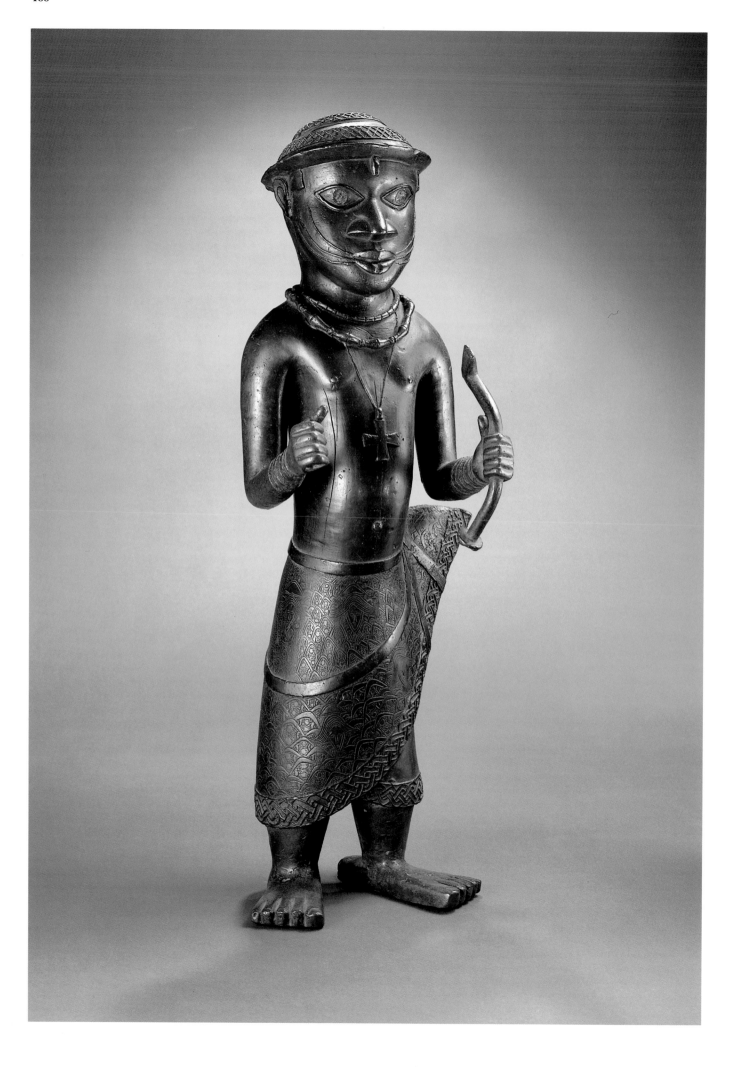

253. Messenger. Benin, Nigeria, second half of the 16th century. Large figures, like all Benin bronzes were made in the lost wax casting method by members of the *iguneromwon,* or bronze caster's guild. Within the guild, there was specialization by object type. The traditional style is generally frontal and symmetrical, and expresses a kind of timeless stillness. 63.5 cm. National Museums of Nigeria, Lagos.

254. Portuguese musketeer. Benin, Nigeria, ca. 16th century. This figure is the first and most successful of three similar figures in which Bini bronze casters have attempted to portray action. The spiral stance along with the robust and well-proportioned body distinguish this figure from the other versions. The hypothesis is that its creation resulted from the suggestions of the Portuguese visitor who also commissioned the ivories. He is credited with introducing movement into Benin art, a quality it did not maintain for long. 38.7 cm. Museum of Mankind, London.

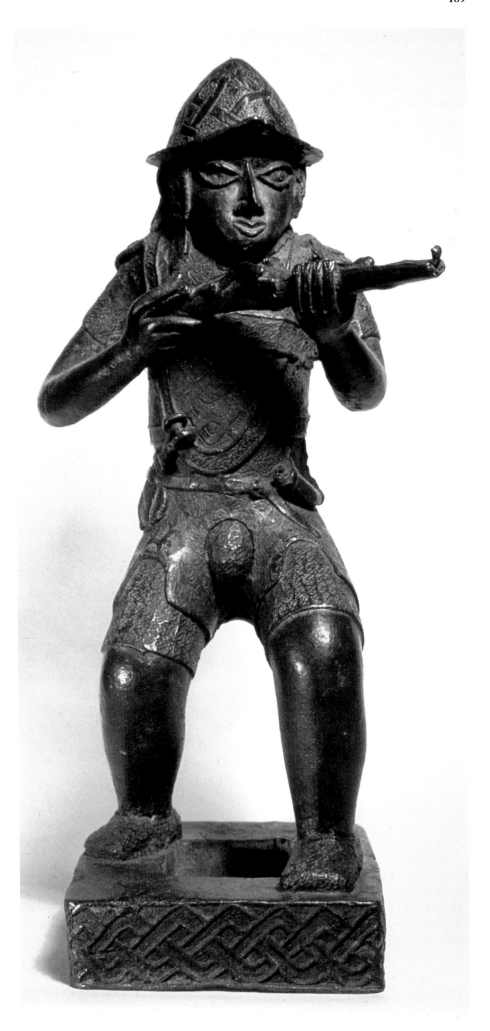

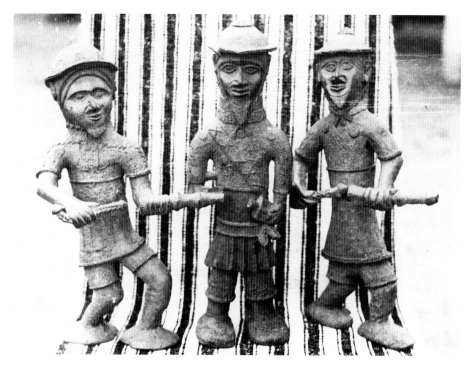

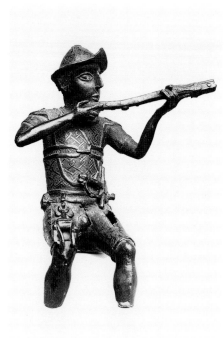

There now comes the bronze caster from Udo, about fifteen miles from Benin, where they had set up a casting industry of remarkably short duration, perhaps only twenty years or even less. Only fifteen or twenty bronze heads or figures were ever found there, all marked by an idiosyncratic, rather rustic style. In the 1950s R.E. Bradbury could not find traces of the casting activities on the ground such as are normal (old street names etc.). The Udo visitor or visitors must have decided to copy what they had seen, and wondered at the change that had come over the rigid art of Benin, at least in one small corner of the city. But, alas, the copies were a fiasco, mere cardboard imitations of the genuinely, all round, three dimensional sculpture—quite the opposite of the advice which our commissioner might have given if he had been consulted.[130]

It is abundantly clear from the two figures with flexed knees that the caster had seen the real thing and had failed to recognize the nature of the mini-revolution. When we next find Portuguese soldiers in bronze in the record, about 1650, a century after the commissioner's hypothetical intervention, the Middle Period has passed. It looks as though one or two examples may have been lost during the remaining part of the Middle Period; the figures executed during the Late Period number perhaps ten more. It must be recorded that, with the exception of the three Portuguese figures from Udo, all show a reasonable fidelity to the precepts of the commissioner. More remarkable still, no Benin casting in the round, other than Portuguese figures, has ever been noted as having the slightest trace of movement or other European influence attributable to this source. We can see the ghostly presence of the commissioner reaching through two centuries into the Eresoyen renascence ca. 1735–1750.

255. Three figures. Udo town, Benin Kingdom, Nigeria, 16th-18th century. About fifteen miles from Benin, Udo produced a small corpus of bronzes derivative of Benin works. These three rather rustic figures show a provincial and imperfect grasp of the principle of movement in sculpture. National Museums of Nigeria, Lagos.

256. Portuguese crossbowman. Benin, ca. 16th century. Second in the series of three, this figure begins to show departures from the instructions of the hypothetical commissioner of the ivories. Though the rotation of the body is maintained in the later versions, the legs are weak and the arms are disproportionately slight. Bronze, 35.5 cm. Museum of Mankind, London.

CHAPTER 10
A PROBLEMATIC YORUBA-PORTUGUESE SALTCELLAR

An isolated example of an unusual double container (no. 179) was discovered by one of us (E.B.) in the Kunsthistorisches Museum in Vienna. From the documents it appears to have been the property of Marchese Tommaso degli Obizzi in his Castle of Catajo near Padua and may be the object described in an inventory of 1806 as a "round ivory pot, decorated with human and animal figures, badly carved."

The larger spherical chamber, divided into a hemispherical bowl with a lid, rests on a conical base and is surmounted by a smaller container that has lost the domed lid commonly found on this type of artifact. The base as well as the lid of the lower container seem to have been turned on a lathe, possibly indicating that the ivory had been damaged and was refashioned in Europe.

Horizontal bands organize the surface. In the narrower bands a basket-weave pattern forms lozenges or triangles; in the main register of the bottom container appear birds—perhaps ibis—in profile, and on its lid mudfish as if seen from above. In addition to this low relief decoration, a set of four figures, almost in the round, is portrayed at the top and at the bottom of the piece: each set is composed of two kneeling women with raised arms, who alternate with two seated monkeys eating out of their right paws.

The ivory bears a label on the bottom with the phrase "*urna pera sal*," (bowl for salt). A close examination and comparison of this ivory with other Afro-Portuguese saltcellars, Sapi and Bini, exclude both of these origins. It bears resemblances, however, to sculptures of another Nigerian people, the Yoruba.

A nude female figure is a recurring subject in ivory sculptures from the Yoruba city of Owo, and similarities between this problematic saltcellar and such Owo works are striking. The facial features and the hair, carved in relief as a kind of cap marked by crosshatching, are typical of Owo sculptures. The treatment of the navel and the scarifications on the torso are identical, especially the lozenge-shaped marking in the center which can be seen clearly on Owo sculptures.

The Museum of Mankind also has an ivory monkey almost certainly of Owo craftsmanship, which, though less refined, is very similar to those carved on the Vienna container.[131] In the same style, it is also carrying food to its mouth, in a similar pose. Two monkeys carrying food to their mouths are also carved on a very old ivory armlet in the Frum collection in Toronto, which one of us (W.B.F.) places without hesitation in the Owo corpus.[132] The animals, seen in profile, are more highly stylized, but the striking angle formed by the forehead and the snout is also evident here. The bowl in the Museum of Mankind provides another example of the monkey image in Owo art: two monkeys carved in low relief face each other as they gobble fruit from a branch gripped firmly in their paws. Though the heads are raised, the deeply set eyes are noticeable. On a second lidded bowl in the Musée des Beaux Arts in Lille, a monkey on a lead of a European hunter is also eating fruit.[133] The birds and mudfish

257 and 258. Bracelet. Yoruba, Owo, Nigeria, before 1800. The seated monkey with hand to mouth is a motif characteristic of Owo art. The dark color of the ivory, which is preferred in Africa, is produced by rubbing with red palm oil (in West Africa), or with powdered camwood (in central Africa). Ivory, 14 cm. The Barbara and Murray Frum Collection, Toronto.

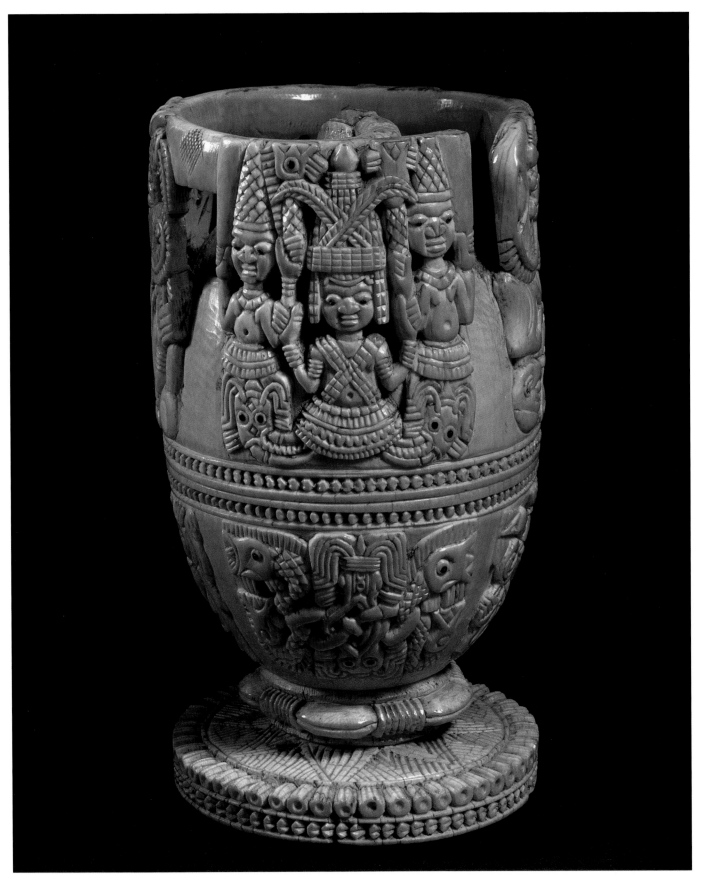

259. Lidded vessel. Yoruba, Owo, Nigeria, before 1800. A coiled serpent circles the top of the lid, his head turned down to devour the lower half of a man. The form, decoration, and iconography of this object are typical of Owo and show no trace of contact with Europe though it must have been made after the Portuguese landed on the coast. Owo is about twice as far from the sea as Benin is, and does not seem to have received European visitors until the nineteenth century. (See view of other side, page 176). Ivory, 21 cm. Private collection.

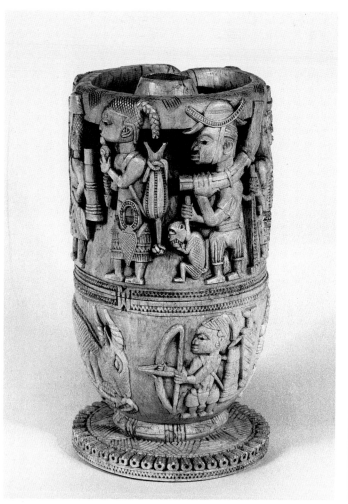

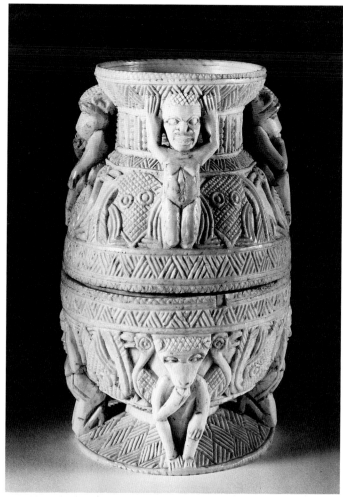

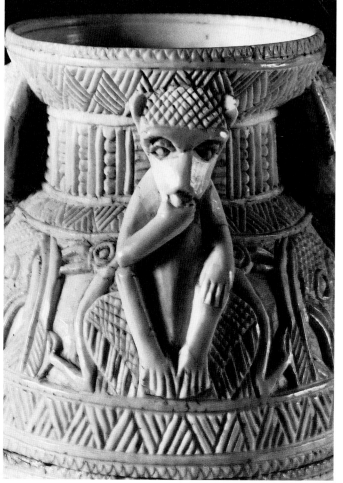

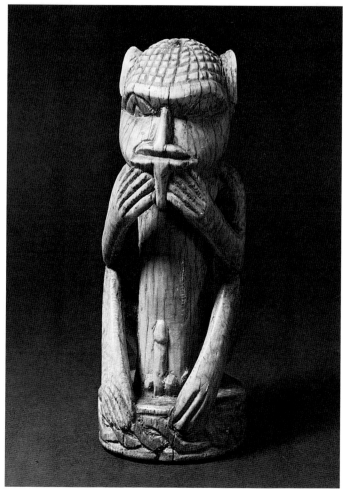

260. Lidded vessel. Yoruba, Owo, Nigeria, before 1800. Identical in configuration to the previous vessel, this one nevertheless seems to show a European presence. The figure wearing a brimmed hat with a chin strap, shirt and trousers may be a European. He carries an ivory tusk or horn over his shoulder, and leads a monkey on a leash. Two motifs we have previously discussed as typical of Owo art can be seen here: the monkey seated, hand to mouth, and an antelope eating leaves (in the lower register). Ivory, 24.5 cm. Musée des Beaux Arts, Lille.

261. Base and midsection of a saltcellar (missing lid). Owo-Portuguese, Nigeria. 16th century (?). The double chambered type of vessel is found in Africa only among works made for the Portuguese, leading to the conclusion that this must be an Afro-Portuguese work. The presence of the beaded line (placed vertically on the band around the neck of the vessel) also supports such a conclusion. The Owo origin is revealed by the figures of monkeys eating fruit, and the style of the female figures. In particular, the long flame-shaped scarification on their torsos is typical of Owo. 12.5 cm. Kunsthistorisches Museum, Vienna (no. 179).

262. Detail of the Owo-Portuguese lidded vessel. The typically Owo rendering of the monkey's jutting forehead can be seen here. Note the triangulated basket-weave pattern seen on other Owo vessels. Incised into the background is a bird. Kunsthistorisches Museum, Vienna (no. 179).

263. Monkey. Yoruba, Owo, Nigeria. The face is treated in a way nearly identical to the one on the Owo-Portuguese saltcellar. Ivory, 12.6 cm. Museum of Mankind, London.

264. Kneeling female figure. Yoruba, Owo, Nigeria. The style and details of hair and scarification are similar to those seen on the Owo-Portuguese vessel. The kneeling caryatid is also similar and it is a frequent theme in African art. Like much African art made for African use, this small figure has great presence and seems to express contained power. Ivory, 28.5 cm. Pitt Rivers Museum, University of Oxford.

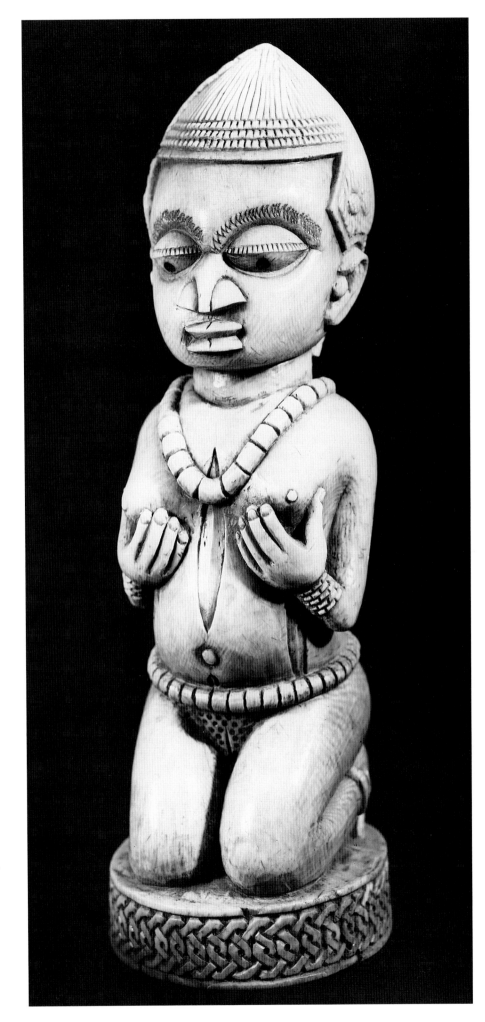

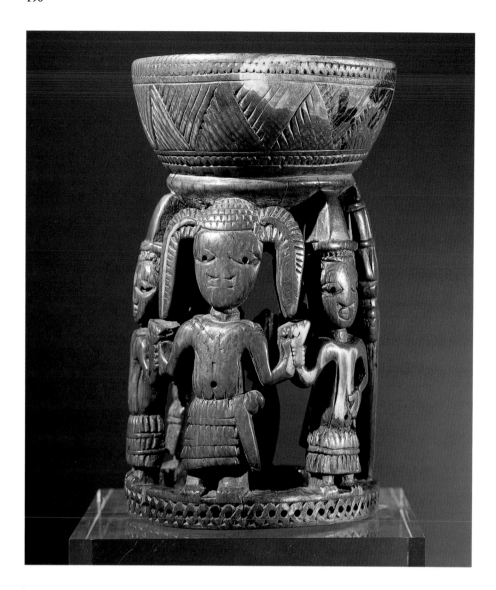

265. Caryatid vessel. Owo, Nigeria, before 1800 (?). The pendulous headdress marks the central figure as a priest of a Yoruba cult. Note the similarity between the basket-weave pattern on the vessel here and that on the base of no. 179, the Owo-Portuguese salt on page 194. Ivory, 15.6 cm. Leloup Gallery.

on the problematic ivory (no. 179) also belong to Owo, and more broadly to Yoruba iconography, as well as to that of Benin. Finally, the basket-weave pattern on the base of the container is also a common motif in Yoruba art.[134]

A close examination of the problematic ivory reveals that at least one motif of probable European origin is present in the decoration of the stem of the upper container—the Manueline beaded line. This motif is also used to separate the different figures on the surface of three bracelets attributed to Owo.[135]

Considering this evidence, the fact that the double container form is found only in saltcellars made for Europe, and that very thin walls are characteristic of Afro-Portuguese ivories, one might hypothesize that this container is a novel version of these refined artifacts. An apparently unique sculpture, it is important as proof that the Portuguese had obtained from the Yoruba a type of artifact that was believed to be created only by Sapi or Bini artists.

CHAPTER 11
THE AFRO-PORTUGUESE APOCRYPHA

Having exhausted the list of works created for export that unquestionably merit the name "Afro-Portuguese" ivories, a number of problematic works remain to be discussed. Though these works combine European and African elements in their decoration or structure, there is insufficient evidence to prove indisputably that they were destined for Europe. We prefer, therefore, to call these works "Afro-Portuguese apocrypha" until one finds more convincing evidence to tip the balance to one side or the other.

AN ENIGMATIC SAPI-PORTUGUESE OLIPHANT

Among these works is an ivory oliphant in the Pigorini Museum in Rome (no. 180). This work has more or less the same proportions, the same thickness and the same type of apical mouthpiece as the Sapi-Portuguese oliphant in Lisbon, no. 107, but without lugs and with totally original decoration. The sides are completely covered with cross-hatching on which a nude woman and a crocodile are carved. The features of the woman's face recall those of the *nomoli,* while the slender silhouette of

266. Oliphant. Sapi-Portuguese, 16th century (?). The strange, elongated figure on this horn combines the facial features of the *nomoli* with reptilian limbs, and cross-hatching strikingly similar to that on the nearby crocodile. Only the apical mouthpiece suggests a European destination. 32.5 cm. Museo Nazionale Preistorico e Etnografico, Rome (no. 180).

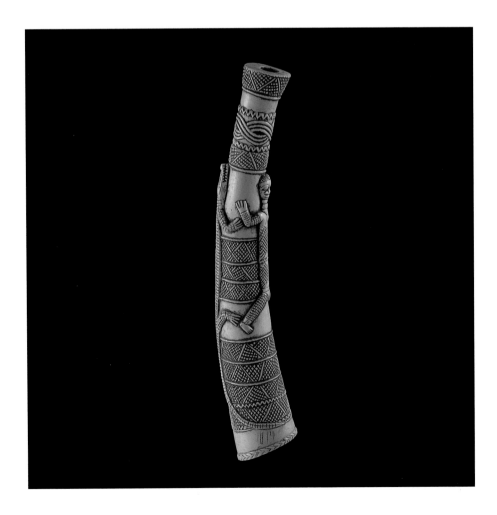

the crocodile, recalls the reptiles carved on other Sapi-Portuguese ivories, saltcellars and oliphants. The similarities with the Lisbon oliphant, along with the human/crocodile combination found in stone as well as in ivory sculpture, suggest that this oliphant was carved in Sierra Leone with traditional African motifs, possibly for European use (considering the apical mouthpiece).

THE KONGO OLIPHANTS

A problematic group of seven exceptionally elegant horns (nos. 181-187) bears evidence of yet another area of contact between Africa and Europe in the sixteenth century. Two of these oliphants (nos. 181 and 182) now in the Museo degli Argenti in Florence are, to our knowledge, the earliest African works to enter a European collection. They are recorded in 1553 in the inventories of the estate of Cosimo I de Medici, Grand Duke of Florence, under the heading of "two ivory horns decorated with engraved motifs."[136] While this sixteenth century allusion does not guarantee the identity of the objects (the first incontestable record is not until the eighteenth century), it can only refer to these two works, since this is the only pair of oliphants that we know of in the Medici collection with purely geometric design.

A third oliphant (no. 183) might also have been part of the Florentine group. A fourth horn (no. 184) is traditionally credited to the collection of the Peruvian writer Garcilaso de la Vega (1505–1536). The history of the other three oliphants is unknown.[137]

All of these oliphants are magnificent works of art, extremely elegant in line and exquisitely decorated over the whole surface with a plaited and interlaced pattern based on the Greek fret. This pattern fills both a horizontal register and a spiral zone which narrows as it approaches the end of the tusk. The mouthpiece is placed in the traditional African way—on the concave side of the tusk.

Stylistic similarities in the form and decoration of these seven horns are so apparent that we believe all seven are the work of a single artist. This master, gifted with a great artistic sensitivity, was capable of meticulous workmanship fully the equal of European Renaissance artists'. While the design is extremely complex, it is nevertheless entirely clear in its transparent geometry and rhythmic order; it is the work of a virtuoso who had complete mastery over technique. Like virtually all African sculpture and textiles except those made for Europeans, it was most probably produced without drawings or plans.

Geometric patterns perfectly distributed in a spiral space over the surface of the cone-shaped oliphants is a tour de force use of forms assimilated and fixed in the artist's visual memory. The design on the horns is typically African.

But the oliphants in question also have one or two lugs for suspension, carved out of the thickness of the tusk. The presence of lugs suggests European patrons, for lugs are never incorporated into traditional African oliphants. The placing of the mouthpiece on the side and the decoration of traditional Kongo motifs are African elements, but the addition of lugs is European. Perhaps the horns were to be presented to a European nobleman.

Indeed the two Florentine oliphants were very likely sent as gifts to the Pope by the king of the Kongo. During the first half of the sixteenth century, two Popes were members of the Medici family, the estate in which the oliphants were inventoried: Leo X was Giovanni de'Medici,

267. Oliphant. Kongo-Portuguese (?), Zaire or Angola (?), 16th century. Even though the design on the horn resembles the Greek fret and lozenge, it in fact belongs to the traditional decorative repertoire of the Kongo people. This horn is believed to have been in the collection of the famous Spanish writer of Peruvian origin, Garcilaso de la Vega (1505-1536). 61 cm. Museo de Infanteria, Toledo. (no. 184).

268. Oliphant. Kongo-Portuguese (?), Zaire or Angola (?), 16th century. The mouthpiece is placed in the traditional African way—on the concave side of the tusk. The stylistic similarities in the form and decoration of this group of oliphants lead us to believe that all are the work of a single artist. 70 cm. Musée de Cluny, Paris (no. 185).

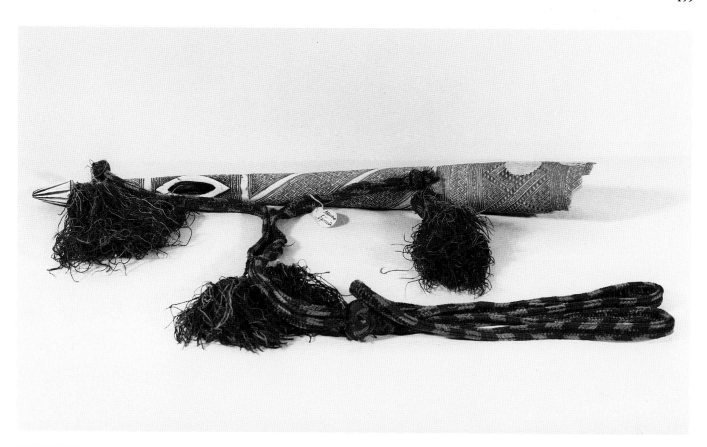

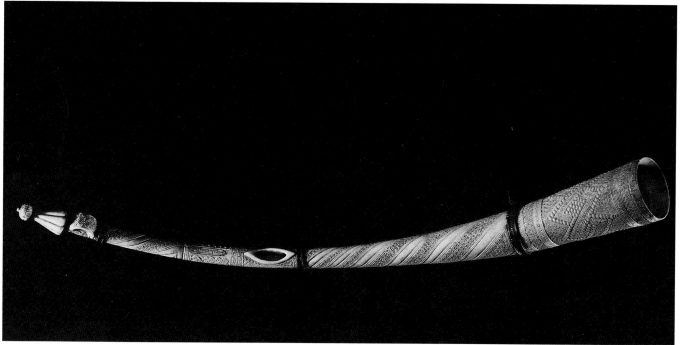

(1515–1521), and Clemente VII was Giuliano de'Medici (1523–1534). Moreover, Leo X is known to have appointed the son of the king of the Kongo as bishop. It is very likely, therefore, that the two instruments were presented by an ambassador of the distant African kingdom, with other signs of respect and devotion, to the Chief of Christianity.

On the other hand, it is equally conceivable that they were carved for the royal treasury of a Kongo king sometime after the arrival of the Portuguese, and only later were given away as gifts. If the oliphants were not made for export, but for local use, then the lugs were simply incorporated as an element of foreign exotica, and the name of "Afro-Portuguese apocrypha" is therefore justified.[138]

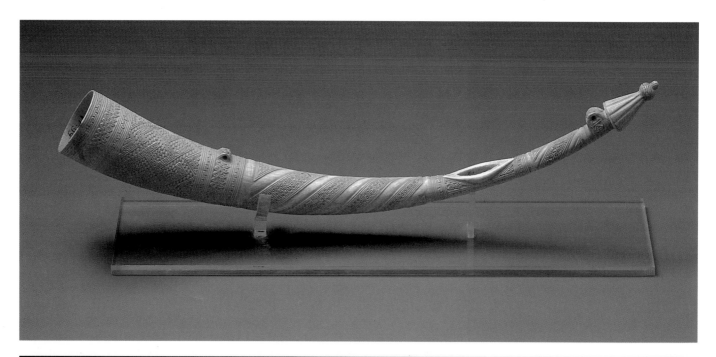

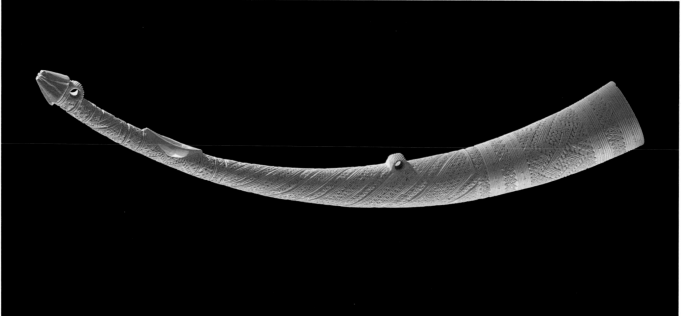

A UNIQUE KONGO KNIFE CASE

Another ivory documents contact between Europe and the Kongo Kingdom, a unique, elongated, vertical container, no. 190, supported by four partially nude figures standing on a round base. Four men in European costume, armed with swords, are carved in high relief on the sides of the square lid; their legs extend into the main body of the work.

While the human figures are not related to a known style—the heads of the figures on the lid even resemble Lega ivory heads from Eastern Zaire—the overall guilloche pattern is typical of the Kongo, and, though less inventive here, resembles that on the oliphants. This ivory was described in a sale catalogue of 1902 as a "knife case,"[139] and well it may be, given the shape of the cavity. If it is, then it would have been created for export, as there is no evidence of this type of artifact in a traditional Kongo context. Furthermore, it corresponds exactly to the taste of European nobility in the sixteenth century, as expressed in the Sapi-Portuguese and Bini-Portuguese ivories, and may be a true example of a "Kongo-Portuguese" ivory.

269. Oliphant. Kongo-Portuguese (?), Zaire or Angola (?), 16th century. One of the earliest African works to enter a European collection, this oliphant was alluded to in 1553 in the inventories of the estate of Cosimo I de Medici, Grand Duke of Florence. It was probably sent as a gift to the Pope by the king of the Kongo. During the first half of the 16th century, two Popes were members of the Medici family. 83 cm. Museo degli Argenti, Florence (no. 181).

270. Oliphant. Kongo-Portuguese (?), Zaire or Angola (?), 16th century. Two lugs carved out of the thickness of the tusk and used for suspension are clearly evident. Their presence suggests European patrons, as lugs were not seen on traditional African oliphants. 63 cm. Museo Nazionale Preistorico e Etnografico, Rome (no. 183).

271. Knife Case, Kongo-Portuguese (?), Zaire or Angola (?), 16th century(?). Two sets of four human figures surround the container: a partially nude group at the base, and a European costumed group with swords, on the case. While these figures do not correspond to any known style, the heads resemble Lega ivory heads from Eastern Zaire, while the overall patterning on the knife case is typical of the Kongo. Ivory, 30 cm. Detroit Institute of Arts (no. 190).

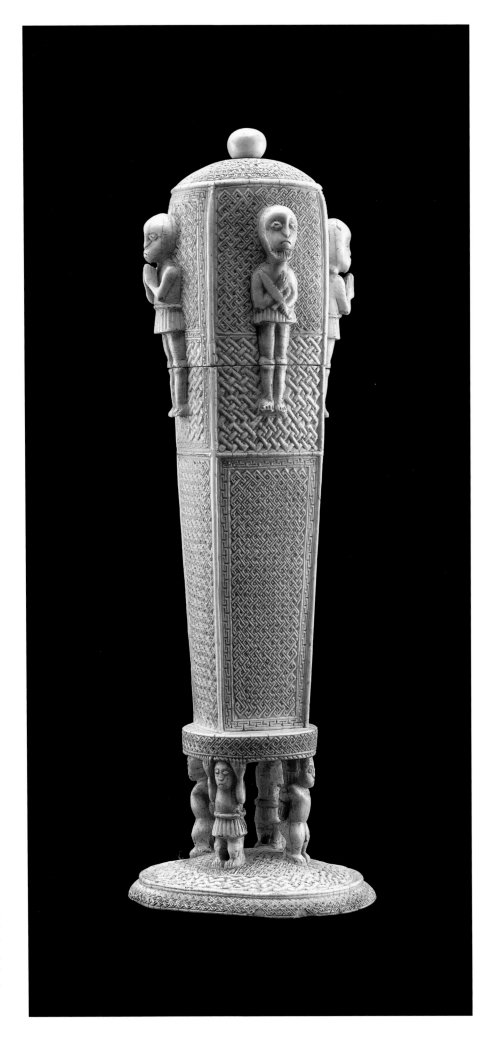

KONGO GEOMETRIC MOTIFS

The geometric patterns on the horns and knife case belong to the traditional decorative repertoire of the Kongo people inhabiting the area around the mouth of the Congo River, including parts of the modern Republic of the Congo, Zaire, and Angola, as well as the Cabinda enclave. They are present in all forms of Kongo figurative arts, including carvings in wood and ivory, textiles, knitted caps, mats, and baskets. They are found even in body decoration, and have persisted into the twentieth century, as is evident in the scarification patterns on the back of a young Kongo woman photographed by a Belgian ethnographer.[140]

It is almost certain that these motifs were developed before the Portuguese arrived in the Kongo area in 1482. In *Decadas da Asia,* the monumental work by Portuguese scholar João de Barros, the first edition of which appeared in Lisbon in 1552, the author states, "the king had on his head a cap as tall as a miter made of very fine and delicate palm leaf cloth, with decorations in high and low relief, similar to the velvet in our country."[141] This passage recounts a reception given by the king of the Kongo for the Portuguese ambassadors, headed by Ruy de Sousa in January 1490. It describes the caps we know perfectly, and may refer to the same kinds of patterning we can see on the oliphants. One of these wonderful caps entered the Danish Royal Kunstkammer in 1674.[142]

272. Seated mother and child figure, back view. Kongo (Yombe), Zaire, 19th-20th century. This finely carved mother and child figure is shown as elaborately scarified with traditional patterns from the Kongo repertoire. The all-over pattern of intersecting lozenge shapes, filled in with smaller geometric variations, are found in all forms of Kongo decorative art: wood carvings, ivories and textiles. Wood, 27 cm. Barbara and Murray Frum Collection, Toronto.

273. Photograph of a Kongo (Yombe) Woman. Zaire, early 20th century. This photograph of a young woman shows the distinctive cosmetic decoration worn by women from this region. This design bears striking resemblance to those found on textiles and ivories from the Kongo area. A prominent element that occurs elsewhere is the interlocking zig-zag pattern or knotlike interlace which dominates most designs, with subtle variation. Musée Royal de l'Afrique Central, Tervuren.

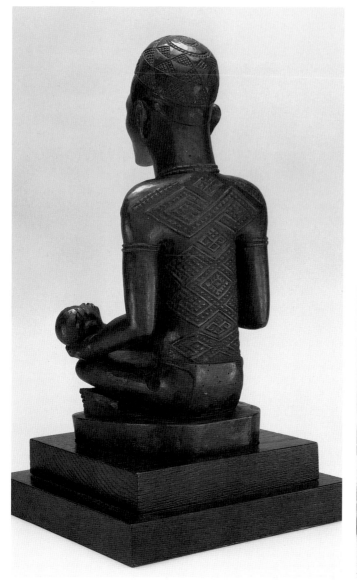

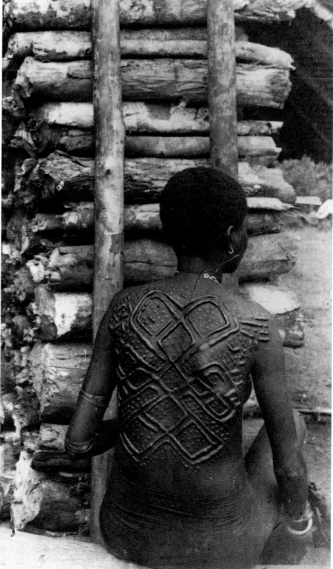

274. Woven Raffia cloth. Kongo, Zaire or Angola. 17th century. The geometric designs in low relief are similar to patterns found on ivory oliphants and other decorative art work from the Kongo region. They were sought after as "rare treasures" by Europeans in the 16th century. 70 x 39 cm. Museo Nazionale Preistorico e Etnografico, Rome.

Pile-cloths bear the most complete renderings of these traditional motifs. For this reason, they were sought after "as rare treasures" by European visitors, as evidenced in later reports of the seventeenth century. Some forty of these cloths have been identified in early European collections, but they were first registered in European inventories only after the second half of the seventeenth century. Then, as mentioned in the first chapter, they appear in the list of possessions of Alvaro Borges, the Portuguese settler who died in São Tomé in 1507.[143] In the same document, the word *enfulla* is used for the first time, evidently a corruption of the Kikongo name *mfula* or *pfula* to indicate one of the three cloths, while for the other two it is specified that they are "*avjlotados*" which means velvetlike.

Filippo Pigafetta, the Italian humanist previously mentioned, wrote a monumental work, *Relatione del Reame di Congo,* published in Rome in 1591, basing his account on the information of Duarte Lopez, ambassador to the Vatican from the king of the Kongo. Pigafetta found it "necessary to describe the wonderful art of the peoples of this and nearby countries, of weaving in different kinds of cloths such as velvets with and without pile, brocades, satins, sendals, damasks and similar cloths." He states that because the Africans do not know about silkworms, they weave their cloths with threads of "equal finesse and delicacy," obtained from palm leaves.[144]

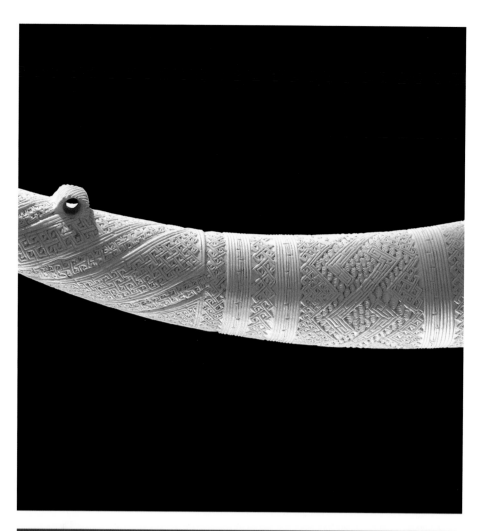

275. Detail of a Kongo-Portuguese oliphant (?). The refined geometric design of this oliphant is similar to designs found on African textiles and sculpture from the Kongo area. The interlocking structure of the zig-zag pattern results in a visually lively surface. The larger motifs dominate a wider surface area at the mouth of the horn, and are crisply raised from the surface. This is a feature also found in pile cloths from the Kongo. Museo Nazionale Preistorico e Etnografico, Rome (no. 183).

276. Detail of a Kongo-Portuguese oliphant (?). Clarity and sureness of line applied to the curved surface of this oliphant show the artistic sensitivity and meticulous workmanship of the finest African artists. While the design is extremely complex, it is nevertheless entirely clear in its transparent geometry and rhythmic order. It is the work of a virtuoso who had mastered a technique to wrap this design seamlessly around the complex curved and tapering form of the oliphant. Like virtually all African sculpture and textiles of geometric design it was probably produced without drawings or plans. Museo degli Argenti, Florence (no. 182).

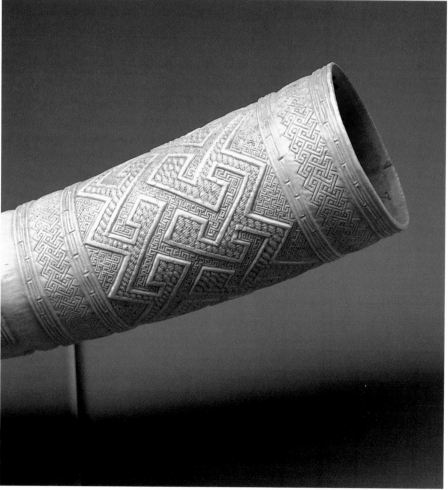

277. Seated mother and child figure, front view. Kongo (Yombe), Zaire, 19th-20th century. Geometric designs carved on the back extend to the front of this figure, covering the shoulders. The textural quality of the design is subtly expressed in this relief carving. A tactile element is frequently present in oliphants, pile cloths and other decorative arts, including cosmetic body decoration, depicted on this figure. Wood, 27 cm. The Barbara and Murray Frum Collection, Toronto.

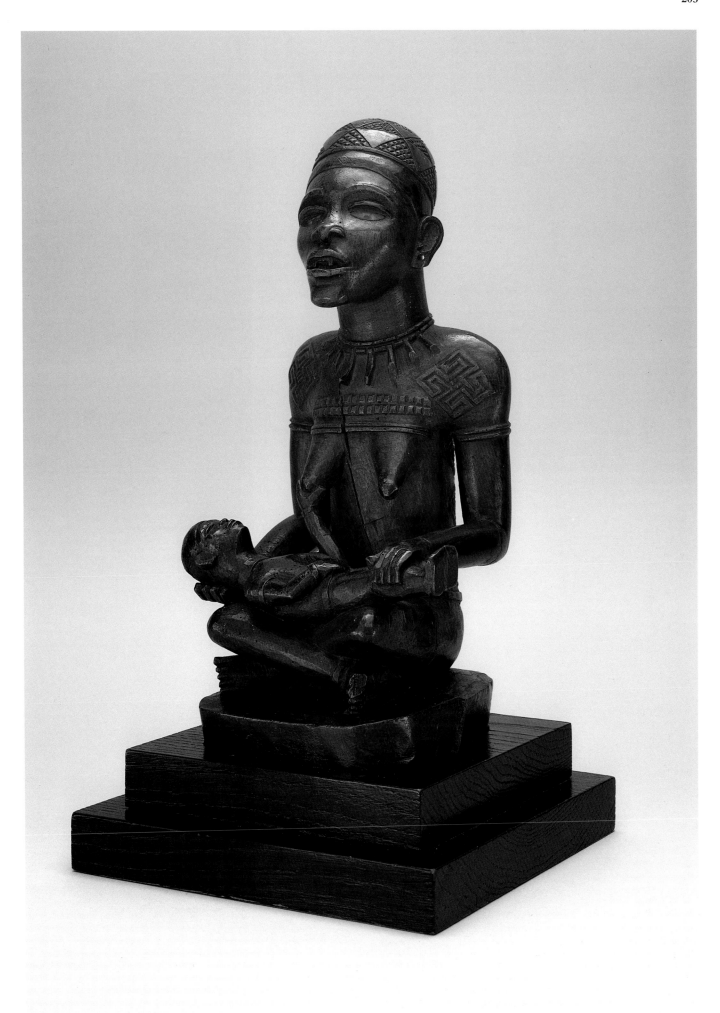

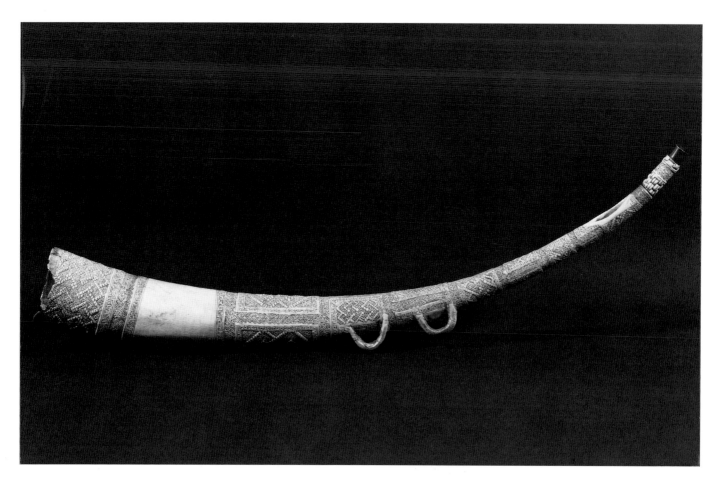

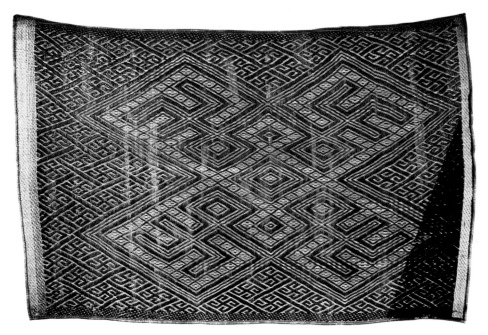

278. Oliphant. Kongo-Portuguese (?), Zaire or Angola (?), 16th century. Oliphants of this type are noted for their design. Its geometric patterns are perfectly distributed over the surface of this cone-shaped oliphant. The mouthpiece placed on the concave side of the tusk is a typically African feature and suggests it was made by African artists not for export to Europe, but for use in Africa. The presence of two lugs for suspension, is however an anomaly for an African horn and suggests that it may have been a gift. A commission specifically made for export to Europe would probably have had its mouthpiece placed at the tip of the horn. 71 cm. Fondation Dapper, Paris (no. 189).

279. Mat. Kongo (Sundi, Yombe). This mat, woven of pandanus leaves, was used as a decoration in the bridal house. The main pattern represents the wooden *kunda* bell of the healer. The patterns on this mat, collected in the colonial era, resemble those depicted on the mat in the Annunciation opposite. The technique of manufacture, however, is different from that shown in the painting. Fiber, 110 x 72 cm. Musée Royal de l'Afrique Centrale, Tervuren.

Along with oliphants, decorated cloths and caps were also part of the regalia of the king and chiefs. Both cloths and ivory carvings were mentioned together as being sent to Portugal as a present from the king of the Kongo immediately after the discovery of the Kingdom. Oliphants were used on special occasions, such as investitures and funerals, or in battle as discussed by Pigafetta.[145] Admiration for the cloths and for the motifs which embellish them and other Kongo works of art, most likely caused some imitation in Europe. This might be the origin of the so-called "Lisbon mats" common in the Portuguese capital, which show a geometric decoration reminiscent of the Kongo motifs.[146]

280. Annunciation by an unknown master. Portuguese school, 16th century. Renaissance Europe imported textiles and woven mats from Africa. The mat that forms part of the foreground here displays a common Kongo pattern. The artist's incorporation of this mat into an Annunciation scene which is not set in a humble domestic interior, suggests recognition of the value of African crafts in the 16th century. One 16th century account of the Kongo describes "the wonderful art of the peoples of this and nearby countries, of weaving in different kinds of cloths such as velvets with or without pile, brocades, satins, sendals, damasks and similar cloths." It is interesting to note that during this period Africa was exporting manufactured products. 6.95 cm. x 12.95 cm. Museu de Arte Antiga, Lisbon.

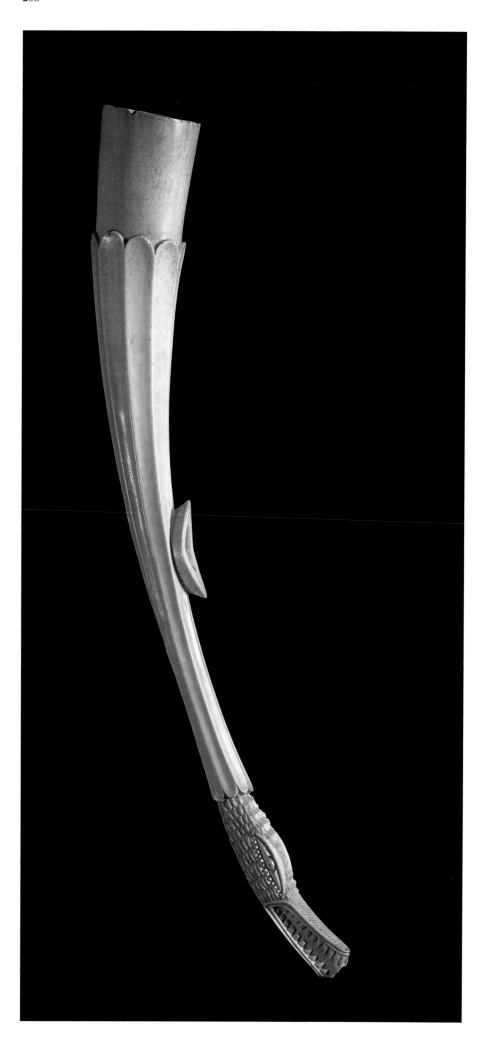

281. Oliphant. Afro-Portuguese (?), 16th century (?). Though they appeared in Europe at about the same period or slightly later than the Afro-Portuguese ivories, the fluted oliphants may have been made for African use. Like the Kongo examples, they have no European features aside from the lugs that appear on some of them. 62 cm. The National Museum of Denmark, Copenhagen (no. 193).

282. Oliphant. Mende (?), Sierra Leone. 19th-20th century. This unique horn, collected in Africa in recent times, is closer in form to the fluted oliphants than any others known, but the fact that no similar ones are known makes this an inconclusive comparison. Ivory. Staatliches Museum für Völkerkunde, Munich.

THE MYSTERIOUS FLUTED OLIPHANTS

A last mysterious group of oliphants pose more or less the same problems of origin and patronage as the Kongo corpus. This group includes seven complete examples (nos. 191-196 and 198a), and two fragments (nos. 197 and 198). They are ornamented with fluting that terminates in regular scalloped ends leaving an undecorated band at the mouth. Like the Kongo oliphants, they are extremely elegant in their streamlined forms. A lozenge-shaped mouthpiece in high relief is placed on the concave curve of the tusk, the end of which is carved in the form of a crocodile head. Like the Kongo oliphants, this group of instruments is entirely homogeneous and must have been produced by a single workshop in a short period of time.

There is evidence to suggest that this group of instruments dates to the sixteenth century. In fact, a complete oliphant now in Vienna (no. 191) may have been part of the collection belonging to the Castle of Ambras in Tyrol, that included the Bini-Portuguese spoons. "An ivory horn smooth and octagonal" is mentioned in the inventory of 1596. As Heger surmised as early as 1899, the mention could very well refer to the Viennese horn.[147]

The first fluted oliphant unambiguously identified is no. 197 (now reduced to a fragment), formerly in the collection of John Tradescant, gardener of the king of England. It is described in a manuscript catalogue of 1685 as "an Indian ivory curved trumpet; one end shows a human hand. In the middle it has a hole to play it."[148] We know, however, that the greatest part of the Tradescant collection was constituted before 1638, the year of the collector's death and may suppose, therefore, that the oliphant was carved some years earlier. The Indian attribution is not surprising since African ivories of a highly refined quality were frequently ascribed to the Orient. We know, furthermore, from a letter written by John Tradescant to "the Merchants of the Ginne Company and the Gouldcoast", on July 31, 1625, that he was seeking "instruments of the long ivory fluts."[149] This reference reinforces both the early date and the African origins of these oliphants.

Three other complete instruments appear in eighteenth century collections (nos. 192-194), and for the remaining four (three complete and one fragment) we have no information.[150] Despite the paucity of documentation, the early date of this type of horn is supported by an illustration in a book by Michael Praetorius, *Theatrum Instrumentorum,* published in 1619, which represents one of these African fluted oliphants.[151] Though the model for this particular drawing has disappeared, the drawing is nevertheless useful because it fixes an unquestionable *terminus ante quem* for the carving of these oliphants. Furthermore, this provides indirect evidence to support the identification of the oliphant mentioned in the inventory of the Castle of Ambras, and consequently, the probable attribution of the whole group of fluted oliphants to the sixteenth century.

It is difficult to assign the group with certainty to any particular point of the West African littoral. It is unlikely that it can be attributed to any Nigerian ethnic group; Benin in particular is ruled out by the position of the mouthpiece on the inner rather than the outer curve, the rule for Benin. East Africa can also be eliminated as a possible place of origin, despite the similarities of the flutings on the *siwa* horns of Arabian origin. The shape of the mouthpiece and the decoration above it are so different from the *siwa* horns and the overall size of the latter is so much greater (they are about two meters), that we can exclude an East African provenance.

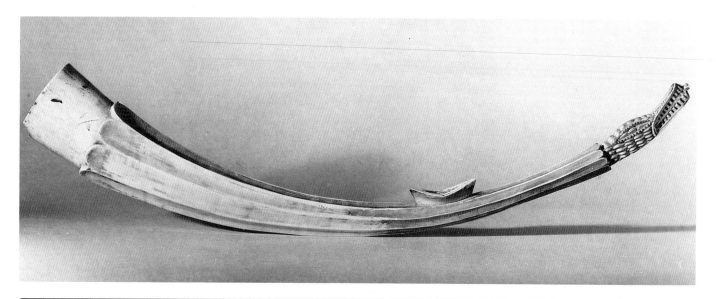

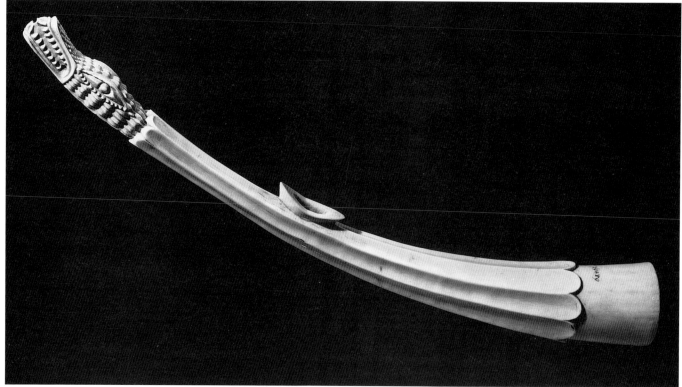

283. Oliphant. Afro-Portuguese (?), 15th–16th century. The seven known horns in this style are nearly identical and probably came from a single artist or workshop, though it is difficult to place. There are some indications for Sierra Leone (see ill. 282) and others for the lagoon peoples of the Ivory Coast. An early description of such a horn alludes to a hand (now lost) carved at the tip. This motif occurs on ivory staffs in a kindred style made by the Akye and Ebrie peoples of Ivory Coast. 79.5 cm. Musée de l'Homme, Paris (no. 195).

284. Oliphant. Afro-Portuguese (?) 15th–16th century. This horn may be the "ivory horn, smooth and octagonal" mentioned in the inventory of 1596 made at the Castle of Ambras in Tyrol. Other Afro-Portuguese ivories came from

Ambras. Despite the small number of fluted oliphants known today, a great number are depicted in hunting scenes on tapestries. 71 cm. Museum für Völkerkunde, Vienna (no. 191).

285. Oliphant. Mende, Sierra Leone. 19th–20th century. In modern times the Mende have made ivory horns for their own use that terminate in a head or figure in a style similar to their wood sculpture. Though they have little in common with the 15th and 16th century examples, they follow the same configuration as the fluted horns, some of which terminated in a head wearing a hat. The small figure of a lion engraved faintly on the side of this horn is unusual and recalls motifs carved on the Sapi-Portuguese horns. Ivory, approx. 43 cm. The Virginia Museum of Fine Arts, Richmond.

286. Oliphant. Mende, Sierra Leone, 19th–20th century. Ivories used in Africa are usually colored a deep reddish brown with red palm oil or powdered camwood, a dye. This color—or the lack of it can be taken as a marker for objects made and used in Africa as opposed to those made for export and preserved outside Africa. Ivory, approx. 38 cm. Private collection.

287. Seated figure. Akye or Ebrie, Ivory Coast. An early station for the export of ivory, (Sierra Leone was known as the Grain Coast) the Ivory Coast may be the source for the fluted oliphants. Figures like this from a staff top bear a resemblance to the head shown in an early drawing of a fluted horn. Ivory, approx. 10 cm. Musée Barbier-Mueller, Geneva.

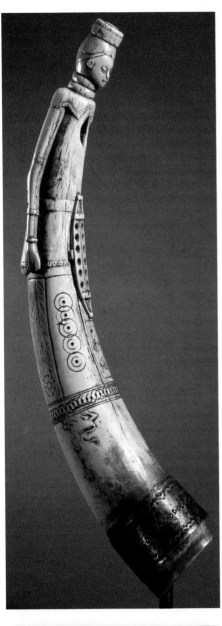

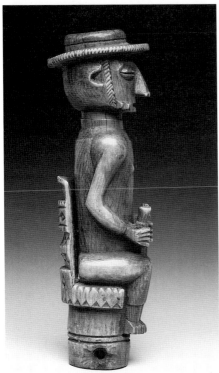

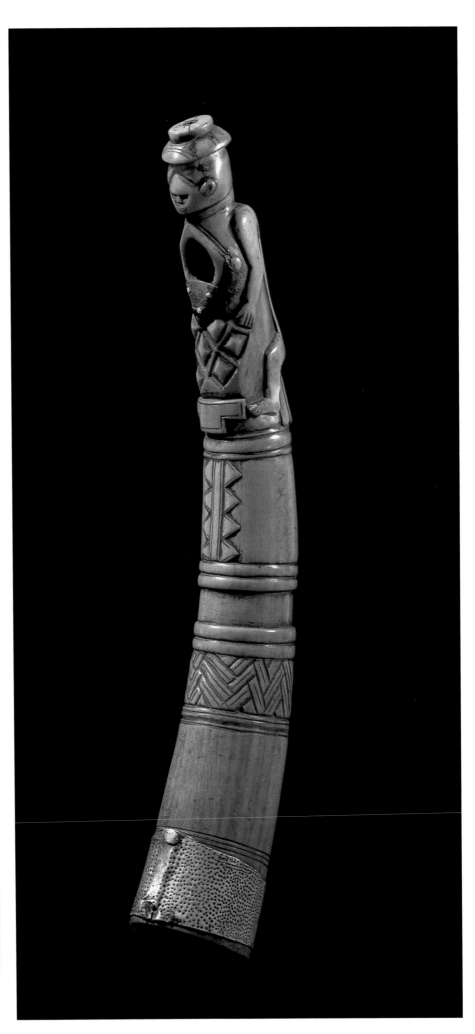

Sierra Leone is a possible source: nineteenth and twentieth century oliphants belonging to Mende paramount chiefs have lozenge-shaped mouthpieces similar to those we are considering.[152] Some are fluted and scalloped. Moreover, the motif of the crocodile was frequently represented in Sierra Leone in the sixteenth century as seen on the Sapi-Portuguese ivories, though the artistic conventions differ.

The carved terminal of the horn, illustrated in *Praetorius,* that shows a human head coming out of the mouth of a crocodile is reminiscent of a considerable number of eighteenth and nineteenth century ivory carvings from the Kingdom of Kongo and the Ivory Coast. These include scepters and staves surmounted by representations of seated Europeans with head-gear very similar to that on the *Praetorius* oliphant (no. 199).[153]

The oliphants nos. 192 and 196, the fragment in Oxford, no.197, and the instrument illustrated in *Praetorius,* all show a lug on either the concave or convex side of the tusk, much like the Kongo oliphants. The presence of this device and the fluting are both European traits, but the lack of any evidence of their production for European patrons, or of their exportation to Europe, forces us to confine these wonderful works of art, as the previous ones, to the limbo of the Afro-Portuguese apocrypha.

288. Illustration from *Theatrum Instrumentorum,* published in 1619. A fluted oliphant appears here unlike any that have survived. The head of a man wearing a hat emerges from the jaws of the crocodile head like the one that terminates all the known examples.

CHAPTER 12
CONCLUSIONS ON THE AFRO-PORTUGUESE IVORIES

After years of study we have drawn many conclusions—often speculative—because in some instances there were no definite elements on which to base our research. Since the creators of the Afro-Portuguese ivories left no written records, we have been obliged to rely on information drawn from art objects and European sources. Only in very few cases has African oral tradition been helpful.

We have placed the varied and fragmentary information, in some cases only a few bookkeeping notes, next to each other like the pieces of an incomplete puzzle. When we then added an analysis of the form of the works in question, we were able to outline an interesting phenomenon: the cross-cultural interaction between Europe and Africa, documented in art at the very beginning of contact.

The evidence shows two very different cultures in touch with each other for about half a century in the workshops that were in areas now known as Sierra Leone, Nigeria and Zaire. African artists have left us the only concrete result of this encounter in the ivories in which they merged African and European elements to produce a new artistic style. Original and derivative at the same time, this style is correctly termed Afro-Portuguese.

The presence and originality of traditional elements in commissioned art depends on the importance and power of the local artistic tradition. In Black Africa a strong and sophisticated local artistic tradition had existed for a long time. The new contacts introduced elements of European origin into a few objects made for local use, as is evident in oliphant no. 201, now in Paris.

Other European elements were also absorbed into art made for local use, although in a less direct way than in the ivory workshops. The new contact gave rise to—in the case of Benin—aquamaniles in the shapes of animals, and the brass plaques portraying Portuguese visitors. It is interesting to consider the possibility that the rectangular shape of the plaques, a shape rarely encountered in African art, is probably derived from European and Asian illustrations and represents an important feature inspired by non-African sources.

The coastal kingdom of the Kongo was the area most exposed to European influence. There we find: crucifixes and images of the Madonna and saints which survived, drained of all Christian meaning, to be used in the rituals of traditional African religions; swords which recall sixteenth century Iberian models; and the finials of Kongo staffs. In wood and ivory, these depict a nobleman wearing a typical sixteenth century European costume—pantaloons, a high-collared jacket and one pendant earring, all of which appear on the lists of items the Portuguese brought to Africa as commodities and gifts. These were worn by wealthy and important Africans on ceremonial occasions.

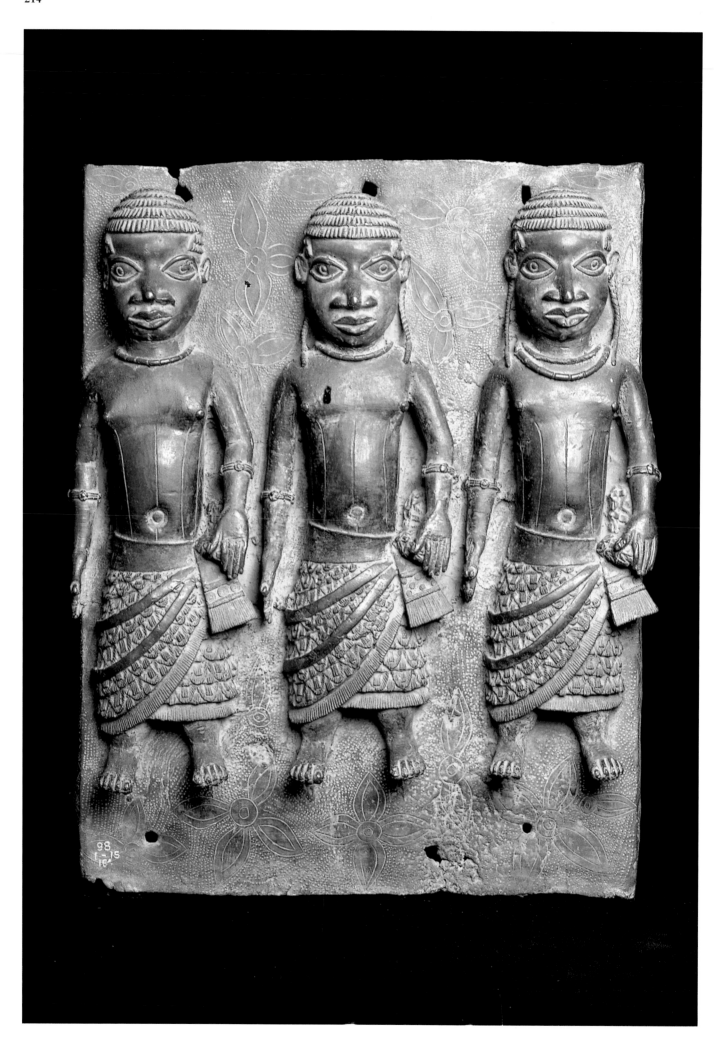

289. Plaque Showing Three Court Attendants. Benin, Nigeria, late 16th or early 17th century. The pictorial and narrative quality of Benin plaques set them apart from the great body of African artistic expression. They are distinguished from the art of other African peoples by being bas-relief sculptures, rather than sculpture in the round, and by their rectangular format. A good case may be made for the argument that they were inspired by European picture books and may owe something to European bas-relief sculpure as well. Bronze, 48.9 cm. Nigerian National Museum, Lagos.

290. Leopard. Benin, Nigeria, 16th-18th century. Ever-diminishing echoes of the contacts with Renaissance Europe lingered in African art and culture for centuries. Though the leopard is a widespread symbol of kingship on the African continent, figures such as this one may have been inspired by late medieval aquamaniles, European water vessels in the shape of animals. Bronze, 43.2 cm. Minneapolis Institute of Arts.

In the early discovery period, the Portuguese' dealings with the local populations were mostly commercial—in which the Europeans found themselves at no particular advantage. Skin color did not play a determining role, as it would later on. The ivories and the conditions in which they were created shed light on the extent of cultural exchange: for their part, Europeans commissioned the works, supplied models, and in some cases gave the artistic direction, as we see in the saltcellars from Benin; on the other hand, the artists were African, so gifted that their works were sought for the houses of aristocrats and as gifts to Popes and royalty.

The duration and quality of the experiences which produced the Sapi-Portuguese and the Bini-Portuguese ivories were different. The Bini carvers of saltcellars were fewer in number and worked for a shorter period in the service of the Portuguese than did the artists of Sierra Leone. They also followed the alien commissioner/teacher more closely, limiting their subjects to Portuguese dignitaries, and depicting movement introduced here for the first time.

The artists of Sierra Leone clearly enjoyed greater freedom. Most of the motifs on the saltcellars are their own and the style in which they are represented, especially the portrayal of humans and animals in the round and in high relief, conforms to local canons. Even in the oliphants which consist mainly of foreign imagery in the hunting scenes, the artists ignore the accepted European canons for depicting space.

The creation of the Afro-Portuguese ivories is a unique event in the history of African art. In no other period of the intercultural relationship between Europe and Africa has artistic creation been so fruitful. As regards European appreciation, only Kongolese textiles were admired as much as the Afro-Portuguese ivories. Though we find no contemporary written expressions of this favorable judgment it becomes obvious when we consider the destination of the ivories. Both the preciousness of the material and the skill of execution of European designs played important roles in this appreciation. The exotic origin of these splendid "ivories curiously wrought" was no doubt also an element, but a fairly balanced relationship between the two cultures was probably the determining factor. Not long after this period, the slave trade and the Industrial Revolution radically transformed the relationship between Europeans and Africans. The slave trade could only exist if Africans could be redefined as inferior beings. Industrialized Western nations attributed to racial differences what they perceived as their superiority, without taking into account the plunder of Black Africa at the hands of the Western world or the price paid by their society for their own development. This claim to superiority, corroborated by so-called scientific proofs, which today appear both wicked and ridiculous, enabled the European powers to enforce their "rights," camouflaged as duties, and to spread their civilization in exchange for raw materials at a very low price. The culmination of this operation was the division of Africa in the second half of the nineteenth century, as sanctioned by the Berlin Conference of 1884–1885.

The later unequal, and often brutal, encounters contrasted with the reasonably benign relationship between the two cultures during the Renaissance. Works from later periods, European paintings and sculptures portraying Africans, and African sculpture portraying Europeans, are often scornful, satirical and harsh, documenting this change in attitude.

Africans appear in sixteenth and early seventeenth century European works of art clothed in the sumptuous robes of the Magi, or in those of ambassadors. One example is the portrait in marble of Antonio Manuel ne Vunda, the cousin of the king of the Kongo and the Ambassador to

291. Staff. Yombe, Zaire, 18th-19th century. The man depicted here in pantaloons, doublet and an earring is a Kongo chief. Full costumes in a style fashionable in Europe in the 16th century continued to be portrayed in Kongo ivories long after the Portuguese had ceased to be a presence, and these styles were no longer worn in Europe. In Benin, Portuguese figures always appear this way. Items of European clothing were probably gifts to African rulers, who no doubt preserved them as exotic curiosities. Africans seem to have appreciated these European clothes mainly as precious exotica, but the styles seem to have had no particular influence on African dress. Wood, ivory, metal, 99 cm. Carlo Monzino collection.

292. Aquamanile in the shape of a horse. German, 15th century. Aquamaniles, water vessels, in the form of various animals and birds, were made in the 13th-14th century in northern Europe, mainly in Germany and Flanders. They seem to have been the source for the leopard figures made in Benin in the 17th and 18th centuries. Both have pierced nostrils through which to pour, and a small lidded opening (vestigial in the leopard on page 215) through which to fill the vessel. Metalwork, bronze, 47.6 cm. The Metropolitan Museum of Art, Gift of William M. Laffan, 1910.

293. Crucifix, Kongo, 17th century. Christian converts in the Kongo kingdom fell away from the Catholic religion fairly rapidly, but preserved its most dramatic symbol, the crucifix. They made numerous replicas for use in hunting cults and rituals connected with rulers. Examples like this one with a metal corpus on a wooden cross are rarer and thought to be earlier than the all metal ones. Wood, bronze, 34.3 cm. Ernst Anspach collection.

294. Crucifix. Kongo, 18th century. In the course of time, Christian symbols became intermingled with African ones. Here the artist has placed small figures of attendants and mourners on the body of the cross itself. The gesture of right hand to the shoulder is a sign of respect or deference to a superior; the hand to the mouth is also a mark of submission. The figure at the top of the cross incongruously takes the posture of the Venus Pudica, even to her flexed knee. Metal, 27.9 cm. Ernst Anspach collection.

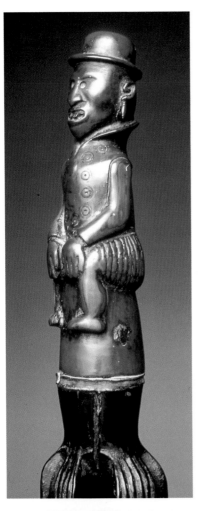

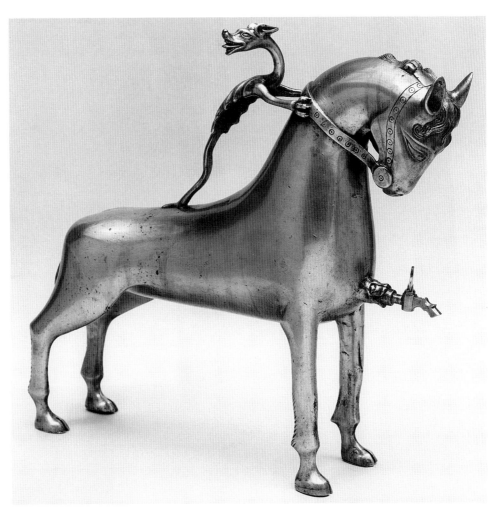

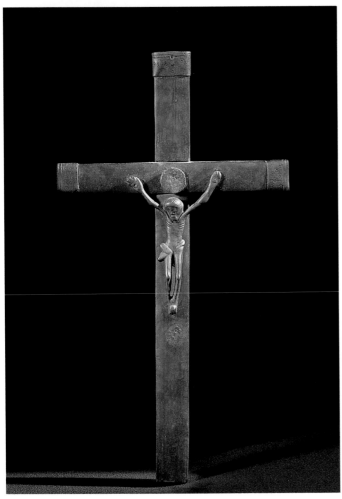

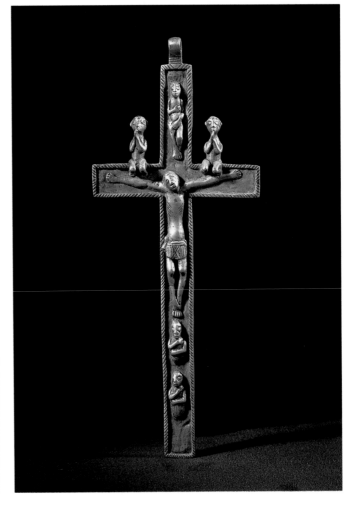

218

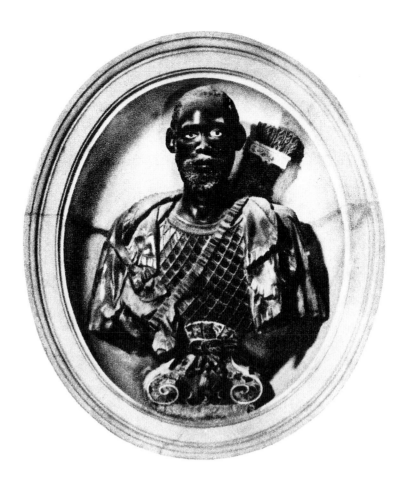

the Holy See, who died in Rome in 1608. It was carved by Francesco Caporale and can be seen in the chapel of Santa Maria Maggiore in Rome. In colonial days, however, Africans are shown either in the clothing of servants and slaves or as cruel and stupid savages. In African art of the earlier contact period Europeans are portrayed—on the Bini plaques— nobly on horseback, or accompanied by attendants, as was the *oba;* later they are shown in less dignified attitudes, often with a bottle of alcohol and a glass in their hands.

During the period of colonial domination, Europeans accumulated thousands of works by African artists, often without documentation or consideration of their aesthetic qualities. Placed in natural history or ethnographic museums, they were treated as simple artifacts demonstrating a way of life, one which was compared to the earliest phases of human development, equivalent to European prehistory.

Only after 1906 did the "discovery" of African sculpture in France and Germany by avant-garde artists, their writer friends and art dealers begin to overturn the situation. Works of the anonymous and, until then, despised African artists became inspirational models. Within half a century classical African art had come to major art museums where it took its place with the greatest art of other cultures, just as four centuries earlier the Afro-Portuguese ivories had become part of the *kunstkammern* of exacting Renaissance kings and noblemen.

295. Portrait of Manuel ne Vunda by F. Caporale, Rome, ca. 1608. Made of colored marble, this bust is one of a series portraying distinguished personages in the baptistry of the church of Santa Maria Maggiore. The only African in the group, Manuel ne Vunda, known as Antonio Nigrita, was the ambassador from the king of the Kongo to the Holy See. Marble. Chapel of Santa Maria Maggiore.

NOTES

1. Laude 1968, p. 19.

2. The Latin manuscript, *De Canaris et insulis reliquis ultra Hispaniam in Oceano noviter repertis,* is in the Biblioteca Nazionale, Florence, Fondo Magliabechiano, no. 122.

3. da Mota 1960, p. 17.

4. Crone 1937.

5. Some of the precious metal carried to Europe was in the form of jewels. Shipping documents record that in 1502 the Portuguese imported from the Gold Coast about 2,000 ounces of gold "all in manillas and jewels which the natives are accustomed to wear." Later accounts similarly record great sums of gold fetched in "trinkets and gold pieces." Blake 1942, vol. I, pp. 93, 237.

6. Curtin 1969.

7. An English adventurer, Thomas Wyndham, in 1553 sent his Portuguese captain, Pinteado, to Benin to pay his respects to the *oba* (Esigye in his last days?), who spoke Portuguese. Pinteado was well received and was promised a cargo of pepper for the return voyage. R. Hackluyt, *The Principal Navigations Voyages Traffiques & Discoveries of the English Nations,* Glasgow, 1904, Vol. VI pp. 145-152.

8. Filesi 1967.

9. Ibid.

10. Ibid.

11. de Pina, Coimbra, 1950. Chapt. LVIII, p. 148.

12. Bassani 1975.

13. The Vicentine humanist, Filippo Pigafetta, in his *Relatione del Reame di Congo et delle circonvicine contrade,* published in Rome in 1591, devoted a long description to cloths.

14. da Mota, personal communication to E.B.

15. Rodney 1967, p. 241. Rodney's statement was questioned by P.E.H. Hair who believes that the Mani made a small scale migration, rather than a real invasion. Hair 1968 and 1974.

16. Ibid. pp. 240, 241.

17. Fagg 1959.

18. Skeleton celestial globe of metal rings, representing the tropics, etc.

19. Dürer, Berlin, 1918, p. 74. Calicut is the present town of Kozhikod on the Gulf of Oman. It was the first Indian port at which Vasco de Gama called in 1498.

20. Foy 1900-1901, pp. 20–22.

21. Ryder 1964, da Mota 1975.

22. Ibid.

23. Pacheco Pereira 1905, book I, Chapt. 33.

24. Fernandes 1951, p. 96.

25. de Gois 1945, p. 119.

26. de Pina 1792, chapt. LVIII, p. 148; de Resende 1545, chapt. CLV; Osorio 1944, vol. I, book III, p. 133.

27. Welsh 1904, p. 252.

28. Cordeiro 1881, p. 27.

29. Bonanni 1709, pp. 235 and 299.

30. Allison 1968; Dittmer 1967; Lamp 1983; Tagliaferri 1974.

31. Purchas 1625, p. 2.

32. The strict plural according to Lamp is *nomolisia,* but we retain the singular for convenience.

33. Now in the Morigi collection in Lugano, and in the Peabody Museum, Cambridge, Ma. See Sieber 1980, p. 135.

34. A famous example is the saltcellar made by Benvenuto Cellini for the King of France, Francis I. It is now in Vienna.

35. The covered cup, probably of Portuguese origin, decorated with a diaper of pearled bosses with a trellis pattern of wriggle work is a good example. Victoria and Albert Museum, London. inv. no. M.49.1959, silver gilt, 28 cm.

36. See the Adoration of the Magi, painted by Hans Memling in 1464 now in the Prado.

37. See prints by Venceslas of Olmutz, Albrecht Altdorfer (1480–1538), and Hieronimus Hopfer, active in Augsburg c. 1520, a great copyist after Dürer. Hollstein 1954, vol. I, nos. 103-120. Hébert 1982, nos. 1489-1491, 1493, 1494, 1844-1846, 2869-2871.

38. Uffizi, Florence, inv. no. 1758A, sepia on paper, 34 x 34 cm.

39. Fyfe 1964, p. 29.

40. An example of a saltcellar with a conical base, no. 15, has four human figures in high relief. The pillowlike form (without serpents) and the usual decoration of convex, spiral bands, separated by rows of beads, are all elements characteristic of the first category. This one is different from all others examined so far: it has two superimposed containers (the upper cover is lost), just as one finds in saltcellars from Benin, although these differ in shape.

41. Two men in Portuguese dress alternating with two women, stand upright on salts nos. 33 and 34, while the container is decorated with rows of beads set too close together to leave any empty fields. One example, no. 50, known only from a photograph, bears no human figures, but only geometric elements supporting the disk on which the cup rests. Salt no. 49, missing its lid, in place of the customary figures shows two women, a child and two warriors, alternating with the vertical supports for the disk, which are surrounded by four crocodiles in the act of devouring men.

42. The man carved on the base of a saltcellar in the Bowes Museum (no. 16) carries a typical round shield and two spears with large blades. The woman wears a series of bracelets and a peculiar ornament at the neck.

43. The saltcellar in the Royal Scottish Museum (no. 17) bears a particularly rich decoration. One section of the figures in the round decorating the lid has been lost, but is visible in a drawing done before the object was broken. In addition to the figures of men, women, dogs, parrots, and serpents carved on the base, also note that the snakes slither across the pillowlike form and hold little birds in their jaws. The form of the container is also rather unusual, in fact, the diameter of the lid, adorned with crocodiles in low relief, is smaller than that of the container. The finial group is composed of a circular plate across which crawl two serpents, attacking two parrots. In the center of the plate a chameleon climbs up a tree trunk. On the other side, (as revealed in the drawing) was a man in Western dress holding a third snake attacking yet another parrot. As we have stated, we cannot explain the meaning of this scene, but it seems that as originally carved it was well within the cultural repertoire of the ethnographical picture of the Sapi culture.

44. Note that the first of these saltcellars has been restored; Margaret Plass has written that the group on the lid is a replacement and W.B.F. agrees, but the experts at the Oberlin Museum do not share this view.

45. Daniel, one of the four great Prophets of the Bible, lived in Babylon at the court of the King Nebuchadnezzar. Being unjustly accused by Satraps envious of the prestige he enjoyed with the king, he was thrown in the lions' den, but was saved by God who sent an Angel (or, in another version, Habacuc) to his rescue. In Christian iconography the episode of Daniel in the lions' den is often reduced to its simplest expression: a man between two lions, which is also a Near Eastern motif appearing for example in the low reliefs on the Assyrian sarcophagus representing Gilgamesh, killer of the lions (Réau, 1954, pp. 391-407). Daniel and the lions was commonly represented in Christian sculpture.

The low relief on the saltcellar no. 19 resembles the capital in the Duomo of Fidenza by an anonymous carver of the twelfth century, known as "The Master of the Judges." The representation of Daniel in the lions' den, and of the Holy Virgin beside the group of three youths, allows us to identify the latter as an illustration of another biblical episode: the three Israelite children of Babylon in the fiery furnace. The *Book of Daniel* relates that Shadrach, Meshach and Abednego, followers of the prophet David, having refused to worship a golden statue, were thrown by order of the Babylonian king into a burning furnace from which they safely emerged, demonstrating the power of the Jewish God. The subject was interpreted as a prefiguration of the immaculate conception of Mary. The theme is also one of the oldest in Christian

art, though not found as frequently as Daniel and the lions; after the end of the Middle Ages these subjects seldom appear.

The Bible specifies that the youths were fully dressed, but they were normally represented as naked, and in some instances with a veil on their heads, put there by an angel to save their hair. They are represented on the saltcellar with the veil as on a capital in the twelfth century cathedral of St. Lazare in Autun. In the older iconography the three youths are often represented as emerging from the flames, which are not visible on the salt.

46. The group that crowned the lid of no. 20 has been lost and replaced with a modern restoration, but its base shows an unusual organization: four parrots, set upon a base underneath the container, are confronted by four snakes, rolled up into an elegant spiral, and rising from below. The decoration in low relief, however, consists of geometric patterns and stylized floral motifs which are quite similar to those on the saltcellar no. 19. Carved in low relief on the base is an animal with a long neck, held by a chain.

47. The decoration on the base of saltcellar no. 24 demonstrates many repetitions in the rendering: humans alternate with dogs fighting snakes; two men in European dress, one wearing a tunic, the other in shirt, trousers and codpiece; two women in long skirts, presumably Africans, but all wearing the same kind of cap. The decoration in low-relief is composed of European motifs: a lily, a stylized torch, a bird, a wyvern, but also includes two apes.

The bases of saltcellars (nos. 23-25) are similar to the base of saltcellar no. 22, formerly in the collection of Richard Rawlinson, the English scholar of the eighteenth century. Although it is lost, it is perfectly reproduced in an eighteenth century print. On this example there are eight dogs, divided equally above and below the serpents; the human figures include a European woman wrapped to her feet in a heavy gown, and three European men. One of them is dressed in a tunic as are several figures on saltcellars nos. 33 and 34, while the other two wear long cloaks. The three men hold, respectively, a pen, a key, and a book.

The low relief decoration is again made up of European motifs: a wyvern, stylized torches, braids, the Cross of Beja held in the mouth of a monstrous serpent, the motto *"Ave Maria"* and two other indecipherable words. The cover is topped by a rose resting on four supports. A similar rose, held up by four somewhat longer supports, crowns another saltcellar (no. 21) and is repeated on the lid. Set between the dogs on the base of this saltcellar are two women in long skirts with their breasts bared, as on the saltcellar in Berlin (no. 23), and two men armed with lances and shields. One of the shields is round while the other is in the unusual shape of two joined ovals. A series of motifs in low relief, similar to those on the saltcellar crowned by the Madonna and Child (no. 19), can be seen on an example with no lid, no. 51. It, however, has an openwork, cylindrical base (although the trunk tends towards a conical shape). These

motifs are: a siren curiously set near a crocodile, a turtle whose shell is depicted as a coat of arms, a sphinx, some fish, nude youths and geometric forms. The figures, carved in the round and seated on the lower border of the base, are two men dressed in shirts, trousers and codpieces, and two barebreasted women. They are just like the figures on the saltcellars with conical bases (nos. 21-24) mentioned earlier.

A unique decoration appears on the base of a saltcellar in the Museum voor Volkenkunde of Leiden, no. 25. Four lions replace the customary dogs, and carved in low relief in the spaces between the animals are a unicorn, a crowned lion, two deer, and some foliage. These are the same motifs, treated in the same style, as on the oliphants.

48. *Inventario Semplice* 1680, p. 29.

49. See *nomoli* in Museum für Völkerkunde in Munich, inv. no. 66.5.1; Kecskesi 1987, no. 36.

50. Such activity is illustrated, for example, by the work of the Dominicans Heinrich Institor and Jacob Sprenger, who conducted a large number of trials in Germany, which usually ended in a death sentence for the accused men and women. (Institor 1486-1487).

51. Inv. no. 18.867, Cabinet des Dessins, Musée du Louvre, Paris. Burin (1505-1507) 11.5 x 7.2 cm.; Chiaroscuro (1510) 37.4 x 25.7 cm.; Bartsch 1920, 67, 55; Hollstein 1954, 68, 23.

52. A.W. Frank's notebooks were brought to our attention by Dr. Malcolm McLeod.

53. The *nomoli* in the Meneghini collection in Palm Harbor is a good example. Its two elongated, protruding heads recall those on saltcellar no. 40.

54. One in the Bernisches Historisches Museum (inv. no. Sie Leo 279.1926) and another in the Museum für Völkerkunde, Munich (inv. no. 11.400; Kecskesi 1987, no. 37) carry similar shields. Warriors with shields also appear among the stone carvings in the Kissi style in the Meneghini Collection.

55. See the *nomoli* in the Museum of Mankind in London.

56. Fyfe 1964, p. 311.

57. See the stone in the Mangiò collection in Monza, and another formerly in the Monti collection in Milan, the latter including a man carrying a round shield. Tagliaferri 1974, nos. 6 and 7 and p. 22. One saltcellar (no. 32), a work by the same artist, in the Museum of Mankind, exhibits unknown and original compositions both on the base, and in the decoration of the lid. Two stretched-out, nude human figures being attacked by two crocodiles are carved in high relief on the lid. Directly above this group is a serpent coiled into a perfect circle. On its body are visible the claws of six birds of prey, probably originally eagles with folded wings, pecking the knob.

58. The back of a similar chair, richer and adorned with an elephant's head, is all that remains of the finial of saltcellar no. 27 in the Galleria Estense in Modena. It belongs

to the conical-base type with curvilinear elements that form a cage on which the container rests. Note that on these supports, snakes and crocodiles are carved just as on the base of the saltcellar that features the executioner. In addition, the decoration of the lid—rows of beads set together, with circular motifs in the smooth areas—recalls that of the other saltcellar in the Seattle Museum (no. 40), formerly in the collection of Katherine White, also with a cylindrical base. The chair may be an attribute of a person of exalted rank. According to Valentim Fernandes, such people were entombed seated on a chair. Fernandes, p. 90, Lamp, p. 229.

59. Portugal, 16th century, Museu Nacional de Arte Antiga, Lisbon, inv. no. 71 bis; silver, h. 18 cm.

60. Cortez 1967. Cortez suggests also that two figures with the palm of martyrdom could represent St. Vincent, patron of Lisbon, and the birds could be crows, the birds that appear on the coat of arms of the city. Silver coins with the image of St. Vincent with the martyrdom palm in one hand and a ship in the other were first struck in 1555, designed by two great artists, Antonio and Francisco de Hollanda. The hypothesis is suggestive but difficult to prove since the way of representing Saint Vincent on the coin and on the pyx is very different; the two birds could easily be doves, quite frequent in the Christian iconography. Moreover, the two angels supporting the coat of arms of Portugal are very similar to the angels and arms carved on the powder flask (no. 79) that bears the arms of Ferdinand of Castile and Aragon that, as we shall see, should date from the reign of Emanuel I, before 1516.

61. The small number of forks compared to the abundance of spoons can be explained by the fact that the fork was just beginning to come into use in Europe. Like most Africans, most Europeans ate with their fingers and, except for the upper classes, continued to do so until the nineteenth century.

62. Museu National de Arte Antiga, Lisbon. According to M.H. Mendes Pinto the spoon might be a metal one.

63. In the case of Bini-Portuguese ivories, the number of spoons that have survived is greater than the corresponding number of saltcellars.

64. Consider the weight of gold or silver in Portuguese money minted during the reign of Emanuel I (1495-1521): the *cruzado,* the coin corresponding to 400 *reais,* weighed from 3.51 to 3.59 grams of gold and the *tostao,* corresponding to 100 *reais* weighed 8.97 to 9.65 grams of silver. (See Alburquerque 1983 pp. 243, 244 and 284, 285). From the above-mentioned October 16, 1504 record, three spoons were valued at 120 *reais,* i.e., 40 *reais* apiece, while on March 20, 1505, five spoons were set at 480 *reais,* or 95 apiece.

For the saltcellars, one imported on January 2, 1505, was valued at 95 reais, while on October 16 of the preceding year, a saltcellar and three spoons were set down for 700 reais. Ten years later, "two deco-

rated ivory salts" brought from Guinea to the city of Ribeira Grande on the island of Santiago in Cape Verde, were put at 4,000 *reais;* we should note that the customs inspector felt obliged to say that the objects were "decorated." da Mota 1975, p. 585.

65. Knots are carved on the thin handles of nos. 61, 63, 64, 66 and 67 as well as openwork elements wrapped with snakes or topped with carefully delineated animals. The handle of no. 65, decorated with two small parrots, is made up of two parts, carved from the same piece of ivory, inserted into each other (the upper one is movable).

Three of the spoons end in a small shield on which letters have been carved. One spoon, no. 60, differs from the others in that the handle is more solid and the section next to the bowl bears a human figure. Two others, nos. 71 and 72, with shorter handles are known to have been in the Tradescant collection in London during the first half of the seventeenth century. One of these handles bears an upright, nude human figure with features found in the stone sculpture of Sierra Leone, while the other is more simply decorated with a braided pattern. The less refined execution of these pieces, and the late date of their arrival in Europe probably indicate that they are isolated works from a later, decadent period. A receptacle, no. 56, in the Field Museum of Natural History in Chicago, surmounted by a roughly worked quadruped, probably also dates from a later period.

66. See the pieces in the Monzino and the Mangiò collections (Vogel 1985, no. 23 and Tagliaferri 1978, no. 1). This design recurs, however, on other Sapi-Portuguese ivories, such as the saltcellar in the Museum of Mankind (no. 32), and on the oliphant formerly in the Jay Leff collection (no. 84) where the croccodile is biting the man, and in a more consistent way on the instrument created for indigenous use, which is now in the Anspach collection in New York. Example no. 74 terminates in a human head with an immense mouth, which resembles several *nomoli*: see, for example, a figure that was formerly in the Meulendijk collection (present whereabouts unknown; Christie's sale October 21, 1980, lot 11).

67. Buchner 1964, ill. 88, 89.

68. It is more likely that oliphants showing the royal coats of arms, probably commissioned on behalf of or destined for the king, were not duty goods and therefore were not recorded.

69. da Mota 1975, pp. 585, 586 and personal communication to E.B.

70..Ibid., p. 586.

71. The horns vary greatly in their size and in the quality of their carving. One oliphant, no. 108, features the head from which the mouthpiece emerges, but its sides are undecorated. Another, no. 107 in the National Museum in Lisbon, has its sides decorated with animals, with coats of arms and with one human figure, but the mouthpiece lacks the customary animal head. The sides of these two instruments are thicker than are

those of the other Sapi-Portuguese instruments.

72. It was destroyed in the second World War, but a cast of it exists in the Museum für Völkerkunde in Berlin.

73. See, for example, the saltcellar no. 17. The animals carved in low relief have iconographic and formal parallels with those on certain oliphants with hunting scenes. Compare the two snakes eating little animals to the snake on oliphant no. 81 devouring a rabbit. The body of the snake on the latter piece is elegantly coiled, but the scaly skin is rendered in the same way as on the snake shown on trumpet no. 201.

The two crocodiles are similar to those seen on many hunting horns, such as nos. 81, 83, 84, 85, and saltcellar no. 17. The body of each reptile, in all of these examples, is slender and elegant, the legs are smooth and the other elements that characterize the head (eyes, mouth, jaws) are similarly treated.

74. Similar to the mouthpieces on the oliphants, a Flemish or German cannon now in the Armoury of the Tower of London, datable to 1520, has a barrel protruding from the jaws of an animal with small pointed ears (inv. no. XIX-103). This is not the only example. Animal heads also appear on European pitchers of the same period in metal, ceramic or glass. Small heads of ermine, marten or sable made in gold, rock crystal or precious stones embellished fur pieces to ward off fleas. The likeness between these animal heads and those on the ivories is striking, even the bridle is suggested in the ivory carvings. (See Hunt 1963; Schiedlausky 1972.) The analogies with the jewels were pointed out to E.B. by M.H. Mendes Pinto.

75. One sees this, for instance, on a Flemish cannon, richly decorated, signed by "Maistre Denis" and dated 1535, in the Tower of London, which sports a pair of these fantastic animals functioning as dolphins.

76. See examples no. 81, 100, and 102. The wyvern, a large, winged reptile with two paws, is a monster that frequently appears not only in the popular imagination, but also in European medieval sculpture, as on the Gothic cathedrals where it functions as a gargoyle. The monster also figures prominently in fifteenth and sixteenth century literature, best known in the legend of St. George, illustrated by among others the Italian artists, Pisanello, Crivelli, Paolo Uccello and Carpaccio, and was certainly reproduced in bestiaries of the time.

77. Forsyth 1952.

78. The manuscript is in the Bibliothèque Nationale, Paris.

79. The artists were of Flemish origin, but French education. The manuscript is in the Musée Condé, Chantilly.

80. *Le Livre d'Heures a la "bombarde"* (embellished with a *bombarde,* the coat of arms of Luis de Bruges, the lord of Gruthyuise) of the first quarter of the sixteenth century is typical. In the wide margins of one of the

illuminations, *The Mass of St. Gregory,* are shown a deer, a bear, two hares, an archer shooting a boar and the culminating moment of a stag hunt: the assault of the dogs and a hunter armed with a pike, while the "master," also armed with a lance, sounds the curved horn to announce the capture of the prey. Durrieu 1921, p. 83.

81. See, for example, the great Devonshire Tapestries: *The Boar and Bear Hunt* and *The Deer Hunt,* Flemish works from the first half of the fifteenth century, now in the Victoria and Albert Museum; the *Party of Falconeers in a Wood,* perhaps made in Tournai in the second half of the fifteenth century, one of the few examples of a bird hunt with bows and arrows, now in the Burrell collection in Glasgow; and the *Stag Hunt* in the Metropolitan Museum in New York, a series of seven tapestries made at the beginning of the sixteenth century by the Franco-Flemish school.

For the hunt as a representation of a spiritual quest see: *The Pursuit of Fidelity,* an Alsatian tapestry from the last quarter of the fifteenth century, in the Burrell Collection, Glasgow; the series of *The Hunt of the Cerf Fragile,* divided between the Metropolitan Museum in New York and a private collection; and *The Hunt of the Unicorn,* which is the jewel of the Cloisters in New York. All of these examples are Franco-Flemish tapestries from the beginning or first half of the sixteenth century. Hunting scenes are also illustrated in allegories of the months, and as details in works depicting scenes of various kinds. In *The Camps of the Gypsies,* a tapestry made in Tournai in 1510, the killing of a stag can be seen in one of the corners. The killing of the boar is illustrated in the background of a tapestry depicting *Scenes of Country Life,* probably from Tournai (first quarter of the sixteenth century) now at the Metropolitan Museum of Art, New York.

82. On the tapestry *The Start of the Hunt* from the series *The Hunt of the Unicorn,* and in a Flemish tapestry from ca. 1500 in the Burrell collection entitled *The Month of September,* as on some others, the men wear plumed hats like those worn by the horsemen carved on oliphants nos. 81, 85 and 87. This is also the case with the shape of the spears—"bear spears" or "winged spears"— European hunting weapons of the end of the fifteenth and early sixteenth centuries— so called because of the wings which kept the blade from penetrating more than a certain depth.

83. Fifteenth century European combs and chess boxes in ivory, sometimes featured hunt scenes, as did some early fifteenth century weapons and sword and dagger hilts, such as those by Spanish swordsmith and damascener Diego de Cajas, or by Damianus de Nerve. See Blair 1970.

84. Woodward 1969, p. 263.

85. See casket in the Schatzkammer der Residenz in Munich, ca. 1540, inv. no. 1242. Birds with intertwined necks appear on a casket from the eleventh century in the Cathedral of Veroli in southern Italy.

86. Compare this horseman with that on the silver plate from the seventh or eighth century, embossed with a hunting scene, in the Museum für Islamische Kunst in Berlin. (Inv. no. 4925).

87. See Fry 1920, p. 80 and pl. IV.

88. Worm 1643, p. 433-35.

89. The motto appears many times on the count's marble tomb in the Church of the Grace in Santarem. We are grateful to M.H. Mendes Pinto for the information.

90. The armillary sphere was assigned to Dom Manuel as an emblem by his cousin and brother-in-law John II, the ruling king, in 1483. The Cross of Beja was the emblem of the Military Order of Christ of which Dom Manuel was the Grand Master after 1484 when he was Duke of Beja.

91. See also the gadrooned round pillars of the upper gallery of the Mosteiro dos Jerónimos; the gadrooned capitals of the portal of the church and the pillars of the Royal Cloister of Batalha, adorned with rows of beads; and the baptismal font with two crowned heads and an armillary sphere now in the Museu National de Arte Antiga in Lisbon (inv. no. 544). The facade tympanum of the convent of San João da Penitencia in Estremoz should be noted for its emblematic quality and completeness: in a rectangle defined by gadrooned bands, the emblem of the House of Aviz, flanked by two armillary spheres, is carved in low relief. The Cross of Beja is set in a circle above the rectangle.

92. ". . . os homês desta terra som muy sotijs negros de arte manual. s. de saleyros de marffim e collares, e assi qualquer obra que lhes debuxa ho corta em marfim." Fernandes 1951, p. 104.

93. For example an engraving by Albrecht Dürer dated 1511 and another by Martin Schongauer are, according to M.H. Mendes Pinto, the models for an ivory plaque depicting the Nativity, carved in Ceylon in the seventeenth century, now in the Museu National de Arte Antiga. inv. no. 625 Esc.; see Pinto 1983, no. 262.

94. Naturally, the episodes of the life of the Virgin and the Passion are also depicted in Books of Hours in many editions, such as Thielman Kerver's (late fifteenth, early sixteenth centuries); the *Vita della Gloriosa Vergine Maria*, published in Venice in 1505 by Nicolò Zoppino; illustrated editions of the Bible, such as the *Biblij Czeska* (Bohemian Bible), also published in Venice in 1506 by Pietro Liechtenstein, and others. We have not been able to find any representations of Daniel in the Lions' Den or of the Three Israelites in the Fiery Furnace in printed works from the fifteenth and sixteenth centuries.

95. Two small prints by German artists active at the end of the fifteenth century, Master W.N.H (a copyist of Schongauer) and Master A.G., show respectively the arms of the Cathedral of Eichstadt and of the Bishopric of Würzburg, held up by two angels. Two unicorns, also on their hind legs, in like manner support the mark of the Italian printer Francescus Garonus de Liburno, in a book from 1524.

96. Pp. 252,253. The same hunting scenes appear in another edition of Pigouchet: *Ces présentes heures à luisage de Rome . . .*, 1500-1501.

97. Often repeated are: the beaters and the dogs, the sighting of the stag, the sounding of the horn, the attack of the dogs, the killing of the animal, and the transport of the carcass on the back of the horse. Compare, for example; the scene of the killing of the stag where the hunter holds his winged-spear at a perfect horizontal; or the scene where the dead prey is carried away as the hunter clutches a horn of the animal; or the man sounding his horn, or other diverse groups of hunters with dogs and spears. The same scenes appear in an identical manner in other Books of Hours, e.g. one published by Thielman Kerver in Paris in 1504. A goat similar to that carved on the oliphants nos. 85, 100 and 103 appears in the margin. Other examples appear in the *Officium Beate Mariae Virginis* printed by Jacobus Pencius de Leucho for Alessandro Pagani in Venice in 1513, and in the *Chiromantia* of Tricasso de Ceresari, published also in Venice by Giovanni Francesco and Giovanni Antonio Rusconi. The woodblocks used for these illustrations had a wide circulation.

98. See also: the Venetian edition of 1537, printed by Nicolò Aristotele, called Zoppino and a plate engraved by Augustin Hirschvogel in 1545.

99. An archer centaur appears with hunting scenes on a hilt of a damascened "ear dagger" signed Diego de Cajas about 1530, now at the Metropolitan Museum of Art, New York, Rogers Fund, 39.159, I. See Blair 1970, ill. 6-8.

100. The knights may also be found in large format in the book by Jean du Pré, the *Horae ad Usum Romanorum* from 1499, and in an *Officium Beatae Mariae Virginis* printed in Venice in 1502.

101. An elephant with a tower on its back is illustrated in the book by the Franciscan Father Noè, *Viaggio da Venetia al Sancto Sepulchro*, printed in Venice in 1518 by Nicolò Zoppino and Vicenzo de Polo. We have not, however, found an illustration of the scene carved on the hunting horn in Paris (no. 82): an elephant held by a chain and mounted by a driver holding a hooked stick.

102. See also the *Book of Hours* of Jean du Pré, printed in 1488.

103. See also the *Book of Hours* by Thielman Kerver, 1499.

104. Two winged monsters appear in the lower border of the *Officium Beatae Mariae Virginis*, printed by Gregorius de Gregoriis in Venice c. 1523. See also the *Vita della Vergine* and the *Regule Ordinum*, printed in Venice for Luc'Antonio Giunta in 1492 and 1500 respectively. The unique scene of the Christian subject, The Deposition, on oliphant no. 78 probably derives from a late fifteenth century German model.

105. The crouching lions are similar to those on the base of no. 25, above all in the nervous treatment of their posteriors and the flattened divided tufts of their tails, treated

like a plant motif. The plaited decoration is identical with that on the cover of saltcellar no. 20.

106. See, for example, no. 36, now lost: the extreme elongation of the torsos of the human figures corresponds to the general composition.

107. We have already suggested the possibility that the maker of the spoon and fork nos. 63 and 70 could be the same man who made saltcellars nos. 17, 27 and 28. One could also conjecture that this artist was responsible for spoon no. 65, because it bears two parrots, however, such birds are also present on salts nos. 13 and 14.

108. According to Lionello Boccia, Director of the Stibbert Museum in Florence, the central figure on oliphant no. 75 wears a *capacete*, a typical Iberian helmet worn from the late fifteenth century to ca. 1520. On the convex side of the complete horns one can see the remains of an animal carved in the round and three identical lugs.

109. A fourth oliphant, probably by the same carver, was in the Museum für Völkerkunde in Berlin until World War II. It is mentioned in the book by Read and Dalton (1899, p. 34) as sporting the "Shield of Portugal, the Armillary Sphere, and the Cross of the Order of Christ (Cross of Beja)." Its length is given as twenty-one inches. It is surely the oliphant of the same length and showing the same coats of arms illustrated in A.W. Frank's nineteenth century notebook, and described as property of the Berlin Museum.

110. Welsh 1904, p. 452.

111. The old inventory mentions twelve spoons, but the museum presently has fifteen.

112. Wolf 1960, p. 420.

113. Heger 1899, p. 109.

114. Bassani 1975, p. 144.

115. Basket weave motifs and lozenges appear also in Manueline architecture. See, for example, the decoration of the fountain in the cloister of the Mosteiro dos Jerónimos in Lisbon.

116. A miniature in a manuscript containing documents on the municipal administration of Lisbon from 1502 to 1796, the *Livro Carmesim* (Arquivo Historico Camara Municipal, Chancelaria Regia, cod. 37, Lisbon) shows a superposition of the armillary sphere, with the Portuguese coat of arms, and shape of the crown similar to the same elements on the oliphant no. 111.

117. Painted in ca. 1460, by Nuno Gonçalves, it is now in the Museu Nacional de Arte Antiga, Lisbon. It is one of a series of seven panels known as the *Paneis de S. Vicente de Fora*.

118. Egerton 1896 (reprint 1968), pl. VI.

119. Royal Ontario Museum inv. nos. L960.9.95.

120. The straight lines of the bow and the stern allow us to identify the ship carved on the saltcellar as an *urca*, a type of cargo vessel

derived from a northern prototype (hulk) and widely used in Portugal until the middle of the fifteenth century, when it was superseded by the more advanced caravels. Nevertheless *urcas* were also used in later years; we know that the stones to build the fortress of Elmina in 1482 were carried by *urcas*. In its heraldic simplification, the ship on the saltcellar does not correspond to the more realistic ones illustrated on sixteenth century maps, books or paintings. For the medieval, archaic rendering, see the seals of the maritime cities of Kiel (1283), Dantzig (1294), Straslund (1301, 1329) and Elbing (1350). We would like to thank Admiral Vasco Viegas of the Museum of the Marine in Lisbon for identification of the vessel.

121. A pointer to the likelihood of a drawing as a model for this ship is the representation of what was supposed to be sheet anchors, flat disks in reality, transformed into balls by the carver, who either misinterpreted the drawing, or preferred the decorative effect of the spheres.

122. Museum für Völkerkunde, Berlin, inv. no. III C 8377, 42 x 52 cm.; inv. no. III C 8488, .60 cm.

123. Museum of Mankind, London, inv. no. 98.1 - 15.46, 45 cm.

124. Eyo and Willet 1980, nos. 70-71.

125. The late Dr. Douglas Fraser told one of us (W.B.F.) that one of his classes working on the spoons had reached the tentative view identifying Bini-Portuguese spoons as Owo production; this was immediately welcomed on the ground that an Owo provenance would better accommodate both the absence of *horror vacui* and the beautiful form of the spoons.

126. In the (posthumous) field notes of R.E. Bradbury a tradition is recorded as current among the ivory workers of the Ishan town of Ewohimi, that ivory carvers came from Owo to work for the *oba* alongside the *igbesamwan* members.

127. Welsh 1904, p. 452.

128. Curnow 1983, pp. 215-217.

129. Museum of Mankind, London, inv. no. 1928.1.121; 38.7 cm.; inv. no. 1949.Af.46.158; 35 cm.

130. Willet 1973, ill. 22.

131. Museum of Mankind, London, inv. no. 1953.Af.7.1. Ivory, 12.6 cm.

132. Fagg 1981, no. 14.

133. Museum of Mankind, London, inv. no. 1978 Af.5.1, ivory, 21.5 cm; Musée de Beaux Arts, Lille, inv. no. 306.B5. ivory, 18.2 cm.

134. See the wooden spherical container in the Museum für Völkerkunde in Berlin (Kreeger 1969, no. 132).

135. In the Museum of Mankind and on the two similar ones in the Tishman collection. Inv. no. 5111. Ivory, diam. 13.5 cm. ; Ivory, diam. 12.7 and 12.1 cm.; Vogel 1981, no. 71.

136. Archivo di Stato, Florence, *Inventario Generale 1553,* Guardaroba Medicea, vol. 36, p. 134.

137. One is in the Musée de Cluny, Paris (no. 185); the second is in the Linden Museum in Stuttgart (no. 186); and the third was sold by Christie's New York in 1984 (no. 187).

138. Two oliphants (nos. 188 and 189) are less refined than the previous seven. The large lugs, placed on the convex side of the tusk interrupt the flow of line. Nevertheless, the geometric motifs on the surface, though not arranged in spiral zones, imply that these oliphants too were carved by a Kongo artist, while the lugs suggest a European destination, or at least European influence.

139. Galleria Sangiorgi, Rome (sale catalogue) 1902, p. 53, pl. 51.

140. Neg. 107645A. Musée Royale de l'Afrique Centrale, Tervuren.

141. de Barros 1944, vol. I, bk. 2, chapt. 3.

142. National Museum of Denmark, Copenhagen, inv. no. EDc123. Palm or pineapple fiber, 18 cm.

143. Bassani 1977; Teixeira da Mota, personal communication to E.B.

144. Pigafetta 1591, pp. 17, 18.

145. Ibid, p. 20.

146. One of the mats is depicted in the foreground in the "Annunciation" by an unknown Portuguese painter of the sixteenth century, now in the Museu de Arte Antiga in Lisbon.

147. Heger 1899, p. 108.

148. MacGregor 1981, p. 148.

149. Allan 1964, p. 115.

150. The deep red patina of oliphant no. 198a sets it apart from the others and suggests that it was used in an African context, having been repeatedly rubbed with palm oil.

151. *Praetorius* 1619, pl. XXX.

152. Joe Henggeler in recent years photographed in the field a group of Mende horns, Henggeler 1981.

153. A passage in the 1685 catalogue of the Ashmolean Museum describes the then-intact oliphant as having a finial in the form of a human hand. Among many Akanspeaking peoples (the Asante, Baule, Anyi, etc.) finials of umbrellas and linguists' staffs frequently are shaped as hands. This combination of facts suggests that the fluted oliphants in question may have originated in the Ivory Coast.

CATALOGUE RAISONNE

"Chez l'Antiquaire" by L.V. Fouquet. 1836. In the great jumble of treasures and things from distant times and places we see hanging on the wall at the left, an Afro–Portuguese horn (no. 200). It is a fluted oliphant that terminates in a crocodile head like those in this book. If this is an accurate picture, it had a broad plain band at the mouth not seen on other examples. This is the only known representation of it. Musée des Art Decoratifs,

The numbers appearing at the end of each entry refer to pages in the text; italics indicate illustrations.

1. SALTCELLAR
Sierra Leone, Sapi-Portuguese
H. 37.5 cm. (finial restored)
Allen Memorial Art Museum,
Oberlin College, Oberlin
Ex collection: Gustave Schindler
[pp. 69, *74*, 123]

2. SALTCELLAR
Sierra Leone, Sapi-Portuguese
H. 19 cm. (lid and two
snakes missing)
Museum of Mankind, London
(Inv. no. 1949.A.46177,
acquired in 1949)
Ex collection: Oldman
[pp. 123, *126*]

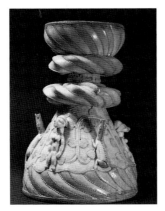

3. SALTCELLAR
Sierra Leone, Sapi-Portuguese
H. 19.5 cm. (lid and one hu-
man figure missing)
Museo del Ejercito, Alcazar
of Toledo
Ex collection: Romero Ortiz;
Moraldo de Monroy

In the monastery of St. Jeronimo
de Juste, Spain until 1854; tra-
ditionally held to have been the
property of Emperor Charles V
(letter of the cura rector of the
Parish of Bejar, 1856, in the Al-
cazar archives).
[p. 123]

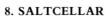

4. SALTCELLAR
Sierra Leone, Sapi-Portuguese
H. 14.4 cm. (bowl and lid
missing; two snakes broken)
The National Museum of Den-
mark, Copenhagen (Inv. no.
EDc67/b)
Ex collection: Gottorp
Kunstkammer, Gottorp Castle
Schleswig-Holstein

Used as a lid for no. 51; regis-
tered in the Gottorp manuscript
inventory of 1743, 87e, with the
lid no. 44, as "Two pieces of
ivory, one in the shape of a cover
surmounted by two-faced head
like Janus bifrontus, the other in
the shape of a goblet on which
pagan gods and animals are
carved." (Dam-Mikkelsen 1980,
p. 46) [pp. 123, *125*, 127]

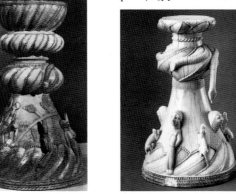

5. SALTCELLAR
Sierra Leone, Sapi-Portuguese
H. 12.6 cm. (lid missing)
Royal Museum of Scotland,
Edinburgh (Inv. no. 1956.1156,
acquired in 1956)
[pp. 123, *127*]

6. SALTCELLAR
Sierra Leone, Sapi-Portuguese
Size unknown (bowl and lid
missing)
Private collection, Paris
[p. 123, not illustrated]

7. SALTCELLAR
Sierra Leone, Sapi-Portuguese
H. 16 cm. (bowl and lid miss-
ing, two of the human figures
damaged)
Private collection
Ex collection: Sidney Burney,
London (note in the Charles
Ratton Archives, Paris)
[pp. 123, *126*]

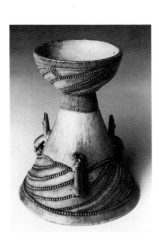

8. SALTCELLAR
Sierra Leone, Sapi-Portuguese
H. 24 cm.
Museo Civico Medievale,
Bologna (Inv. no. 694, ac-
quired in 1878 from the An-
tiche Collezioni Universitarie,
Bologna)
Ex collection: Marchese Ferdi-
nando Cospi, Bologna

Mentioned in the *Inventario
Semplice . . .* by anonymous au-
thor, printed in Bologna, 1680,
p. 29, as, "Old chalice in ivory
with its lid and with figures."
[pp. *66, 72, 76, 111,* 123, *124*]

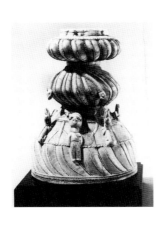

9. SALTCELLAR
Sierra Leone, Sapi-Portuguese
Size unknown
Collection unknown: Sotheby's
sale 4.7.1932, lot 227 (photo-
graph in the Charles Ratton
Archives, Paris, with the men-
tion, "*Vendu à Basfield.*"
[pp. 69, *74,* 123]

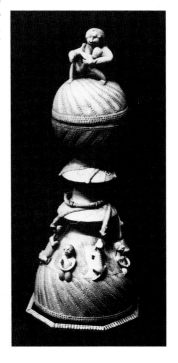

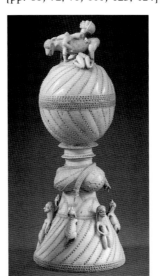

10. SALTCELLAR
Sierra Leone, Sapi-Portuguese
H. 24.3 cm. (finial restored)
Museum für Völkerkunde,
Vienna (Inv. no. 64468)
Ex collection: Kunstkammer of
Archduke Ferdinand of Tyrol,
Ambras Castle, Tyrol (?) (Heger, 1899, p. 108)
[pp. *67*, 69, 123]

11. SALTCELLAR
Sierra Leone, Sapi-Portuguese
Size unknown (lid missing)
Nigerian National Museum,
Lagos (acquired in l956)
Ex collection: Allan Ross, New
York (note in the Charles Ratton Archives, Paris)
[pp. 75, 123]

12. SALTCELLAR
Sierra Leone, Sapi-Portuguese
H. 30.5 cm. (the head of the finial figure is a restoration)
Staatliche Museen Preussischer
Kulturbesitz, Museum für
Völkerkunde, Berlin
(Inv. no. IIIC 4886 a,b)
Ex collection: Imperial
Kunstkammer (Kreiger, 1969,
II, no. 106)
[pp. 69, 123]

13. SALTCELLAR
Sierra Leone, Sapi-Portuguese
H. 17.5 cm. (lid missing)
Seattle Art Museum, Seattle
(Inv. no. 68 A.F.10.9)
Gift of Nasli and Alice
Heeramaneck, 1968
[pp. 69, 93, 123]

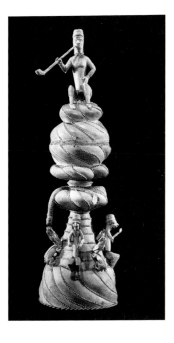
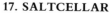
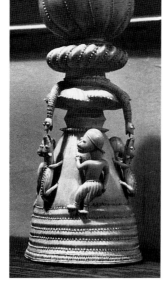
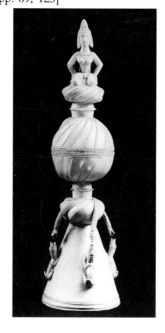
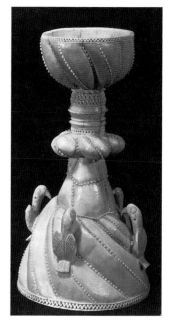

14. SALTCELLAR
Sierra Leone, Sapi-Portuguese
Size unknown (lid missing)
Staatliche Museen Preussischer
Kulturbesitz, Museum für
Völkerkunde, Berlin
Lost or destroyed (see von
Luschan, 1919, pl. 120b)
[p. 123]

15. SALTCELLAR
Sierra Leone, Sapi-Portuguese
H. 21 cm. (lid missing)
Museum für Völkerkunde,
Vienna (Inv. no. 118.610, acquired in 1923)
Ex collection: Dietrich, Feistritz
Castle
[pp. 123, 138, *144*, 146]

16. SALTCELLAR
Sierra Leone, Sapi-Portuguese
H. 12.5 cm. (lid missing)
Bowes Museum, Barnard Castle, Co. Durham (Inv. no.
X531, acquired in the third
quarter of the 19th century,
probably in Paris)
[pp. 123, *145*, 146]

17. SALTCELLAR
Sierra Leone, Sapi-Portuguese
H. 33 cm.
(finial group damaged)
Royal Museum of Scotland,
Edinburgh (Inv. no. 1956-1157,
acquired in 1956 from The National Museum of Antiquities;
purchased in Milan in 1875 by
James T. Gibson-Craig; (Anderson 1876, pp. 336-339)
[pp. 69, *122*, 123, 127, 138]

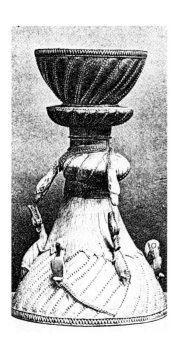
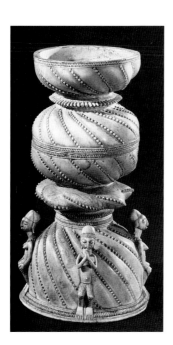
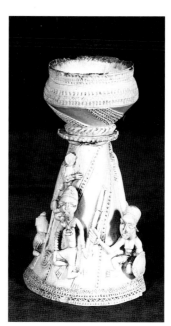
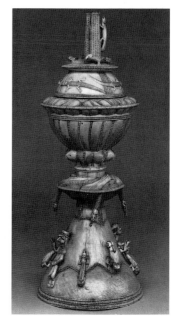

18. SALTCELLAR
Sierra Leone, Sapi-Portuguese
H. 27.4 cm.
Staatliche Museen Preussischer
Kulturbesitz, Museum für
Völkerkunde, Berlin
(Inv. no. IIIC 4888 a,b)
Ex collection: Imperial
Kunstkammer (Kreiger, 1969,
II, no. 106)
[pp. *65,* 69, 123, 137]

19. SALTCELLAR
Sierra Leone, Sapi-Portuguese
H. 30.5 cm.
Museum of Mankind, London
(Inv. no. 1981.AF.35.1, ac-
quired in 1981)
Ex collection: Society of Anti-
quarians of Newcastle, since at
least l876. Formerly in the Al-
lan Museum (Grange near Dar-
lington), as appears from the
Allan sale cat. p. 68, then in
the Natural History Society of
Newcastle. On a piece of paper
stuck to the case shaped to
contain the saltcellar it is writ-
ten: "Joannes E . . . Schlevel
. . . Johannes Schffle. De E
. . . ine hujus poculi. . . . entur
nostrum testimonium" *(Town-
shend Fox* 1827, pp. 183-185).
[pp. 62, 64, 72, *73, 74,* 123,
126, 137, 144]

20. SALTCELLAR
Sierra Leone, Sapi-Portuguese
H. 27 cm. (the finial group is a
replacement)
Robinson collection (?)
Ex collection: Robert Lehman,
Vienna; Sotheby's sale 1974, lot
85
[pp. 64, 83, 123, 126, 137]

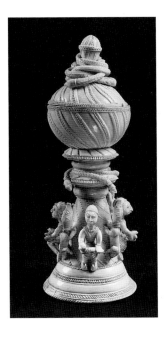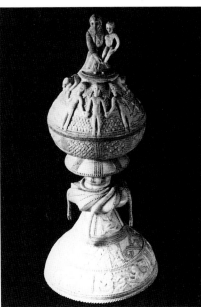

21. SALTCELLAR
Sierra Leone, Sapi-Portuguese
H. 29.8 cm.
Paul and Ruth Tishman collec-
tion, New York
Ex collection: Jay Leff
[pp. 64, *69,* 123, 126, *128,* 137]

22. SALTCELLAR
Sierra Leone, Sapi-Portuguese
Size unknown
Richard Rawlinson collection,
18th century; lost or destroyed
(illustrated in one of Richard
Rawlinson's books)
[pp. 64, 123, 126, 137]

23. SALTCELLAR
Sierra Leone, Sapi-Portuguese
H. 10 cm. (bowl and lid
missing)
Rijksmuseum voor Volken-
kunde, Leiden (Inv. no. 1131-1,
acquired in 1896 from the
Rijksmuseum van Oudheden)
Ex collection: Anatomy and
Rarities, Leiden, until 1858
(Schmeltz 1897, pp. 261-264).
[pp. 72, *75,* 123, 126, 137]

24. SALTCELLAR
Sierra Leone, Sapi-Portuguese
H. 8.7 cm. (bowl and lid
missing)
Staatliche Museen Preussischer
Kulturbesitz, Museum für
Völkerkunde, Berlin (Inv. no.
IIIC 168, acquired in 1852)
Ex collection: Sommer
[pp. 123, 126, *127,* 137]

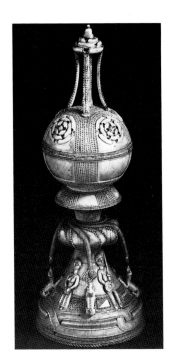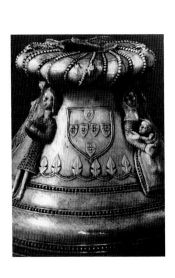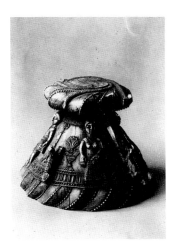

25. SALTCELLAR
Sierra Leone, Sapi-Portuguese
H. 7.5 cm. (bowl and lid missing, heads of the lions damaged)
Rijksmuseum voor Volkenkunde, Leiden (Inv. no. IB 87-4; on loan from the Rijksmuseum, Amsterdam, since 1953)
[pp. 123, 126, 137]

26. SALTCELLAR
Sierra Leone, Sapi-Portuguese
H. 21 cm.
Staatliche Museen Preussischer Kulturbesitz, Museum für Völkerkunde, Berlin
(Inv. no. IIIC 17036 a,b)
Ex collection: Imperial Kunstkammer (Kreiger 1969, II, no. 103)
[pp. 72, 106, 123, 126, *129,* 137]

27. SALTCELLAR
Sierra Leone, Sapi-Portuguese
H. 29 cm.
(finial group damaged)
Galleria e Museo Estense di Modena, Modena (Inv. no. 2433, acquired in 1866)
Ex collection: Duke of Este, Modena
[pp. 62, *68,* 69, 127, *131,* 138]

28. SALTCELLAR
Sierra Leone, Sapi-Portuguese
H. 20.2 cm. (lid missing)
Pitt Rivers Museum, University of Oxford (Inv. no. 1884.68.73, acquired in 1883)
Ex collection: Pitt Rivers Museum, Farnham
[pp. 69, 127, *130*]

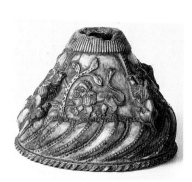 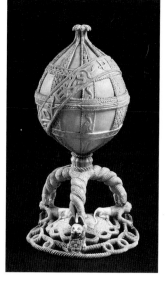 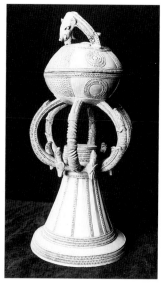 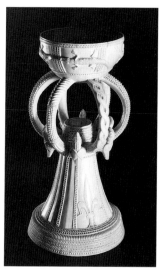

29. SALTCELLAR
Sierra Leone, Sapi-Portuguese
H. 13.5 cm. (bowl and lid missing)
Alain de Monbrison collection, Paris
[pp. 69, 127, 138]

30. SALTCELLAR
Sierra Leone, Sapi-Portuguese
H. approx. 13 cm. (bowl and lid missing)
Collection unkown: Sotheby's sale 15.11.1965, lot 122
[pp. 69, 127, 138]

31. SALTCELLAR
Sierra Leone, Sapi-Portuguese
H. 43 cm. (finial group at the top partly restored)
Museo Nazionale Preistorico e Etnografico, Rome (Inv. no. 104079, acquired in 1973; formerly in a private collection in Rome)
[pp. 75, *81, 110, 132,* 134, 135]

32. SALTCELLAR
Sierra Leone, Sapi-Portuguese
H. 23.5 cm. (top damaged)
Museum of Mankind, London (Inv. no. 67.3.25.1 acquired in 1867)
Ex collection: W. Wareham
[pp. *55, 61,* 69, 134]

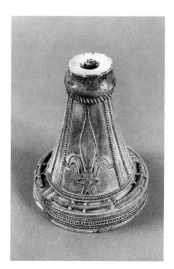 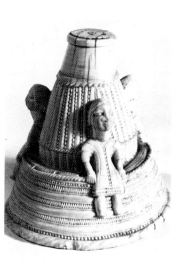 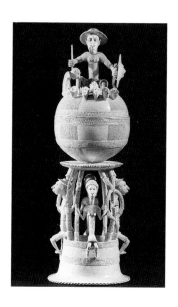 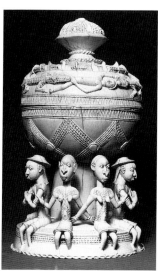

33. SALTCELLAR
Sierra Leone, Sapi-Portuguese
H. 19.5 cm. (top missing)
Private collection, Lisbon
Ex collection: Roudillon; Sadruddin Aga Khan
[pp. *52,* 134, 135]

34. SALTCELLAR
Sierra Leone, Sapi-Portuguese
H. 11.7 cm. (lid missing)
Museum of Mankind, London
(Inv. no. 1979 Af 1.3157)
Presented by A.W. Franks, 1877
[pp. 134, 135]

35. SALTCELLAR
Sierra Leone, Sapi-Portuguese
H. 22.5 cm.
Museum für Völkerkunde, Vienna (Inv. no. 118.609, acquired in 1923)
Ex collection: Dietrich, Feistritz Castle
[pp. 75, *78, 79,* 134, 135]

36. SALTCELLAR
Sierra Leone, Sapi-Portuguese
Size unknown (top missing)
Collection unknown: offered in l883 by Henry Duval, Liège, to the British Museum, London
[pp. 134, 135, 138]

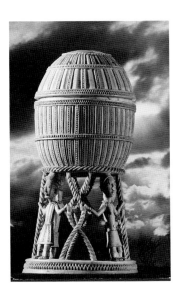
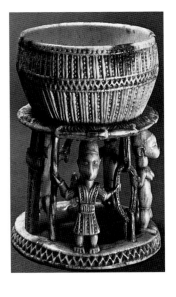
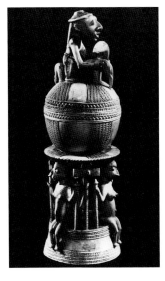
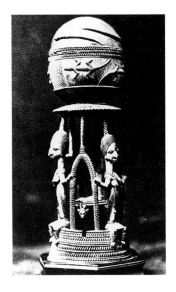

37. SALTCELLAR
Sierra Leone, Sapi-Portuguese
H. 9.2 cm.
(bowl and lid missing)
Staatliches Museum für Völkerkunde, Munich (Inv. no. 5380)
Ex collection: "Vereinigte Sammlungen" of the Kings of Bavaria (Kecskési 1980, no. 99).
[pp. 134, *135,* 135]

38. SALTCELLAR
Sierra Leone, Sapi-Portuguese
H. 16.8 cm. (lid missing)
Städtisches Museum, Braunschweig (Inv. no. VW7.1-63/7, acquired in 1906)
Ex collection: Dukes of Braunschweig

Registered in the Dukes of Braunschweig manuscript inventory of l805, no. 85, as "One round container with a tall foot, on which different figures are carved in gothic style" (Andree 1901, pp. 156-157).
[pp.134, 135, *137*]

39. SALTCELLAR
Sierra Leone, Sapi-Portuguese
H. 6 cm. (bowl and lid missing)
Collection unknown: until 1981 in the Rolin Gallery, New York
Ex collection: Pitt Rivers Museum, Farnham
[pp. 134, 135]

40. SALTCELLAR
Sierra Leone, Sapi-Portuguese
H. 30.4 cm.
Seattle Art Museum, Seattle (Inv. no. 81.Af.17.189)
Ex collection: Katherine White
[pp. 75, *133,* 134, 135, 137, 138]

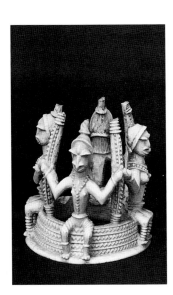
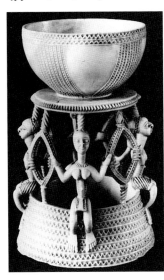
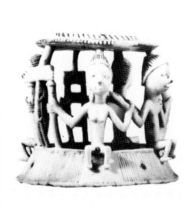
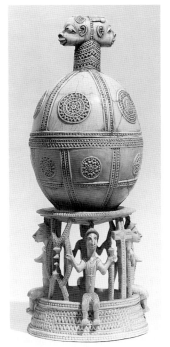

41. SALTCELLAR
Sierra Leone, Sapi-Portuguese
H. 24.5 cm.
Museo Nazionale Preistorico e
Etnografico, Rome
(Inv. no. 5286, acquired in 1876)
Ex collection: Museo Kircheri-
ano of the Jesuits, Rome. Pos-
sibly from the collection of
Cardinal Flavio Chigi (died
1693), Rome.

In the manuscript inventory of
1706 the registration number
reads, "An ivory vessel with two
heads on top of the lid" (Incisa
1966, no. 745).
[pp. *70, 71*, 75, 134, 135, 137]

42. SALTCELLAR
Sierra Leone, Sapi-Portuguese
H. 28 cm. (lid damaged)
Museum of Mankind, London
(Inv. no. 5117 C.C.)
Presented by A.W. Franks, 1868
[pp. 75, 134, 135, *137*, 137]

43. SALTCELLAR
Sierra Leone, Sapi-Portuguese
H. 17.1 cm.
(lower part missing)
Museum of Mankind, London
(Inv. no. 1952.AF.18.1 a,b)
Acquired in 1952 from J.J. Kle-
ijmann, New York
[pp. 75, *77*, 134, 135, 137, 138]

44. SALTCELLAR
Sierra Leone, Sapi-Portuguese
H. 15 cm. (lid)
The National Museum of Den-
mark, Copenhagen (Inv. no.
EDc66)
Ex collection: Gottorp
Kunstkammer, Gottorp Castle
Schleswig-Holstein

Registered in the Gottorp manu-
script inventory of 1743, 87e
with saltcellar nos. 4 and 49
(Dam-Mikkelsen 1980, pp. 46).
[pp. 75, *134*, 134, 135, 137,
138]

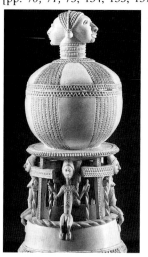
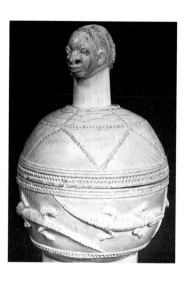
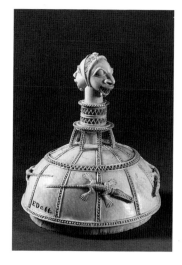

45. SALTCELLAR
Sierra Leone, Sapi-Portuguese
Size unknown
Collection unknown
Ex collection: princely
Kunstkammer Grünes Ge-
wölbes, Dresden

Sketched in a notebook by A.W.
Franks in the last quarter of the
nineteenth century and described
as: "Carved ostrich egg forming
a box. Two negro heads on top.
Open work ivory stand carved
in four compartments—in each a
sitting figure (Princesses' coll.)."
[pp. 75, 134, 135]

46. SALTCELLAR
Sierra Leone, Sapi-Portuguese
H. 5.5 cm. (fragment, used as a
dagger hilt)
Glasgow Museums and Art
Galleries, Glasgow (Inv. no.
A74220)
[pp. 75, *77*, 89, 134, 135]

47. SALTCELLAR
Sierra Leone, Sapi-Portuguese
H. 11.6 cm. (lid)
Museum of Mankind, London
(Inv. no. 7398)
Presented by A.W. Franks, 1871
[pp. 75, *77, 88*, 134, 135, 137]

48. SALTCELLAR
Sierra Leone, Sapi-Portuguese
H. 20.7 cm. (lower part miss-
ing, the base a replacement)
Seattle Art Museum, Seattle
(Inv. no. 68.Af. 10.10 a.b.)
Gift of Nasli and Alice
Heeramaneck, 1968
[pp. 62, *63, 82*, 134, 135, 138]

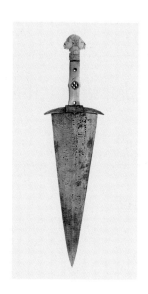
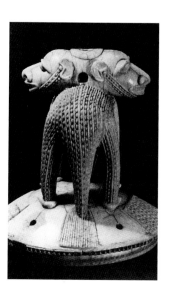
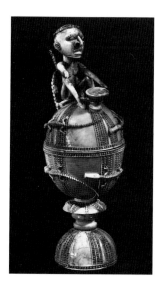

49. SALTCELLAR
Sierra Leone, Sapi-Portuguese
H. 13 cm. (lid missing)
Museum für Völkerkunde,
Basel (Inv. no. 111.21.474, acquired in 1978)
Ex collection: Dr. van Hirsch
[pp. 69, *72,* 134, 135, 137]

50. SALTCELLAR
Sierra Leone, Sapi-Portuguese
Size unknown (lid missing)
Collection unknown: photograph in the Charles Ratton
Archives, Paris
[pp. 134, 135, 137]

51. SALTCELLAR
Sierra Leone, Sapi-Portuguese
H. 16 cm. (lid missing)
The National Museum of Denmark, Copenhagen (Inv. no.
EDc67a)
Ex collection: Gottorp
Kunstkammer, Gottorp Castle,
Schleswig-Holstein

Exhibited with no. 4 as a complete saltcellar; registered in the
Gottorp manuscript inventory of
1743, 87e with nos. 4 and 44
(Dam-Mikkelsen 1980, pp. 46).
[pp. 83, 135, *136,* 137]

52. SALTCELLAR
Sierra Leone, Sapi-Portuguese
H. 8.1 cm. (fragment)
Collection unknown: Sotheby's
sale 23.6.1981, lot 190
[pp. 138, 146]

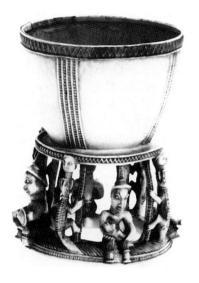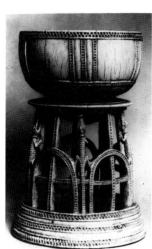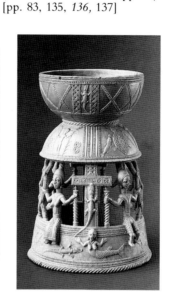

53. SALTCELLAR
Sierra Leone, Sapi-Portuguese
H. 7.5 cm. (fragment)
Museum of Mankind, London
(Inv. no. 7398) Acquired by
A.W. Franks in Bruxelles in
1871 and presented to the museum in the same year.

54. SALTCELLAR
Sierra Leone, Sapi-Portuguese
Size unknown (fragment)
F. Rieser collection
[p. *49*]

55. SALTCELLAR
Sierra Leone, Sapi-Portuguese
Size unknown (fragment)
Vander Straete collection,
Lasne
[not illustrated]

56. SALTCELLAR (?)
Sierra Leone, Sapi-Portuguese (?)
H. 9.4 cm.
Field Museum of Natural History, Chicago (Inv. no. 210425,
acquired in 1938 with the Fuller
collection)

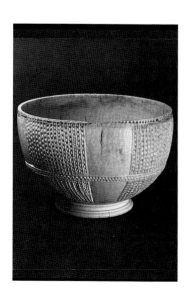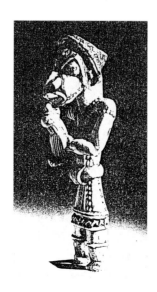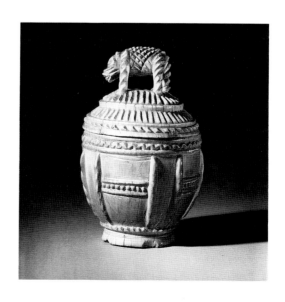

57. PYX
Sierra Leone, Sapi-Portuguese
H. 14.5 cm. (finial group damaged)
Museu de Grão Vasco, Viseu
[pp. 83, *84*, 138]

58. PYX
Sierra Leone, Sapi-Portuguese
H. 23 cm. (finial group on lid damaged)
Private collection
[pp. 83, *84, 114,* 115, 138]

59. PYX
Sierra Leone, Sapi-Portuguese
Size unknown (lid and feet missing)
The Walters Art Gallery, Baltimore
[pp. *83,* 83, *113,* 115, *138,* 138]

60. SPOON
Sierra Leone, Sapi-Portuguese
L. 23.3 cm.
The Metropolitan Museum of Art, New York
Ex collection: Nelson Rockefeller, New York
[p. *86*]

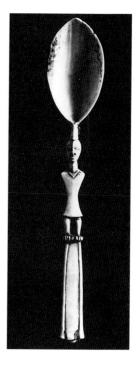

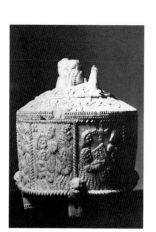

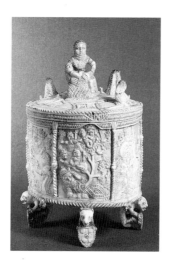

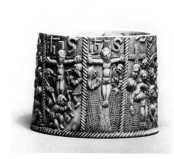

61. SPOON
Sierra Leone, Sapi-Portuguese
L. 22 cm.
The National Museum of Denmark, Copenhagen (Inv. no. EAc136)

Registered in the Royal Kunstkammer manuscript inventory of 1689, 44, with no. 161 as, "Two East Indian carved spoons, with lizards and snakes on the handles." (Dam-Mikkelsen 1980, pp. 47, 48).
[pp. 146, *147*]

62. SPOON
Sierra Leone, Sapi-Portuguese
L. 24 cm.
Städtisches Museum, Braunschweig (Inv. no. VW.7.1-63/A, acquired in 1906)
Ex collection: Dukes of Braunschweig

Registered in the Dukes of Braunschweig manuscript inventory of 1805, no. 88 (Andree 1901, pp. 157, 158).

63. SPOON
Sierra Leone, Sapi-Portuguese
L. 24 cm.
Museum of Mankind, London (Inv. no. 1856.6-23.163, acquired in 1856)
Ex collection: W. Haskell
[pp. 127, *131*]

64. SPOON
Sierra Leone, Sapi-Portuguese
L. 21.2 cm.
Museum of Mankind, London (Inv. no. 1856.6-23.164, acquired in 1856)
Ex collection: W. Haskell
[p. *85*]

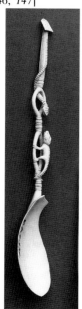

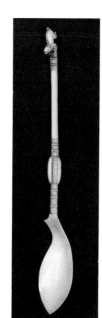

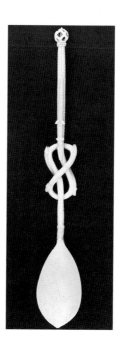

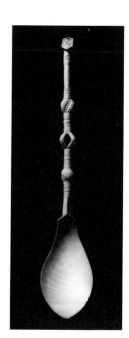

65. SPOON
Sierra Leone, Sapi-Portuguese
L. 24 cm.
Staatliches Museum für Völkerkunde, Munich (Inv. no.
26.N.129, acquired from the
Bayerisches National Museum)
Ex collection: Kunstkammer
der Residenz
[p. 93]

66. SPOON
Sierra Leone, Sapi-Portuguese
L. 20 cm.
Musée de la Renaissance Château d'Ecouen, Ecouen (Inv. no
22.254a)
Ex collection: Musée National
des Thermes et de l'Hôtel de
Cluny, Paris
[p. 86]

67. SPOON
Sierra Leone, Sapi-Portuguese
L. 25.2 cm.
Museo de America, Madrid
(Inv. no. 16.832, acquired from
the Museo Arqueológico Nacional, Madrid)
Ex collection: Museo de Ciencias Naturales, Madrid, until
1868
[p. 58]

68. FORK
Sierra Leone, Sapi-Portuguese
L. 14.4 cm.
Museum für Völkerkunde, Vienna (Inv. no. 91908)
Ex collection: Archdukes of
Tyrol, Ambras Castle, Tyrol
(?) (Heger 1899).
[pp. 87, 89]

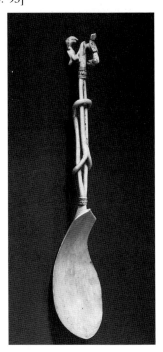 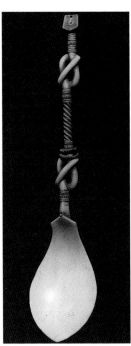 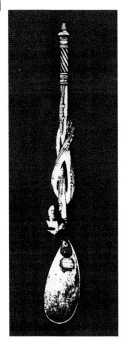 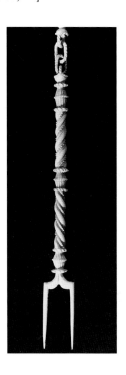

69. FORK
Sierra Leone, Sapi-Portuguese
L. 20 cm.
Musée de la Renaissance Château d'Ecouen, Ecouen (Inv.
no. 22.254b)
Ex collection: Musée National
des Thermes et de l'Hôtel de
Cluny, Paris
[pp. 87, 89]

70. FORK
Sierra Leone, Sapi-Portuguese
L. 24.5 cm.
Museum of Mankind, London
(Inv. no. 7845)
Presented by A.W. Franks, 1872
[pp. 127, 131]

71. SPOON
Sierra Leone, Sapi-Portuguese (?)
L. 16 cm.
Ashmolean Museum of Art and
Archaeology, Oxford
(Inv. no. 23)
Ex collection: J. Tradescant

Possibly mentioned by J. Tradescant, 1656, p. 38 among,
"Divers rare and ancient pieces
carved in Ivory" (MacGregor
1983, no. 22).

72. SPOON
Sierra Leone, Sapi-Portuguese (?)
L. 15.1 cm.
Ashmolean Museum of Art and
Archaeology, Oxford
(Inv. no. 22)
Ex collection: J. Tradescant

Possibly mentioned by J. Tradescant, 1656, p. 38 with no. 71.
(MacGregor 1983, no. 23).

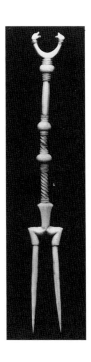 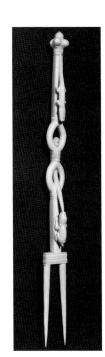 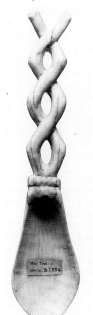 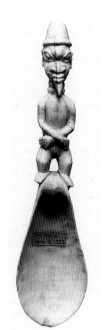

73. KNIFE HAFT OR DAG-GER HILT (?)

Sierra Leone, Sapi-Portuguese
L. 11.4 cm.
Museum of Mankind, London
(Inv. no. 9037)
Presented by A.W. Franks,
1874
Ex collection: Greville Chester
[pp. *88, 89*, 138]

74. KNIFE HAFT OR DAG-GER HILT (?)

Sierra Leone, Sapi-Portuguese
L. 17.6 cm.
Seattle Art Museum, Seattle
(Inv. no. 68.28)
Gift of Nasli and Alice
Heeramaneck, 1968
[pp. *89, 89*, 138]

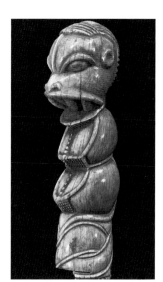

75. OLIPHANT

Sierra Leone, Sapi-Portuguese
L. 68.5 cm.
Australian National Museum,
Canberra (Inv. no. 79. 2148,
acquired in 1979)

Ex collection: George Ashby,
until 1802; Lord Spencer,
Drummond Castle, after 1802
(de Sampayo Ribeiro 1964).
[pp. *100, 101, 103*, 109, 139,
140, 141]

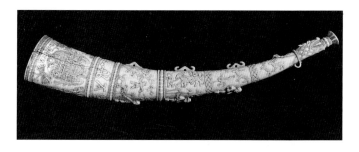

76. OLIPHANT

Sierra Leone, Sapi-Portuguese
L. 63.5 cm.
The Paul and Ruth Tishman
Collection of African Art, Walt

Disney Co., Los Angeles
Formerly Private collection,
France
[pp. *99, 107*, 109, *139*, 140, 141]

77. OLIPHANT

Sierra Leone, Sapi-Portuguese
L. 65 cm.
Collection unknown
Ex collection: Feodor Varela
Gil, 1927

Formerly (8.3.1927) in the pos-
session of Feodor Varela Gil,

Spanish Consul in Southampton,
inherited from his great uncle,
the Marquis of Monroy, Estre-
madura, to whom it is said to
have been given by a king of
Portugal (W. Blackburn).
[pp. 109, 140, 141]

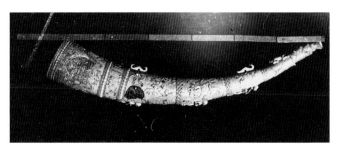

78. OLIPHANT

Sierra Leone, Sapi-Portuguese
L. 61 cm.
Museo Nacional de Artes
Decoratives, Madrid
Ex collection: Cabinete de His-
toria Natural of Charles II King

of Spain (1716-1788) Museo
Arqueológico Nacional, Mad-
rid, Ethnographic Dept.

Illustrated in a drawing in Rosell
y Torres, 1878 (Estella 1984, no.
1002).
[pp. 102, 106, *108, 140*, 143]

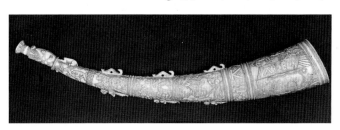

79. POWDER FLASK

Sierra Leone, Sapi-Portuguese
Ivory and metal, L. 29 cm.
(from a fragment of an oli-
phant)
Instituto Valencia de Don Juan,
Madrid (Inv. no. 4.873)

This powder flask and no. 80
might be the remnants of the
same broken oliphant. See how
the hunting scene in no. 79 con-
tinues on the surface of no. 80.
[pp. 109, 115, *116*, 140, 141]

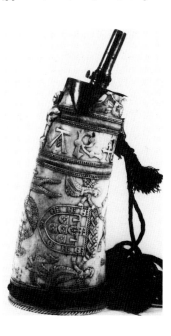

80. POWDER FLASK

Sierra Leone, Sapi-Portuguese
Ivory and metal, L. 26 cm.
(from a fragment of an oli-
phant)
Carlo Monzino collection
(See no. 79)
[pp. 140, 141]

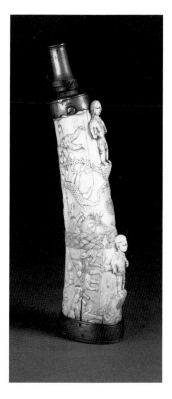

81. OPLIPHANT

Sierra Leone, Sapi-Portuguese
L. 63 cm.
Armeria Reale, Turin
(Inv. no. Q.10, acquired in 1833 from the Museo di Antichità)

Registered in the manuscript inventory of 1832 of the Museo di Antichità as, "Tooth of elephant with many figures." Possibly from the collection of the Dukes of Savoy. In 1521, D. Beatrize, daughter of King Manuel I of Portugal, married Charles III Duke of Savoy.
[pp. *56, 95,* 102, *114,* 115, 117, 143]

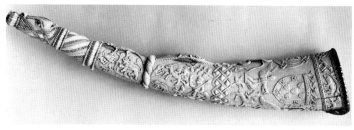

82. OLIPHANT

Sierra Leone, Sapi-Portuguese
L. 77 cm.
Musée de l'Homme, Paris

(Inv. no. 33.6.1, on loan from the Bibliothèque Nationale, Cabinet des Medailles, Paris)
[pp. 102, 115, 143]

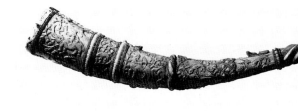

83. OLIPHANT

Sierra Leone, Sapi-Portuguese
L. 48.2 cm.

Museum of Mankind, London
(Inv. no. N.N.25)
[pp. 102, 143]

84. OLIPHANT

Sierra Leone, Sapi-Portuguese
L. 49.5 cm.
Private collection, New York

Ex collection: Jay Leff;
Nasli and Alice Heeramaneck
[pp. *90, 94, 96,* 143]

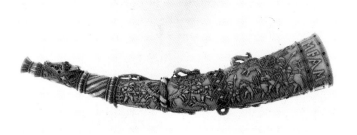

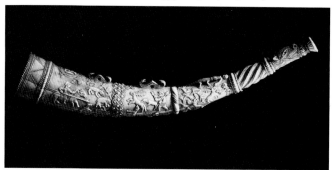

85. OLIPHANT

Sierra Leone, Sapi-Portuguese
L. 43.5 cm. (mouthpiece missing)
Hermitage, Leningrad
(Inv. no. F.635, acquired from the Arsenal of Tsarsko Selo, 1886)
Ex collection: Bertu, Paris, until 1861
[pp. 102, 106, *116,* 117, 143]

86. OLIPHANT

Sierra Leone, Sapi-Portuguese
L. 51 cm.
Städtisches Sammlungen, Tubingen (Inv. no. 3895) Presented by Karl von Kolle, 1850, who bought it between 1817 and 1833 in Rome
[pp. 97, 143]

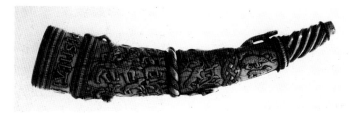

87. OLIPHANT

Sierra Leone, Sapi-Portuguese
L. 48 cm.
Hermitage, Leningrad
(Inv. no. F.576, acquired from the Arsenal of Tsarsko Selo, 1886)
Ex collection: Grand Duke of Tuscany, Florence

Illustrated in O. Worm, 1643, p. 435. Registered in a manuscript inventory of 1768 (*Sindacati e Revisioni* no. 71), no. 3213, as, "An ivory horn for hunters all carved in bas-relief with dogs, animals, and birds, with a tiger carved in the round . . ."
[pp. 97, 106, 117, 143]

88. OLIPHANT

Sierra Leone, Sapi-Portuguese
L. 48.5 cm.
Musée National des Thermes et de l'Hôtel de Cluny, Paris (Inv. no. Cl.1859)
Ex collection: Grand Duke of Tuscany, Florence

Illustrated in O. Worm, 1643, p. 434. Registered in a manuscript inventory of 1768 (*Sindacati e Revisioni* no. 78/bis), no. 1004, together with no. 87 as ". . . two (horns) with scenes in bas-relief of stags and hunting."
[pp. *54,* 115, 143]

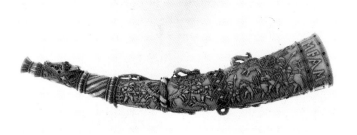

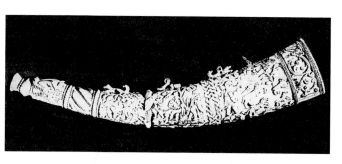

89. OLIPHANT
Sierra Leone, Sapi-Portuguese
L. 53 cm.

Private collection, New York
[pp. *141, 143*]

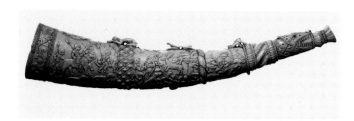

90. OLIPHANT
Sierra Leone, Sapi-Portuguese
L. 53.5 cm.
Ex collection: Staatliche Museen Preussischer Kulturbesitz, Museum für Völkerkunde, Berlin
Lost or destroyed

Mentioned in Read and Dalton, 1899, p. 34. Sketched in a note-

book by Sir A. W. Franks, in the last quarter of the nineteenth century, with the note: "Round the upper band arms of Portugal, 2 large birds with their necks entwined, globe, and cross within knots. Great band stag hunting and figure riding a dog or fantastic animal."
[p. 143]

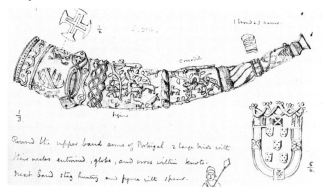

91. OLIPHANT
Sierra Leone, Sapi-Portuguese
L. 32.2 cm.
Württembergisches Landesmuseum, Stuttgart (Inv. no. KK124)
Ex collection: Royal Collections of Württemberg

Registered in a manuscript inventory of 1753/5, p. 31, as "An ivory horn: on the surface every sort of figures, wild animals, hunters with spears, bows and arrows, and also other strange figures."
[pp. 97, 115, 143]

92. OLIPHANT
Sierra Leone, Sapi-Portuguese
L. 43.2 cm.
Collection unknown: Christie's

sale 14.7.1971, lot 60 (Blonders)
Ex collection: E. Frosses, Iowa City
[p. 143]

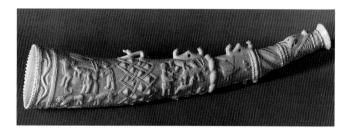

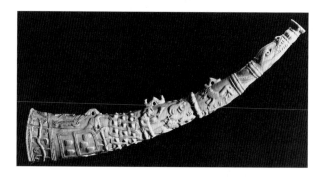

93. OLIPHANT
Sierra Leone, Sapi-Portuguese
L. 43 cm.
Museo Nazionale Preistorico e Etnografico, Rome (Inv. no. 108828, acquired in 1982)
Ex collection: Museo Kircheriano of the Jesuits in Rome

Illustrated in F. Bonanni, 1709, pl. 299, p. 235 and described as, "An ivory horn brought from Africa, with different figures very nicely carved."
[pp. *59*, 115, 143]

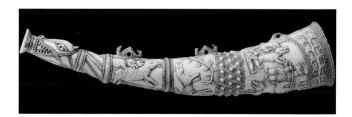

94. POWDER FLASK
Sierra Leone, Sapi-Portuguese
L. 24.5 cm. (from a fragment

of an oliphant)
Private collection, Paris
[p. 115]

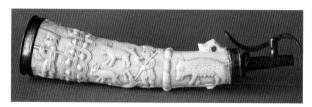

95. OLIPHANT
Sierra Leone, Sapi-Portuguese
L. 47 cm.
Ex collection: Staatliche Museen Preussischer Kulturbesitz, Museum für Völkerkunde,

Berlin
Lost or destroyed

Illustrated in Read and Dalton, 1899, p. 34.
[p. 143]

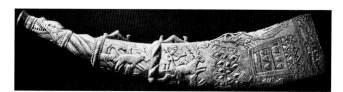

96. OLIPHANT
Sierra Leone, Sapi-Portuguese
L. 32 cm.
Museu Nacional de Arte Anti-

ga, Lisbon (Inv. no. 988 Div., acquired in 1982)
Ex collection: Rolin, New York
[p. 143]

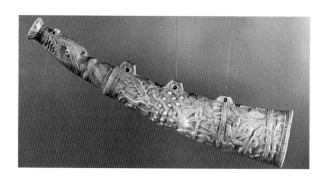

97. OLIPHANT
Sierra Leone, Sapi-Portuguese
L. 29 cm.
Museu Nacional de Arte Anti-
ga, Lisbon (Inv. no. 987 Div.,
acquired in 1982)
Ex collection: Rolin, New York
[p. 143]

98. OLIPHANT
Sierra Leone, Sapi-Portuguese
L. 36 cm. (later made into a
powder flask)
Collection unknown: Sotheby's
sale 23.6.1986, lot 28
Ex collection: Charles Ratton,
Paris
[p. 143]

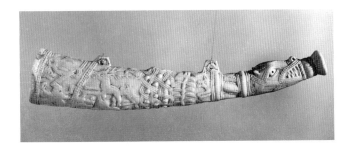

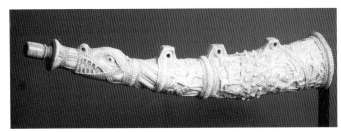

99. OLIPHANT
Sierra Leone, Sapi-Portuguese
L. 31 cm. (later made into a
powder flask)
Musée National des Thermes et
de l'Hôtel de Cluny, Paris (Inv.
no. 17079, acquired in 1883)
[p. 143]

100. OLIPHANT
Sierra Leone, Sapi-Portuguese
Ivory, L. 57.2 cm.
Merseyside County Museums,
Liverpool (Inv. no. M 1304)
Presented in 1867 by Joseph
Mayer who bought it in 1851.
Ex collection: Gabor Fejervary
[pp. 102, 105, 115, 117, *141,*
143, 144]

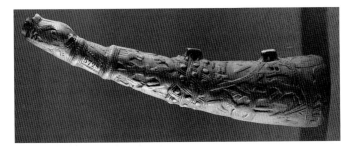

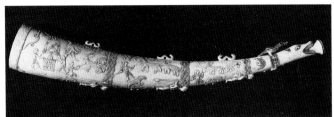

101. OLIPHANT
Sierra Leone, Sapi-Portuguese
L. 54 cm.
Private collection, New York
[pp. *92, 92, 93,* 102, *106,* 115,
117, *120,* 143, 144]

102. OLIPHANT
Sierra Leone, Sapi-Portuguese
L. 57.l cm.
Museum of Mankind, London
(Inv. no. 7009)
Presented by A.W. Franks, 1870
[pp. 105, 117, 143, 144]

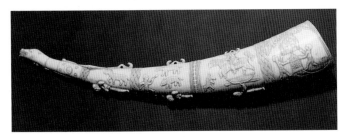

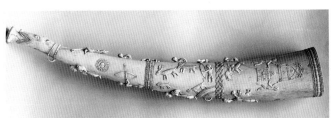

103. OLIPHANT
Sierra Leone, Sapi-Portuguese
L. 60 cm.
Historicshes Museum, Dresden
(Inv. no. X497)
Ex collection: Princely Kun-
stkammer

Mentioned in a manuscript in-
ventory 1732, p. 83 as, "One
large ivory hunting horn carved
overall with men and exotic an-
imals and birds. The horn is al-
most a cubit long. It was deliv-
ered by Mr. Rattichen on Nov.
26th 1658."
[pp. 102, 115, 117, *142,* 143, 144]

104. OLIPHANT
Sierra Leone, Sapi-Portuguese
L. 54 cm.
The National Museum, De-
partment of Historical Archae-
ology, Prague (Inv. no. 3623,
acquired in 1859)
Ex collection: Emperor Ru-
dolph II (1552-1612) (?)
[pp. *105,* 115, 143, 144]

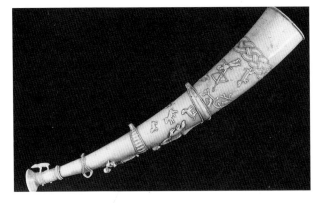

105. OLIPHANT
Sierra Leone, Sapi-Portuguese
L. 56 cm.
Madame N. Kugel collection,
Paris
[pp. 102, 115, 117, *118, 119, 144*]

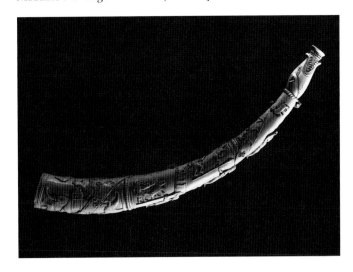

106. OLIPHANT
Sierra Leone(?), Sapi-Portu-
guese(?)
Size unknown
Collection unknown
Ex collection: Munchner
Kunstkammer, Munich

Registered in a manuscript in-
ventory (Fickler, 1583, p. 60v,
no. 725) together with other
ivory horns as, "Three ivory
carved Indian trumpets[. . .], on
the other figures of men and an-
imals are carved all over and
wound round the inscription '*Da
Pace Dne in diebus nr*' . . . ,
everything seems Indian work."
It might be the oliphant no. 98
or no. 100 which bears the same
inscription.
[not illustrated]

107. OLIPHANT
Sierra Leone, Sapi-Portuguese
Ivory, L. 26.5 cm.
Museu Nacional de Arte Anti-
ga, Lisbon (Inv. no. 732/Div.,
acquired in 1953)
[p. 107]

108. OLIPHANT
Sierra Leone, Sapi-Portuguese
Ivory, silver, L. 29 cm.
Collection unknown: Sotheby's
sale 6.5.1983, lot 368
Ex collection: Hever Castle

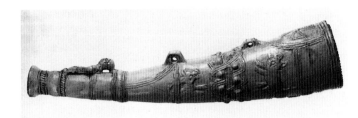

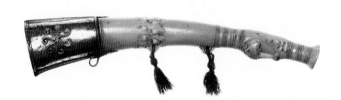

109. OLIPHANT
Sierra Leone (?), Sapi-Portu-
guese (?)
Size unknown
Museum für Deutsche Ges-
chichte, Berlin
Lost or destroyed

F. von Luschan, 1919, p. 473, pl.
16, illustrates a cast in the Staat-
liche Museen Preussischer Kul-
turbesitz, Museum für Völker-
kunde, Berlin (Inv. no. IIIC
8094)
[p. 92]

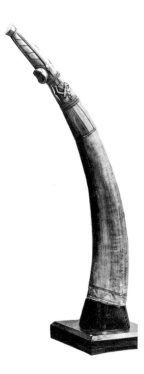

110. OLIPHANT
Sierra Leone (?), Sapi-
Portuguese (?)
Size unknown
Collection unknown
Ex collection: Archduke Ferdi-
nand of Tyrol, Ambras Castle,
Tyrol

Registered in the manuscript in-
ventory of 1596, p. 403, as, "One
ivory horn, bound in the middle,
up and down with silver; on the
surface the coat of arms of Por-
tugual and Tercera is clear; it
hangs from three silver chains
with 2 silver rings" (Heger 1899).
[not illustrated]

111. OLIPHANT
Nigeria, Bini-Portuguese
L. 57 cm.
Rautenstrauch-Joest-Museum,
Cologne (Inv. no. 46888, ac-
quired in 1944)
Ex collection: Gurlitt Gallery,
Dresden
[pp. 156, *157, 158*]

112. OLIPHANT
Nigeria, Bini-Portuguese
L. 39.4 cm. (damaged)
Museum of Mankind, London
(Inv. no. 1979 AF.1.3158, ac-
quired in 1961)
[pp. 156, *157*]

113. OLIPHANT
Nigeria, Bini-Portuguese
L. 50.8 cm. (damaged)
Collection unknown: Sotheby's
sale 6.3.1983, lot 367
Ex collection: Hever Castle
[pp. 156, *159*]

114. SALTCELLAR
Nigeria, Bini-Portuguese
H. 29.2 cm.
Museum of Mankind, London
(Inv. no. 78.11.1.48)
Presented by A.W. Franks, 1878
[pp. *160, 170,* 170, 179, *180,*
180]

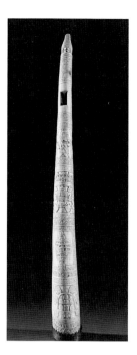 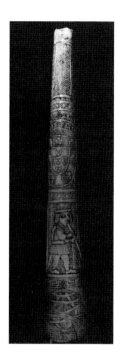 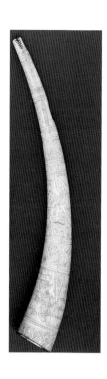 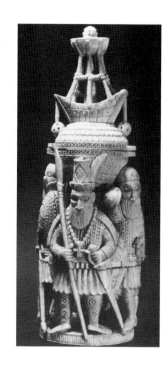

115. SALTCELLAR
Nigeria, Bini-Portuguese
H. 11.3 cm.
(middle section)
Royal Museum of Scotland,
Edinburgh (Inv. no. 1956.1155,
acquired in 1956)
[pp. *179,* 179]

116. SALTCELLAR
Nigeria, Bini-Portuguese
Size unknown
(middle section)
Staatliche Museen Preussischer
Kulturbesitz, Museum für
Völkerkunde, Berlin
Lost or destroyed

Illustrated in F. von Luschan,
1919, pl. 119a
[p. 179]

117. SALTCELLAR
Nigeria, Bini-Portuguese
H. 18.1 cm. (lid missing)
The Metropolitan Museum of
Art, New York (Inv. no.
1972.63, acquired in 1962)
[pp. *163, 180,* 180]

118. SALTCELLAR
Nigeria, Bini-Portuguese
H. 9.1 cm. (middle section)
Museum of Mankind, London
(Inv. no. 79.1.1, acquired in
1879)
Ex collection: Henry Willet,
Arnold House, Brighton
[pp. *180,* 180]

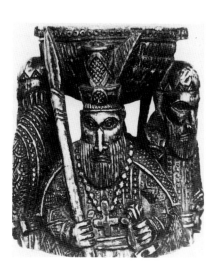 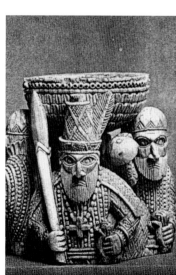 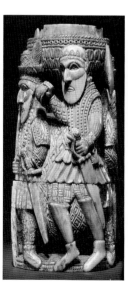 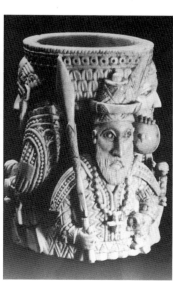

119. SALTCELLAR
Nigeria, Bini-Portuguese
H. 18.2 cm. (lid missing)
Museum of Mankind, London
(Inv. no. 97.7.1.1, acquired in
1856)
[pp. *167, 168,* 180, *181,* 182]

120. SALTCELLAR
Nigeria, Bini-Portuguese
H. 18.3 cm. (lid missing)
Royal Museum of Scotland,
Edinburgh (Inv. no. 1950.3,
acquired in 1950)
Ex collection: Sydney Burney,
London
[pp. *164,* 180, 182]

121. SALTCELLAR
Nigeria, Bini-Portuguese
H. 8.3 cm.
(middle section)
The Paul and Ruth Tishman
Collection of African Art, Walt
Disney Co., Los Angeles
Ex collection: David Litton
Cobbold
[pp. 182, *183]*

122. SALTCELLAR
Nigeria, Bini-Portuguese
H. 8.3 cm.
(middle section)
Lipchitz collection, New York
[p. 182]

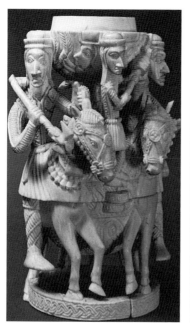
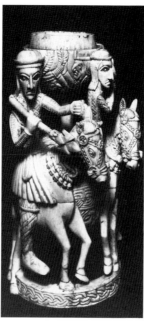
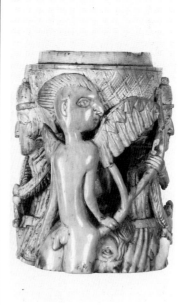
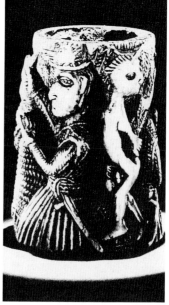

123. SALTCELLAR
Nigeria, Bini-Portuguese
H. 19.2 cm.
Etnografisch Museum, Ant-
werp (Inv. no. A.E.74.25.1,
acquired in 1974)
Ex collection: F. Olbrechts
[pp. 161, 165, 182, *184]*

124. SALTCELLAR
Nigeria, Bini-Portuguese
H. 14 cm. (lid missing)
Museum voor Volkenkunde,
Leiden (Inv. no. 1323-1, ac-
quired in 1901 from the Mu-
seum of History and Art)
[pp. 161, *164,* 165, 182, *184]*

125. SALTCELLAR
Nigeria, Bini-Portuguese
H. 9.1 cm.
(middle section)
Australian National Museum,
Canberra (Inv. no. 73.528 ac-
quired in 1973).
[pp. 161, 165, *168,* 182]

126. SALTCELLAR
Nigeria, Bini-Portuguese
H. 12 cm.
(lower part and top missing)
Staatliche Museen Preussischer
Kulturbesitz, Museum für
Völkerkunde, Berlin
(Inv. no. IIIC 4890 a.b.)
Ex collection: Imperial
Kunstkammer (Kreiger 1969,
no. 102)
[pp. *149,* 161, 165, *177,* 182]

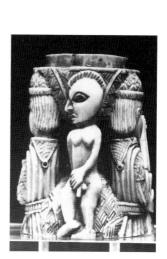
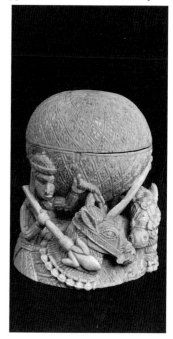

127. SALTCELLAR

Nigeria, Bini-Portuguese
H. 19.2 cm.
(lower part missing)
Museu Nacional de Arte Anti-
ga, Lisbon (Inv. no. 750/Escul-
tura, acquired in 1951)
[pp. 161, 182, *183*]

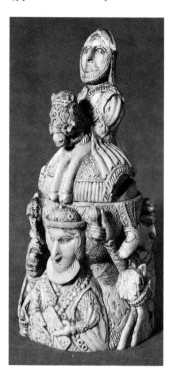

128. SALTCELLAR

Nigeria, Bini-Portuguese
H. 28 cm.
The National Museum of Den-
mark, Copenhagen (Inv. no.
EKc90)
Ex collection: Royal Kun-
stkammer

Registered in a manuscript in-
ventory 1674,165. sp.2 as, "A
carved openwork ivory cup on
which a horseman" (Dam-Mik-
kelsen 1980, p. 46).
[pp. 150, *153, 185,* 186]

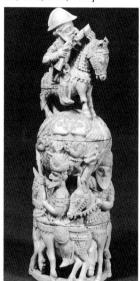

129. SPOON

Nigeria, Bini-Portuguese
L. 25 cm.
Museo Nazionale di Antropol-
ogia e di Etnologia, Florence
(Inv. no. 216/1)
Ex collection: Cosimo I de
Medici, Grand Duke of Tus-
cany, Florence

Registered in a manuscript in-
ventory of 1560, together with
nos. 130-133 as, "Five spoons of
mother-of-pearl, one is broken,
delivered by SS [the Grandu-
chess?] as above in the journal"
(Bassani 1975/2).
[pp. 150, 171]

130. SPOON

Nigeria, Bini-Portuguese
L. 24.8 cm.
Museo Nazionale di Antropol-
ogia e di Etnologia, Florence
(Inv. no. 216/2)
Ex collection: Cosimo I de
Medici, Grand Duke of Tus-
cany, Florence, since 1560 (see
no. 129)
[pp. 150, 171]

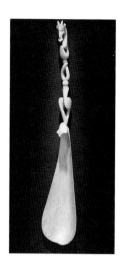

131. SPOON

Nigeria, Bini-Portuguese
L. 25.7 cm. (handle damaged)
Museo Nazionale di Antropol-
ogia e di Etnologia, Florence
(Inv. no. 216/3)
Ex collection: Cosimo I de
Medici, Grand Duke of Tus-
cany, Florence, since 1560 (see
no. 129)
[pp. 150, 171]

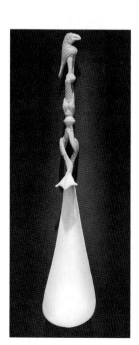

132. SPOON

Nigeria, Bini-Portuguese
L. 24.8 cm.
Museo Nazionale Preistorico e
Etnografico, Rome (Inv. no.
6515/G) Acquired in 1913 from
E.H. Giglioli who had this and
no. 133 from the Museo Na-
zionale di Antropologia e Et-
nologia, Florence
Ex collection: Cosimo I de
Medici, Grand Duke of Tus-
cany, Florence, since 1560 (see
no. 129)
[pp. 150, 171]

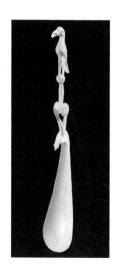

133. SPOON

Nigeria, Bini-Portuguese
L. 26 cm.
Museo Nazionale Preistorico e
Etnografico, Rome (Inv. no.
6516/G) Acquired in 1913 from
E.H. Giglioli who had this and
no. 132 from the Museo Na-
zionale di Antropologia e Et-
nologia, Florence
Ex collection: Cosimo I de
Medici, Grand Duke of Tus-
cany, Florence, since 1560 (see
no. 129)
[pp. 150, *152,* 171]

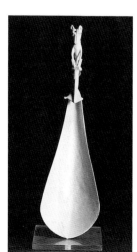

134. SPOON

Nigeria, Bini-Portuguese
Ivory, L. 24 cm.
Staatliches Museum für Völk-
erkunde, Dresden (Inv. no.
43672)
Ex collection: Kunstkammer of
Prince Christian of Saxony, af-
ter 1590, with other spoons

The mention in the manuscript
catalogue of 1595, p. 368 reads,
"The Prince Christian of Saxony
bought in Leipzig in the year
1590, 12 ivory spoons made in
Turkey." This might be incor-
rect as fifteen spoons are in the
Dresden Museum: nos. 134-148
(Wolf 1960).
[pp. 150, 171]

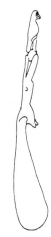

135. SPOON
Nigeria, Bini-Portuguese
L. 25 cm.
Staatliches Museum für Völkerkunde, Dresden (Inv. no. 43673)
Ex collection: Kunstkammer of Prince Christian of Saxony, after 1590 (see no. 134)
[pp. 150, 171]

136. SPOON
Nigeria, Bini-Portuguese
Ivory, L. 25.5 cm.
Staatliches Museum für Völkerkunde, Dresden (Inv. no. 43674)
Ex collection: Kunstkammer of Prince Christian of Saxony, after 1590 (see no. 134)
[pp. 150, 171]

137. SPOON
Nigeria, Bini-Portuguese
L. 25 cm.
Staatliches Museum für Völkerkunde, Dresden (Inv. no. 43675)
Ex collection: Kunstkammer of Prince Christian of Saxony, after 1590 (see no. 134)
[pp. 150, 171]

138. SPOON
Nigeria, Bini-Portuguese
L. 24.6 cm.
Staatliches Museum für Völkerkunde, Dresden (Inv. no. 43676)
Ex collection: Kunstkammer of Prince Christian of Saxony, after 1590 (see no. 134)
[pp. 150, 171]

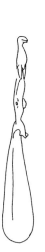
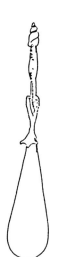
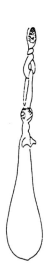
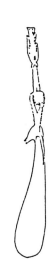

139. SPOON
Nigeria, Bini-Portuguese
L. 25.4 cm.
Staatliches Museum für Völkerkunde, Dresden (Inv. no. 43677)
Ex collection: Kunstkammer of Prince Christian of Saxony, after 1590 (see no. 134)
[pp. 150, 171]

140. SPOON
Nigeria, Bini-Portuguese
L. 25.3 cm.
Staatliches Museum für Völkerkunde, Dresden (Inv. no. 43678)
Ex collection: Kunstkammer of Prince Christian of Saxony, after 1590 (see no. 134)
[pp. 150, 171]

141. SPOON
Nigeria, Bini-Portuguese
L. 24 cm.
Staatliches Museum für Völkerkunde, Dresden (Inv. no. 43679)
Ex collection: Kunstkammer of Prince Christian of Saxony, after 1590 (see no. 134)
[p. 150]

142. SPOON
Nigeria, Bini-Portugues
L. 24 cm.
Staatliches Museum für Völkerkunde, Dresden (Inv. no. 43680)
Ex collection: Kunstkammer of Prince Christian of Saxony, after 1590 (see no. 134)
[pp. 150, 171]

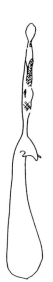
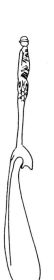
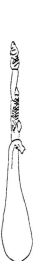
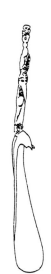

143. SPOON
Nigeria, Bini-Portuguese
L. 26 cm.
Staatliches Museum für Völkerkunde, Dresden (Inv. no. 43681)
Ex collection: Kunstkammer of Prince Christian of Saxony, after 1590 (see no. 134)
[pp. 150, 171]

144. SPOON
Nigeria, Bini-Portuguese
L. 24.9 cm.
Staatliches Museum für Völkerkunde, Dresden (Inv. no. 43682)
Ex collection: Kunstkammer of Prince Christian of Saxony, after 1590 (see no. 134)
[pp. 150, 171]

145. SPOON
Nigeria, Bini-Portuguese
L. 26.5 cm.
Staatliches Museum für Völkerkunde, Dresden (Inv. no. 43683)
Ex collection: Kunstkammer of Prince Christian of Saxony, after 1590 (see no. 134)
[pp. 150, 171]

146. SPOON
Nigeria, Bini-Portuguese
L. 21 cm.
Staatliches Museum für Völkerkunde, Dresden (Inv. no. 43684)
Ex collection: Kunstkammer of Prince Christian of Saxony, after 1590 (see no. 134)
[pp. 150, 171, not illustrated]

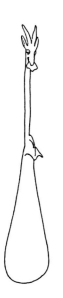

147. SPOON
Nigeria, Bini-Portuguese
L. 27.2 cm.
Staatliches Museum für Völkerkunde, Dresden (Inv. no. 43685)
Ex collection: Kunstkammer of Prince Christian of Saxony, 1590 (see no. 134).
[pp. 150, 171]

148. SPOON
Nigeria, Bini-Portuguese
L. 23.2 cm.
Staatliches Museum für Völkerkunde, Dresden (Inv. no. 43686)
Ex collection: Kunstkammer of Prince Christian of Saxony, l590 (see no. 134)
[pp. 150, 171]

149. SPOON
Nigeria, Bini-Portuguese
L. 25.3 cm.
Museum für Völkerkunde, Vienna (Inv. no. 91909)
Ex collection: Kunstkammer of Archduke Ferdinand of Tyrol, Ambras Castle, Tyrol

Registered in the manuscript inventory of 1596, together with nos. 150-154 as, "Six long ivory spoons carved very thin with different motifs in turkisch form" (Heger 1899).
[pp. 150, 171]

150. SPOON
Nigeria, Bini-Portuguese
L. 25 cm.
Museum für Völkerkunde, Vienna (Inv. no. 91910)
Ex collection: Kunstkammer of Archduke Ferdinand of Tyrol, Ambras Castle, Tyrol, l596 (see no. 149)
[pp. 150, 171, *172*]

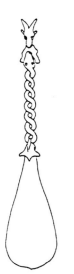

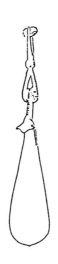

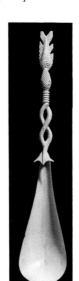

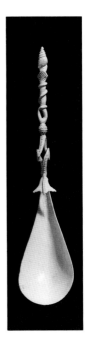

151. SPOON
Nigeria, Bini-Portuguese
L. 20.8 cm. (tripartite hook of
the bowl damaged)
Museum für Völkerkunde, Vienna (Inv. no. 91911)
Ex collection: Kunstkammer of
Archduke Ferdinand of Tyrol,
Ambras Castle, Tyrol, 1596
(see no. 149)
[pp. 150, 171]

152. SPOON
Nigeria, Bini-Portuguese
L. 24 cm.
Museum für Völkerkunde, Vienna (Inv. no. 91912)
Ex collection: Kunstkammer of
Archduke Ferdinand of Tyrol,
Ambras Castle, Tyrol, 1596
(see no. 149)
[pp. 150, 171]

153. SPOON
Nigeria, Bini-Portuguese
L. 26.5 cm.
Museum für Völkerkunde, Vienna (Inv. no. 91913)
Ex collection: Kunstkammer of
Archduke Ferdinand of Tyrol,
Ambras Castle, Tyrol, 1596
(see no. 149)
[pp. 150, 171]

154. SPOON
Nigeria, Bini-Portuguese
L. 26 cm.
Museum für Völkerkunde, Vienna (Inv. no. 91914)
Ex collection: Kunstkammer of
Archduke Ferdinand of Tyrol,
Ambras Castle, Tyrol, 1596
(see no. 149)
[pp. 150, 171, *172*]

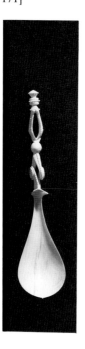 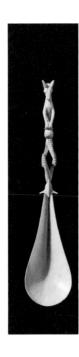 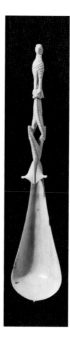 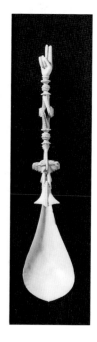

155. SPOON
Nigeria, Bini-Portuguese
L. 22.4 cm. (stem damaged)
Museum für Völkerkunde, Vienna (Inv. no. 118.148, acquired in 1952)
Ex collection: B. Kurz, Vienna
[pp. *53*, 171]

156. SPOON
Nigeria, Bini-Portuguese
L. 26.5 cm.
Ulmer Museum, Museum der
Stadt Ulm (Inv. no. 4/a)
Ex collection: Christoph
Weickmann, Ulm (acquired before 1659 with 157-160)

In the printed catalogue of 1659,
p. 53, only one spoon is mentioned as, "One indian spoon in
ivory; on the handle different
figures of animals are carved"
(Andree 1914).
[pp. 171, *174, 175*]

157. SPOON
Nigeria, Bini-Portuguese
L. 27 cm.
Ulmer Museum, Museum der
Stadt Ulm (Inv. no. 4/b)
Ex collection: Christoph
Weickmann, Ulm, before 1659
(see no. 156)
[p. 171]

158. SPOON
Nigeria, Bini-Portuguese
L. 27.9 cm.
Ulmer Museum, Museum der
Stadt Ulm (Inv. no. 4/c)
Ex collection: Christoph
Weickmann, Ulm, before 1659
(see no. 156)
[pp. *152*, 171]

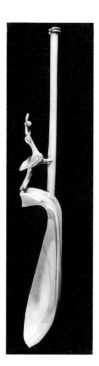 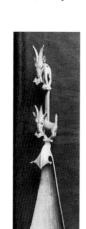 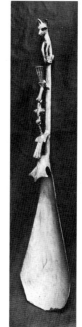 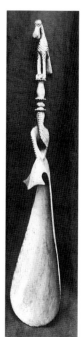

159. SPOON
Nigeria, Bini-Portuguese
L. 26 cm.
Ulmer Museum, Museum der
Stadt Ulm (Inv. no. 4/d)
Ex collection: Christoph
Weickmann, Ulm, before 1659
(see no. 156)
[pp. *152,* 171]

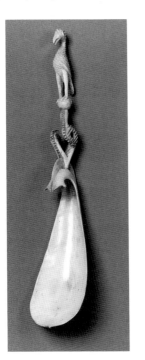

160. SPOON
Nigeria, Bini-Portuguese
L. 22.4 cm.
Ulmer Museum, Museum der
Stadt Ulm (Inv. no. 4/e)
Ex collection: Christoph
Weickmann, Ulm, before 1659
(see no. 156)
[pp. *152,* 171]

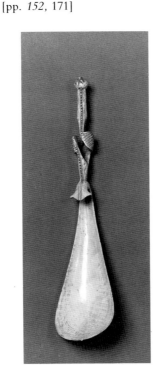

161. SPOON
Nigeria, Bini-Portuguese
L. 25 cm.
The National Museum of Den-
mark, Copenhagen (Inv. no.
EAc137)
Ex collection: Royal Kun-
stkammer, Copenhagen (see
no. 61)

Registered in the manuscript in-
ventory of 1689 (Dam-Mikkelsen
1980, pp. 47, 48).
[p. 171]

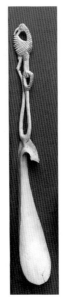

162. SPOON
Nigeria, Bini-Portuguese
L. 24 cm.
The National Museum of Den-
mark, Copenhagen (Inv. no.
EAc135)
Ex collection: Royal Kun-
stkammer, Copenhagen

Registered in a manuscript in-
ventory of 1690, 59, as, "A cu-
rious Japanese spoon carved out
of ivory" (Dam-Mikkelsen 1980,
p. 47). [p. 171]

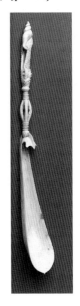

163. SPOON
Nigeria, Bini-Portuguese
L. 26 cm.
The National Museum of Den-
mark, Copenhagen (Inv. no.
EAc138)
Ex collection: Royal Kun-
stkammer, Copenhagen

Registered in a manuscript in-
ventory of 1690, 60, as, "An un-
usual spoon of ivory" (Dam-
Mikkelsen 1980, p. 48).
[p. 171]

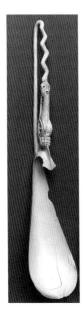

164. SPOON
Nigeria, Bini-Portuguese
L. 29.3 cm.
Universitets Konstmuseum,
Uppsala
Ex collection: King Gustavus
Adolph the Great of Sweden
(1594-1632)

Registered in a manuscript in-
ventory of 1694 as ". . . One
further (spoon) long of ivory,
decorated."
[p. 171]

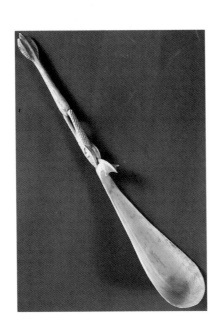

165. SPOON
Nigeria, Bini-Portuguese
L. 26.5 cm.
Städtisches Museum, Braun-
schweig (Inv. no. VW7.1-63/6,
acquired in 1906)
Ex collection: Ducal Kun-
stkammer

Registered in a manuscript in-
ventory of 1805, no. 641 (Andree
1901, pp. 157, 158.
[pp. *171,* 171]

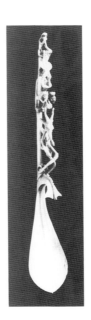

166. SPOON
Nigeria, Bini-Portuguese
L. 24 cm.
Städisches Museum, Braun-
schweig (Inv. no. VW7.1-63/3,
acquired in 1906)
Ex collection: Ducal Kun-
stkammer

Registered in a manuscript in-
ventory of 1805, no. 87 (see no.
165).
[p. 171]

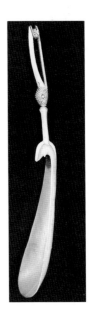

167. SPOON
Nigeria, Bini-Portuguese
L. 25.5 cm.
Städtisches Museum, Braun-
schweig (Inv. no. VW7.1-63/5,
acquired in 1906)
Ex collection: Ducal Kun-
stkammer

Registered in a manuscript in-
ventory of 1805, no. 640 (see no.
165).
[p. 171]

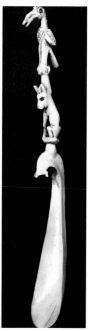

168. SPOON
Nigeria, Bini-Portuguese
L. 19 cm. (stem damaged)
Staatliches Museum für Völk-
erkunde, Munich (Inv. no.
26.N.130, acquired from the
Bayerisches National Museum)
Ex collection: Kunstkammer
der Residenz(?)
[p. 171]

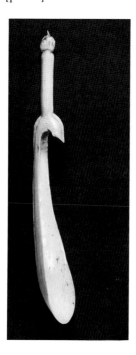

169. SPOON
Nigeria, Bini-Portuguese
23.9 cm.
National Museum, Historical
Department, Prague (Inv. no.
3.654, acquired in 1850)
Ex collection: Kunstkammer of
the Emperor Rudolph II (1552-
1612) (?), Brandys Castle.
[pp. 171, *174*]

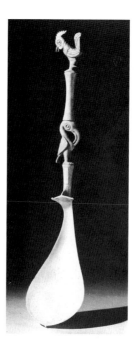

170. SPOON
Nigeria, Bini-Portuguese
L. 25.5 cm.
Museo Civico di Torino, Turin
(Inv. no. 32/avori, acquired in
1871 from the Museo Egizio)
Ex collection: Museo di Anti-
chità, Turin

Registered in a manuscript in-
ventory of 1832, no. 8, as "A
broken ivory spoon: in the mid-
dle a tiger is devouring an ani-
mal, the stem consists of a snake,
on the top an ox." Possibly from
the collection of the Dukes of
Savoy (see no. 81).
[p. 171]

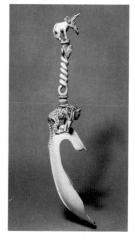

171. SPOON
Nigeria, Bini-Portuguese
L. 19.7 cm.
Museum of Mankind, London
(Inv. no. 9194) Presented by
A.W. Franks, 1875
Ex collection: Wilson
[pp. 171, 172, *177*]

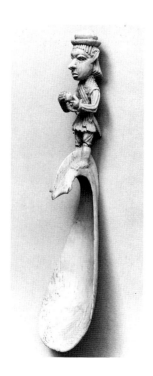

172. SPOON
Nigeria, Bini-Portuguese
L. 25.5 cm.
Museum of Mankind, London
(Inv. no. 1979 Af 1. 3154) Pre-
sented by A.W. Franks, 1872
[p. 171]

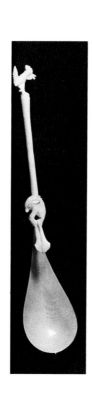

173. SPOON
Nigeria, Bini-Portuguese
L. 23.5 cm.
Museum of Mankind, London
(Inv. no. 5229) Presented by
A.W. Franks, 1892
Ex collection: Magniac
[p. 171]

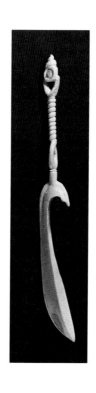

174. SPOON
Nigeria, Bini-Portuguese
L. 26 cm.
Museum of Mankind, London
(Inv. no. 1979 Af 1. 3155) Pre-
sented by A.W. Franks, 1872
[p. 171]

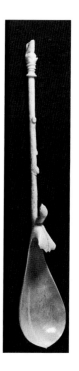

175. SPOON
Nigeria, Bini-Portuguese
L. 15.8 cm.
National Museum of African
Art, Smithsonian Institution,
Washington (Inv. no. 69-20-4)
Ex collection: Wood-Bliss
[p. 171]

176. SPOON
Nigeria, Bini-Portuguese
L. 21.5 cm.
P.G. Ginzberg collection
Ex collection: Dover Museum,
Kent (Sketched in a notebook
by A. W. Franks in the last
quarter of the 19th century).
[p. 171]

177. FRAGMENT OF A SPOON (?)
Nigeria, Bini-Portuguese
L. 12.6 cm.
Yale University Art Gallery,
Yale University (Inv. no.
1954.28.35)
[p. 171]

178. HUMAN FIGURE (fragment)
Nigeria, Bini-Portuguese
Size unknown
Hermitage, Leningrad
Information by M. H. M. Pinto, Lisbon.

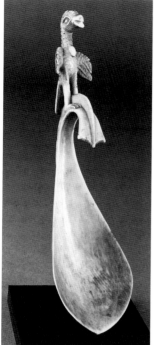

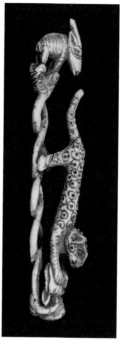

179. SALTCELLAR (?)
Nigeria, Owo-Portuguese (?)
L. 12.5 cm. (lid missing)
Kunsthistorisches Museum, Vienna (Inv. no. 8297 E)
Ex collection: Obizzi, Castle of Catajo

Registered in a manuscript inventory of 1806 as, "A round ivory vase decorated with human figures and animals, of bad workmanship" (Bassani 1984).
[pp. 191, *194, 196*]

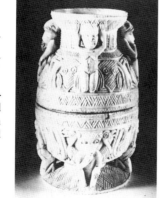

180. OLIPHANT
Sierra Leone, Sapi-Portuguese (?)
L. 32.5 cm.
Museo Nazionale Preistorico e Etnografico, Rome (Inv. no.

63112, acquired in 1899)
Ex collection: E. and G. Brassart
[p. *197*]

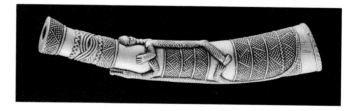

181. OLIPHANT
Zaire or Angola, Kongo-Portuguese (?)
L. 83 cm.
Museo degli Argenti, Florence (Inv. no. 2/Bargello)
Ex collection: Cosimo I de Medici, Grand Duke of Tuscany, Florence

Registered in a manuscript inventory of 1553, together with no. 180 as, "Two ivory horns decorated with engraved motifs" (Bassani 1975/1).
[pp. 47, 198, *200*]

182. OLIPHANT
Zaire or Angola, Kongo-Portuguese (?)
L. 57.5 cm.
Museo degli Argenti, Florence (Inv. no. 3/Bargello)

Ex collection: Cosimo I de Medici, Grand Duke of Tuscany, Florence, 1553 (see no. 181)
[pp. *46,* 47, 198, *204*

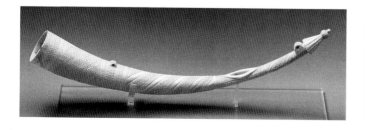

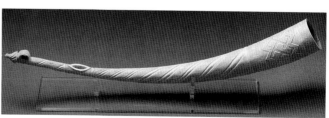

183. OLIPHANT
Zaire or Angola, Kongo-
Portuguese (?)
L. 63 cm.
Museo Nazionale Preistorico e
Etnografico, Rome (Inv. no.
5290, acquired in 1887 from the
Museo Nazionale of Naples)
(Bassani 1975/1).
[pp. 198, *200, 204*]

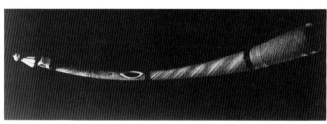

184. OLIPHANT
Zaire or Angola, Kongo-
Portuguese (?)
L. 61 cm.
Museo de Infanteria, Toledo
(Inv. no. 1003)
Presented by Count Paredes de
Nava
Traditionally credited to the col-
lection of the Spanish writer of
Peruvian origin, Garcilaso de La
Vega. (Estella 1985, no. 1003).
[pp. 198, *199*]

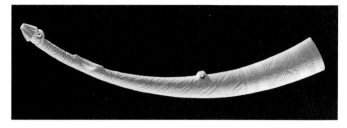

185. OLIPHANT
Zaire or Angola, Kongo-
Portuguese (?)
L. 70 cm.
Musée National des Thermes et
de l'Hôtel de Cluny, Paris (Inv.
no. CL428, acquired before
1843)
Ex collection: A. du Sommer-
ard
[pp. 198, *199*]

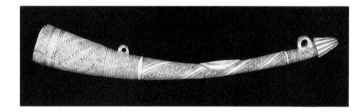

186. OLIPHANT
Zaire or Angola, Kongo-
Portuguese (?)
L. 69 cm.
Linden Museum, Stuttgart
(Inv. no. 18359)
Ex·collection: Krongut
[p. 198]

187. OLIPHANT
Zaire or Angola, Kongo-
Portuguese (?)
L. 43 cm.
Collection unknown: Christie's
sale 24.6.1985, lot 60
[p. 198]

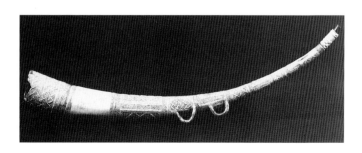

188. OLIPHANT
Zaire or Angola, Kongo-
Portuguese (?)
L. 40 cm. (finial missing)
Museo Nacional de Arte Anti-
ga, Lisbon (Inv. no. 21/Esc.)

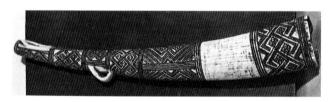

189. OLIPHANT
Zaire or Angola, Kongo-
Portuguese (?)
L. 71 cm.
Foundation Dapper, Paris
Ex collection: Charles Ratton,
Paris
[p. *206*]

190. KNIFE CASE (?)
Zaire or Angola (?), Kongo-
Portuguese (?)
H. 30 cm.
Detroit Institute of Arts, De-
troit (Inv. no. 25.183, acquired
in 1902, sale "Guidi" at the
Galleria Sangiorgi, Rome, 21-
27.4.1902, lot 402)
[pp. 200, *201*]

191. OLIPHANT

West Africa (?), Afro-Portuguese (?)
L. 71 cm.
Museum für Völkerkunde, Vienna (Inv. no. 63467)
Ex collection: Kunstkammer of Archduke Ferdinand of Tyrol,

Ambras Castle, Tyrol (?)
Registered in a manuscript inventory of 1595 as, ''One smooth, octagonal ivory horn plated in the middle, at the top and at the end'' (Heger 1899).
[pp. 209, *210*]

192. OLIPHANT

West Africa (?), Afro-Portuguese (?)
L. 66 cm.
The National Museum of Denmark, Copenhagen (Inv. no EGc15)

Ex collection: Gottorp Kunstkammer, Gottorp Castle, Schleswig-Holstein (see no. 106)
Registered in the manuscript inventory of 1710, VI/7 (Dam-Mikkelsen 1980, p. 49).
[pp. *99,* 209, 212]

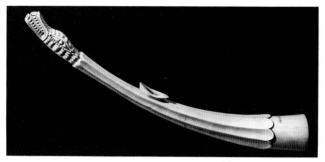

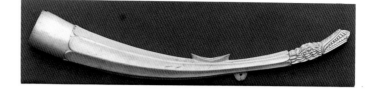

193. OLIPHANT

West Africa (?), Afro-Portuguese (?)
L. 62 cm.
The National Museum of Denmark, Copenhagen (Inv. no. EGc17)

Ex collection: Royal Kunstkammer
Registered in the manuscript inventory of 1737, 759/219 as, ''An ivory horn without base'' (Dam-Mikkelsen 1980, p. 49).
[pp. *208, 209*]

194. OLIPHANT

West Africa (?), Afro-Portuguese (?)
L. 53.5 cm.
Staatliches Museum für Völkerkunde,

Munich (Inv. no. Orb.20)
Ex collection: Ferdinand Orban (1657-1732), Ingolstadt (Krempel 1968).
[p. 209]

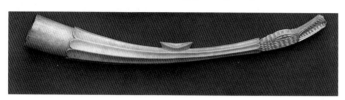

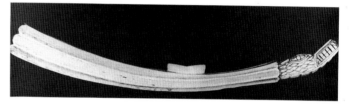

195. OLIPHANT

West Africa (?), Afro-Portuguese (?)
L. 79.5 cm.
Musée de l'Homme, Paris; on

loan from the Bibliothèque Nationale, Cabinets des Medailles, Paris
[pp. 209, *210*]

196. OLIPHANT

West Africa (?), Afro-Portuguese (?)
L. 59 cm.

L & R Entwistle and Co. Ltd., London
[pp. 209, 212]

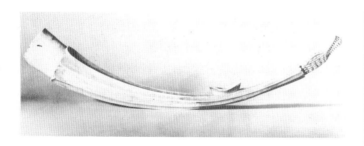

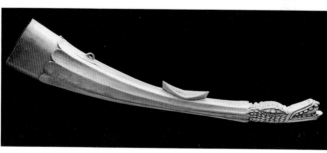

197. OLIPHANT

West Africa (?), Afro-Portuguese (?)
L. 38 cm. (fragment)
Ashmolean Museum of Art and Archaeology, Oxford (Inv. no. B.755)
Ex collection: J. Tradescant

Registered in a manuscript inventory of 1685, no. 755 as, ''Ivory indian trumpet, curved; one end shows a human hand. In the middle it has a hole to play'' (MacGregor 1983, no. 26).
[pp. 209, 212]

198. OLIPHANT

West Africa (?), Afro-Portuguese (?)
L. 36 cm. (fragment)

Collection unknown: Sotheby's sale 6.5.1983, lot 369
Ex collection: Hever Castle
[p. 209]

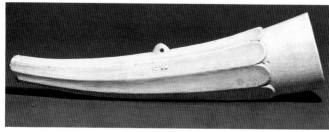

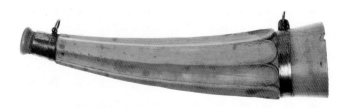

198a. OLIPHANT
West Africa (?), Afro-Portu-
guese (?)
L. 73 cm.
Private collection, U.S.A.
[p. 209]
[not illustrated]

199. OLIPHANT
West Africa (?), Afro-Portu-
guese (?)
Size unknown
Collection unkown

Illustrated in M. Praetorius,
1619, pl. XXX, no. 4, and de-
scribed as, "Ivory indian horn."
[p. 212]

200. OLIPHANT
West Africa (?), Afro-Portu-
guese (?)
Size unknown
Collection unkown
Ex collection: A. du Sommer-
ard, Paris

Illustrated in the painting, *Chez
l'Antiquaire,* by L.V. Fouquet,
1836, Musée des Arts Decoratifs,
Paris (Inv. no. 15814). It might
be oliphant no. 195.

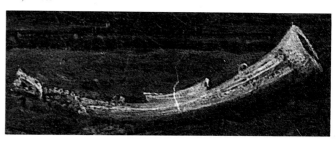

201. OLIPHANT
Sierra Leone, Sapi
L. 79 cm.
Musée de l'Homme, Paris (Inv.

no. 33.6.4, on loan from the
Bibliothèque Nationale, Cabi-
net des Medailles, Paris)
[pp. *91, 92, 93, 144,* 146]

202. OLIPHANT
Sierra Leone, Sapi
L. 64 cm.
The National Museum of Den-
mark, Copenhagen (Inv. no.
EGc12)
Ex collection: Gottorp Kun-
stkammer, Gottorp Castle
Schleswig-Holstein

Registered in the Gottorp manu-
script inventory of 1710, VI/7,
together with four other horns,
as, "Five large and small *litui* or
blow-horns of the savages made
of the teeth of elephants" (Dam-
Mikkelsen 1908, p.49).
[pp. 92, 93]

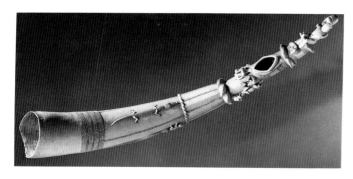

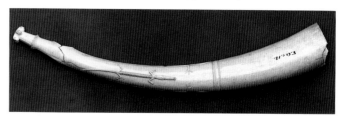

203. OLIPHANT
Sierra Leone, Sapi
L. 32 cm.
Ernst Anspach collection, New

York
Ex collection: H. Coray, Ag-
nuzzo
[pp. 92, *93,* 93]

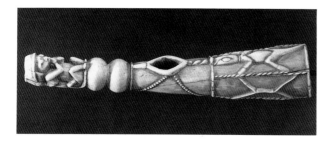

BIBLIOGRAPHY

AINAUD, J. "La Copa afro-portuguesa del Emperador." *Coloquio* 7(1960):33-36.

de ALBUQUERQUE, L. et al. *Os Descobrimentos Portugueses e a Europa do Renascimento—As Navigações Portuguesas e as suas consequências no Renascimento.* Lisbon, 1983.

ALLAN, M. *The Tradescants: their plants, gardens, and museum.* London, 1964.

ALLDRIDGE, T.J. *The Sherbro and its Hinterland.* London, 1901.

ALLISON, P. *African Stone Sculpture.* London, 1968.

de ALMADA, A.A. *Tratado Breve dos Rios de Guiné do Cabo Verde.* Leitura, Introduçao e notas de A. Brasio. 1594. Reprint. Lisbon, 1964.

ANDERSON, J. "Notice of a Carved Ivory Ciborium, the Property of James T. Gibson-Craig, Esq." *Archeologia Scotica* 5(1876):336-338.

ANDERSON, R.M. *Hispanic Costume, 1480-1530.* New York, 1979.

de ANDRADE, S.G. et al. *Os Descobrimentos Portugueses e a Europa do Rinascimento—As Descobertas e o Renascimento, Formas de Coincidência e de Cultura.* 1 & 2. Lisbon, 1983.

ANDREE, R. "Alte westafrikanische Elfenbeinschnitzwerke in Herzog Museum zu Braunschweig." *Globus* 79(1901):156-159.

———. "Seltene Ethnographica des Städtischen Gewerbe-Museum zu Ulm." *Baessler-Archiv* 4(1913):29-38.

ANGELUCCI, A. *Catalogo dell'Armeria Reale.* Turin, 1980.

Antiquarian Gleanings in the North of England being examples of antique furniture, plate church decorations, objects of historical interest, etc.— drawn and etched by William B. Scott. London, ca. 1850.

ATHERTON, J. and M. KALOUS. "Nomoli." *Journal of African History* 11(1970):303-317.

BARRETO, A.M. et al. *Os Descobrimentos Portugueses e a Europa do Renascimento—Armaria.* Lisbon, 1983.

de BARROS, J. *Décadas da Asia.* Porto, 1944.

BARROS, F. et al. *Os Descobrimentos Portugueses e a Europa do Renascimento—Antecedentes dos Descobrimentos.* Lisbon, 1983.

von BARTSCH, A. *Le peintre graveur.* 21 vols. Nuremberg, 1854.

———. *The Illustrated Bartsch.* New York, 1981.

BASSANI, E. "Antichi avori africani nelle collezioni Medicee 1-2." *Critica d'Arte* 143(1975):69-80 and 144(1975):8-23.

———. *Scultura Africana nei musei italiani.* Bologna, 1977.

———. "Oggetti Africani in antiche collezioni italiane 1-2." *Critica d'Arte* 151, 153(1977):151-182 and 154-156(1977):187-202.

———. "Gli olifanti afro-portoghesi della Sierra Leone." *Critica d'Arte* 163-165(1979):175-201.

———. "Trompes en ivoire du XVI siècle de la Sierra Leone." *L'Ethnographie* 85(1981-1982):151-168.

———. "Antichi manufatti dell'Africa Nera nelle collezioni Europee del Rinascimento e dell'Eta Barocca." *Quaderni Poro* 3(1982):9-34.

———. "A newly discovered Afro-Portuguese ivory?" *African Arts* 17, 4(1984):61-63.

BASSANI, E. and M. McLEOD. "African Material in Early Collections. In "*The Origins of Museums,* edited by O. Impey and A. MacGregor, 245-250. Oxford, 1985.

da BELARD, F.A. *O Misterio dos Paneis: Ao Personagens e a Armaria.* Lisbon, 1959.

BEN-AMOS, P. "Professionals and Amateurs in Benin Court Carving." In *African Images: Essays in African Iconology,* edited by D. McCall and E. Bay, 170-189. New York, 1975.

———. *The Art of Benin.* London, 1980.

Biblj Czeska. Petrus Lichtenstein: Venice, 1506.

BLACKMORE, H.L. *The Armouries of the Tower of London—I Ordnance.* London, 1976.

BLACKMUN, B.W. "Reading a Royal Altar Tusk." In *The Art of Power, The Power of Art—Studies in Benin Iconology,* edited by P. Ben-Amos and A. Rubin. Los Angeles, 1983.

BLAIR, C. "A Royal Swordsmith and Damascener: Diego de Çaias." *Metropolitan Museum Journal* 3(1970):149-198.

BLAKE, J.W. *Europeans in West Africa, 1450-1560.* London, 1942.

———. *West Africa: Quest for God and Gold.* London, 1977.

BONANNI, F. *A.P. Philippo Bonanni Societatis Jesu Musaeum Kircherianum sive a P. Athanasio Kirchero in Collegio Romano Societatis Jesu Jam Pridem inceptum Nuper restitutum auctum descriptum et iconibus illustratum.* Rome, 1709.

BONTINK, F. "La première Ambassade à Rome (1514)." *Etudes d'Histoire Africaine.* Kinshasa, 1970.

BOXER, C.R. *The Portuguese Seaborne Empire, 1415-1825.* New York, 1970.

BRADBURY, R.E. *The Benin Kingdom and the Edo-Speaking Peoples of South-Western Nigeria.* Reprint. London, 1970.

———. *Benin Studies.* Oxford, 1973.

BRASIO, A.D. *Monumenta Missionaria Africana: Africa Occidental.* 1st ser., 12 vols. Lisbon, 1952-1981.

———. *Monumenta Missionaria Africana.* 2nd ser., 5 vols. Lisbon, 1958.

BUCHNER, A. *Gli strumenti musicali attraverso i secoli.* Milan, 1964.

BURLAND, C. *The Exotic White Man.* New York, 1969.

Ces presentes heures à luisage de Rome ont esté faites pour Simon Vostre. Philippe Pigouchet: Paris, 1500-1501.

CHURCHILL, A. and J., comps. *A Collection of Voyages.* 6 vols. London, 1732.

CORDEIRO, L. *Viagens, exploraçoes e conquistas dos Portugueses— Da Mina ao Cabo Negro segundo Garcia Mendes Castelo Branco.* Lisbon, 1881.

CORTESÃO, A. *Historia da cartografia Portuguesa.* Coimbra, 1969.

CORTESÃO, A. and T.A. da MOTA. *Portugaliae monumenta cartografica.* 6 vols. Lisbon, 1960.

CORTESÃO, J. *Os descubrimentos portugueses.* Lisbon, 1960.

CORTEZ, F.R. "O Hostiário luso-africano do Museu de Grão Vasco." *Panorama* 4th ser., 21(1967):69-72.

COUTO, J. and A. N. GONÇALVES. *A Ourivesaria em Portugal.* Lisbon, 1960-1962.

de CRESCENTIS, P. *In commodum ruralium cum figuris libri duodecim.* P. Drach: Spira, ca.1490.

CRONE, G.R. *The Voyages of Ca' da Mosto and other documents on Western Africa in the second half of the fifteenth century.* London, 1937.

CURNOW, K. *The Afro-Portuguese ivories: classification and stylistic analysis of a hybrid art form.* Ph.D. diss., Indiana University, 1983.

CURTIN, P.D. *The Atlantic Slave Trade: A Census.* Wisconsin, 1969.

DALBY, D. "The Mel Languages: A Reclassification of Southern West Atlantic." *African Language Studies* 6(1965):1-17.

DAM-MIKKELSEN, B. and T. LUNDBAEK, eds. *Ethnographic Objects in the Royal Danish Kunstkammer, 1650-1800.* Copenhagen, 1980.

DAPPER, O. *Description de l'Afrique.* Amsterdam, 1686.

DARK, P. *An Introduction to Benin Art and Technology.* New York, 1973.

DARK, P. et al. *Benin Art.* London, 1960.

DEGEN, K. "Das Köllesche Elfenbeinhorn." *Heimatkundliche Blätter für der Kreis Tübingen* 4(1952):14-15 and 1(1953):18-19.

DITTMER, K. "Bedeutung, Datierung und kulturhistorische Zusammenhänge der 'prähistorischen' Steinfiguren aus Sierra Leone und Guinée." *Baessler-Archiv* 15(1967):183-238.

DONELHA, A. *Descrição da Serra Leoa e dos rios de Guiné do Cabo Verde.* Edited by T.A. da Mota. Translation and notes by P.E.H. Hair. Lisbon, 1977.

de DORNELLAS, A. "Instituçã do vinculo de morgadio des Condes de Villa Real, feita em Ceuta em 1431." *Elucidario Nobilarquico* 1(1928):309-313.

DÜRER, A. *Niederländische Reise.* Vol. 1, edited by J. Veth and S. Muller. Berlin, 1918.

————. *Albrecht Dürer, Diary of his Journey to the Netherlands.* Greenwich, Connecticut, 1971.

DURRIEU, P. *La Miniature flamande au temps de la Cour de Bourgogne,(1415-1530).* Brussels, 1921.

EECKHOUT, P. *Albert Dürer aux Pays-Bas.* Brussels, 1977.

EGERTON, Lord of Tatton. *A Description of Indian and Oriental Armour.* 1896. Reprint. London, 1968.

EGHAREVBA, J. *A Short History of Benin.* Ibadan, 1960.

ESTELLA, M.M. *La escultura barroca de marfil en España-Escuelas europeas y colonial.* 2 vols. Madrid, 1984.

EYO, E. "Igbo Laja Owo." *West African Journal of Archaeology* 6(1976):37-58.

EYO, E. and F. WILLET. *Treasures of Ancient Nigeria.* New York, 1980.

FAGE, J.D. *A History of Africa.* Cambridge, 1978.

————. "A Comment on Duarte Pacheco Pereira's Account of the Lower Guinea Coastlands in his *Esmeraldo de Situ Orbis* and some other Early Accounts." *History in Africa* 7(1980):47-80.

FAGG, W.B. *Afro-Portugues Ivories.* London, 1959.

————. *Nigerian Images.* New York, 1963.

————. "The Carvers of the Afro-Portuguese Ivories." *International Congress of the Anthropological and Ethnological Sciences.* 1964.

————. "The African Artist." In *Tradition and Creativity in Tribal Art,* edited by D. Biebuyck, 42-57. Berkley, 1969.

————. *Divine Kinship in Africa.* London, 1970.

————. *African Majesty from Grassland and Forest.* Toronto, 1981.

FAVA, A.S. "Storia delle collezioni etnologiche del Museo Civico." *Africa America Oceania—Le Collezioni Etnologiche.* 5-11. Turin, 1978.

FERNANDES, V. *Description de la Côte Occidentale d'Afrique, (Sénégal au Cap de Monte Archipels).* Edited by T. Monod, A. T. da Mota and R. Mauny. Bissau, 1951.

FERRAO, B. "Imaginaria indo-portuguesa de marfim." *Panorama* 4th ser., 32(1969):76-83.

FILESI, T. "Le Relazioni tra il regno del Congo e la Sede Apostolica." *Africa* 22, 3(1967):247-285 and 4(1967):411-460.

FILGUEIRAS, O.I. "A presumptive Germanic heritage for a Portuguese boat building tradition." *Medieval ships and harbours in Northern Europe.* Greenwich, Connecticut. 1979.

FLEISCHHAER, W. *Kunstkammern und kronejuwelen.* Stuttgart, 1977.

FORSYTH, W.H. "The Medieval Stag Hunt." *The Metropolitan Museum of Art Bulletin,* 1952, 203-210.

de la FOSSE, E. "Voyage a la côte occidentale d'Afrique, 1479-1480." In *Boletim Cultural da Guiné Portuguesa,* edited by R. Mauny. Vol. 4, 14(1949):181-195.

FOY, W. "Zur Frage de Herkunft einiger alter Jagdhörner: Portugal oder Benin?" *Abhandlungen und Berichte des Konig. Zoolog. und Antropologisch-Ethnographischen Museums zu Dresden* 9(1900-1901):20-22.

FRÖLICH, W. "Das westafrikanische Elfenbeinhorn aus dem 16 Jahrundets im Rautenstrauch-Joest Museum." *Ethnologica* 2(1960):426-432.

FRY, R. *Vision and Design.* London, 1920.

FYFE, C.S. *Sierra Leone Inheritance.* London, 1964.

GIGLIOLI, E.H. *La Collezione del Prof. Enrico Hyllier Giglioli geographicamente classificata.* 2 vols. Citta di Castello, 1912.

GODINHO, V.M. *Os descobrimentos e a economia mundial.* 3 vols. 2nd ed. Lisbon, 1982.

de GOIS, D. *Opuscolos Historicos.* Translated by Dias de Carvalho. Porto, 1945.

————. *Chronica do Felicissimo Rei D. Manuel, composta por Damiao de Gois.* 2 vols. Nova ediçao conforme a primera da 1566. Coimbra, 1949-1954.

GROTTANELLI, V.L. "Discovery of a Masterpiece: A Sixteenth Century Ivory Bowl from Sierra Leone." *African Arts* 8(1975):14-23.

HAIR, P.E.H. "An Ethnolinguistic Inventory of the Lower Guinea Coast before 1700: Part I." *African Language Review* 7(1968): 47-73.

————. "From language to culture: some problems in the systematic analysis of the ethnohistorical records of the Sierra Leone region." In *The Population Factor in African Studies,* edited by R.P. Moss & R.J.A.R. Rathbone, 71-83. London, 1974.

HACKLUYT, R. *The Principal Navigations Voyages Traffiques and Discoveries of the English Nations.* Vol. 4. Glasgow, 1904.

HANTZSCH, V. "Beiträge zur alten Geschichte der Kurfürstlichen Kunstkammer in Dresden." *Neues Archiv für Sächs. Geschichte und Altertumskunde* 23(1902):220-296.

HÉBERT, M. *Inventaire des gravures des Écoles du Nord, 1440-1550.* 2 vols. Paris, 1982.

HEGER, F. "Alte Elfenbeinarbeiten aus Afrika in den Wiener Sammlungen." *Mitteilungen der anthropologischen Gesellschaft Wien* 29(1899):101-109.

HENGGELER, J. "Ivory Trumpets of the Mende." *African Arts* 14, 2(1981):59-63.

HOLLSTEIN, F.W.H. *German Engravings, Etchings and Woodcuts, ca 1400-1700.* 28 vols. Amsterdam, 1954.

Horae ad usum Romanorum/Io. de prato. Jean du Pré: Paris (?), 1499 (?).

Horae Beatae Mariae Virginis. Thielman Kerver: Paris, 1499.

Horae Beatae Mariae Virginis. Philippe Pigouchet pour Simon Vostre: Paris, 1498.

HUNT, J. "Jewelled neck furs and 'Flohpelze.' " *Pantheon* (1963): 151-157.

INCISA, della ROCCHETA G. "Il Museo di curiosità del Card.

Flavio I Chigi." *Archivio della Società Romana di Storia Patria*, 3d. ser., vol. 89 (1966):141-192.

INSTITOR, H. (Krämer) and J. SPRENGER. *Malleus maleficorum tria continens quae ad maleficium concurrunt, ut sunt Daemon, Maleficus et Divina permissio*. Strasbourg, 1486-1487.

Inventario Semplice di tutte le materie esattamente descritte che si trovano nel Museo Cospiano. Bologna, 1680.

JACOBAEUS, H. *Museum Regium seu Catalogus rerum tam naturalium quam artificialium quae in basilica bibliothecae Augustissimi Daniae Norvegiaeque Monarchae Christiani quinti Hafniae asservantur*. Copenhagen (Hafnia), 1696.

JOYCE, T.A. "Steatite Figures from West Africa in the British Museum." *Man* 5(1905):96-100.

———. "Steatite Figures from Sierra Leone." *Man* 9(1909):64-77.

KAPLAN, F., ed. *Images of Power: Art of the Royal Court of Benin*. New York, 1981.

KECSKESI, M. *African Masterpieces and selected works from Munich: The Staatliches Museum für Völkerkunde*. New York, 1987.

KOHLHAUSSEN, H. *Nürnberger Goldschmiedkunst des Mittelalters und der Dürerzeit: 1240 bis 1540*. Berlin, 1968.

KREMPEL, U. "Die Orbansche Sammlung, eine Raritätenkammer der 18 Jahrhunderts." *Münchner Jahrbuch der bildenden Kunst*, 3d. ser., 29(1968):169-184.

KRIEGER, K. *Westafrikanische Plastik*. 3 vols., Berlin, 1965-1969.

KUP, A.P. *History of Sierra Leone, 1400-1787*. Cambridge, 1961.

———. *Sierra Leone: A Concise History*. New York, 1975.

LAMP, F. "House of Stones: Memorial Art of Fifteenth Century Sierra Leone." *The Art Bulletin* 65, 2(1983):219-237.

LAUDE, J. *La peinture française (1905-1914) et "l'art nègre."* Paris, 1968.

LIPS, J. *The Savage Hits Back*. London, 1937.

von LUSCHAN, F. *Die Altertümer von Benin*. 3 vols. Berlin, 1919.

MacGREGOR, A., ed. *Tradescant's Rarities: Essay on the Foundation of the Ashmolean Museum 1683, with a Catalogue of the Surviving Early Collection*. Oxford, 1983.

McLEOD, M. *Treasures of African Art*. New York, 1980.

Mer des Hystoire. Pierre le Rouge for Vincent Commin. Paris, 1488.

da MOTA, T.A. "A Escola de Sagres." *Anais do Clube Militar Naval* Numero Especial (1960):5-20. Lisbon.

———. "Gli Avori africani nella documentazione portoghese dei secoli 15-17." *Africa* 30, 4(1975):580-589.

———. *Some Aspects of Portuguese Colonization and Sea Trade in West Africa in the Fifteenth and Sixteenth Centuries*. Bloomington, 1976.

MULLER, C.C. *400 Jahre Sammeln und Reisen der Wittelsbacher*. Munich, 1980.

NEUBECKER, O. *Heraldry: Sources, Symbols and Meaning*. New York, 1976.

NEWBURY, C.W. *The Western Slave Coast and its Rulers*. Oxford, 1961.

NIKEL, H. "Tracht und Ausrüstung der Konquistadoren und Entdecker im frühen 16 Jahrundert." *Mitteilungen der Gesellschaft für historische Kostüm und Waffenkunde* (1957):4-9.

NORMAN, A.V.B. *The Rapier and Small Sword, 1460-1820*. New York, 1980.

Officium Beatae Mariae Virginis. Venice, 1502.

Officium Beatae Mariae Virginis. Jacobus Pencius de Leucho per Alessandro Pagani: Venice, 1513.

Officium Beatae Mariae Virginis. Gregorius de Gregoriis: Venice, 1523.

OLBRECHTS, F.M. "Contribution to the study of the chronology of African plastic art." *Africa* 14, 4(1943):183-193.

OLEARIUS (Oelschlager), A. *Gottorffische Kunstakammer . . .* Schleswig, 1666.

de OLIVEIRA, A.H. *Daily Life in Portugal in the Late Middle Age*. Wisconsin, 1971.

OMAN, C. *The Golden Age of Hispanic Silver, 1400-1665*. London, 1968.

OSORIO, J. *Da vida e feitos de el rei D. Manuel*. Porto, 1944.

OVIDIUS. *Le Metamorfosi*. Nicolò di Aristotele detto Zoppino: n.p., 1537.

———. *Metamorphoses*. Franciscus Mazalis: Parma, 1505.

PACHECO PEREIRA, D. *Esmeraldo de situ orbis*. Ed. critica e anotada por A. Epifanio da Silva Dias. Lisbon, 1905.

PERSON, Y. "Les Kissi et leur statuettes de pierre dans la cadre de l'histoire ouest-africaine." *Bulletin de l'Institut Français de l'Afrique Noire* 23, 1-2(1961):1-60.

PETTAZZONI, R. "Avori scolpiti in collezioni italiane—Contributo allo studio dell'arte del 'Benin.' " *Bollettino d'Arte* 5(1911):56-74 and 6(1912):147-160.

PICO, della MIRANDOLA G. *Libro detto strega overo le illusioni del Demonio del Signor Giovanni Francesco Pico della Mirandola*. Venice, 1556.

PIGAFETTA, F. *Relatione del Reame di Congo et delle Cirvonvicine Contrade—Tratta dalli scritti et ragionamenti di Odoardo Lopez Portoghese*. Rome, 1591.

———. *Warhaffte und Eigentliche Beschreibung des Königreiches Congo in Africa*. Frankfort, 1597.

———. *Regnum Congo hoc est vera Desriptio . . .* Frankfort, 1598.

———. *Description du Royaume du Congo et des Contrées Environnantes par Filippo Pigafetta et Duarte Lopez*. Translated by Willy Bal. Louvain, 1965.

de PINA, R. *Chronica del rey D. Joao II*. Coimbra, 1950.

PINTO, M.H.M. "Contador Indo-Portugues de tipo Mogul." *Observador* 19(1971).

PINTO, M.H.M. et al. *Os Descobrimentos Portugueses e a Europa do Renascimento—A Arte na Rota do Oriente*. Lisbon, 1983

PLASS, M. "Above the Salt." *Expedition* 5, 3(1963):38-41.

PRAETORIUS, M. *Theatrum Instrumentorum*. Wolfenbüttel, 1619.

PURCHAS, S. *Hackluytus Posthumous or Purchas his Pilgrims, 1584*. London, 1625.

———. *Hackluytus Postumous*. Glasgow, 1905.

RAMUSIO, G.B. *Primo volume delle Navigationi et Viaggi Nel Qual si contiene la Descrittione dell'Africa, Et del paese del Prete Ianni, con vari viaggi . . .* Venice, 1550.

READ, C.H. and O.M. DALTON. *Antiquities from the City of Benin and from other parts of West Africa*. London, 1899.

RÉAU, L. *Iconographie de l'Art chrétien*. Paris, 1954.

Regule Ordinum. Jo. Emer. de Spira, per Luc'Antonio Giunta: Venice, 1500.

de RESENDE, G. *Chronica de Dom João II.* Lyuro da Obras de Garcia de Resêde, Lisbon, 1545.

———. *Chronicas dos valerosos e insignes feitos d'El Rey D. João II.* Lisbon, 1902.

RODNEY, W. "A Reconsideration of the Mane Invasion of Sierra Leone." *Journal of African History* 8, 2(1967).

———. *A History of the Upper Guinea Coast, 1545-1800.* Oxford, 1970.

de la RONCIÈRE, C. "Découverte d'une relation de voyage datée du Touat e décerivant en 1447 le bassin du Niger". *Bulletin de la Section de geographie du Comité des travaux historiques* (1919).

ROSELL Y TORRES, I. "La Bocina da Caza de Marfil del Museo Arqueologico Nacional," edited by J.G. Dorregaray. *Museo Espanol de Antigüedades* 9(1878):183-189.

ROTH, H.L. *Great Benin: Its Customs, Art, and Horrors.* London, 1903.

RÜTIMEYER, L. "Über westakfrikanische Steindole." *International Archiv für Ethnographie* 14(1901):195-207.

RYDER, A.F.C. "A Note on the Afro-Portuguese Ivories." *Journal of African History* 5(1964):363-365.

———. *Benin and the Europeans, 1485-1897.* London, 1969.

SACHS, C. *The History of Musical Instruments.* New York, 1940.

de SAMPAYO RIBEIRO, M. "O Olifante de Drummond Castle." *Panorama* 4, 9(1964).

SANCEAU, E. *The Reign of the Fortunate King, 1495-1521.* Coimbra, 1950.

SANTOS, R. dos, *O estilo manuelino.* Lisbon, 1952.

SANTOS, R. dos and I. QUILHÓ. *Ouriversaria portuguesa nas collecçoes particulares.* Lisbon, 1959.

SANTOS, V.P. dos. et al. *Os Descobrimentos Portuguese e a Europa do Renascimento—A Dinastia de Avis.* Lisbon, 1983.

SCHEDEL, H. *Liber Chronicarum.* Nuremberg, 1493.

SCHIEDLAUSKY, G. "Zum sogennante Flohpelz." *Pantheon* (1972):469-480.

von SCHLOSSER, J. *Kunst und Wunderkammern der Spätrenaissance.* Leipzig, 1908.

SCHMELTZ, J.D.E. *Medeelingen uit's Rijks Ethnographisch Museum.* 10(1897):261-264.

SIEBER, R. *African Furniture and Household Objects.* Bloomington, 1980.

SOTHEBY'S, *Catalogue of Works of Art from Benin.* London, 1980.

SPIRITO, L. *Libro della Ventura ovvero libro della sorte.* Pietro Martire Mantegazza per Giovanni Legnano: Milano, 1500.

SPRINGER, B. *B. Springer dise nachoulgenden figüren des wandels und gerbrauchs der Kunigreich . . .* s.l., 1508.

SVOBODA, A. *Illustrierte Musik-Geschichte von Adalbert Svoboda mit Abbildungen von Max Freiherrn von Branca.* 3 vols. Stuttgart, 1892-1894.

TAGLIAFERRI, A. "Survivors." *Notiziario—News and Comments.* Galleria Lorenzelli, Milan: 7(1978):4-8.

TAGLIAFERRI, A. and A. HAMMACHER. *Fabulous Ancestors: Stone Carvings from Sierra Leone and Guinea.* New York, 1974.

TARDY, A. *Les ivoires.* 2 vols. Paris, 1977.

THOMPSON, R.F. *The Four Moments of the Sun.* Washington, 1981.

TOWNSHEND, F.G. *Synopsis of the Newcastle Museum—late the Allan, formerly the Tunstall or Wycliff Museum.* Newcastle, 1827.

TRICASSO de CERESARI. *Chiromantia.* Giovanni Francesco e Giovanni Antonio Rusconi: Venice, n.d.

Viaggio da Venetia al Sancto Sepulchro. Nicolò Zoppino and Vicenzo Polo: Venice, 1518.

Vita della Gloriosa Vergine Maria. Nicolò Zoppino: Venice, 1505.

Vita della Vergine. per Luc'Antonio Giunta: Venice, 1492.

VOGEL, S. *For Spirits and Kings—African Art from the Tishman Collection.* New York, 1981.

———. *African Aesthetics—The Carlo Monzino Collection.* New York, 1986.

WELSH, J. "A voyage to Benin beyond the countrey of Guinea made by Master James Welsh, who set forth in the yeere 1588." In *The Principal Navigations Voyages Traffiques and Discoveries of the English Nation,* edited by R. Hackluyt. London, 1904.

WILLET, F. "The Benin Museum Collection." *African Arts.* 6, 4(1973): 8-17.

WOLF, S. "Afrikanische Elfenbeinlöffel des 16 Jahrhunderts im Museum für Völkerkunde Dresden." *Ethnologica* 2(1960):410-425.

WOODWARD, J. and J. BURNETT. *Treatise on Heraldry.* 1892. Reprint. 1969.

WORM, O. *Danicorum Monumentorum.* Copenhagen, 1643.

ZEILER, M. *Exoticophylacium Weikmannianum . . .* Ulm, 1659.

PHOTOGRAPH CREDITS

Academia das Ciencias, Lisbon, 4, 163; Allen Memorial Art Museum, Oberlin College, 55; W. Graham Arader III Gallery, New York, XVI; Archivo Fotografico, Vatican, 10; Arquivo Historico da Câmara Municipal, Lisbon, 207; Armeria Reale, Turin, (no. 81); Ashmolean Museum, University of Oxford, (no. 71), (no. 72), (no. 197); Australian National Museum, Canberra, (no. 75), 112, 114, 115, 119, 177; Dirk Bakker, 253, 289; Ezio Bassani, 40, 52, 54, 60, 62, 102, 113, 116, 118, 120, 127, 130, 138, 140, 142, 144, 145, 147, 150, 223; Beinecke Rare Book and Manuscript Library, Yale University 5; Biblioteca Ambrosiana, Milan, 12; Bibliothèque Nationale, Cabinet des Manuscripts, Paris, 3, 148; The Bowes Museum, Barnard Castle, Co. Durham (no. 16), 186; Antoinin Blaha, (no. 106); The British Library, 26; The British Museum, (no. 2), 28, (no. 32), (no. 34), 34, 35, (no. 43), (no. 45), 51, (no. 53), 53, 56, (no. 63), 63, 64, 70, (no. 70), (no. 73), (no. 77), 79, (no. 83), 90, (no. 90), (no. 102), (no. 119), 158, 167, 168, (no. 171), (no. 173), 174, (no. 174), 200, 201, 209, 219, 221, 225, 237, 238, 241, 243, 244, 254, 256, 263. The Burrell Collection, Glasgow, 153; Mario Carrieri, XI, 19, 36, (no. 80), 104, 199, 291; Christie's, London, (no. 58), 77, 101; The Cloisters Collection, The Metropolitan Museum of Art, New York, 108, 117; A.C. Cooper, (no. 92), 141, (no. 187); Robert David, (no. 33); The Detroit Institute of Arts, Detroit, 121, 122, 271 (no. 190); Ursula Didoni, (no. 186), 197; Direcçao de Serviços de Monumentos Nacional, Portugal, 131, 132, 134; Etnografisch Museum, Antwerp, (no. 123), 249, 250; Field Museum of Natural History, Chicago, (no. 56); The Barbara and Murray Frum Collection, Toronto, 257, 258, 272; Fundaçao Madeiros e Almeida, Lisbon, 22; Galleria Estense, Modena, (no. 27), 46; Glasgow Museums and Art Galleries, Glasgow, (no. 46), 66, 88; Philippe Guimiot, Brussels, (no. 196); Courtesy of Jay and Clayre Haft collection, XIII; Ken Heinen, (no. 175); The Hermitage Museum, Leningrad, (no. 87,) 146; Instituto Valencia De Don Juan, Madrid, 143; Jurgen Karpinski, 183; Kugel collection, Paris, 149; Kunsthis-

toriches Museum, Vienna, XV, 261, 262; Henrik Larsen, 1, (no. 4), 14, 15, (no. 44), (no. 51), (no. 61), 111, (no. 128), 157, (no. 161), (no. 162), (no. 163), 171, 173, 187, (no. 192), (no. 193), 196, (no. 202), 252, 281; Leloup Gallery, New York, 265; Foundation Dapper, Paris, 2, 6, 8, 278; Fritz Mandl, (no. 10), (no. 15), (no. 68), (no. 149), (no. 150), (no. 151), (no. 152), (no. 153), (no. 154), (no. 155), (no. 191), 284; Vittorio Mangio Monza, 89; Meneghini collection, 65, 71; Merseyside County Museums, Liverpool, 182, (no. 117); The Metropolitan Museum of Art, New York, 82, 97, 212, 242, 292; The Minneapolis Institute of Arts, Minneapolis, 290; Monbrison collection, Paris, (no. 52); F. Monti collection, 72; Musée Barbier-Muller, Geneva, 287; Musée des Arts Decoratifs, Paris, (no. 200); Musée des Beaux Arts, Lille, 260; Musée de Cluny, Paris, 27, (no. 88d), 268; Musée de la Renaissance, Château d'Écouen, Paris, 83, 86; Musée de l'Homme, Paris, VI, X, (no. 82), 96, 283; Musée Royal de l'Afrique Central, Tervuren, 273, 279; Museo Civico di Palazzo Madama, Torino, (no. 170); Museo Civico Medievale, Bologna, (no. 8), 43, 59; Museo Nacional de Artes Decorativas, Madrid, 179, 180; Museo del Ejercito, Alcazar, Toledo, (no. 3); Museo de Grão Vasco, Viseu, 78, (no. 57); Museo de Infanteria, Toledo, 267; Museo de America, Madrid, 31, 58; Museo di Antropologia e Etnologia, Florence, (no. 132), (no. 133); Museo Nazionale Preistorico e Etnografico, Rome (no. 41), 274; Museo Kircherino, Rome, 32; Museu Nacional de Arte Antiga, Lisbon, 23, 76, (no. 78), 80, 81, (no. 96), (no. 107), (no. 127), (no. 188), 210, 213, 224, 247, 248; Museum für Islamiche Kunst, Berlin, 126; Museum für Völkerkunde, Basel, 50; Museum für Völkerkunde, Berlin, 9, (no. 12), 42, 229, 239; Swantje Autrum Mülzer, (no. 37), 61, (no. 65), (no. 168), 172, (no. 194), 282; Museum für Völkerkunde, Vienna, (no. 10), 25, 45, 67, 68, 69, 84, 184, 206, 227, 228; National Museums of Scotland, 154, 155, 161, 240; National Museum, Lagos, V, (no. 11), 235, 255; O.E. Nelson, 222; The Newark Museum, i; Larry Ostrom, 277; Manuel Palma, 136; Peabody

Museum, Harvard University, Cambridge, 37; Francesco Pellizzi collection, 18; Jan Picha, 231; Maria Helena Mendes Pinto, Lisbon, (no. 178); Pitt Rivers Museum, Oxford, (no. 28), 165, 190, 264; Rheinisches Bildarchiv, Cologne, 202, 203, 204, 205; Stan Ries, (no. 203), 211; F. Reiser collection, 20; Rijksmuseum voor Volkenkunde, Leiden, (no. 25), 58, 215, 251; Fred Rolin, New York, (no. 39); The Royal Armouries, H.M. Tower of London, 105, 107; Royal Ontario Museum, Toronto, 217; Schatzkammer der Residenz, Munich, 21; W. Schneider-Schutz, (no. 18), (no. 26), (no. 126), 160, 164, 189, 229; Tom Scott, 214; Seattle Art Museum, Seattle, (no. 13), 38, (no. 40), 74, (no. 76), 92, 170; Sotheby's, London, (no. 20), (no. 98), (no. 108), (no. 113) (no. 198); Soprintendenza Per I Beni Artistici E Storici Del Piemonte, Turin, (no. 183); Städtisches Museum, Braunschweig, (no. 62), (no. 166), (no. 167), 175, 226; Städtisches Sammlungen, Tubingen, (no. 86); Staatliche Museen Preussischer Kulturbesitz Gemaldegälerie, Berlin, XIV; Jerry L. Thompson, front cover, IX, (no. 8), 13, 16, 24, 29, 30, 33, (no. 41), 41, 46, 47, 48, 49, 73, (no. 76), (no. 84), 87, (no. 89), 91, (no. 93), 93, 94, 95, 98, 99, 100, (no. 101), 103, 106, 109, 128, (no. 129), 129, (no. 130), (no. 131), (no. 132), 135, 139, 151, 152, 156, 162, 166, 169, 178, (no. 180), 181, (no. 182), (no. 183), 191, 192, 198, 216, 227, 228, 236, 245, 246, 259, 266, 269, 270, 275, 276, 293, 294; Paul and Ruth Tishman Collection of African Art, Walt Disney Co., Los Angeles, 17, (no. 121); Uffizi, Florence 44; Ulmer Museum, Ulm, (no. 156), (no. 157), (no. 158), (no. 159), (no. 160), 193, 194, 195, 232, 233; Universitets Konst Museum, Uppsala Universitet, (no. 164); The University Museum, University of Pennslyvania, Philadelphia, 230; Vatican Museum, Rome, 110; Gerhard Vesely, 185; Victoria and Albert Museum, London, 39, 85, 123; The Virginia Museum of Fine Arts, Richmond, 285; Susan Vogel, VII; The Walters Art Gallery, Baltimore, 75, 137, 176; Andrew Wilson Photography, 159; Württembergisches Landesmuseum, Stuttgart, (no. 91); Yale University Art Gallery, (no. 177).

This book was produced by
The Center for African Art, New York.
Editor-in-chief, Susan Vogel.
Edited by Jeanne Mullin.
It was composed in Bembo, derived from
a fifteenth century Venetian typeface,
set by David Seham Associates, Inc.
It was printed and bound in Japan
by Dai Nippon Printing.
Designed by John Morning.